CENTURY
CITY

ART
AND CULTURE IN THE
MODERN
METROPOLIS

TATE PUBLISHING

SPONSORED BY

PUBLISHED BY ORDER OF THE TATE TRUSTEES 2001
ON THE OCCASION OF THE EXHIBITION AT TATE MODERN,
LONDON, 1 FEBRUARY – 29 APRIL 2001

ISBN 1 85437 344 7

A CATALOGUE RECORD FOR THIS PUBLICATION
IS AVAILABLE FROM THE BRITISH LIBRARY

PUBLISHED BY TATE GALLERY PUBLISHING LTD
MILLBANK, LONDON SW1P 4RG

CATALOGUE DESIGN BY SMITH

PRINTED AND BOUND IN GREAT BRITAIN
BY BALDING + MANSELL, NORWICH

MEASUREMENTS ARE GIVEN IN
CENTIMETRES, HEIGHT BEFORE WIDTH

COVER: TOKYO IN THE SMOG, 1967
PHOTO: ASAHI SHIMBUN

CENTURY CITY

ART

AND CULTURE IN THE
MODERN
METROPOLIS

EDITED BY IWONA BLAZWICK

SPONSOR'S FOREWORD

Century City is Tate Modern's first major exhibition. It is ambitious in concept, exciting in content and breathtaking in execution.

Tate Modern's team of expert curators has brought together successfully some of the world's most important works of art to illustrate the influence of urban culture in our intellectual development.

The works selected for *Century City* have been produced at defining moments in our modern day society. They are works that capture the essence of the modern metropolis, the cultural richness of modern day living and the exploration of man's purpose through artistic expression.

This exhibition is a rare insight in to the range and quality of human endeavour and a reminder of how remarkable, ingenious and controversial the creative process can be in helping to fashion the world, the way we think and the way we live.

As a company which is international in outlook and progressive in its thinking, CGNU is proud to sponsor *Century City*.

Pehr G Gyllenhammar
Chairman, CGNU plc

FOREWORD

Century City explores the relationship between the metropolis and the creation of art. It focuses not only on the traditional twentieth-century art centres of Paris, New York, Vienna, Moscow and London; but also on other intensely creative environments: Bombay/Mumbai, Lagos, Rio de Janeiro and Tokyo. These cities have been the sites for pioneering artistries, for paradigm shifts in modern art. Moving from 1900 to the present, the project focuses on cultural flashpoints which have illuminated the twentieth century and which continue to ignite contemporary culture. *Century City* also shows that visual art does not develop in isolation but rather in dialogue with a wide variety of cultural expressions such as design, architecture, film, dance, music and literature. *Century City* is thus classic and contemporary, global and local, cross cultural but with a firm focus on visual art. In this it resembles Tate Modern.

Indeed *Century City*, which launches Tate Modern's exhibition programme, can be seen as a mission statement which forecasts the richness, breadth and direction that we hope will characterise our activities in the coming years. The give and take across the demarcation lines that traditionally separate various cultural expressions will be the subject of continued exploration at Tate Modern, both in monographic and thematic exhibitions and in a growing offering of special events. The global remit of *Century City* indicates Tate Modern's ambition to widen our cultural perspective, from a Western concept of internationalism – in the case of modern museums often synonymous, embarrassingly enough, with the NATO alliance – to one which is truly worldwide. Like *Century City* the programme will be at the same time classic and cutting edge, large scale and intimate, aesthetically appealing and intellectually challenging.

Century City is one of the largest and most complex exhibition projects ever undertaken by a museum in this country. I would like to thank all the artists who have agreed to participate in this ambitious project and those institutions, galleries and individuals who have not only lent works but provided invaluable advice and support.

We have worked in collaboration with a number of distinguished international experts and curators. Lutz Becker, Richard Calvocoressi, Okwui Enwezor, Serge Fauchereau, Keith Hartley, Geeta Kapur, Olu Oguibe, Reiko Tomii and Paulo Venancio Filho have worked alongside Tate Modern curators Donna De Salvo, Emma Dexter and Susan May, and with associate curators Michael Asbury and Ashish Rajadhyaksha to identify histories and places, key individuals and works. Without their commitment, enthusiasm and expertise this exhibition could not have been realised. I simply cannot thank them enough – not only for their curatorial vision, but also for their contributions to this publication. Their city focused essays are followed by three texts which look at the postcolonial metropolis, the city and cultural identity, and the relationship between urban and cultural economics. I would like to thank Ziauddin Sardar, Joachim Schlör and Sharon Zukin for their scholarly and revelatory texts. The curatorial and editorial teams have been led by Iwona Blazwick who also provides an introduction to the exhibition and this book.

I am immensely grateful to the Tate Modern team which has overseen the shaping, design and delivery of the project. Particularly Sarah Tinsley and Phil Monk who, along with Kirsten Berkeley, Susanne Bieber, Juliet Bingham, Sophie Clark, Stephen Dunn, Claire Fitzsimmons, Adrian George, Nickos Gogolos and Sophie McKinlay, have worked to make a vision into a reality. The care and installation of some 1,000 works has been undertaken by a dedicated team of registrars, researchers, conservators and technicians, the delivery of this book by Tim Holton and Mary Richards at Tate Publishing. The architects Caruso St. John and the designer Stuart Smith have provided a brilliant spatial and aesthetic solution for bringing together the diversities of *Century City*.

Finally, I would also like to express my great appreciation to Pehr Gyllenhammar and his colleagues on the Board of CGNU, without whose enlightened sponsorship we could never have realised the full ambitions of this project.

Lars Nittve
Director, Tate Modern

CENTURY CITY

IWONA BLAZWICK

Who hasn't felt a thrill run up their spine on looking out of a plane at night and seeing the electric geometries of the nocturnal city? Lines of red and white light pulse in and out of a spatial web, sodium orange and flourescent blue at its industrialised edges, points of rainbow-coloured neon through the centre. The city seems to stretch across the dark land mass: inhaling traffic, resources, people; exhaling refuse, spectacle, ideology and change. The city is the medium for the modern.

What is it about the metropolis that has made it the platform for modernity, for modernisation – and for Modernism itself? To explore the relationship between vanguard culture and the urban, *Century City* focuses on nine cities from Africa, Asia, the Americas and Europe which have, at specific historical moments, acted as crucibles for cultural innovation. Each city has witnessed a flashpoint generated by artists and other cultural practitioners. Each of these moments represents a pivotal artistic and intellectual movement. *Century City* maps the alchemical processes that transform raw aspiration into cultural phenomena.

Before focusing on individual cities, each expertly mapped by the curators who have co-authored this book, what follows is an attempt to define those characteristics of the modern metropolis that make it the context for cultural production.

THE CITY AS EVENT By contrast with the stability of small town life, the metropolis offers a ceaseless encounter with the new. Writing in 1902, the philosopher Georg Simmel defined life in the city: 'On the one hand, life is made infinitely easy for the personality in that stimulations, interests, uses of time and consciousness are offered to it from all sides. They carry the person as if in a stream and one needs hardly swim for oneself. On the other hand, however, life is composed more and more of these impersonal contents and offerings which tended to displace the genuine personal colorations and incomparabilities.'[1] To survive these conditions Simmel argues that the metropolitan psyche adopts a patina of indifference and engages in a struggle not only for economic survival but for the assertion of a high profile individualism. In many ways this accords with the figure of the modern artist, a displaced and disruptive presence.

Cultural theorist Raymond Williams describes the expansion of twentieth-century cities into transnational capitals which became stopping off points for artists and intellectuals on an international circuit: 'Paris, Vienna, Berlin, London, New York took on a new silhouette as ... the most appropriate locale for art made by the restlessly mobile émigré or exile, the internationally anti-bourgeois artist ... Such endless border crossing ... worked to naturalise the thesis of the non-natural status of language. The experience of visual and linguistic strangeness, the broken narrative of the journey and its inevitable accompaniment of transient encounters with characters whose self-presentation was bafflingly unfamiliar raised to the level of universal myth this intense, singular narrative of unsettlement, homelessness, solitude and impoverished independence'.[2]

Within the metropolis, assumptions of a shared history, language or culture may not apply. Encounters of difference offer the possibility of discarding the past, the familiar, the traditional; assumptions of one's culture and identity as naturally given can be undermined, made to seem contingent and ripe for invention. The cities featured in this

exhibition are characterised by the heterogeneity of their populations; they are stages for a polyphony of voices, different ethnicities and nationalities, religions, classes and sexualities. They offer the possibility of cultural identities 'drawn from the domains of the erotic, the alien, the pre-colonial and the repressed' coming into contact.[3] Meetings of like-minded strangers, looking to shape a yet to be invented future, can be seen as intrinsic not only to the notion of the avant-garde but to Modernism itself.

Long before the radiating lines of airline companies criss-crossed the world, artists and intellectuals had tracked the trade routes of ideas around the globe. These routes had hubs. Cities like Barcelona, Paris and London were stopping off points for artists from Moscow to Japan, Nicaragua to Nigeria. Perhaps the Western metropolis should not be understood as a point of origin in the genesis of Modernism, so much as a site for cross-pollination in a reciprocal process of global exchange. Artists arrived from around the world, bringing with them their own versions of the modern which were to undergo a process of exchange and hybridisation, to be further enriched as artists continued their circuits or returned to their own cities.

It is a paradox of the metropolis that its scale and heterogeneity can generate an experience both of unbearable invisibility and liberating anonymity; of alienating disconnectedness, indeed impotence; and of the possibility of unbounded creativity. Yet this tension seems integral to the city's power as an incubator of revolutions. The modern crisis of the self, the sense of being alone in a crowded world, of being severed from a community of shared, comforting meanings, is an inescapable part of the liberating flux of urban life, of the condition in which it is possible to make the world, as well as oneself, anew. This sense of the loss of identity and the promise of new beginnings accords with the desire of many early Modernists for a ground zero from which to launch a vanguard.

The metropolitan dweller is not only a potential creator, but also an audience and a consumer, with a body to accommodate and style, a sensibility to stimulate and a consciousness to raise. At any given time, a citizen may be subject to the efforts of a huge range of disciplines. Powered by the development of new technology and markets, art, design, architecture, dance, music, film and literature are brought into relation with each other through the framework of the urban. *Century City* examines these points of conjunction between different modes of production and creative expression, where two lines of enquiry intersect to give new directions to both.

In some cases, expediency and a shared hunger for a rupture with the past demand collaboration. Who should devise the language of the manifesto if not a poet? Who should design posters for a radical new theatre production if not a radical artist? In other instances, the emergence of an artistic phenomena – communicated through the media, contextualised through critical discourse and sustained through a public or private economy – generates an irresistible momentum that sweeps into its orbit the young and the hungry from a constellation of disciplines.

THE CITY AS SUBJECT A time-lapse film of any city would show buildings rise, fall, accrue prosthetics, blaze in the light of reflected dawns and sunsets, illuminate the night with their grids of white light, extinguish and become invisible. Streets flood and

empty in a purposeful rush by day, a meandering flow after dark, until the rhythm of the crowd is replaced by the dead stillness of the homeless. Modes of communication and transport reach a velocity of invisibility or a gridlock of stasis. In the city, dazzling display combines with abject poverty, symbols of power with demonstrations of resistance. Its edge moves ever outwards, sprawling around the lacunae of strip malls and retail warehouses, or the fragile cardboard and metal sedimentations of the favellas.

The picturing of modern urban life represents a powerful strand in the art and culture of the twentieth century. Harnessing the aesthetic of the city might involve the narration of its events and rituals to celebrate, critique or simply record modern society. It may also involve the deployment of its 'aesthetic'. The grid, architectonics, the fragment, dynamism – these are all typical formal characteristics of modern art which have been inspired by the spatial, structural and temporal dimensions of the city.

There is another equally powerful response to the urban. As Charles Harrison has noted, the reaction of Modernist art and culture towards modernity and modernisation is not always one of unbridled enthusiasm.[4] Numerous canonical Modernist and contemporary works produced and exhibited through the context of the urban are attempts at escape from the modern city and all that it represents. One has only to think of synchronous works made in Paris by Severini and Matisse, or in Moscow by Rodchenko and Chagall to see utterly opposing tendencies which at one extreme reach for the revolutionary, even utopian possibilities of a technologically driven future, and at the other, yearn for the archetypal essentialism of a primitive, archaic past.

This conflicted response to urban modernity is similarly prompted by the mass media. Its multivalent forms are locked into a cannibalistic *pas de deux* with artistic milieus. Buzzing like insect life the media is both parasitic and cross-pollinating. It fills the city with words and images taken from 'fine art' to market products or sell newspapers. At the same time the media's ephemeral ubiquity offers artists an index of the everyday and its strategies a means of communicating a radical cultural agenda. The Russian Constructivists wallpapered the walls of Moscow with a photograph of a revolutionary figure repeated through print and flyposted to create an entire (two dimensional) army.

METAPHORS OF PROGRESS To be able to jettison history is a powerful impulse shared by any society rebuilding itself from the ravages of war or economic depression, or leaving behind an 'ancien regime' or a colonial oppressor. The European colonial powers that had dominated the globe through the nineteenth century sought to obliterate and distort the indigenous cultural identities of their domains; yet by the twentieth century they were also a vehicle for communicating ideas of the modern which were to be assimilated and deployed by postcolonial societies in the creation of new national identities. Twentieth-century Modernism offered a symbolic means for erasing not only the monuments but the memories of the recent past offering a model for a new, forward looking identity – coupled with the resurgence of suppressed cultures. Concrete, skyscrapers, flyovers, radio towers – these were the public signifiers of progress given an intellectual and cultural agenda by the avant-gardes of art, cinema, dance, music and literature. The city took on a utopian mantle, providing the platform from which the world could witness the emergence of a new society. Yet these

brave new worlds – from Lagos to Brasília, from Tel Aviv to Birmingham – have tended to evolve from utopian aspiration to dystopian reality, testaments to the fragility of social structures projected onto tabula rasa.

URBAN SPACE AS LABORATORY 'Come on! Set fire to the library shelves! Turn aside the canals to flood the museums! ... Oh the joy of seeing the glorious old canvases bobbing adrift on those waters, discoloured and shredded! ... Take up your pickaxes, your axes and hammers and wreck, wreck, wreck the venerable cities, pitilessly!'[5]

From at least the mid nineteenth century, artists and intellectuals have demonstrated a conflicted, some might say Oedipal, relationship to the institutional spaces of the city. Art academies or schools, galleries and museums have nurtured innovation, promoted diversity, generated artistic community and acclaimed brilliance. They have also stifled all of the above, to such a degree that they have triggered revolt. When institutional ossification sets in, creative dissent is not far behind, finding an outlet through the invisible academies of studios, artist-run spaces – and bars.

The salon culture, where the speculations and seductions of informal dialogue flourished, contributed to making nineteenth-century Paris the centre of intellectual life in Europe. By the beginning of the twentieth century however, the private and privileged space of the salon (a prototype for social gatherings from Berlin to Rio) had given way to the public and multicultural space of the café. In fact an alternative history of art might be traced via the informal laboratory of bars, described by Joachim Schlör as 'the real urban intermediate zones between private and public living'.[6] In the early 1900s they represented the exotic realms of a *demi-monde* where a male flâneur might encounter men of different classes, and women, who by virtue of even appearing in a public space, could be regarded as 'fallen'. Through the century however, walks on the wild side became not so much a matter of a detached voyeurism, as a desire for immersion: in a zone outside domesticity or work which was licensed for bad behaviour. The bar or café continues to represent a venue for the gossip, performance, debate, flirtation, negotiation and occasional fight that make for an art scene.

Delving further into the fabric of the city, other spaces of production emerge. Urban geographers such as Edward Soja see cultural production, economics and development as intimately related: 'urban spatialisations can ... be seen as 'layered' one on top of the other to reflect pronounced shifts in the geographies of investment, industrial production, collective consumption and social struggle. The sedimentation, however, is more complex and labyrinthine than a simple layering, for each cross-section contains representations of the past as well as the contexts for the next round of restructuring'.[7]

In the early twentieth century, electricity turned night into day, opening up the street and the cafe into an out of hours pleasure zone. Distances shrank with rapid forms of transport and communication. Even the sky seemed nearer with the erection of buildings such as the Eiffel Tower and the Empire State. Whether through airborne destruction or the modernising zeal of urban planners, whole districts were rebuilt, while industry and housing pushed the suburbs ever outwards. The street itself, with its crowds, traffic, spectacle and abjection inspired an avant-garde aesthetic. In the post-industrial city however, technologies have shifted from creating new forms in the

material fabric of the urban topology, to the creation of virtual spaces of telecommunications. As architectural critic Martin Pawley commented in the late 1980s, 'London is being rebuilt not as a city, but as the tip of just one tentacle of a stupendous octopus of electronic communications whose head is in outer space and whose other tentacles touch all other cities everywhere.'[8] While its financial institutions sleep, accountants and brokers in Bombay or Hong Kong continue the global, twenty-four-hour circulation of capital.

And in the city itself physicality is replaced by a kind of opaque transparency, powerfully evoked by cultural theorist Paul Virilio: 'If monuments in fact exist today, they are no longer inscribed in the aesthetic of volumes assembled under the sun – but in the terminal's obscure luminosity – the wait for service in front of machinery, communication or telecommunication machines, highway tollbooths, the pilot's checklist, computer consoles … The metropolis is no longer anything but a ghostly landscape, the fossil of past societies for which technology was still closely associated with the visible transformations of substance, a visibility from which science has gradually turned us away.'[9]

From São Paolo to Manchester, Antwerp to New York, cities which had once flourished as manufacturing bases entered a post-industrial economy; their built environments were increasingly abandoned rather than expanded. Empty factories and warehouses, bankrupted shops or empty civic buildings proved ripe for comment, inscription or creative takeover. Artists have exposed the abandonment of structures once dedicated to manufacture, trade or the civic good as symbols of the ruthless imperatives of capitalist development. Others have regarded the derelict site as a ready-made, a giant surface to project on, or a plastic material to cut and inscribe. Most significantly however, vanguard tendencies have been associated with the re-use of these sites, for cultural production and the invention of new economies.

The use of industrial techniques and materials to create ever larger works of art generated the need for a different kind of studio space, of industrial proportions and ethos. By the 1960s many Western artists stressed their role as workers, regarding the studio and the gallery as factory, workshop or playground. The impact of phenomenology on a post-war generation foregrounded the importance of space as an experiential environment. Industrial architecture with its deep receding perspectives and the potential danger of its unlit stairwells, machined surfaces and semi-decayed structures, stimulated a thrilling experience of place. Works were not only produced in such spaces but increasingly exhibited in them. But the arrival of an artistic community brings in its wake the property developers and gentrifiers. As sociologist Sharon Zukin has pointed out in her pivotal study *Loft Living*, this relationship is one of mutual dependence.[10] Exorbitant rents force artists and budding gallerists out of the very areas they have revived; yet it is the new landlords and increasingly elite tenants who provide a market for the art once created in their glamorously renovated lofts.

The spaces of the city have also inspired less tangible responses which might best be described as psychogeographic. Writing about post-war art, critic Christal Hooevoet comments, 'The problem faced by contemporary artists tackling urban space was twofold: first how best to apprehend the experience of urban space not as spectator but

as actor; second how to best re-present urban space, not in terms of figure and ground, on a two dimensional plan, but in active physical and mental intervention. The first question was solved through *dérive* and its ulterior forms in Fluxus and Conceptual Art; the second by the topographical mapping of drifting processes, or cognitive mapping.'[11] In fact the idea of giving over authorship to the city itself has preoccupied artists, writers and film-makers, offering a compelling strategy. Aimless wandering, ludic nomadism, shadowing strangers, co-opting the streetwise strategies of direct action, cutting across the grooves of commuterdom – by turns playful and dangerous, such 'senseless acts of beauty'[12] bear witness to the great Situationist slogan '*Sous le pave, la plage*' – under the pavement, the beach.

CENTURY CITY – THE EXHIBITION In 1940, the poet and art critic Harold Rosenberg wrote: 'up to the date of the occupation, Paris had been the holy Place of our time ... Paris was the only spot where necessary blendings could be made and mellowed, where it was possible to shake up such "modern doses" as Viennese psychology, African sculpture, American detective stories, Russian music, neo Catholicism, German technique, Italian desperation ... What was done in Paris demonstrated clearly and for all time that such a thing as international culture had a definite style: the Modern'.[13]

In the way its social groupings transcended nationality and its modernisation sent out shockwaves that rippled across visual culture, Paris is a paradigm for *Century City*. At the same time it should not be regarded as the only site of Modernism's origin. Rather it represents the site for one of many modernisms that proliferated in cities around the world. To return to Rosenberg, he makes two crucial points. His essay is titled, 'The Fall of Paris', making clear that the conditions which combine to inspire seismic periods of creativity are tenuous. They may be abruptly extinguished by the cataclysms of war, despotism, cultural and religious fundamentalism or economic depression. They may slowly evaporate as the utopian revolutionary strategies of today become the orthodoxies of tomorrow; or as one generation becomes the Oedipal target of the next.

Secondly, he makes clear that Paris was not unique: 'Despite the fall of Paris, the social, economic and cultural workings which define the modern epoch are active everywhere.'

The challenge for Tate Modern has been to reflect this sense of a global phenomenon with finite space and resources. We were guided by a desire to reflect new scholarship and research and bring it into dialogue with canonical Western narratives. A group of expert curators was then invited to work with us on selecting cities and identifying specific periods in their cultural history. The featured cites could be replaced with many others. Each one, however, can be regarded as being both culturally distinct and emblematic of wider, global tendencies.

The communal riots of 1992 provide a starting point and a political backdrop for a survey of Bombay/Mumbai's cultural scene. Curators Geeta Kapur and Ashish Rajadhyaksha identify a fusion of modernist abstraction with street-based realism which draws on popular culture and the politics of class, gender and national identity. Contemporary artists working in new media, such as Rummana Hussain and Nalini

Malani can be seen alongside modern masters such as M.F. Husain, Atul Dodiya and Bhupen Khakhar. The immense success of the Bombay film industry is explored alongside a powerful new literary genre contributed by the Dalit, people from the lowest caste.

At the moment of Nigerian independence, Lagos set the stage for a new African identity. The 'Mbari' clubs, founded in nearby Ibadan by writers including Chinua Achebe, Duro Lapido and Wole Soyinka, were cells for experimental writing, performance and art. They provided a platform for artists such as Adebisi Akanji, Georgina Beier and Jacob Lawrence, who revives the genre of history painting to celebrate African roots. Looking at an era from 1955 to 1970 curators Okwui Enwezor and Olu Oguibe also identify 'High Life', which became the theme tune for this fusion of a suppressed tradition and a contemporary vision, with musicians such as King Sunny Ade contributing a radical new dimension to world music.

Europe at the beginning of the twenty-first century is represented by London. Emma Dexter pictures the city through the work of practitioners who have taken it as a readymade. Artists such as Keith Coventry, Gary Hume, Sarah Lucas, Michael Landy, Juergen Teller and Gillian Wearing, and designers such as Tord Boontje, Tom Dixon and Hussein Chalayan have taken the people, the urban environment and low-tech entrepreneurship as the subject of their work, defining an aesthetic that fuses street style, cultural diversity and the indexing of everyday life.

In 1917 the Russian artist Mayakovsky declared, 'The streets shall be our brushes – the squares our palettes.' Lutz Becker traces the explosive combination of political and artistic revolution in Moscow from 1916 to 1930. For the Constructivists, geometry and photography offered dynamic forms of mass communication. A theatre run by Vsevold Meyerhold provided their meeting place. He took his multi-media agit-prop performances to the street, while film-makers Sergei Eisenstein and Dziga Vertov pioneered the use of montage, combined with imaging the city itself to create a revolutionary cinema.

The phenomena of the SoHo loft scene has its origins in a bankrupted city of New York and a group of enterprising artists, dancers and film-makers who let the city author the work. Donna De Salvo explores the period from 1969 to 1974 when Adrian Piper used the bus as a performance venue, Vito Acconci took to following strangers, Trisha Brown danced on the rooftops of Manhattan and Gordon Matta-Clark turned the city into sculpture and a restaurant into a work of art called simply, 'Food'. Feminism was the new avant-garde, with film and video pioneers such as Yvonne Rainer interweaving the personal and the political.

Focusing on the period between the eruption of Fauvism at the 1905 Salon d'Automne and the First World War, Serge Fauchereau traces the evolution of Cubism and Futurism. Refracted into the multidimensional canvases of Georges Braque, Robert Delauney, Pablo Picasso or Diego Rivera are signs of the city – fragments of the Eiffel Tower, slivers of newspapers, glimpses of brimming ashtrays and empty glasses. Paris summed up cosmopolitan modernity, attracting not only artists from around the world but writers and dancers such as the Ballet Russes, whose debut performance of Igor Stravinsky's *Rites of Spring* caused a sensation. Literary developments range from

Guillaume Apollinaire's concrete poetry to acerbic artist-produced satirical magazines.

The lush coastline of Rio de Janeiro is edged with op art pavements that echo the cool geometries of Neoconcretist paintings and sculptures. 1950s Rio also gave birth to the rhythms of Bossa Nova, the realism of Cinema Nuovo and an architecture that blends the influence of Le Corbusier with an essentially Latin American sensibility. Paulo Venancio Filho identifies key players including artists Sérgio Camargo, Lygia Clark, Hélio Oiticica, Lygia Pape and Franz Weissmann, the architect Oscar Niemeyer, musicians Joao Gilberto and Tom Jobim and film-makers including Glauber Rocha.

In the late 1960s the group Provoke changed the course of Japanese photography with their raw images of Tokyo. Reiko Tomii focuses on Tokyo from 1967 to 1973, when groups such as Bijutso Techo and Mono-ha redefined the process, materiality and meaning of art. Urban interventions include Tent Theatres set up in the streets, Akasegawa Genpei's zero-Yen note – a work of art circulated as currency, or Horikawa Michio's stones collected from the river (in parallel with Apollo 11's lunar rock gathering) and sent into orbit by means of the post. In an atmosphere of cultural protest artists such as Yoko Ono and Kusama Yayoi reflect the impact of feminism, whilst Isozaki Araka suggests a new architecture that dismantles the very precepts of modernism.

Described by Karl Kraus as an isolation cell where you are permitted to scream, Vienna became the forum for the ideas of Sigmund Freud, Karl Kraus, Arthur Schnitzler and Ludwig Wittgenstein. These in turn provided the intellectual context for the expressionistic paintings of Oskar Kokoschka, Egon Schiele and Richard Gerstl, the atonal music of Arnold Schoenberg and the functionalist aesthetic of architect Adolf Loos. Richard Calvocoressi and Keith Hartley look at the years 1908 to 1918 as a questioning of modernity through an emphasis on language, aesthetics, memory and the self.

This book also includes case studies by Joachim Schlör, Sharon Zukin and Ziauddin Sardar. Using different cities as examples, their essays reflect broader debates around art, culture and the city. Schlör looks at the defining characteristics of the modern urban dweller and makes analogies with Jewish identity and the city itself as an avant-garde project. Zukin explores the complexities of the economics of art and urban development. Sardar discusses opposing tendencies between Western and non-Western metropolitan cultures.

Century City is an exhibition, a book and a series of events which take nine moments from across a century and from around the world, to celebrate the idea of the modern as it has been defined, dismantled and reinvented in the context of the metropolis.

Notes

1 Georg Simmel, 'The Metropolis and Mental Life', *Gehe-Stiftung zu Dresden*, Winter 1902–3, trans. Kurt H. Wolff.

2 Raymond Williams, 'When was Modernism?', *New Left Review*, London, May/June 1989.

3 David Craven, 'The Latin American Origins of 'Alternative Modernism', *Third Text*, no.36, Autumn 1996.

4 Charles Harrison, *Modernism*, London 1999.

5 F. T. Marinetti, *The Foundation and Manifesto of Futurism*, 1909.

6 Joachim Schlör, *Tel Aviv: From Dream to City*, London 1999.

7 Edward W. Soja, 'Urban and Regional Restructuring', *Postmodern Geographies*, London 1989.

8 Martin Pawley, *Blueprint*, London, June 1988.

9 Paul Virilio, 'The Overexposed City', *Zone 1/2*, New York 1986; trans. from the French by Astrid Hustvedt from 'L'espace critique', Christian Bourgeois, Paris 1984.

10 Sharon Zukin, *Loft Living*, New York, 1982.

11 Christel Hollevoet, 'Wandering in the City, Flanerie to Derive and After: The Cognitive Mapping of Urban Space', *The Power of the City, The City of Power*, Whitney Museum of American Art, New York 1992.

12 This phrase associated with eco-activism is also the title of a book by George McKay, London, 1996.

13 Harold Rosenberg, 'The Fall of Paris', *Partisan Review*, New York 1940.

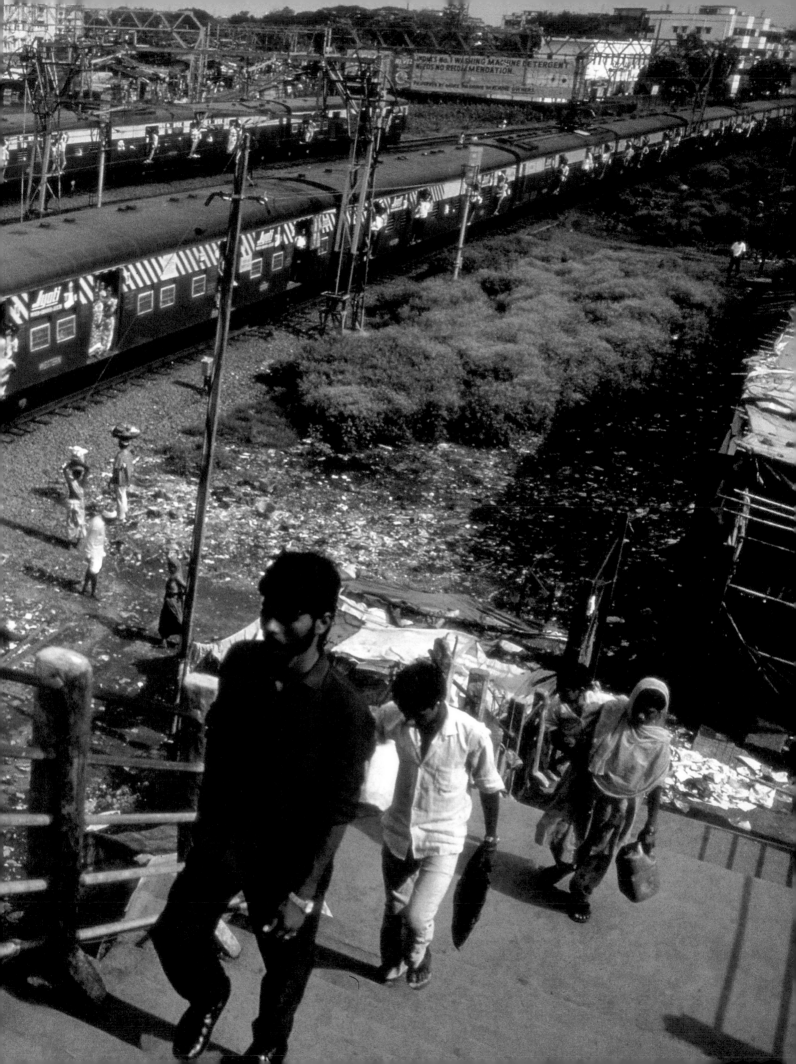

BOMBAY/MUMBAI
1992-2001
GEETA KAPUR AND
ASHISH RAJADHYAKSHA

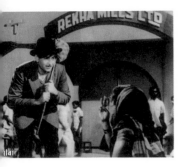

ARRIVING IN BOMBAY A possible start to this essay could be Bombay's Hindi cinema in one of its epochal moments: the beginning of Raj Kapoor's film *Shri 420* (1955) heralding the arrival of a fictional immigrant to the city of Bombay.[1] With his cloth bundle on a stick, Raj, the fabled tramp, enters the city singing a song that was to become a perennial favourite: 'My shoes are Japani, my trousers Englistani, the red cap on my head is Russi yet my heart is Hindustani.'

The Indian state is less than five years old, the Indian nation still, therefore, in the process of formation when Raj arrives at Bombay's doorstep to pawn his honesty medal. The song's ironic, affectionate reference to Nehru's nationalist *modernism* – the right that the newly formed nation gave to its citizens to view the world as a benign, and in political terms non-aligned, affiliation – comes, significantly, from an ingenuous migrant to the metropolis.

Bombay's famed Hindi film industry offers numerous allegories of survival. Radical theatre workers and poets came to this city during the 1940s and 1950s, many of them displaced during the country's Partition, to become actors, directors, script- and song-writers. They were celebrated and also assimilated, for survival meant negotiating with a growing industry. This was the period when the post-war boom in industry and real estate demolished the more stable studio systems of the pre-war period, when film production in India more than doubled, and Indian cinema marked an achievement unparalleled in the third world's cinema history by setting up a national market for a national culture industry virtually independently of State support.

This film industry also developed a distinct narrative mode that has since been theorised as nationalist melodrama: Bombay's freshly acculturated artists provided a language of exchange for the rest of India – images, prose, songs and sheer *rhetoric* that is about arriving, about survival.

It is in the melodramatic mode that Bombay cinema delivers the city to the Indian public. It is also in the peculiar promise of Bombay that this cinematic genre continues to serve a paradigmatic function: intertwined stories of faith, corruption, love, betrayal help mediate the anguish of a transition from country to city, from feudal to capitalist modes of production. Melodrama engages with the civil society that ensues in the transition; at the same time it promotes subjectivity, among other things through an identification with the highly wrought personae of the stars. In replacing the sacred icon with the beloved, melodrama plays a role in giving the country's internal 'exiles' a hold on their experience of modernity. It also means that Bombay melodrama, featuring modern consciousness as a painful *mastering* of life in the metropolis, becomes ideologically complicit with the male protagonist.

SURVIVORS' MODERNITY Here is also a clue about how the existential position of a metropolitan rebel becomes Indian modernism. Take Francis Newton Souza. Goan Catholic by birth, he came to Bombay with his working-class mother, studied at the Sir J J School of Art, founded the Bombay Progressive Artists Group in 1947, then migrated to London. Here he became a volatile 'native'-modernist of his time:

Then my mind began to wander into the city I was bred in: Bombay with its ... stinking urinals

opening page

RAGHUBIR SINGH

From *Bombay: Gateway to India*:

Commuters, Mahim 1991 (detail)

Photograph 63.5 × 85

Estate of Raghubir Singh

left

Actor Raj Kapoor in the film

Shri 420 **(1955)**

below

Bombay Riots, January 1993

Photograph: Hoshi Jal, Times of

India, Mumbai

and filthy gullies, its sickening venereal diseased brothels, its corrupted municipality, its Hindu colony and Muslim colony and Parsee colony, its bug ridden Goan residential clubs, its reeking, mutilating and fatal hospitals, its machines, rackets, babbitts, pinions, cogs, pile drivers, dwangs, farads and din.[2]

Souza's version of 'outsider' modernism can be set against locally pitched forms of modernism such as that of the Marathi playwright from Bombay, Vijay Tendulkar. Introducing a form of urban social realism in theatre in the late 1950s, Tendulkar created a space that his existential anti-hero of the middle class could inhabit. In the plays *Gidhade* (The Vultures, 1962) and *Sakharam Binder* (1971) he developed an idiom that could speak explosively of class war and caste transgression and touched the territory rightfully occupied by the Dalits.[3]

The Dalit liberation movement produced an explosive form of Marathi literature in the 1970s. Dalit poets like Namdeo Dhasal, defining their bind with metropolitan space, gave Bombay its wager for a caste war:

Their Eternal Pity no taller than the pimp on Falkland Road
No pavilion put up in the sky for us.
Lords of wealth, they are, locking up lights in those vaults of theirs.
In this life, carried by a whore, not even the
sidewalks are ours.[4]

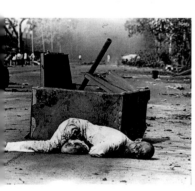

The Dalits writers spoke about how you arrived in Bombay to escape the civilisational malaise of 'untouchability'. To do so you had to preserve but as likely to win a subjectivity and forge a modernity that could grasp it. And, certainly, you had to invent your citizenship since nobody else was going to do it for you. In the metropolitan encounter, in the struggle to inherit the city, you came face to face with the naked truth of the 'citizen subject' in India. Or, as Baburao Bagul writes, in the last line of his best known short story: 'This is Bombay. Here men eat men. And Death is getting cheaper.'[5]

BOMBAY 1992 In December 1992 and January 1993, Bombay raged with a spate of 'communal' (sectarian) riots on a scale it had never seen before. The cataclysmic events of these months were foundational: Bombay became the stage for acting out fierce contradictions in the nation's encounter with modernity.

These riots followed the destruction of the Babri Masjid (the sixteenth-century mosque situated in the northern city of Ayodhya) by right-wing pro-Hindutva fanatics. This pivotal event in India's political sphere had nationwide consequences. In Bombay the motivated intensity of the riots so crucially transformed the city's complex melange of local, national and transnational groupings that the moment could be seen to mark the end of Bombay's century-old cosmopolitanism.

In the aftermath of the riots the evidence of the Srikrishna Commission appointed by the State Government proved that Shiv Sena was largely responsible.[6] Since its formation in 1966, Shiv Sena, an explicitly anti-Communist labour grouping, has had a history of strikes, riots and violence against a range of minorities, including Gujaratis,

TYEB MEHTA

Head (Kali) 1996

Acrylic on canvas 75 × 61

Suresh and Saroj Bhayana Family

Collection, New Delhi

Muslims, South Indians and Dalits. In the 1992–3 riots, the murder and arson directed against the city's Muslim population raised the larger question of the extraordinary fragility of civil society: in January 1993, 150,000 people fled the city that proudly claims to be India's financial capital.[7]

The reprisals that followed – serial bomb blasts in March 1993 in some of the city's key business centres – suggested that religious difference was only one among the motivations for violence. A gamble had been set apace by the majority community to settle territorial disputes in the city: real estate criminals, smuggling mafias, rivalries within the trade unions, conflicts over caste and region had ignited the riots.

BOMBAY/ MUMBAI: INDUSTRIAL CITY In 1995, a year after the Shiv Sena–Bharatiya Janata Party government took over power in Maharashtra state, the city's name was formally changed from the colonial 'Bombay' to its vernacular version, 'Mumbai'. This seemingly innocuous move was contextualised by the riots and the rise of a xenophobic nationalism. There is irony here: Shiv Sena's Mumbai is a city that has now pushed its corporate status over the threshold into globalisation. Here is an island city, home to twelve million[8] Indians, rejecting its more capacious cultural cosmopolitanism but bidding for a place in the path of global finance moving eastward from New York and London to Singapore, Hong Kong, Tokyo, Shanghai.

Bombay was a major industrial metropolis of the colonial world from the middle of the nineteenth century. The elaborate infrastructure that was put in place by the British colonial power – a mercantile ethos modernised by the establishment of dockyards, cotton mills and the legendary Indian Railways – induced complex moves in native trade and manufacture culminating in the establishment of an Indian textile industry offering competition to Lancashire itself. This produced a class of indigenous industrialist-entrepreneurs who later aspired to the condition of a bourgeoisie in its fullest sense and cast a determining gaze upon the city and the nation.

This same infrastructure – then and ever since – became the means of arrival for a working population that gradually gave Bombay its proletarian base. The division of the colonial city into White and Black Towns translates into ever more confrontational polarities in the contemporary city; class divisions can be plotted in the way that the three local railway lines still divide the city into its white collar employees (who take the coastal Western Railway line), textile workers (who use the Central Railway which goes through the heart of the mill areas), and workers who use the Harbour Line (recalling Bombay's ancestry as a port city).

Within the context of its highly articulated class structure, Bombay lays claim to the origins of the labour movement and, from the 1940s, to the activity of the Communist Party of India. The city's history can be marked by famous trade union strikes, most crucially in the textile sector which, dominated by a negotiating Congress Party trade union, saw a retaliatory strike in 1982–3; led by an independent militant, it became the longest, most tragic labour struggle in India. Huge mills closed down and an estimated 75,000 workers lost their jobs.[9] With escalating real estate speculation, another kind of immigrant labour has poured into the city in the form of construction workers living like nomads on construction sites. The two dominant categories of the working class

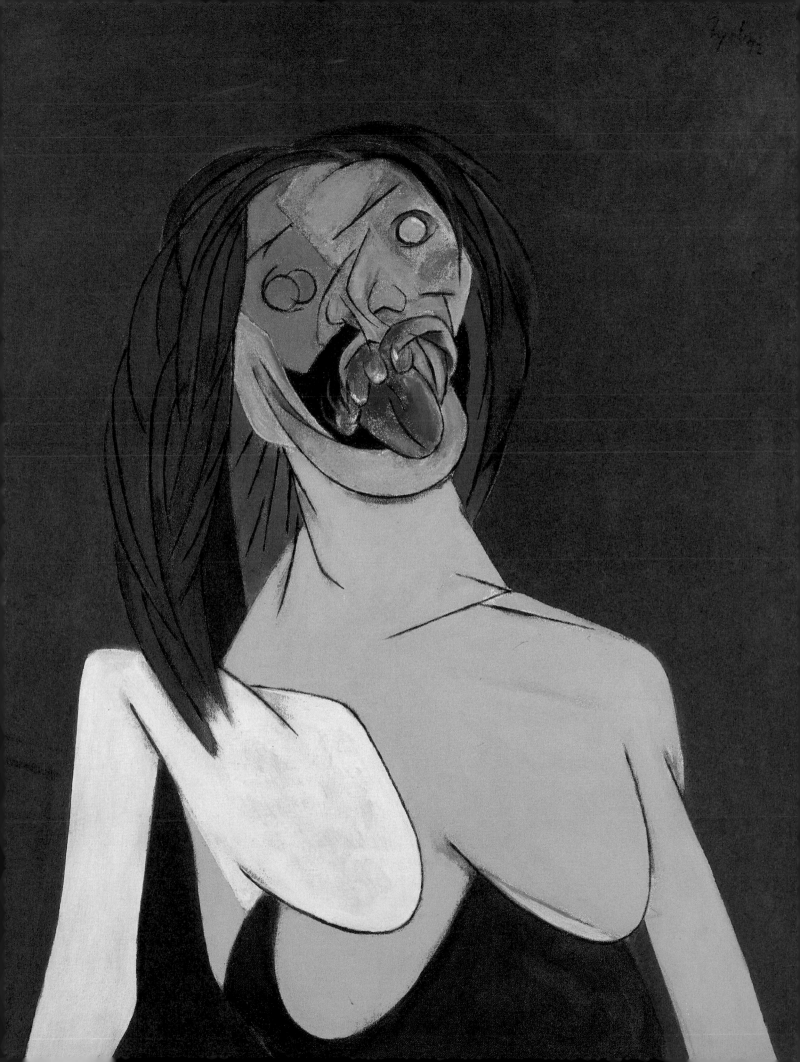

coalesced after 1983, when mill owners made their profits through selling the land on which they were built, forcing workers back to their villages or into 'casual' daily-wage labour. Meanwhile, the disputes over mill lands, spilling over into conflicts between workers' rights versus property developers' interests, highlight the stark reality of metropolitan Bombay where an estimated 5 million people – 55 per cent of the city's population – live in 'illegal' slums, interspersed with properties on prime land that counts with the most expensive real estate in the world.

BOMBAY MODERNISM: 1940S TO 1990S The modernism manifest in the work of Bombay's writers, artists and film-makers from the 1940s is directly related to the actual experience of metropolitan modernity. We argue that the ability to describe the experience springs, paradoxically, from an underlying realm of realism. In India, as often in other parts of the third world, modernity does not precipitate itself into the modernist canon. Familiar aesthetic categories of the modern – realism and modernism – gain complicity on strange ground. It is their peculiar form of overlapping that requires to be taken into account, not only for understanding specific types of cultural praxis but for large-scale revisions, both of the history of modernism and of metropolitan cultures in the twentieth century.

This paradox is also part of the explanatory method we adopt to designate the epochal transition from colonial to postcolonial society. Within this explanation we introduce the term 'subaltern', and elicit from the compressed history of its use in radical discourse (in the subaltern studies historiography of modern India), a figure subordinated in the social hierarchy but valorised in theory. The figure is a means of description and, as Gayatri Spivak puts it in her explication of the term and the processes it instigates, as the site for the 'production of "evidence", the cornerstone of historical truth'.[10]

The term subaltern is specifically used in this essay to designate (*not* the peasant but) a dispossessed urban-insider embodying potential agency. We indicate how the metropolitan artist, in the moment of identification with a subaltern protagonist, can signal every facet of modern life in the city; how this process can then proliferate and become generative of modernism. Equally, seen from a slightly different angle, the modern itself can seem to be elusive, missing, absent. For indeed the modern *here* is always seen as being *elsewhere*, typically of course in the 'West'. And the consequent form of cultural modernism, functioning in unexpected ways around the sense of lack, can be especially befuddling to those who seek ordered categories in practice and in theory.

One straight marker of modernist practice is the Progressive Artists Group launched in Bombay in 1947 by Francis Newton Souza, M.F. Husain, S.H. Raza, K.H. Ara and others. Later affiliates included artists like Akbar Padamsee, V.S. Gaitonde, and Tyeb Mehta. Though the Group disbanded when some of its members moved to Paris and London in the 1950s, this post-Independence generation of Bombay artists has retained a vanguard status in the chronicle of modern Indian art. They are seen to have mastered the cultural and economic struggle of *being* Indian while at the same time inducting this experience into the universalist utopia dreamt up by modernists everywhere in the world.

SUDHIR PATWARDHAN

Fall 1998

Oil on canvas 152.4 × 106.7

Virginia and Ravi Akhoury

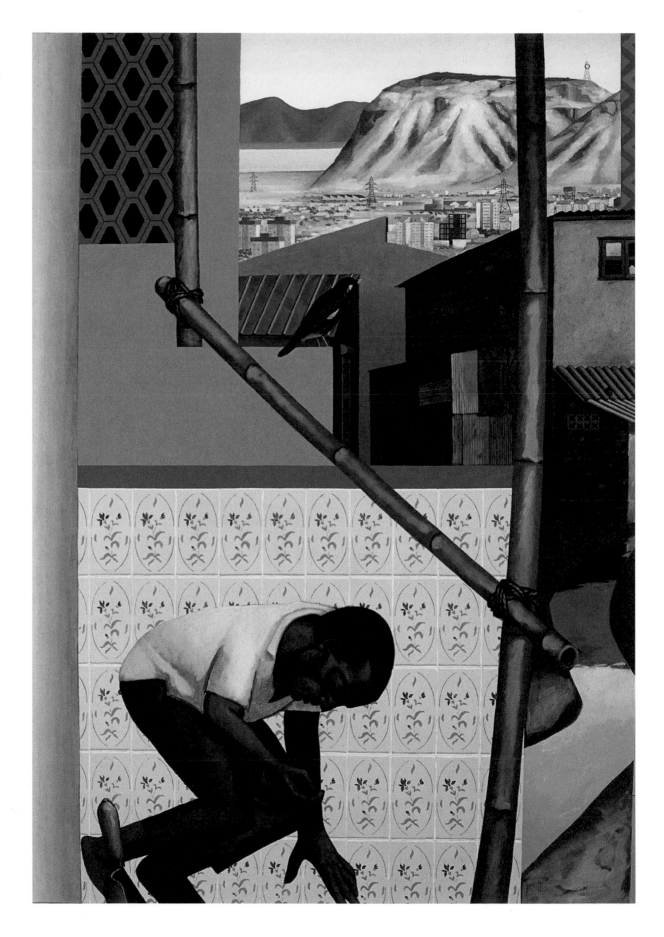

RAGHUBIR SINGH

From *Bombay: Gateway to India*:

Office Worker Leaves Home,

Dharavi 1992

Photograph 63.5 × 85

Estate of Raghubir Singh

It is significant that in India this utopia was envisioned precisely at the point when the Second World War had destroyed the engagement with utopia in western Europe leaving the socialist and the third world to work out the concept in their own terms.

If we bring the modernism of the Bombay Progressives into the 1990s by presenting Tyeb Mehta's recent morphology of his modernist-figurative painting and place this *vis-à-vis* the realist paintings of a younger, Marxist, painter, Sudhir Patwardhan, we will set up one important paradigm for the politics of (self) representation in Indian art. In the last two decades Mehta has introduced a mythological element into his oeuvre by painting Kali, the dark goddess of death and resurrection, followed by a series on the theme of the buffalo-demon, Mahishasura, vanquished by the golden goddess Durga. These images are drawn from an indigenous (arguably pre-Aryan) past; they are imbedded in the material culture of India's sub-continental tribes. Mehta's heterodox use of mythology creates contemporary allegories around the role of the 'cultural outsider'. He gives the contestatory figure an iconic stance in the secular culture of modern India. Patwardhan also works with the insider-outsider question but, in contrast to Mehta, he disinvests his painted image of the mythic aura to make secular identity an everyday phenomenon. Patwardhan establishes contiguity between the artist, viewer and the proletarian body on plain civic ground. From this classic-realist position he raises putatively postmodern questions about the politics of location.

In a series of photographs titled *Bombay: Gateway to India* Raghubir Singh frames punctual encounters of workers, traders, entrepreneurs who fuel the engine of the city. At the same time Singh grasps the strange undertow in metropolitan reality, the dread of oblivion. Sharing something of the mythology of the Asian-city-as-spectacle, the photographs show Bombay as a crammed coloured cosmos revealing itself in a frontal, wide-angle view. The pictures are often literal (glass and mirror) reflections that refract the spectacle into multiple views and all but shatter it. Yet, by deploying strategic framing devices of a modernist aesthetic (based especially on the use of colour and ornament) Singh, like many eminent Indian artists, opts to *condense* and *contain* the chaos, the kitsch and the conflicting class interests within the city.

India's independent cinema movement shows, further, how a calibrated relationship between realism and modernism helps to produce a compassionate and, in its own way, radical iconography. Developing from the militant politics of the late 1960s and early 1970s – which included the extreme Left (Naxalite) movements, repressive State action in the form of the Emergency declared by Indira Gandhi in 1975, and the democratic resurgence in its aftermath, including the entry of the Dalits in national electoral politics – a slew of films set in contemporary Bombay assimilated and transformed the pressure of the insurgencies in Indian society.

Films like Avtar Kaul's *27 Down* (1973), Saeed Mirza's *Albert Pinto ko Gussa Kyon Aata Hai* (What Makes Albert Pinto Angry, 1980), *Mohan Joshi Hazir Ho!* (A Summons for Mohan Josh! 1983), *Saleem Langde Pe Mat Ro* (Don't Weep for Saleem the Lame, 1989) and Sudhir Mishra's *Dharavi* (1991) set themselves the task of engaging with the national agenda for cinematic realism while critiquing its Statist ideology. At the same time they critiqued the mainstream Bombay cinema flaunting its mass 'public' but assimilated the melodramatic devices that oddly spelt modernity. It is through a

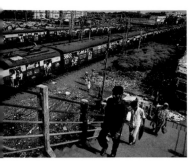

continued transaction between these two cinematic languages that India's independent cinema found a mode to articulate social contradictions. Kumar Shahani's avant-garde melodrama *Tarang* (Wages and Profit, 1984) played out a classic conflict where the bourgeoisie – locked in a tussle between its feudal, nationalist and globalising constituents – confronts a fractious working class divided along uncannily similar faultlines.

URBAN MORPHOLOGY In order to situate the culture of this metropolis in relation to its infrastructure, we need to signpost the enormously impressive project of colonial modernisation.[11] With its industry, civic infrastructure and grand Victorian profile; with its 1930s Art Deco modernism giving the city a flamboyant cosmopolitan style, Bombay was a model for cities in the British empire. Faced with its historical self-image as an 'urban crucible', contemporary planners and citizens working towards a democratic restructuring of the city's social fabric run into problems of determining authority, style and priorities: between restoration and development, and further between the interests of well-entrenched classes with pressing claims.

above

RAGHUBIR SINGH

From *Bombay: Gateway to India*:
Commuters, Mahim 1991
Photograph 63.5 × 85
Estate of Raghubir Singh

right
**Street corner at Worli Naka:
middle-class housing, shops
and workers' tenements in the
mill district. Shiv Sena
noticeboards are seen along the
pavement**
Photograph: Prakash Rao,
Mumbai 2000

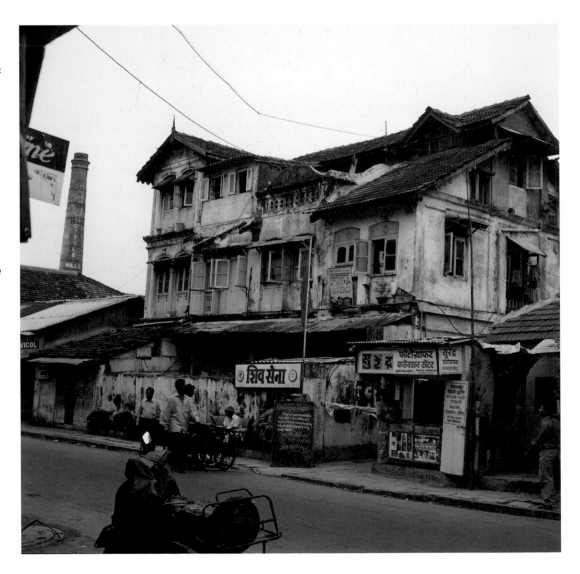

One way to understand the postcolonial phenomena in Bombay is to premise the discourse on national ideology that claims to harbour its own conditions and style of modernity; that claims indeed to give modernism the mandate of social praxis starting at the ground level of poverty. For Charles Correa, Bombay's (and India's) leading modernist architect and planner, his practice has meant eliciting State interventions in city planning, prefiguring large-scale urban expansion, finding solutions to the problems of explosive population growth and narrow traffic corridors.[12] He now extends his understanding to the city's unstructured dynamic:

> Every day [Bombay] gets worse and worse as a physical environment ... and yet better as a city. [E]very day it offers more in the way of skills, activities, opportunity – on every level, from squatter to college student to entrepreneur to artist ... here are a hundred different indications emphasising that impaction (implosion!) of energy and people [really is] a two-edged sword ... destroying Bombay as an environment while it intensifies its qualities as a city.[13]

It is a common contention that postcolonial Bombay has few modernist buildings worth the name. Notwithstanding the row upon row of public and private high-rises, it barely offers the kind of contemporary architectural vision that could transform the city's current self-image as anything but squalid, sprawling tenements and slums. What there is in the name of glamour in contemporary Bombay is the vast area of land reclamation

with its glittering mass of high-rises built in the 1970s along the southern tip of Bombay's Nariman Point and Cuffe Parade. Most of the city's architect-planners agree that this is the corrupt face of Bombay's modernism; it showcases the sinister nexus between State politicians and builders' lobbies working in total disregard of the city regulations and citizens' interests.

With the State mandate on public planning rapidly receding in the face of economic liberalisation; with the city bourgeoisie disinvesting itself of industry, a speculators' economy contemptuous of both the State and the working class comes to the fore. The signs for this can be picked up – not only from the operations of the land mafia – but from the practice of architects who design signatured buildings and developers' housing estates for the new-rich by the kilometre. The high-rises designed by Hafeez Contractor offer a pastiche of surface/façade in an apparently postmodern manner. In effect they are styled to convert the constraint of the city's spatial economy into a seductively packaged life-style. Today, with a definitive shift in the city towards real estate gambles, Bombay leads upbeat India (where a 200-million-strong upwardly-mobile middle class dreams of making it in the globe) into the beginnings of a postmodern fantasy.

Bombay continues to be a city where the interests of slum and pavement dwellers, represented by architect-activists, by a range of political groups and NGOs, remain as prominent as those of land-owners.[14] Urbanists contend that the very survival of even so besieged a city as Bombay is located in the heart of its so-called slums, where no dwelling rights are available to citizens but which are nevertheless sites of intensive production – of labour, services and small-scale industry – symbiotically related to the city's infrastructure. It is hardly surprising that Dharavi, Asia's largest slum, is inducted into Bombay's globalising economy. To reckon with Bombay we have to begin where the middle-class city and its routine definitions of modernism end; where the other city takes over: a city lodged in the interstices of the wealthy city; a 'kinetic city' in the words of Bombay's architect -historian Rahul Mehrotra.[15] A city in perpetual movement, suggesting an entire subterranean economy of transactions between people, produce and capital.

GLOBALISATION AND VISUAL CULTURE A decade before the 1992–3 riots, Bombay had already embarked upon its course of economic and cultural globalisation. As the effect of the riots gradually subsided, this entire episode came to be seen as no more than an interruption to the city's apparently 'larger' agenda – of linking up with the global economy. What is most of interest here is the evidence of a series of shifts that took place in the *visual culture* of the city.

Pledged to the task of globalisation, a new entrepreneurial class has increasingly demonstrated its visual presence in the city. For the first time in independent India, the presence of multinationals deploying new technologies in advertising dominates the streets. Triggering an unprecedented consumerism, they are matched by an increase in shopping malls. Enormous, digitally printed posters have also all but wiped out the large hand-painted hoardings – only a few studios like Balkrishna Arts survive. Relentless ad campaigns celebrate on a global ticket electronic gizmos, film stars, Indian beauty queens, MTV music videos, *et al.* The new media blitz on daily desires produces spectacles, distancing the newly-assembled consumers from the very city they inhabit.

The sweeping flyovers smooth over the rough edges of the city slums and provide the symbolic virtue of speed to the outside investors.

On the other hand, there is the dominance over the political space of representation by the Shiv Sena, evident in its own posters, hoardings and street-corner notice boards. This effectively splits the visual experience on the street into two spheres, each with safely demarcated signifying territories. Indeed there is complicity evident in the way the globalisers and the political right-wing are able to produce a neo-nationalist address from a combination of market-commodification and chauvinist nostalgia. Suitably narrativised in the recent spate of cinema and television, this leads to cultural excess where the question of identity, so valorised in the process, has no stable referents and produces simulacra.

Since the 1970s Bombay/Hindi cinema has offered a special take on the politics of the subaltern. Flamboyantly played by the biggest star of the Indian cinema, Amitabh Bachchan, radical politics is converted into the sheer stance of the anti-hero shown to act out society's ills through the most melodramatic narrative denoument yet seen on the screen. In *Deewar* (Wall, 1975), for example, Bachchan accomplishes some manner of psychological nemesis and political revenge colliding with (and finally colluding with) family, State and nation. By the 1990s these shored-up illusions start to produce a visual culture based on *hyper*-realism – realism itself over the top, repositioning and mutating its frame. Bachchan is in this sense the direct ancestor to the 'naturalist' films of the Marathi/Hindi star Nana Patekar (*Ankush,* Spur, 1985; *Prahaar*, Assault, 1991; *Krantiveer*, Revolutionary, 1994) acting out a right-wing charade of subaltern rage that is frankly perverse. The visual culture produced and nurtured in what is now irreversibly Mumbai frequently endorses Shiv Sena's political claims to the Maharashtrian 'son of the soil' identity/subalternity.

Another category of the Bombay film has emerged in the 1990s: the new 'Bollywood' scenario, playing to the nostalgia industry generated by the increasingly visible Non-Resident Indian (NRI) market of the 1990s.[16] This has subsumed the great Hindi cinema

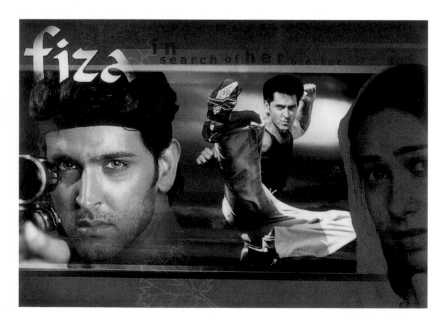

BOMBAY/MUMBAI 1992–2001/GEETA KAPUR/ASHISH RAJADHYAKSHA

Poster designed by M. F.
Husain for his feature film *Gaja
Gamini* (2000), starring
Madhuri Dixit

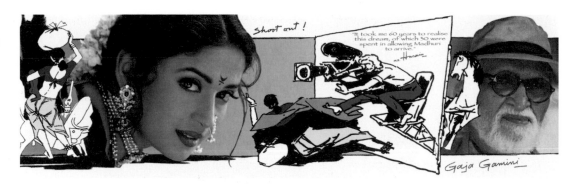

itself and placed it at the service of a globalised culture industry that today includes
cable TV and the Internet and which flaunts a blatantly reactionary cultural nationalism
on the world stage. As the Bollywood blockbusters *Hum Aapke Hain Koun?* (Who am I to
You? 1994), *Kuch Kuch Hota Hai* (You Do Something to Me, 1998) and *Kaho Na Pyar Hai*
(Say You Love Me, 2000), characterised in the industry as 'feel good plus techno',
explode on the scene, the (hyper) realist movie takes another turn: Mani Rathnam's
Bombay (1995) and Ram Gopal *Varma's Satya* (Truth, 1998) promote a new kind of
'belonging' with a citizen-subject adjusted to the changing politics of the nation.

Khalid Mohamed, one of the city's leading film critics, directs *Fiza* (2000), where he
straddles the cruel alternatives of local belonging. Hrithik Roshan, the ultimate symbol of
late 1990s teen machismo, acts out his own death within the thematic setting of the
1992–3 riots. The hero performs a double patricide of the Muslim and Hindu politicians
before he himself dies in the arms of his sister, played by the star Karishma Kapoor.

M.F Husain, the 85-year-old artist-laureate of the Indian State has programmed
himself to become the artist-citizen adjusted to the changing politics of the nation, and to
the visual culture exhibiting this change. When he migrated to Bombay in the 1940s,
Husain painted gigantic 'free-hand' cinema hoardings to earn a living. Soon he became
India's most successful modern artist and unlike any other artist enhanced his national
status by giving himself the persona of a film star. In 1999 he persuaded Madhuri Dixit,
the diva of the 1990s Bombay film industry, to celebrate 'Indian womanhood' in the
mode of entertainment melodrama and embarked on a feature film, *Gaja Gamini* (2000).
He managed to turn the modernist idyll of the artist and his model into a spectacle –
inevitably both frames situate the woman outside the pale of the feminist revolution.
Gaja Gamini invokes what Husain has himself helped put in place as the
national/modern mode of representation within a larger civilisational aesthetic. Husain's
'hand-crafted' feature is a summation of his artistic career: by choosing the stars, writing
the dialogue, painting street-length sets, financing and distributing the film, he re-
inscribes himself in the narrative of a bare-foot modernist hobo in a postmodern garb.

CITING POPULAR CULTURE: A RETAKE ON REPRESENTATIONAL MODES This
essay considers how the multivocal 'texts' of popular visual culture come to be cited by
contemporary artists, and how the citations become an index to map the cultural
crossovers within and beyond the metropolis. Bhupen Khakhar, who grew up in Bombay
but lives and works in Baroda, has developed a painterly genre that can claim to be a key

this page

BHUPEN KHAKHAR

An Old Man from Vasad who had Five Penises Suffered from Runny Nose 1995

Watercolour on paper 116 × 116

The Artist

far right (above)

JITISH KALLAT

Lotus Medallion on a Siamese Twine 1998

Acrylic on canvas 152.4 × 233.7

Suresh and Saroj Bhayana Family Collection, New Delhi

far right (below)

ATUL DODIYA

Missing I 2000

Enamel paint on metal roller shutters and laminate boards

233.7 × 167.6 on 274.5 × 183

The Artist, Commission supported by London Arts

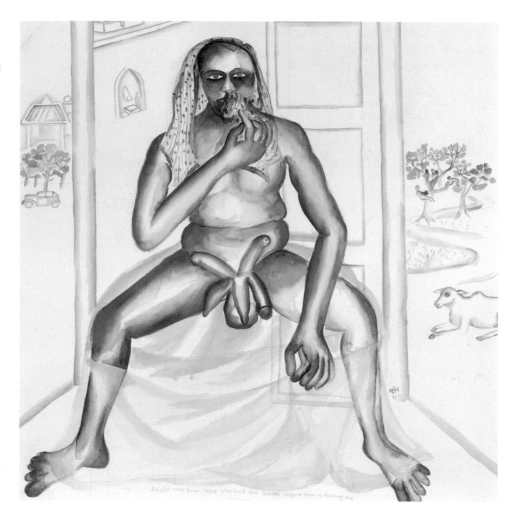

factor in the discourse of high art versus popular culture; of cultural identity in relation to sub-genres in the urban hinterland. Khakhar's sources embellish his innately naïve hand in such a way that when he introduces subaltern figures that are his abject lovers – aging male working-class men (sometimes transvestites), intimately painted, sexually valorised – he unsettles the very locus of (male) subjectivity. He provides a place for the beloved in the wake of the gay revolution, certainly. But, further, while framing the citizen in a democratic norm, he performs a curious artistic manoeuvre: he succeeds in wresting the powers of representation from the morally replete realist mode and puts in its place a composite urban/popular language of sentimental *and* transgressive exchange special perhaps to India.

Atul Dodiya's paintings present a teasing mockery of the realist-melodramatic genre. He maps over images from art history, popular imagery and textbook parables, treating the sources themselves to an egalitarian rule. And though continuing on occasion with the earlier traditions of representation (for example in his watercolours of Gandhi), he positions his art history 'heroes'/mass culture anti-heroes *vis-à-vis* the masquerading self of the artist. The viewer is invited to make a literal reading of painted images across varied surfaces – canvas, paper, laminates, metal. In the recent double tryptich titled *Missing* (2000) he paints autobiographical images on the retractable surface of metal rolling shutters in the manner of street signage; and paints nostalgic image-quotations

BOMBAY/MUMBAI 1992–2001/GEETA KAPUR/ASHISH RAJADHYAKSHA

taken from Bombay's popular culture in a sophisticated montage on the laminates behind. By thus equalising the signs he offers evidence of how metropolitan art becomes by conscious intent part of that signifying chain we call the visual culture of a city.

The younger generation of Indian painters stretch the choice of identity, ideology, ethics to the point of near neurosis. Jitish Kallat, adopting the style of an inflated mass-media image, elicits his own 'portrait' in the manner of a virtual wall-hoarding and produces a simulacrum. Pictorial self-aggrandisement is used as a strategy to go beyond the postmodern cliché of appropriation; the artist presents himself as a mascot and offers a mock-moral pedagogy about the existential anti-hero in postcolonial society. From such double-edged vanity Girish Dahiwale took a devolutionary step into (fatal) narcissism: just before he committed suicide in 1998 at the age of twenty-five, he displayed his handsome body in a painting that said in a tone of abject self-representation: *Yes, you impregnated me!* (1998)

ARTISTS IN THE PUBLIC SPHERE If on the one hand we read visual culture in terms of the popular, on the other we emphasise its place in relation to the discourse of the *public sphere* and position art practice as a witnessing act. In India, in the decade of the 1990s, such political initiatives converge around the increasingly vexed theme of secularism.

Ever since the communal riots, several courageous initiatives have been sustained by

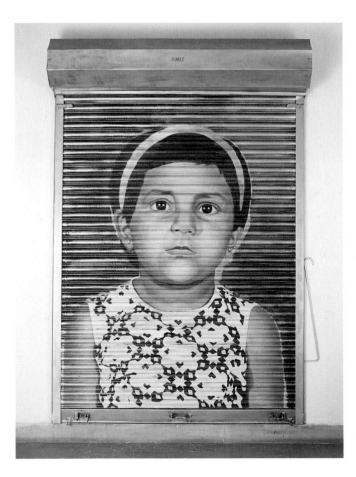

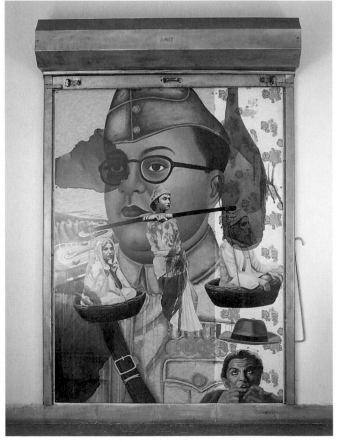

artists, political activists and independent journalists in Bombay. The forum *Communalism Combat* conducts poster campaigns and brings out a newspaper of the same name. Intervening in the now highly regulated public space of the city, the video has transformed the very sphere of the political documentary in the 1990s. Already a decade earlier the Bombay film-maker Anand Patwardhan had revolutionised documentary cinema (until then dominated by the state-owned Films Division) with his own practice of guerrilla films. The radical vocabulary of Patwardhan's *Hamara Shaher* (Bombay Our City, 1985), followed by *Ram ke Naam* (In the Name of Ram, 1993) and *Father Son and Holy War* (1995) served, in the context of the Bombay riots of 1992–3, an express agenda. Activists working with slum dwellers, legal rights groups and women's groups took to the streets and relentlessly recorded the violence perpetrated in their neighbourhoods, to produce testimonies like Madhushree Dutta's *I Live in Behrampada* (1993).

If the call to arms in the socialist mode pitches the artist almost without mediation

into the spheres of civil/political society, the 1990s emphasis on public spectacle, refurbished by the market but regimented more than ever before by right-wing commands, has encouraged artists into a critique of the earlier representational modes of protest. Socialist postering on the one hand, and Shiv Sena's fascistic sloganeering on the other, have forced artists to become more reflexive. The very modalities of the relationship between visual culture and democratic politics is at stake and requires a reconsidered formal response.

Here we present the work of four artists, painters through most of their careers, who have turned to making installations realising that it has become difficult to thematise politics with the full play of painted images. We will see how these artists make use of documentary photography and video footage in installation art – seeking its relationship to a sculptural support, deferring its semiotic function in a relay of objects.

In his conceptually structured installations, Vivan Sundaram proposes that it is precisely the political that remains unrepresented in the widely used representational

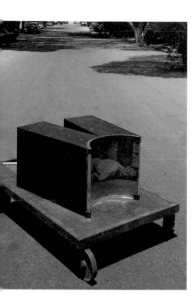

conventions of art. His sculptural installation *Memorial* (1993), based on the newspaper photograph taken in the midst of the communal riots by the Bombay photographer, Hoshi Jal, positions the dead man on the street as an icon of political shame. In an elegiac act the artist gives the man a mantle of nails, places the iron coffin on a gun carriage, buries him on behalf of the State. The act tries to retrieve a political ethic through an acknowledgement of public death. Like Sundaram, Rummana Hussain's installations use the photograph, among other objects, to fix, gloss and defer meaning. In *Home/Nation* (1996), *The Tomb of Begum Hazrat Mahal* (1997), and *Is it What You Think?* (1998) she figured, through her own body, an 'ethnic' representation of a 'muslim woman' and turned it into an allegory of social pain. The chronicle, based on self-inscription, became paradoxical because the installations were conceived as the *mise-en-scène* for an imminent death. Before she died, Hussain issued a testimony in the name of her own mortality in the installation *Space for Healing* (1999), which is at the same time a tomb, a shrine and a hospital room. It allows an apotheosis, whereby it offers to put to rest the urban nightmare – a nightmare in exact inverse of the dreamers' Bombay – that the city so determinedly keeps awake.

Navjot Altaf, privileging social evidence as moral choice, deconstructs the message in installations like *Links Destroyed and Rediscovered* (1994) and *Between Memory and History* (2000). She constructs and punctures real and metaphorical walls by inserting documentary images, confessional recordings, texts that offer informal and participatory

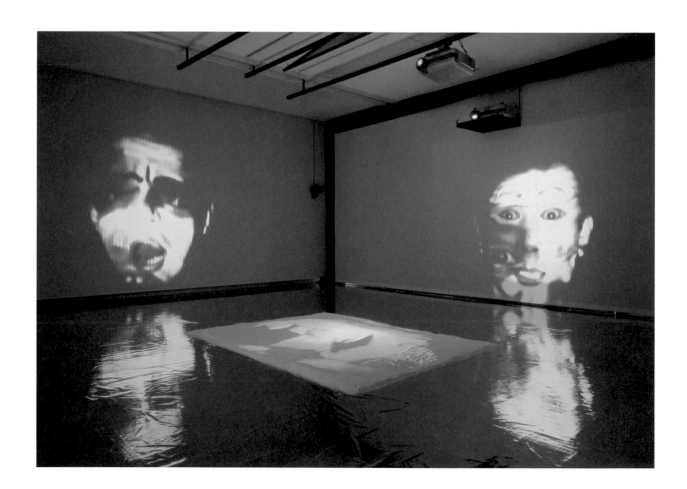

below left

SOONI TARAPOREVALA

From *The Parsis*: High Priest of
Udvada, Ervad Kekobad Dastoor
imparts some words of wisdom
to Kayrus and Rustom Unwala
after performing their *navjote*
1999
Photograph 40.6 × 50.8
The Artist

below right

KETAKI SHETH

From *The Patel Twins in Britain
and India: Twinspotting*: Sanjiv
and Sandip at their parents'
shop, The Apollo News, Ascot
1996
Photograph 40.6 × 50.8
The Artist

states of reparation within the art practice itself. Sundaram, Hussain and Altaf suggest that what is possible today is a material re-coding of the concept of struggle. They reintroduce the trope of utopia within and beyond the visual encounter so as to transform the viewer through a shared stake in citizenship.

New media give Nalini Malani a place to position the 'victim' in relation to power. Her video installation *Remembering Toba Tek Singh* (1998) is based on a famous Partition story by Saadat Hasan Manto, and brought head on into the present by the nuclear confrontation between India and Pakistan. Recently, Malani translates Heiner Mueller's *Hamletmachine* into a video installation and sets up a theatric space where a Japanese *butoh* dancer is imaged – and receives images on his body – in a stoic performance. In both installations, the technology (and ideology) of video animation is used to invoke and confront the ghosts of political criminals. As sounds and images from the fascist moment in Europe and Japan overlap, the threat of suppressed fascism in India surfaces. Malani's political interpretation, with its mandate on reformism, unravels a guilt-ridden gestalt; Hamlet's dilemma catapults into publicly exorcised moral shame at several historical moments. Allowing her artist-subjectivity to be spreadeagled over dangerous terrain, Malani radicalises forms of the 'personal' using well-honed techniques of feminist psychoanalysis wherein the lesson of resistance is continually re-learnt.

PHOTOGRAPHY, MASQUERADE In focusing on the *public* nature of cultural self-assertion, we have repeatedly foregrounded a relationship between artistic identity and an historical responsibility to the deprived subject. Indeed, the question, who is the 'real subject', haunts the imagination of the third world artist; to it is appended the discourse and practice of a critical anthropology wherein photography plays an important part. It negotiates questions of authenticity and artifice; it offers a variety of different readings to the paradox of presence and absence; it problematises location. Putting to rout the flimsier kinds of representational claims, it realises the desire for masquerade.

The work of two women photographers, Sooni Taraporevala and Ketaki Sheth, relates to social communities in an urban anthropological mode. Taraporevala's subjects are the

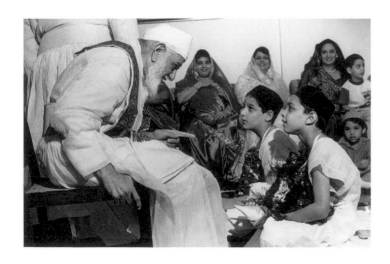

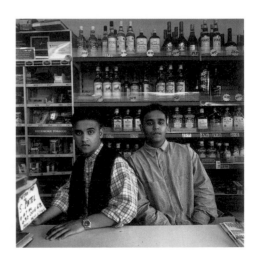

PUSHPAMALA N.

From **Phantom Lady or Kismet.**

A photoromance by

Pushpamala N. Set in Bombay

1996–8

Concept, Direction and

Performance: Pushpamala N.

Photography: Meenal Agarwal

Sixteen photographs, each 30.5 ×

40.6 (edition of ten)

Bradford Art Galleries and

Museums

Parsis who are an ancient diaspora, religious exiles from Persia across the Arabian sea to the western coast of India. They are among the most real subjects of Bombay – by the nineteenth century they were active agents of westernisation and among the leading entrepreneurs in the metropolis. Today, in the era of chauvinist nationalism, they appear like a receding sign. Sheth's subjects are the native and immigrant Gujarati Patels, forming an upwardly mobile middle class spreading out from the western coast of India to Africa, the United Kingdom and the USA. Sheth chooses to photograph the strangely frequent phenomena of the Patel twins in different classes and locations. She finds herself losing/gaining the photographer's discreet subject: the twins appear ghost-like in their inadvertent doubling, in their masquerade produced by biological splitting. The pictures work in a paradoxical manner as the Patel protagonists with absent looks nevertheless endorse themselves with the double stamp of struggle and success and 'win' the battle for a future.

If these works deal with real subjects and their hidden masquerades, Dayanita Singh, plunges herself into the (il)licit space of entertainment and pleasure, pain and embarrassment, and comes up with an openly performative mode. Her photographs frame the transactions of the urban body – the ungainly queen of Bombay films' song and dance routines, the city's sex workers. The photographer presents her popular characters dissembling their way into a respectable world even as a colonial Bombay, in her recent photographs of the city's landmark museum and theatres, turns into a simulacra. These manoeuvres between the real and the make-believe come up-front with the sculptor Pushpamala N. She directs herself as an actress playing a double role to Meenal Agarwals' 'cinematography' and comes up with a series of black-and-white photographs set in Bombay titled *Phantom Lady* or *Kismet* (1996–8) These are not 'film stills' but a synoptic *film noir* narrative where Pushpamala emphasises the performative as an occasion for transgression. She inverts the conservative regulations that determine public morality by her masquerade of the female artist as a classic/cliché of the good/bad girl.

Photography's investment in tracking the real subject has inducted itself into larger representational issues, and the documentary mode has always played an honourable role in bringing to view previously unrepresented realities. The struggle in realism to define the self through defining what is around one is appropriated by a photographer like Swapan Parekh who takes the documentary image into what many would see as its logical culmination: *advertising*. The context, so assiduously elaborated in documentary images, so consistently upturned in avant-garde photography, is returned to you as your neighbourhood market/shopping mall; the image advertising the branded products provides a facile interface between consumption and belonging.

NEW MEDIA, YOUNG ARTISTS This brings us to new media and a conspicuous slippage of *meaning* in the life of the image. Certainly in advertising, in the extension of the image into video (and thus into special effects), or further into purely virtual spaces such as the CD-ROM or the Internet, the public address of the documentary photograph (to which the artist may still determinedly return) is inverted by a programmed manipulation that transfers the image into spectral forms of communication.

New media promotes a cosmopolitanism that is precisely about virtual identities: along with 'Hinglish', Indipop, Bhangra rap, the deliberately low-brow remix of Hindi film tunes and other such cultural makeovers of formerly vernacular idioms, the globalised artist can now revisit and reframe conventions of representation to put up a new charade of meanings. Sudarshan Shetty, working with painting, photos, found objects and fibreglass sculptures, mirrors himself in the kitsch and glitzy commodities as a virtuoso male artist in love with himself and the artwork he deploys to garnish his narcissism. He also makes cherished symbols of Indian culture stand in as a farce: the red fibreglass cow with human babies clinging to it is called *Home* (1998). In contrast, Kausik Mukhopadhyay, naming modernist ready-mades as ideological allies, mimics the increasing commodification of art, then stands it on its head by privileging use-value in urban waste. With an ironical self-evacuation of the artist-persona, he embraces an artisanal ethic, and makes a political gesture. Both aspects are matched by younger women who substitute male with female narcissism in the same idiom of indifference. Sharmila Samant concocts objects with an artisanal flair using the city's detritus and records her obsessive hunt for the global found object in mock-documentary videos (such as *Global Clones*, 1999). Shilpa Gupta works with new technology – video, computer and the Internet and like a new kid in the block makes her earnest neighbours in Indian art uneasy with virtual communication. All these artists have a clever take on consumer society but on the basis of the very consumption of the artwork that they mockingly package and proffer.

Part funky, part pragmatic, the young Bombay artists are levelling the field for high and low art. Swimming in the wake of a vanguard, wearing the aura of the global flâneur, these artists can today function in and out of the galleries, the biennales, the institutions, the market. They negotiate literalism and masquerade, they co-relate the self, the spectacle, the empty sign. Is there a new turn in the very premises upon which art has been made in and for and about the city? Recent initiatives suggest that these artists are beginning to look for a definition of collectivity that can pitch them into acts of cultural intervention. It is possible also that they are beginning to recognise and critique a situation that all too easily slips – the more easily after violence of the early 1990s in Bombay – into the field of the 'post-political'.

This brings the argument in this essay full circle. The current postmodern celebration of visual culture – often a simple fusion of art history and popular culture – needs a minimum political intent to bring cultural creativity into a new phase. If the equation between art practice and the representational modes that cite/site the popular, and between art practice and the discourse of the public sphere, is to gain further signif-icance, artists have to grasp the democratic impulse at work in the city's visual culture. The current postmodern celebration of visual culture – often a simple fusion of high art, popular culture, new media – needs a minimal political intent to bring contemporary cultural creativity into a new equation with the historical avant-garde.

Notes

1. In 1995 the city's name was changed from the colonial 'Bombay' to the vernacular 'Mumbai' (see p.20). While this transition is signalled in the title of this essay, we have chosen to use the name Bombay throughout. Placed in the heterodox history of this city, this choice can maintain a self-explanatory polemic, signalling questions of belonging and appropriation, and of the larger politics of location. The name Mumbai is used in the post 1995 period in the captions, endnotes and timeline.

2. F. N. Souza, 'Nirvana of a Maggot', *Words and Lines*, London 1959, p 15.

3. The lower-caste and untouchable members in the Hindu social hierarchy have adopted the name 'Dalit' (meaning 'ground down', 'oppressed') as a political signal of their self-empowerment. The twentieth-century Dalit movement in Maharashta, spearheaded between the 1930s–1950s by the radical jurist Dr B.R. Ambedkar (the main architect of the Constitution of India) involves a rejection of Hinduism/conversion to Buddhism. It incorporates militant outfits like the Dalit Panthers. Dalit consciousness finds its metropolitan expression in Marathi literature, especially poetry. See Arjun Dangle (ed.), *Poisoned Bread, Modern Marathi Dalit Literature*, Bombay 1992.

4. Namdeo Dhasal, 'Tyanchi Sanatana Daya' (Their Eternal Pity), Golpitha; trans. from the Marathi by Eleanor Zelliot and Jayant Karve. Quoted in Vidyut Bhagwat, 'Bombay in Dalit Literature', in Sujata Patel and Alice Thorner (eds.), *Bombay: Mosaic of Modern Culture*, New Delhi 1996, p.122.

5. Baburao Bagul, 'Maran Swasta Hot Aahe' (Death is getting Cheaper), trans. from the Marathi by Zelliot and Karve, ibid., p.121.

6. See the report of Justice B.N. Srikrishna of the Bombay High Court, *Damning Verdict: Srikrishna Commission Report: Mumbai Riots 1992-93*, Mumbai, n.d.

7. There are numerous studies on the Shiv Sena and on its role in the Bombay riots. See the essays by Sujata Patel, Jayant Lele, Gerard Heuze and Kalpana Sharma in Sujata Patel and Alice Thorner (eds.), *Bombay, Metaphor for Modern India*, New Delhi 1996.

8. The census of 1991 shows 9.9 million for Greater Bombay (12.5 million for the Bombay Metropolitan Region). Projected figures for the Bombay Metroplitan Region in 2005 are 27.5 million.

9. The labour movement in Bombay's textile industry has been extensively chronicled. For the famous 1982-3 textile strike, see Javed Anand, 'The Tenth Month – A chronology of events', in *The 10th Month – Bombay's Historic textile Strike*, Bombay 1983; Rajni Bakshi, *The Long Haul*, Bombay 1987; H. van Wersch, *Bombay Textile Strike 1982-83*, New Delhi 1992. For the peculiar phenomenon of Datta Samant, the maverick trade union leader who led – and lost – the strike and was murdered a decade later, see Sandip Pendse 'Labour: the Datta Samant phenomenon', *Economic and Political Weekly*, vol.16, nos 17 & 18, 1981. See the *Economic and Political Weekly* for intensive coverage of the textile strike during the period 1980–85.

10. Gayatri Chakravorty Spivak, 'Subaltern Studies: Deconstructing Historiography', in Ranajit Guha and Gayatri Spivak (eds.), *Selected Subaltern Studies*, New York and Oxford 1988.

11. For a seminal study of the city of Bombay, see Sharada Dwivedi and Rahul Mehrotra, *Bombay: The Cities Within*, Bombay, 1995.

12. In 1965 Charles Correa (with Pravina Mehta and Shirish Patel) made a seminal proposal to ease the pressure on the island city of Bombay: It entailed developing a twin city, New Bombay, on the northern mainland, where the Maharashtra State Government would be relocated. See Correa, Mehta and Patel, 'Planning for Bombay: 1. Patterns of Growth, 2. The Twin City, 3. Current Proposals', in *Marg*, Bombay, vol xviii no.3, June 1965. It is a measure of Correa's authority and power of intervention that the proposal was accepted at State level and, though the State headquarters did not shift, the twin city came into existence. Begun in the 1970s, the development strategy for New Bombay (1971-91) has been fraught with problems; opinions are polarised over the enterprise.

13. Charles Correa, 'Great City: Terrible Place', in Hou Hanru and Hans Ulrich Obrist (eds.), *Cities on the Move*, Germany 1997, unpag.

14. Contestations regarding the city have produced a large amount of literature from sociologists and urbanists. See the essays by Nigel Harris Swapna Banerjee-Guha, Pratima Panwalkar and P.K. Das in Sujata Patel and Alice Thorner (eds.), *Bombay: Metaphor for Modern India*, New Delhi 1996. Important interventions in the city include the work of P.K. Das and Shabana Azmi (Nivara Hakk Suraksha Samiti); A. Jockin (National Slum Dwellers Federation); Sheela Patel (Society for the Promotion of Area Resources SPARC) and Rahul Mehrotra (The Urban Design and Research Institute, UDRI).

15. Mehrotra used the term in conversation with the authors.

16. Between 150–200 films, mostly made in Bombay, have been produced during the 1990s; this constitutes about one fifth of the total number of films produced in India. For referencing Bombay/Indian films, see Ashish Rajadhyaksha and Paul Willemen, *Encyclopaedia of Indian Cinema*, revised edition, New Delhi 1999.

BOMBAY/MUMBAI

1992

BABRI MASJID MOSQUE DEMOLISHED IN AYODHYA BY HINDUTVA FANATICS. SPARKS NATIONWIDE RIOTING. FIVE DAYS OF VIOLENCE IN BOMBAY AS HINDUS AND MUSLIMS CLASH

1993

SECOND WAVE OF VIOLENCE IN JANUARY AND FEBRUARY RESUL... IN HUNDREDS MORE DEATHS

STOCK MARKET BOOM LEADS TO HARSHAD MEHTA SCANDAL, AS A SMALL NUMBER OF STOCKBROKERS ARE DISCOVERED TO HAVE RIGGED THE BOMBAY STOCK EXCHANGE

RELEASE OF MANI RATHNAM'S CONTROVERSIAL FILM *BOMBAY* SET DURING RIOTS OF 1992-3

SHIV SENA-BHARATIYA JANATA PARTY COALITION WINS MAHARASHTRA STATE ELECTIONS. BOMBAY IS RENAMED MUMBAI

LAKEEREN GALLERY OPENS, COMPLEMENTING GALLERY CHEMOULD, THE CITY'S FIRST FORUM FOR NEW ART

ANAND PATWARDHAN COMPLETES *FATHER, SON AND HOLY WAR*, THE LAST IN HIS FILM TRILOGY ON COMMUNALISM IN INDIA

ARTIST PRABHAKAR BARWE DIES

SHIV SENA LEADER, BAL THACKERAY, LAUNCHES SHORT-LIVED 'FREE HOME' SCHEME FOR SLUM DWELLERS, INVITING BUILDERS TO RE-HOUSE SQUATTERS WHILE PROFITING FROM THE SALE OF LAND THEY OCCUPIED

1996

THE SHIV SENA OBJECTS TO A 'NUDE' ADVERTISEMENT FEATURING MODELS MADHU SAPRE AND MILIND SOMAN FOR TUFF SHOES, STARTING A SERIES OF CONTROVERSIES OVER CENSORSHIP

PROTEST FOLLOWING NUCLEAR TESTING AT POKHRAN, RAJASTHAN. PAKISTAN RETALIATES THREE WEEKS LATER

PRO-BJP MARATHI PLAY MI NATHURAM GODSE BOLTOI IS BANNED BY THE MAHARASHTRA GOVERNMENT

M.F. HUSAIN'S HOUSE IS VANDALISED BY BAJRANG DAL ACTIVISTS PROTESTING AGAINST HIS NUDE PAINTING OF THE GODDESS SARASWATI MADE OVER 20 YEARS EARLIER

MOHILE PARIKH CENTRE FOR VISUAL ART BECOMES A VENUE FOR INTERNATIONAL SEMINARS ON ART PRACTICE AND THEORY

SHIV SENA LAUNCHES A... ON DEEPA MEHTA'S FILM

ARTIST GIRISH DAHIWALE COMMITS SUICIDE

STATE GOVERNMENT STARTS BUILDING 55 FLYOVERS, PLANS SEA-BRIDGES AND COASTAL HIGHWAYS IN THE CITY. ENVIRONMENTALISTS PROTEST

IN MARCH SERIAL BOMB BLASTS OCCUR AT THE BOMBAY STOCK EXCHANGE, AIR INDIA BUILDING AND ELSEWHERE – ATTRIBUTED TO MUSLIM RETALIATION

MADHUSHREE DUTTA'S *I LIVE IN BEHRAMPADA*, SUMA JOSSON'S *BOMBAY'S BLOOD YATRA* BECOME VIDEO TESTIMONIES OF THE RIOTS. THE JOURNAL *COMMUNALISM COMBAT* IS LAUNCHED

SANJAY DUTT, SON OF MOVIE STARS NARGIS AND SUNIL DUTT (CONGRESS-I MP), IS ARRESTED FOR HIS ALLEGED ROLE IN RIOTS

RUPERT MURDOCH'S *STAR TV* TAKES 49 PER CENT STAKE IN THE INDIGENOUS ZEE-TV CHANNEL, MARKING THE PERMANENT PRESENCE OF MULTINATIONAL CABLE TV CHANNELS IN BOMBAY

REAL ESTATE PRICES PEAK, MAKING OFFICE SPACE IN SOME AREAS THE MOST EXPENSIVE IN THE WORLD. THE FOLLOWING YEAR PRICES FALL BY 40 PER CENT

1994

1995

HUM AAPKE HAIN KOUN BECOMES THE MOST SUCCESSFUL HINDI FILM EARNING OVER $500 MILLION IN NET TICKET SALES WORLDWIDE

ART INDIA MAGAZINE LAUNCHED

THE SUCCESS OF 'INDIPOP' AND BHANGRA RAP WORLDWIDE CONTRIBUTES TO BOOM IN INDIAN (NON-FILM) MUSIC INDUSTRY

NATIONAL GALLERY OF MODERN ART OPENS WITH EXHIBITION OF MUMBAI'S FAMOUS PROGRESSIVE ARTISTS' GROUP OF THE 1940S-50S

CHRISTIE'S OPENS MUMBAI OFFICE

1997

MAVERICK TRADE UNIONIST DATTA SAMANT, LEADER OF 1982-3 TEXTILE STRIKE, IS GUNNED DOWN BY OPPONENTS

SAKSHI OPENS IN REFURBISHED MILL SHED BECOMING INDIA'S LARGEST PRIVATE ART GALLERY

1998

STATUE OF DALIT LEADER BABASAHEB AMBEDKAR IS DESECRATED IN SUBURB BY AN ANONYMOUS GROUP, TRIGGERING STATEWIDE PROTESTS

COMMERCIAL FAILURE OF FORMER MEGASTAR AMITABH BACHCHAN'S COMEBACK FILM MRITYUDAATA IS A SET-BACK FOR HINDI FILM INDUSTRY

300,000 SQUATTERS EVICTED FROM SANJAY GANDHI NATIONAL PARK FOLLOWING PROTESTS BY ENVIRONMENTALISTS. GROUPS SUPPORTING RIGHTS OF THE 55 PER CENT OF MUMBAI'S POPULATION LIVING IN SLUMS FIGHT FOR ALTERNATIVE SITES

ARTIST RUMMANA HUSSAIN DIES

1999

KALA GHODA FESTIVAL ESTABLISHED AS MAJOR CITY ART EVENT COMBINING ART, MUSIC AND FILM, TOGETHER WITH CITY CONSERVATION EFFORTS SUPPORTED BY PUBLIC AND PRIVATE SECTORS

SHIV SENA-BJP COALITION LOSE POWER TO THE MIDDLE GROUND NCP-CONGRESS COALITION IN STATE ELECTIONS

POPULATION OF MUMBAI ESTIMATED TO RISE TO 27.5 MILLION BY 2005, MAKING IT THE WORLD'S SECOND MOST POPULOUS CITY

US PRESIDENT BILL CLINTON MEETS YOUNG INDIAN ENTREPRENEURS

2000

M.F. HUSAIN COMPLETES FILM *GAJA GAMINI* STARRING MADHURI DIXIT

LAGOS
1955-1970

OKWUI ENWEZOR AND OLU OGUIBE

LAGOS IN THE CULTURE OF TWENTIETH-CENTURY MODERNITY
OKWUI ENWEZOR

Despite the utopian nature of what it describes, modernity is a deeply ambivalent term, the more so when viewed from the perspective of the twentieth century. For many, modernity is not only the elsewhere of the utopian imaginary, that citadel of hope and idealism, where our deepest dreams of progress, individualism and enlightened consciousness are built, but also the non-place of exile and displaced hope. Modernity's cultures emerge at the twilight of improbable loss: faith, community, ideas. It beckons those whose experiences are bound together by a communion to create a viable social project and a cultural ethic. Consequently, modernity seems always to my thinking a paradoxical process of eternal regress (consumed as it is with the past), a nowhere of the mind whose strongest attributes burn bright through a series of elisions and detours. It is always a work of perpetual undoing and reconstruction, never a fixed meaning. It is no surprise then that the idea of the city beginning with the Futurists has come to dominate, at least in the West, the idea of modern life. Out of this obsession a stock image has also emerged. Thus, when people in the arts speak about modernity they try to visualise it, that is to put it into a field of vision. How then to think of the twentieth-century city, that exemplar, par excellence, of modernity?

I will try to sketch an orientation in this text, that does not seek a fixed meaning either, but a value of how spaces so disparate in their consciousness and experience of the twentieth century, so different in their cultural and social life, could be seen as examples of modernity. This notion of modernity implicates many narratives, sometimes juxtaposing, at other times counterposing them with new, emergent and counter narratives; all of which jostle for clear space within which the knotted idea of the twentieth-century modern self could be fashioned.

By all accounts, for many, the twentieth century has been a terrible wound. Given the tumultuous and enormous changes wrought on the very idea of modern life, from the decline of industrial statism to the rise of the information revolution and multinational global interests, it goes without saying that cities, like the century which has just passed, have also undergone tremendous changes. Some wounded by war and ideology, others uplifted by economic prosperity and new technological achievements, seek new horizons, a perpetual drive to attain that which modernity is seen to exemplify: progress. I would like to invest in the belief that there are other kinds of cities. Two of these, often unaccounted for, come to mind. They are cities which could be imagined as veritable non-places, neither inhabiting any discernible connection to the idea of progress nor wholly tethered to the brittle and outmoded machinery of the past.

The first city, for which a whole different nomenclature has to be invented, is quite resonant, and vividly demanding on our historical understanding of those forms and spaces of dwelling, production and exchange aligned to the history of colonial conquest. The colonial city and its experience produce for those who inhabit it a new order of knowledge. Such a knowledge not only questions the very temporality of the colonial city's spatial concept, it cuts the city from any fixed point on a cartographer's instrumental and Cartesian logic. The colonial relationship has also underwritten the

LAGOS 1955–1970/OKWUI ENWEZOR/OLU OGUIBE

very production of multiple narratives of even such stalwart cities as London and Paris; to speak of the history of the twentieth-century city is to speak of heterogeneous and complexly textured patterns of movement, migration, expulsion and assimilation.

The other kind of city, much nearer to our time, and to which we may also turn our attention, is very much attached to the traditional understanding of the linkage between technology and progress. This aspect challenges, in the most radical fashion, the idea that cities are concrete places of dwelling and organising forms of social life. In this case, nothing can surpass the net as perhaps the most intricately organised network of activities that productively link up labour and capital, but also cultural production and exchange. The sociologist Manuel Castells, in his highly influential book *The Rise of the Network Society*, has identified what he considers an increasingly bipolar universe in which 'Our societies are increasingly structured around the opposition between the net and the self.' From the above, all concepts of cities respond to another idea, an architecture of non-place around which myriad, highly complex activities are organised. Within such an idea we may then discuss what makes a city and what makes such an identity worthy of our attention, especially as the traditional views we have of cities continue to be destabilised. But if we move beyond the framework of what the actual manifestation of a city may be, whether as an imaginary transposal of structures and sensations (as the Situationist psycho-geographic play book may have it), or the ethereal formation of network societies, we may have arrived at a point where new models and forms of cities in their historical, temporal and spatial characters could be more adequately investigated. That model incorporates old ideas and concepts around the formation of what we call society. For while the city is a manifestation of highly temporalised and spatialised groups of activities and forms, society is a much more intangible idea.

Here, I wish to offer only one example of the constant detours that create a punctum in the old conception of the city. Western enlightenment logic has often taught us to think of time as linear; as a series of quantifiable and measurable units; as something concrete and in itself irrefutable. Out of such a logic we have constructed a narrative of history, which rather than being elliptical has constantly returned us to a totalised time. This logic specifies that there be no asynchrony. We all share the same consciousness of our place within what essentially is European time. But modern cities have taught us otherwise, the more so because their very constitution runs counter to Enlightenment logic. Take a small neighborhood in Brooklyn, New York: here we have arrived at the limits of historical narration which connects time and space. This limit is marked out for us when we observe how traditions (secular and religious, cultural and economic, political and social, and often racial) live next to each other. Crossing between the social, cultural and racial imaginaries that form a city like New York, we experience a deep sense of a detemporalised city. Or put another way we are confronted with a spatial concept that exceeds the linear logic of Cartesian time. The Brooklyn neighbourhood of Crown Heights occupied by Hasidic Jews and Caribbean immigrants will suffice in this analysis. The two communities occupy the same spatial grid, but live an entirely asynchronic temporality. Friday evening: as the deeply religious Haredim hurry home to observe Sabbath, we become witnesses to the transformation of the consciousness of a community we all call home and our city. A few blocks away the Caribbean youth prepare for an evening of

JACOB LAWRENCE

The Journey 1965

Gouache on paper 55.2 × 74.9

Bill and Holly Marklyn

reverie and social rituals that help bind them not to a place but to a culture; to an imaginary homeland. Religious and secular, this small neighbourhood does something to the concept of time in a spatial context that makes the very idea of a city paradoxical. Such that, instead of a city we may begin to speak of meta cities as the norm rather than the exception of modernity. Cities gain their value, then, both in terms of this historical residue and in their capacity to host these contradictions and receive new cultures; to create spaces for new expressions and experimentation; to transform, transmit, communicate and make visible to their societies new values, all of which remain perpetual works in progress. Such hosting is important for the spatial project we call Lagos. No more no less. Lagos is not a quantifiable entity, though its memories are part of its history. And the density of those memories is the subject here.

MODERN LAGOS: 1850-1945 Along the lucrative Atlantic coastline of West Africa (part of the infamous slave coast which stretched from Ijebu in the inland part of the country to Warri, Badagary, Ouiddah and Porto Novo), between the Bights of Benin and Biafra, lies the city of Lagos. Known to its local inhabitants as Eko, a name still very much part of the city's identity today, Lagos inherited its present name via Portuguese traders who had established a trading post there in the sixteenth century. Until it became the administrative seat of the British colonial government, Lagos was known for its lucrative slave trade market, located further down the coast in Badagary. But when, in the mid-nineteenth century, slavery was permanently abolished, and a scramble to find alternative trades ensued amongst European powers and their trading companies, Lagos, then under the rule of the slave trading King Kosoko, was bombarded by British gun-boats on the pretence of prosecuting the king's slave trading.

From a slave-trading outpost to its present industrialised, modern outlook; from the former seat of the Federal government of Nigeria to the most important economic and commercial centre of the country with a growing urban population which ranges between ten to fifteen million inhabitants, Lagos has remained a magnet of vital economic activity and cultural production in West Africa. In today's urban parlance, Lagos is a mega city. It is a city stitched together from towns, fishing villages, islands, and reclaimed swamp areas. Today it stretches from the exclusive and luxurious Victoria Island, and Ikoyi and Lagos Island, to the mainland and suburbs of Surulere, Ikeja, Yaba, Apapa, to new model cities such as Satellite Town, Festac Town, down to the border of Benin.

The hallmark of the city's character is its multi-ethnic, multi-cultural and international outlook. This outlook, which remains one of the signal attractions of Lagos, is part of the modern beginnings of the city in the 1830s. After its sacking by the British, a new social, political, religious, cultural and economic transformation of the city resulted in the arrival of European traders vying for important controlling interests in the lucrative agricultural trade with the interior of the country. Along with trade, religious activities designed through Christian missions spurred the rapid evangelisation and conversion of the entire area. Most importantly, Lagos was established as a city for the return of freedmen and women and their children after the abolition of slavery. Two distinct groups of returnees arrived within this period. The first group comprised mostly freed slaves from Europe and the USA, who were first settled in Freetown, Sierra Leone. The Sierra Leonians first

LAGOS 1955-1970/OKWUI ENWEZOR/OLU OGUIBE

began migrating down to the city through trade. Most of these freedmen and women were Christian converts, spoke English and were fairly well educated. The other important group were Brazilian returnees, who were in fact the first to arrive establishing a strong cultural connection between Lagos, Porto Novo and Brazil. This group, less educated than the Sierra Leonians, was mostly Roman Catholic, spoke Portuguese, and formed the majority of the city's skilled labour. Many were fine craftspeople. Lagos owes its unique architectural character to the craftmanship of the Brazilian returnees. Their architecture of elegant grill work in iron, sculpted balustrades, and sloping, peaked roofs made out of corrugated iron is a unique heritage of Lagos's old city.

But the culture of the returnees extends to other aspects of Lagos's critical culture that still persist today. For example, the music of Juju and Highlife trace their origins to the proto-postcolonial rubric, trans-national migrations, assimilations and creolisation of Lagos. The city's early population during the late nineteenth century was diverse. Beside ethnic Yoruba who comprised the largest population and whose ancestral land incorporates the Lagos continuum, there were Hausa, Edo, Fulani, Kanuri, Borguwa, Nupe, and various West Africans from the Gold Coast, Dahomey, Liberia and the Cameroons who settled in the city, making it one of the first cosmopolitan centres of trade and culture in West Africa.

The city was prosperous. And the establishment of institutional structures such as schools, churches, missionary organisations, and many of the famous cultural societies started by the returnees, provided a strong social and cultural base. By the 1870s through the 1890s Lagos would enjoy an unprecedented population growth, and moreover the industrial revolution in Europe brought benefits with the construction of new wharfs, warehouses and trading companies which contributed to a new urbanism. Streets and boulevards with street lamps were added in a new plan of the city in a grid format. The establishment of telegraph linkage in 1886 and electrification in 1894 transformed the city into a world-class metropolis. In addition, an important intellectual tradition grew from the intense interest in culture of the Sierra Leonian group who established newspapers and publishing companies. It would not be too long before this

ADEBISI AKANJI

Untitled (Four Screens) *c.*1966
Cement and metal. Four parts,
each 156.8 × 101.6
National Museum of African Art,
Smithsonian Institution,
Washington, D.C. Gift of Mr. and
Mrs. Walkemar A. Nielsen, 94-20-
1, 94-20-2, 94-20-3, 94-20-4

LAGOS 1955–1970/OKWUI ENWEZOR/OLU OGUIBE

**Lady Ademola Honoured in
London** July 1959

Photograph 40.6 × 50.8

Public Records Office

rise in intellectual ferment also radically politicised the educated upper middle-class elite who began to seek greater political autonomy for the city.

NATIONALISM, PAN-AFRICANISM, NATIONHOOD: 1945-1960 From the time the Northern and Southern parts of what is today known as Nigeria were amalgamated as one political unit in 1914, the political fortunes of the country in its struggle against colonisation have always been linked to Lagos. Two important political and ideological cultures emerged in Lagos. The first was founded on the Pan-African ideology strongly propagated and promoted by the Oxford-educated historian Edward Wilmot Crummel, who was American by birth and a Liberian citizen and a fierce defender of African autonomy and independence. His ideas, circulated through lectures, books and articles, led to the establishment of a political awareness and a cultural consciousness of racial pride amongst the educated middle class. Some of these ideas, with their notions of racial solidarity, a strong work ethic and Christian idealism, would be taken up by another émigré, Herbert Macaulay, and sharpened into a potent nationalist movement. Macaulay's movement was transformed into a broad political base by the American-educated Nnamdi Azikiwe (who would become, upon independence, the first president of Nigeria). For Azikiwe and Macaulay, co-founders of the National Council of Nigeria and the Cameroons (NCNC) in Lagos in the late 1930s, pan-Africanism and African nationalism were essentially cut from the same broad historical cloth. Through his network of newspapers and other publishing interests, the most notable of which was *The West African Pilot*, Azikiwe took the mantle of the party after Macaulay's death and reorganised it into the only pan-ethnic national political party after the Second World War in preparation for the final push towards independence and nationhood.

LAGOS: FROM INDEPENDENCE TO THE POSTCOLONIAL CITY, 1955-1970
Though Lagos has enjoyed a long history of prosperity, both illicit and legal, no period could quite match the years between 1955 and 1970. The Lagos of this period, like the rest of the country, was in the midst of a great economic surge. It was the period of independence, and the headiness of it all unleashed a jouissance amongst the various

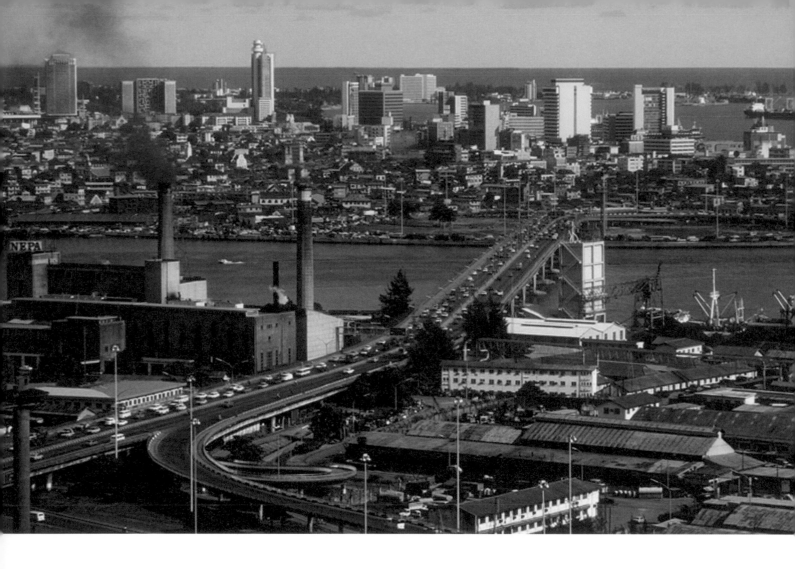

social classes of the city's political elite and the working class quite unlike what had been seen before. And with impending independence came a rapid urbanisation process that brought large populations from Nigeria's various regions to the city in search of work and fortune. This period marked another great moment: the shift of the city from a colonial to postcolonial city with a strong cosmopolitan culture. Everywhere, because of the booming economy and the need to develop new infrastructures to accommodate the bourgeoning population and businesses, a series of projects for urban renewal was initiated. New buildings were being constructed by new companies. Large-scale public works of roads, bridges and mass housing constructions were initiated by the both the government and private concerns. The architecture of this period was mostly realised by expatriate architects such as John Godwin and Gillian Hopwood, Maxwell Fry and Jane Drew, James Cubitt, Alan Vaughan Richards, Architecture Co-Partnership, and young Nigerian architects such as Alex Ifeanyi Ekwueme, Oluwole Olumiyiwa and the architectural department of the Federal Public Works Department. During this period the Mainland and Eko Bridges were constructed, linking Lagos Island to the mainland.

The transition from colonial vassalage to postcolonial client perhaps made the most critical impact in the city's urban development. The newly minted political class demanded monumental architecture to appease the gods of independence. The concrete structures produced during this period form part of a large global modernist tradition of Corbusierian functionalist architecture (in fact, Fry and Drew worked with Corbusier and

LAGOS 1955-1970/OKWUI ENWEZOR/OLU OGUIBE

Louis Kahn in the plan and development of Chandigarh in India); however, to a large degree, the response of architects, who had to adapt modernism to the tropics, in response to the city's unique architectural heritage, gave the architecture a blend of quasi-traditional form but within the Cartesian grid of modernism. The strange mix of international styles agglutinated to the already, wilfully, deformed grid of the city's grid plan of the late nineteenth century, saved Lagos from becoming another experiment in meaningless internationalism. Lagos's chaos is part of its identity. Rather than a hierarchical structure of verticality, the city rises in the carefully controlled parts where the elite sequester themselves in kitsch luxury and opulence, and then drifts into the tangled sprawl of informal and formal neighbourhoods that long ago abandoned any sense of order as a rationale for urban planning. The time of the city therefore is circular and circuitous; a tangled web of spatial relationships organised by asychronic time.

This Lagos represents a concatenation of competing narratives, voices and critical spaces. But most importantly, throughout the twentieth century it has remained a vital meeting point of cultures, providing strong platforms for exchange, and serving as the collection and dissemination point of a complex postcolonial cultural and intellectual output. The tradition of tolerance for difficult contemporary ideas has made Lagos, more than any other city in Africa a representative space, placing at the service of its inhabitants and numerous communities an environment in which concepts of mixing are instrumentalised not as theories of modernity, but as part of the transnational experience of modernity. It is here that the strange relationship between the postcolonial and the pan-African is knotted. This is easily visible in the style of the urban dwellers, and in the dizzying ambiance of Jankara and Balogun markets, with their meandering sections. Like the Oshodi motor park which inhales and regurgitates millions of passengers each day from all points of the city, Lagos sits at the crossroads of becoming and collapse; its postcolonial, pan-African illusion both fully earned and squandered.

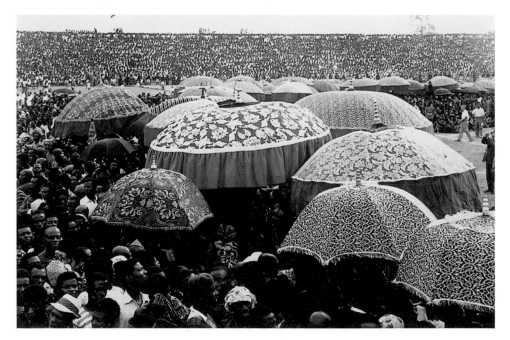

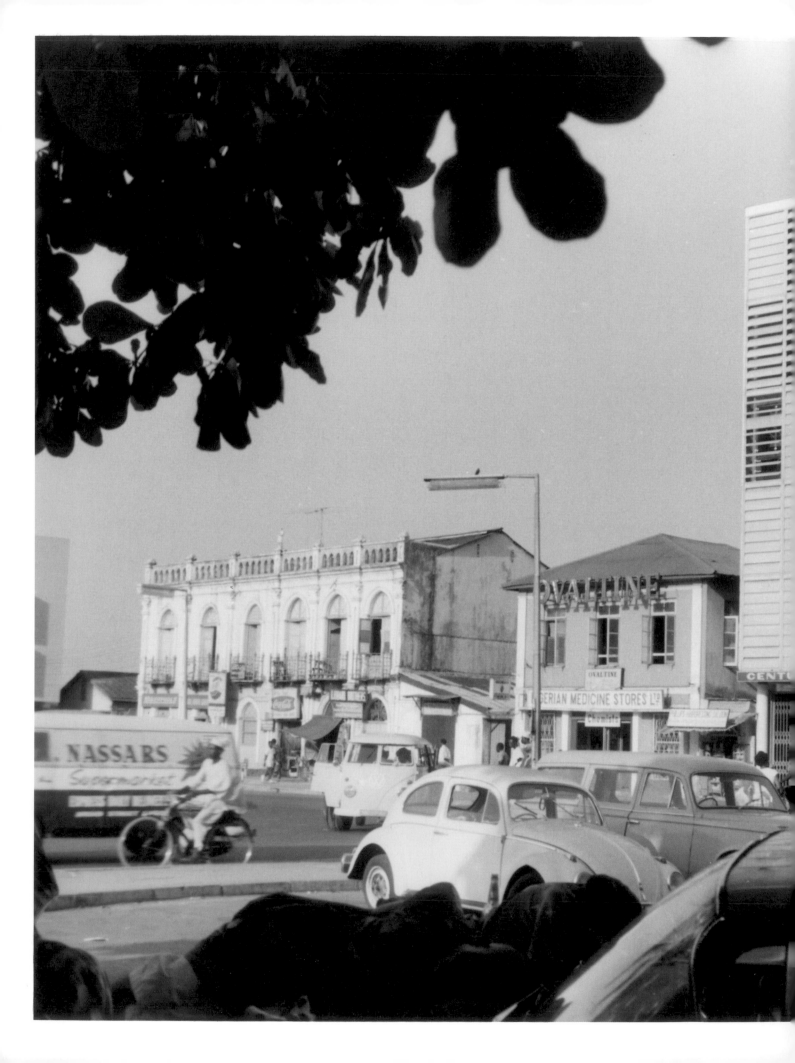

JOHN GODWIN AND GILLIAN
HOPWOOD
Office Block, Lagos 1958
From the archive of John Godwin
and Gillian Hopwood

HIGHLIFE: A CULTURAL AND SOCIAL ETHIC So far, I have tried to trace a vision of Lagos that is more structural than performative. This approach gives us only the benefit of seeing the fundamental social base of the city as well as its history. But examined strictly from this angle, Lagos becomes just like any other international city with an airport whose whirr and pull appeal to global capitalism. But there is in the makeup of the city's identity an elusive performative dimension which defies the logic of global capitalism. I wish to look at what this means through the lens of Highlife, a musical genre that flourished and found its fullest expression in the nightclubs of Lagos during the 1950s and 1960s.

The origin of the term Highlife and its current usage to describe a musical form is hard to determine, but suffice it to say that Highlife exemplified a creative effervescence in twentieth-century African popular culture that is at once cultural, social and political. The earliest beginnings of the form, as I mentioned earlier, can be traced to the returned slaves from Brazil, Europe, the USA and the Caribbean. This group of immigrants brought with them a musical style that blended European and African influences that would be transformed again when it reached shore. This linkage to the diasporic population of Lagos gave Highlife its pan-African character. Throughout the 1950s and 1960s, the music of Highlife, itself a response by African musicians across West, East and Central Africa to the sounds of Cuban rumba and Latin music, which in any case derived from African forms, produced a unique blend of African diasporic musical entities, from blues to jazz, with new African reinterpretations. By its nature, Highlife was pan-ethnic, transnational, transcultural, deterritorialised. The music not only captured the sense of an emergent African nationalism, it took on the most critical and creative forms of a salvage paradigm operation, making of the music a new minted currency of transcultural exchange.

But the great period of the music did not arrive until the great Ghanaian band leader and musician E.T. Mensah toured Lagos shortly after the Second World War. This legendary tour transformed the outlook of the city's musicians, and overnight Highlife in its modern incarnation became the rage. The luminaries of the scene are many. They include Bobby Benson and His Caban Bamboos, I.K. Dairo, Victor Olaiya and His Cool Cats, Roy Chicago, E.C. Arinze, Israel Nwaoba (known also as Njemanze) and Cardinal Rex Lawson.

But there is something else suggestive of Highlife, which is not only in its form, but a social attitude linked to the formation of a new leisure class. The period of independence or its imminence created a space of subjectivity that affected every facet of the society: in the arts, literature, music, theatre, fashion and politics. Photographers such as Jackie Phillips, Peter Obe, Okhai Ojeikere and numerous studios are sources and repositories of this change. For many, to live the Highlife was an expression of cultural modernity, a certain *belle vie*, a culture of mixing which sought through those who lived it to fuse tradition and modernity and make of both the bookends of the same reality. The city embodied this social, cultural and political ferment, while the inhabitants acquired a new awareness of their own potential. Therefore, if the activities of the Mbari club, outlined below in Olu Oguibe's essay, are an expression of the development of artistic and intellectual connections of an emergent, decolonising Nigeria, Highlife exemplified its more social character. Lagos binds them as the space of its political and economic dramatisation, the drive towards progress, towards modernity and internationalism.

LAGOS 1955–1970/OKWUI ENWEZOR/OLU OGUIBE

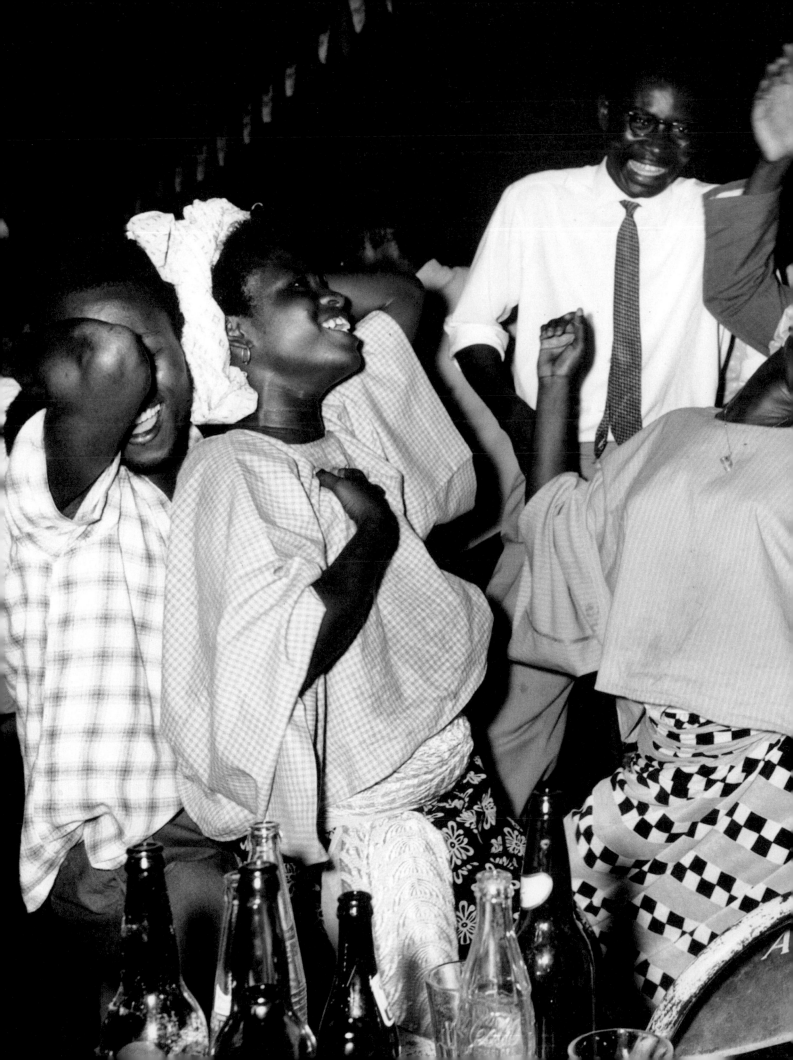

DANCING TIME NO. 5

COMMANDER IN CHIEF
STEPHEN
OSITA OSADEBE
AND HIS
NIGERIAN
SOUND MAKERS

PHILIPS

PHILIPS *West African* RECORDS

DANCING TIME NO. 3

PASTOR REX LAWSON
and his
MAYOR'S DANCE BAND

PHILIPS

PHILIPS *West African* RECORDS

HUBERT
OGUNDE

HOEP 2007

KOBO OJUMO
AWA YIO BO AJAGA

SONG OF THE PEOPLE

CABAN BAMBOO

PHILIPS

Bobby Benson
and
His Combo

PHILIPS

below

CHINUA ACHEBE

No Longer at Ease 1960

Book 19 x 26 (open)

The British Library Board

TWIN CAPITALS OF NASCENT AFRICA
OLU OGUIBE

And we flourished in Nigerian freedom, even while it was still a colony. And we
were drawn into its life by the people, who were at ease with themselves. And
we loosened up in the tropical-African milieu of Nigerian cities like Lagos and
Ibadan, which were nothing like white cities such as Johannesburg and
Pretoria. Nigeria restored Africa to us.
Es'kia Mphalele, *Afrika, My Music,* Johannesburg 1984, p.28.

The high-octane energy of Lagos with its bars and parlours and driven musicians
defined the social character of modernity in Africa from mid-century through the 1960s.
This essay also traces its broader cultural and intellectual configuration which originated
in Ibadan, about fifty miles away. Then West Africa's largest city and the continent's most
populous, Ibadan was also host to Nigeria's oldest University College, which not only
produced highly skilled administrators and intellectuals as the country prepared for
independence, but also provided ground for a crucial, cultural ferment. Young graduates
from Ibadan joined the civil service in Lagos, but maintained a thriving intellectual
community in Ibadan, in the same way that many Highlife musicians played clubs in both
cities. In effect, a constant traffic in culture and ideas coursed between the twin cities
that was vibrant and effervescent, reflecting the exuberant mood of a continent.

This effervescence found expression in literature, theatre and the visual arts that
turned Lagos and Ibadan into a formidable international literary and artistic nexus by the
early 1960s. Within the decade, a fierce and prodigious young generation of Nigerian
writers and artists emerged to instant international acclaim. Equally important, this
energy drew a long retinue of other young writers, critics, artists, theatre practitioners
and even radical politicians from across Africa, Europe and the Americas to Lagos and
Ibadan.

Among young Nigerian writers, the novelist Chinua Achebe soon gained the arguable
accolade of the father of the African novel, this based mostly on his first novel, *Things
Fall Apart* (1958), which he published at the age of twenty-seven. Working first in Ibadan
as a student, and then in Lagos as head of external broadcasting with the Voice of
Nigeria, Achebe published what many consider the defining work of his career as a
novelist between 1958 and 1964, sweeping through the epic of Africa's encounter with
Europe since the turn of the century in *Things Fall Apart, No Longer At Ease* and *Arrow
God*. Achebe's novels drew comparison to the great Greek tragedies for their
monumental and unsentimental exploration of the tragic flaw in human character, and
the correlation between this fatal element and the near-collapse of the world of the
colonised. Each novel presented as its protagonist a brave and decent figure confronted
with the overwhelming forces of a rapidly changing historical moment in the face of which
he either bends or ultimately breaks.

Achebe's close friend Amos Tutuola, still in his early thirties, had already drawn
comparisons to James Joyce with his first novel, *The Palm-Wine Drinkard*, which was
personally recommended to the board of Faber and Faber in London for publication by the

Welsh poet Dylan Thomas in 1952. In this and the four other novels that Tutuola produced between then and 1962, he inserted the folklore of his Yoruba heritage in the canons of English literature. Even more important, perhaps, he turned the language of the English literary tradition on its head in the same manner as Joyce, subordinating it entirely to his preoccupation with the business of the narrative.

Another colleague and former course-mate at the University College, Ibadan, Wole Soyinka, also in his mid-twenties, would soon return from further studies at Leeds in England, to found one of the first professional theatre companies in the country, the 1960 Masks. His first play, *A Dance of the Forest* (1963), would be produced to much acclaim in both Britain and Nigeria. Between 1963 and 1965, Soyinka would write, produce, and publish five highly acclaimed plays that earned him the reputation of Africa's leading playwright, as well as a taut and difficult novel on what he called the 'cannibalism in human nature'. His 1960s Masks, later renamed Orisun Theatre, produced his own plays: *The Lion and the Jewel*, *The Swamp Dwellers* and *The Trials of*

left

Spear January 1965

Magazine 24 x 31

African Music Archive, University of Mainz

right

Flamingo (Nigerian edition)

Magazine 21.5 x 28

African Music Archive, University of Mainz

Brother Jero, as well as those of other playwrights including Saif Easmon's *Dear Parent and Ogre*.

Working out of Ibadan, another former mate at the University College, Christopher Okigbo, produced in the same period the slim but unrivalled body of poetry that would eventually make him the most celebrated and most influential of Africa's modern poets. After only four years of serious interest in writing poetry, during which period he made his transition from composing music, Okigbo published the collection *Heavensgate* in 1962, describing it as merely the opening poem of a longer cycle. In 1964, he published another segment of the cycle entitled *Limits*, which many consider his finest work. Three years later, at age thirty-five, Okigbo died in battle as a soldier on the Biafra front, leaving only two volumes that made up the complete cycle, *Labyrinths*.

Yet another former student at the Ibadan College, John Pepper Clark, having moved to Lagos where he worked as a newspaper editor, added to the surge in literary energy with his own equally highly praised work, especially the tragedy *Song of A Goat*, produced in

1961 by Soyinka and the 1960 Masks, and eventually published in 1962. Among other young writers in Lagos, Onuora Nzekwu quickly published a number of accomplished novels including *Wand of Noble Wood* (1961) and *Blade Among the Boys* (1962), on the difficult task of navigating modernity. Having left the relative certainties of the countryside for the city, Nzekwu's characters faced unanticipated trials and temptations that challenged their personal integrity and the delicate fabric of the new world they encountered. Nkem Nwankwo published the novel *Danda* in 1964. Most of these novels were published by the British publisher William Heinemann, which began a new series, The African Writers Series, to cater for the burgeoning market that these writers and their works occasioned.

However, the real texture of the modern urban moment in Africa came out most resoundingly and unaffectedly in the work of the true doyen of the Nigerian novel, a Lagos pharmacist and government functionary named Cyprian Ekwensi, who also studied at Ibadan and then at the Chelsea School of Pharmacy in London. Ekwensi provided the link between the upsurge of youthful literary energy enumerated above, and an earlier, equally vibrant tradition that many believe laid the foundation for the later by preparing the West African audience for modern literary production. In the 1940s Ekwensi began writing as part of a loose movement of amateur pulp fiction writers, whose genre of popular novellas and pamphlets later became known as Onitsha market literature, after the sprawling upper Niger market city where it sprouted.

Whereas the majority of practitioners in this genre were poorly educated merchants and workers whose sole drive was the joy and financial viability of story-telling, and perhaps the thrill of literary agency in the form of self-publishing, Ekwensi transcended this through his knowledge and methodical application of the craft of the novel, with Hemingway, Dickens, Steinbeck and particularly Chekhov as his confessed models. Through his poignant and earthy studies of life in contemporary Lagos, Ekwensi provided the bridge between the popular and the supposedly profound, mirroring the synergy that was the reality of urban life in modern West Africa.

His hugely popular first novella, *When Love Whispers* (1947), was part market literature and part elite urban chronicle, and would prepare the way for his account of city life in Lagos, *People of the City* (1954). The latter was brought together, in the tradition of Dickens, from a series of stories written for the media over ten days. Its protagonist was a paradoxical character who worked as a popular band leader at night, and a highly moralistic journalist in the day, dipping in the street as in high culture in the same manner as he struggled between rectitude and sin. His personal struggles mirrored the battles of an emergent modernity mired in inevitable moral and social conflicts, wedged as it were between an old order in remiss and an uncontrollable new world. Ekwensi's most successful novel, *Jaguar Nana* (1961), the story of the guile and travails of a city prostitute, was written in twelve days. Even before self-rule and the collapse of social and moral structures that followed and ultimately brought this period of renaissance to a chaotic and most tragic end, Ekwensi had already begun to engage the inevitable seediness of modernity even as he chronicled its allure and glamour. In many ways his novels would presage Achebe's *No Longer at Ease,* which later addressed the same theme.

UCHE OKEKE

Ana Mmuo 1961

Oil on board 91 × 121.9

National Museum of African Art,

Smithsonian Institution,

Washington, D.C.

Like the protagonist of *People of the City* who doubled as critic and popular musician, many of the young writers in Lagos and Ibadan had other talents that enabled them to move effortlessly between the high-minded literary conversations that defined their attitude to writing, and full immersion in popular culture. Both Soyinka and Okigbo played in bars and clubs as musicians. The rest were regulars at the Caban Bamboo in Lagos or the numerous hotel bandstands and clubs in Ibadan where they commingled with the heaving youth crowd of the most vibrant cities on the West African coast.

Most of the writers came from what Okigbo described as a 'coterie of friends' who remained within proximity of one another. In an interview with the South African critic Lewis Nkosi in Lagos in 1962, Achebe described this circle as 'a community' and mentioned that they had in mind to found a writers' society in Lagos as 'a theatre on which to do battle' with each other regarding the calling of the writer in a new nation. Speaking to the same critic, Soyinka spoke of his plans to organise a 'writers palaver … a slanging session' where writers, critics and a curious audience could slug it out freely and constructively. Ekwensi duly founded a writers' association in Lagos.

A vibrant forum for this cultural slugging out was provided with the founding of the Mbari Writers and Artists Club in Ibadan in 1961. At the helm were some of the writers; Soyinka, Clark, Okigbo, Achebe, as well as the expatriate German critic Ulli Beier, who had lived and worked in Ibadan since 1952, and the ethnologist Janheinz Jahn, an avid enthusiast of Negritude. The first chair of the club was exile South African writer Es'kia Mphalele, who came to Nigeria in 1958 upon banishment from his homeland. Mphalele had moved on to Paris where he worked with the Congress for Cultural Freedom and through it, and from where he provided funding for the fledgling club. Earlier in 1957, Beier and Jahn had begun one of the continent's first serious literary journals, *Black Orpheus*, the name of which was inspired by Jean Paul Sartre's essay on Negritude, Jahn's own book of the same title published in 1954, and arguably the very successful Brazilian film of that title which won the first prize at the Cannes Film Festival that year. Mphalele joined *Black Orpheus* as a co-editor upon arrival in Ibadan in 1958, at which point the journal extended its pages to include not only criticism but new fiction also. *Black Orpheus* was later co-edited by J. P. Clark, and would provide material for the first notable anthology of modern African writing since Langston Hughes's earlier in the century.

With the establishment of Mbari and *Black Orpheus*, not forgetting *Nigeria* magazine, which had come under the editorship of Michael Crowther and Onuora Nzekwu and published regular features on artists, writers and culture in general, the scene was set for the most productive artistic and literary moment in modern Africa. *Black Orpheus* published criticism and creative writing by writers from all over the African diaspora, giving room for many to publish their work for the first time. The Mbari club set up a gallery, a performance space, a workshop and a book-publishing project, eventually establishing a network of clubs also located in Lagos. In addition to publishing most of the writers mentioned above, Mbari also published many other African writers including the South African Alex La Guma whose first novella, *A Walk in the Night*, was published by Mbari in 1961 while the author was under house arrest in South Africa. The same year Mbari published the first collection of poems by South African poet Dennis Brutus, who

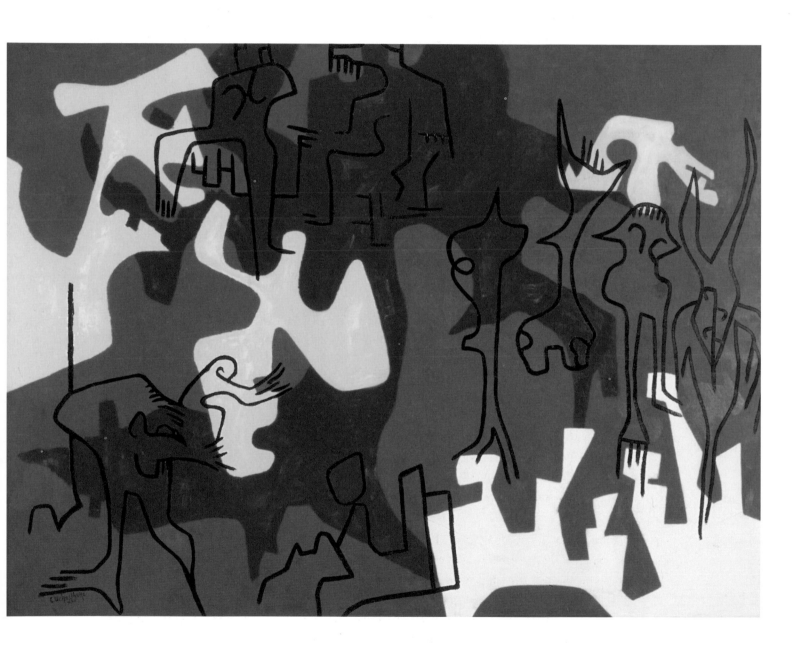

MALANGATANA NGWENYA

The Story of the Letter in the Hat: a) The husband departs for work carrying his wife's hidden letter to her lover 1960

Oil on board 69.8 x 40.4

D. and A. d'Alpoim Guedes

MALANGATANA NGWENYA

The Story of the Letter in the Hat: b) The husband returns from work with the lover's reply in his hat 1960

Oil on board 69.8 x 40.4

D. and A. d'Alpoim Guedes

MALANGATANA NGWENYA

The Story of the Letter in the Hat: c) At 2am the wife, Luisa, puts another letter in the hat while the husband sleeps 1960

Oil on board 69.3 x 69.3

D. and A. d'Alpoim Guedes

was in prison. *Sirens, Knuckles, and Boots* established Brutus as one of the most remarkable poets of the century.

In other words, Mbari played a major role in the birth of modern African literature. The club also published drawing portfolios and catalogues of emerging artists from all over Africa, including the Sudanese Ibrahim Salahi and the Mozambican Malangatana Ngwenya, both exhibited at the club. Other artists, Nigerian and foreign, were also invited, among them Ghana's leading modern artist Vincent Kofi and American painter Jacob Lawrence, both of whom conducted workshops at Mbari. Salahi, Ngwenya, Kofi and Nigeria's leading artist of the time, Ben Enwonwu, were all proponents of an African cultural renaissance, the germ of which they believed was taking root in Ibadan. Enwonwu, who worked in Lagos, became the national artist, producing monumental sculptures that glorified Africa's emergent leaders in works like his bust of Nigeria's first president, Dr. Nnamdi Azikiwe. With other works like his *Sango* and *Anyanwu*, he reinserted African legends and historical figures into the visual culture. Lawrence had pioneered a revival in history painting in America and applied it to the chronicling of the experience of the African in the Americas. He joined a long train of prominent African-American political and cultural figures who came to reconnect with the energy of a new Africa. Out of his visit came a new series of paintings, the *Nigerian Series* (1964–5) in which he tried to capture the vivacity, colour and assuredness that made Ibadan and Lagos the social and cultural capitals of renascent Africa (see pp.46–47)

Through Mbari, former members of the Zaria Art Society, which emerged in the late 1950s as the avant-garde of modern Nigerian art, joined energies with their literary contemporaries. Formed at the Nigerian College of Arts and Science, Zaria in 1958, the society articulated its conceptual strategies under the aegis of a 'new synthesis', which proposed a resolution of surviving African art traditions and the language of modernity. After college, members like Bruce Onobrakpeya, Yusuf Grillo and Demas Nwoko moved to Lagos and Ibadan. Like the writers, they actively and methodically engaged in rediscovering a cultural heritage mediated by colonialism, and mining it for techniques, metaphors and sensitivities appropriate to the present.

In his brief on the concept of 'natural synthesis' in 1960, Uche Okckc, thc leading

member of the group, wrote: 'Our new nation places huge responsibilities upon men and women in all walks of life and places much heavier burden on the shoulders of contemporary artists … Therefore, the great work of building up new art culture for a new society in the second half of this century must be tackled by us in a very realistic manner.' Okigbo, Okara and Soyinka held the same views, and applied themselves to the task of rediscovering the peculiar and thriving nerve-ends of their cultures with which they enriched their work. Mbari's most crucial role, then, was to serve as a fusion chamber for these similar propensities, and through its stream of international collaborations forge them into a cosmopolitan phenomenon.

The sculptor and painter Demas Nwoko became a leading member of the Mbari club. Nwoko not only exhibited his own works with Mbari, he also made illustrations for books by his writer friends, in the same manner that Picasso did for Cezaire and the Surrealists in Paris earlier in the century. Another member, the painter Bruce Onobrakpeya turned to printmaking after a workshop organised by Mbari, and would go on to become Africa's greatest master printmaker. Onobrakpeya illustrated books by Ekwensi and others, but most significantly he also undertook major public commissions including murals and commemorative portfolios. Onobrakpeya's mural *14 Stations of the Cross* for St. Paul's Church, Ebute-Meta Lagos, interpreted the story of Christ's suffering on the way to

above

BEN EWONWU

Bust of Nnamdi Azikiwe 1962

Lead. Height 30

Mr Atose Aguelle. Courtesy of Nimbus Art Gallery, Lagos

right

IBRAHIM SALAHI

The Last Sound 1964

Oil on canvas 122 x 122

The Artist

above

BRUCE ONOBRAKPEYA

From ***The Last Supper with 14 Stations of the Cross*: Jesus Falls for a Second Time** 1969

Lino engraving on paper. Fourteen parts, each approx. 22.9 x 58.4

The Artist

right

GEORGINA BEIER

Sunbirds 1964

Oil on board, approx. 122 × 137

Stanley Lederman

Golgotha, through African motifs, using subtle tropes to relate it to the African colonial experience. This provoked fierce challenge and impassioned defence from different sections of the public, and helped to thrust modern art into the public arena. Uche Okeke exhibited at the Mbari club; a competent poet in his own right, he also provided illustrations for some of Achebe's novels, just as some of his own paintings would subsequently be inspired by Achebe's work. Yussuf Grillo, another member of the Zaria vanguard, also became an active member of Mbari when the club opened its chapter in Lagos.

This coming together of the Lagos and Ibadan writers, and the former Zaria artists, was a most significant event in the definition and consolidation of a modern cultural identity in West Africa. Just as the writers were determined to invent and produce a new literature for a new nation, the Zaria society came together with the intention to define a new aesthetic and visual for a post-colonial, cosmopolitan society.

In 1962 Duro Ladipo opened a new chapter of Mbari in the little town of Oshogbo, fifty miles from Ibadan, as a venue for his plays and operas, and a centre for local, creative exchange. The centre, inadvertently renamed Mbari Mbayo by the locals, also became the venue for workshops in visual arts conducted by both resident artists like British artist Georgina Beier and the Guyanese painter and teacher Dennis Williams, but also by a series of foreign artists over the years. At the Oshogbo Mbari, a new art movement was founded around the work of local farmers, workers, and members of Ladipo's theatre company who came to the centre to join in the workshops. With guidance principally from the Beiers, and an earlier contribution by Austrian artist Susanne Wenger, then a resident and devotee of the Yoruba religion, Oshogbo art emphasised folklore as a source of subject matter, and the disavowal of art school training. Where the Ibadan Mbari was now seen as a den for intellectual intercourse, Oshogbo ostensibly rested itself on folk creativity, and a recombinant approach to all the arts from theatre and poetry to the visual. Asiru Olatunde, Twins Seven, Muraina Oyelami

and several others shot to international limelight from Oshogbo, though the centre never quite enjoyed closeness to the circle in Lagos and Ibadan.

Nascent self-determination, and the optimism and challenges consequent on it, fuelled a prodigious band of creative individuals and young intellectuals in Lagos and Ibadan in the 1950s and 1960s, who not only caught the attention of the world with their work, but also transformed the twin cities into a world centre of art and literature. Mphalele notes in *Afrika, My Music*, the second part of his autobiography, that Lagos and Ibadan gave Africa back to him and led him to rediscover universal humanism. The young artists, writers, musicians and dramatists who defined modernity in Africa at mid-century, found sanctuary in the heady urbanism emblametised by Lagos, and in that singular decade laid the foundations for a continent's cultural emergence from the past.

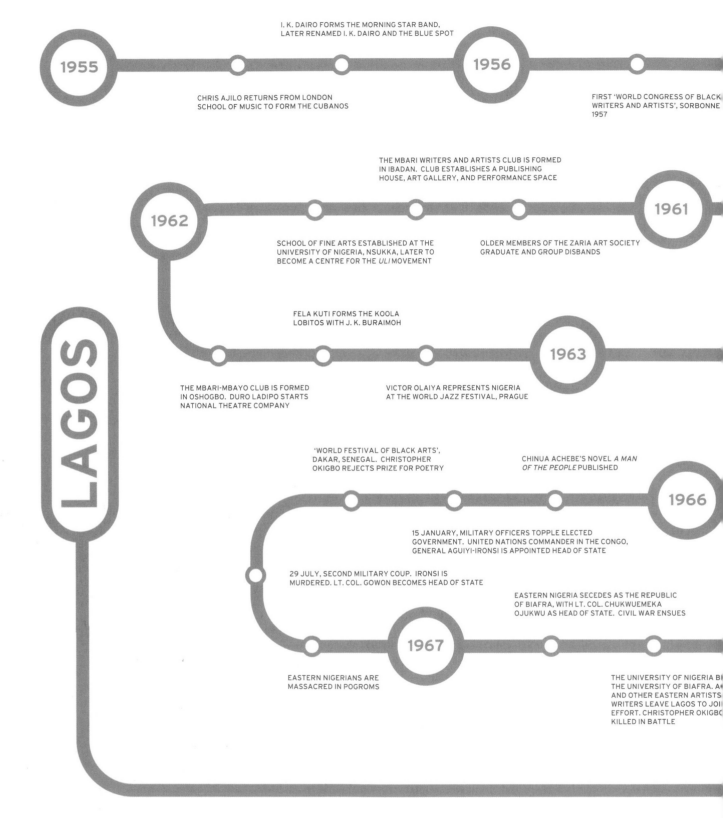

1955

I. K. DAIRO FORMS THE MORNING STAR BAND,
LATER RENAMED I. K. DAIRO AND THE BLUE SPOT

CHRIS AJILO RETURNS FROM LONDON
SCHOOL OF MUSIC TO FORM THE CUBANOS

1956

FIRST 'WORLD CONGRESS OF BLACK
WRITERS AND ARTISTS', SORBONNE
1957

THE MBARI WRITERS AND ARTISTS CLUB IS FORMED
IN IBADAN. CLUB ESTABLISHES A PUBLISHING
HOUSE, ART GALLERY, AND PERFORMANCE SPACE

1962

SCHOOL OF FINE ARTS ESTABLISHED AT THE
UNIVERSITY OF NIGERIA, NSUKKA, LATER TO
BECOME A CENTRE FOR THE *ULI* MOVEMENT

OLDER MEMBERS OF THE ZARIA ART SOCIETY
GRADUATE AND GROUP DISBANDS

1961

FELA KUTI FORMS THE KOOLA
LOBITOS WITH J. K. BURAIMOH

1963

THE MBARI-MBAYO CLUB IS FORMED
IN OSHOGBO. DURO LADIPO STARTS
NATIONAL THEATRE COMPANY

VICTOR OLAIYA REPRESENTS NIGERIA
AT THE WORLD JAZZ FESTIVAL, PRAGUE

LAGOS

'WORLD FESTIVAL OF BLACK ARTS',
DAKAR, SENEGAL. CHRISTOPHER
OKIGBO REJECTS PRIZE FOR POETRY

CHINUA ACHEBE'S NOVEL *A MAN
OF THE PEOPLE* PUBLISHED

1966

15 JANUARY, MILITARY OFFICERS TOPPLE ELECTED
GOVERNMENT. UNITED NATIONS COMMANDER IN THE CONGO,
GENERAL AGUIYI-IRONSI IS APPOINTED HEAD OF STATE

29 JULY, SECOND MILITARY COUP. IRONSI IS
MURDERED. LT. COL. GOWON BECOMES HEAD OF STATE

EASTERN NIGERIA SECEDES AS THE REPUBLIC
OF BIAFRA, WITH LT. COL. CHUKWUEMEKA
OJUKWU AS HEAD OF STATE. CIVIL WAR ENSUES

1967

EASTERN NIGERIANS ARE
MASSACRED IN POGROMS

THE UNIVERSITY OF NIGERIA B
THE UNIVERSITY OF BIAFRA. A
AND OTHER EASTERN ARTISTS
WRITERS LEAVE LAGOS TO JOI
EFFORT. CHRISTOPHER OKIGB
KILLED IN BATTLE

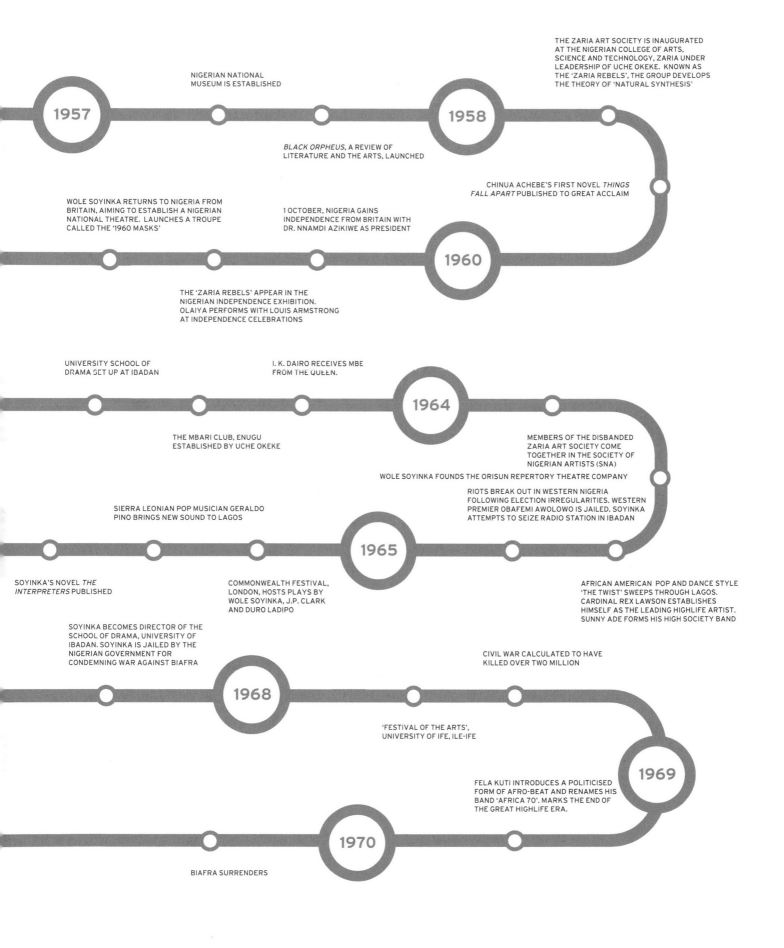

1957

NIGERIAN NATIONAL MUSEUM IS ESTABLISHED

THE ZARIA ART SOCIETY IS INAUGURATED AT THE NIGERIAN COLLEGE OF ARTS, SCIENCE AND TECHNOLOGY, ZARIA UNDER LEADERSHIP OF UCHE OKEKE. KNOWN AS THE 'ZARIA REBELS', THE GROUP DEVELOPS THE THEORY OF 'NATURAL SYNTHESIS'

1958

BLACK ORPHEUS, A REVIEW OF LITERATURE AND THE ARTS, LAUNCHED

CHINUA ACHEBE'S FIRST NOVEL *THINGS FALL APART* PUBLISHED TO GREAT ACCLAIM

WOLE SOYINKA RETURNS TO NIGERIA FROM BRITAIN, AIMING TO ESTABLISH A NIGERIAN NATIONAL THEATRE. LAUNCHES A TROUPE CALLED THE '1960 MASKS'

1 OCTOBER, NIGERIA GAINS INDEPENDENCE FROM BRITAIN WITH DR. NNAMDI AZIKIWE AS PRESIDENT

1960

THE 'ZARIA REBELS' APPEAR IN THE NIGERIAN INDEPENDENCE EXHIBITION. OLAIYA PERFORMS WITH LOUIS ARMSTRONG AT INDEPENDENCE CELEBRATIONS

UNIVERSITY SCHOOL OF DRAMA SET UP AT IBADAN

I. K. DAIRO RECEIVES MBE FROM THE QUEEN.

1964

THE MBARI CLUB, ENUGU ESTABLISHED BY UCHE OKEKE

MEMBERS OF THE DISBANDED ZARIA ART SOCIETY COME TOGETHER IN THE SOCIETY OF NIGERIAN ARTISTS (SNA)

WOLE SOYINKA FOUNDS THE ORISUN REPERTORY THEATRE COMPANY

RIOTS BREAK OUT IN WESTERN NIGERIA FOLLOWING ELECTION IRREGULARITIES. WESTERN PREMIER OBAFEMI AWOLOWO IS JAILED. SOYINKA ATTEMPTS TO SEIZE RADIO STATION IN IBADAN

SIERRA LEONIAN POP MUSICIAN GERALDO PINO BRINGS NEW SOUND TO LAGOS

1965

SOYINKA'S NOVEL *THE INTERPRETERS* PUBLISHED

COMMONWEALTH FESTIVAL, LONDON, HOSTS PLAYS BY WOLE SOYINKA, J.P. CLARK AND DURO LADIPO

AFRICAN AMERICAN POP AND DANCE STYLE 'THE TWIST' SWEEPS THROUGH LAGOS. CARDINAL REX LAWSON ESTABLISHES HIMSELF AS THE LEADING HIGHLIFE ARTIST. SUNNY ADE FORMS HIS HIGH SOCIETY BAND

SOYINKA BECOMES DIRECTOR OF THE SCHOOL OF DRAMA, UNIVERSITY OF IBADAN. SOYINKA IS JAILED BY THE NIGERIAN GOVERNMENT FOR CONDEMNING WAR AGAINST BIAFRA

CIVIL WAR CALCULATED TO HAVE KILLED OVER TWO MILLION

1968

'FESTIVAL OF THE ARTS', UNIVERSITY OF IFE, ILE-IFE

1969

FELA KUTI INTRODUCES A POLITICISED FORM OF AFRO-BEAT AND RENAMES HIS BAND 'AFRICA 70'. MARKS THE END OF THE GREAT HIGHLIFE ERA.

1970

BIAFRA SURRENDERS

LONDON
1990-2001
EMMA DEXTER

PICTURING THE CITY

Art can become the praxis and poiesis on a social scale, the art of living in the city as a work of art.[1]
Henri Lefebvre

This exhibition and text look at London according to Henri Lefebvre's observation that a city is a living work of art, collectively created by all its citizens. Both trace the practice of living in a city, evidenced and allegorised by the productions of artists, designers, photographers and stylists, film-makers and activists. They describe a special relationship between the city, its people, its streets and the creative industries of the capital, and examine how the fabric of the city itself enters into works of art and design. They reflect the civilising function of a modern city – a place where difference can be accommodated, and even celebrated. They demonstrate the symbolic use of the city by government and people – the need for demonstrations, actions, carnivals, gestures to balance the rituals of monarchy and state. They reveal how London's citizens are the inspiration for numerous works of art, fashion stories or designs. 'Picturing the City' also reflects the working processes and lives of artists, the networks, attitudes and structures which have helped make London one of the most important sites for the production of contemporary art, design and fashion in Europe.

The period covered both by this essay and the exhibition is framed by the events and ideologies of the 1980s, which saw, through the implementation of Thatcherite policies,

previous page

NICK KNIGHT

Family (detail)

Published in *i-D* magazine, 1998

Photography Nick Knight, styling

Simon Foxton and Jonathan Kaye,

model Lee Cole

Series of twelve colour

photographs, each 20.3 × 15.2

Nick Knight

BANK

The Bank (edition 24) 1997

Magazine 29 × 21

BANK

LONDON 1990–2001/EMMA DEXTER

the development of an American-style enterprise culture simultaneous with an erosion of state subsidy and safety nets. The changes to London's cultural industries over this period cannot be isolated from these political and economic legacies and cultures. The 1990s recession was first heralded on 'Black Monday' (19 October 1987) with a huge stock market fall, and exacerbated on 'Black Wednesday' (16 October 1992), when the pound fell to a record low, eventually forcing Britain to leave the European Economic Monetary Union. It is this most recent recession that, ironically, provides the open if not fertile ground for increased cultural activity in the city.

Haussman's urban schemes for Paris and Le Corbusier's functionalism have been seen as methods for clearing the contested and highly valued city centre of workers, activists, artists and bohemians, in the interests of social control. By contrast London is the archetypal unplanned city; yet an escalation in the value of property during economic booms achieves the same function, forcing artists, squatters and others on low rents to be evicted or to move further from the centre, into the cheaper and less glamorous suburbs, ironically vacating areas that their presence initially helped to gentrify or exoticise. During recessions artists, designers and cultural entrepreneurs of all kinds are welcomed back into the empty properties that the speculators can no longer fill.[2] Therefore the recession of 1989 to 1995 became the engine of change for a city gridlocked during the 1980s by speculative greed. It created a huge variety of vacant spaces that were used for unprecedented levels of artist-led activity.[3] This in turn gave artists a sense of empowerment. The city became somewhere impecunious artists, curators, designers and DJs could live, work and play. This sense of agency, of possibility, had not existed previously. From new office blocks to deserted warehouses and factories, to flats and empty shops, artists and curators created myriad exhibiting and production spaces, taking control of a space to think and become.

This essay and exhibition are not about the London art scene, its key players or the art market of the period. These themes have all been extensively covered in other publications and exhibitions.[4] Instead it is a visual essay, a metaphoric walk through the metropolis, which identifies an emblematic use of the city by cultural practitioners. My aim has been to picture London and its people, using an aesthetic that is drawn from its

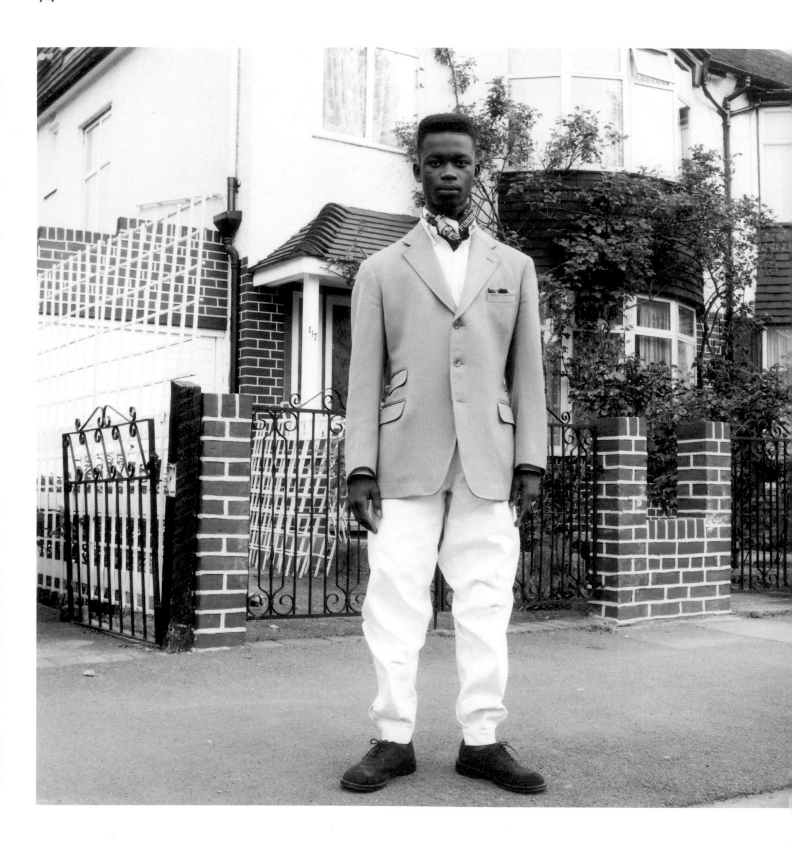

LONDON 1990–2001/EMMA DEXTER

left

JASON EVANS

Strictly (detail)

Published by *i-D* magazine, July

1991. Photography Jason Evans,

styling Simon Foxton. Eight C-type

colour prints, each 76.2 x 76.2

Jason Evans and Simon Foxton

below

STEVE JOHNSTON

Straight Up

September 1980. Opening page

from *i-D*, no.1, published by Terry

Jones

Steve Johnston

vernacular and everyday languages and materials – recycling or recasting, using the street as site or fabric, with a do-it-yourself attitude towards production and distribution. The aesthetic can apply equally to artist Gary Hume's painterly adaptation of ordinary household gloss, to designer Tom Dixon's use of car bumper welding techniques that turn plastic rubbish bins into the beautifully abstract and modular jack-light. London seems to engender a desire to salvage and recuperate old or redundant objects and materials. The transformation of other people's rubbish into art or design objects offers a patina of history combined with the lure of erasure as the object or image takes on its new form. In addition, this selection of cultural products is informed by wishing to address questions of privilege, race and democracy, which are at the heart of our changing sense of national identity. The exhibition also aims to juxtapose the work of well-known artists with their lesser-known peers. It re-presents familiar works by so-called 'YBAs' alongside practitioners from the design and fashion worlds, revealing unexpected correspondences across disciplines. London's style magazines of the period have an important contribution to make because, though many were founded in the 1980s, they have continued into the 1990s with a radical imagery depicting a dynamic multi-cultural London in which numerous borders and fixed identities are transgressed and reordered.

THE STREET OR LOVE AT LAST SIGHT[5] The street life of London has long been used by photographers, artists, designers and editors to suggest the dynamic interplay between the humdrum and the ecstatic. Since the Second World War the street has been the locus for explorations of the city's youth and subcultures. In the 1940s initiatives such as Mass Observation or the popular photographic magazine *Picture Post* developed very different yet powerful means of showing or documenting the lives and views of working-class people. The street is a site whose ownership and use have to be negotiated, yet it is clearly accessible to all; it is where the drama of British urban youth is enacted. For example, Nigel Henderson's photographs of the East End in the 1950s or the glamorous bohemia of West London depicted by Terence Donovan and David Bailey in the 1960s have been key images for a collective memory of post-war London. In the 1960s artists Mark and Joan Boyle saw the bomb sites that were still a feature of their area as 'a kind of alternative London where people could be free; and in those places, in our rags and

this page

NICK KNIGHT

Family

Published in *i-D* Magazine, 1998

Photography Nick Knight, styling

Simon Foxton and Jonathan Kaye,

model Lee Cole. Series of twelve

colour photographs, each 20.3 ×

15.2

Courtesy Nick Knight

right

DONALD RODNEY

Self-Portrait 'Black Men Public

Enemy' 1990

Five lightboxes with five duratran

prints 190.5 × 121.9

Arts Council Collection, Hayward

Gallery, London

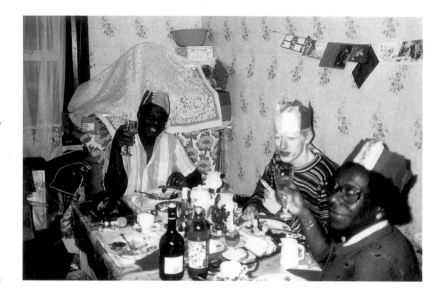

with no place else to work, like refugees we picked through the rubbish and made pictures and sculptures'.[6] Londoners have a deep and continuing relationship with DIY: a self-reliant attitude, an anti-establishment style manifested in successive style waves generated by subcultural groups and tribes from teddy boys to punk.

In 1980 the first issue of *i-D* magazine took up where the radical 1960s fashion magazine *Nova* left off, presenting fashion in a social context, depicting often occluded urban realities as well as providing a space for utopian musings. We can see the style magazine as a venue where Max Weber's notion of the city as a space of freedom is acted out, outside of bourgeois values and codes. Photographers like Derek Ridgers had been documenting street style consistently during the 1970s; but *i-D* provided a space where the identities and innate creativity of a generation could be played out to a mass audience. *i-D* reflected a changing nation: post-punk, but grappling with the war in the Falklands, unemployment, stringent social security regimes, and later in the decade the spectacle of rampant capitalism. *i-D* changed the way that suburban teenagers viewed themselves, by questioning who and what should appear in a fashion magazine. For the first issue, Steve Johnston's article 'Straight Up' featured 'real' people describing themselves, their taste in music and their look. This series defined the identity of the nascent *i-D*, basing itself on re-discovering the ordinary. Its simple frontal photographic style, depicting people against a blank wall, with hand-typed informal text, gave visibility to something everyone on the streets knew: that London was one of the world's most racially diverse cities, with an inspirational creativity to its street style.

In the fashion story 'Strictly' (July 1991), styled by Simon Foxton and photographed by Jason Evans, young black men dressed as pseudo-country gents and dandies are pictured against the incongruous background of a mundane London suburb with its haphazard, botched and nostalgic half-timbering. The story delicately hints at the imperfections and inconsistencies of the official versions of national and class identities. Foxton and Evans have used the vehicle of an innocuous fashion story to subvert the usual media association of black men and the city's streets. In a collaboration with the photographer Nick Knight, entitled *Family*, Foxton has digitally

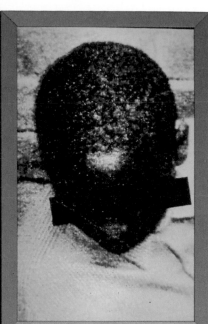
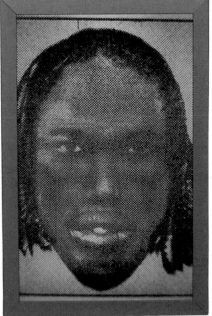
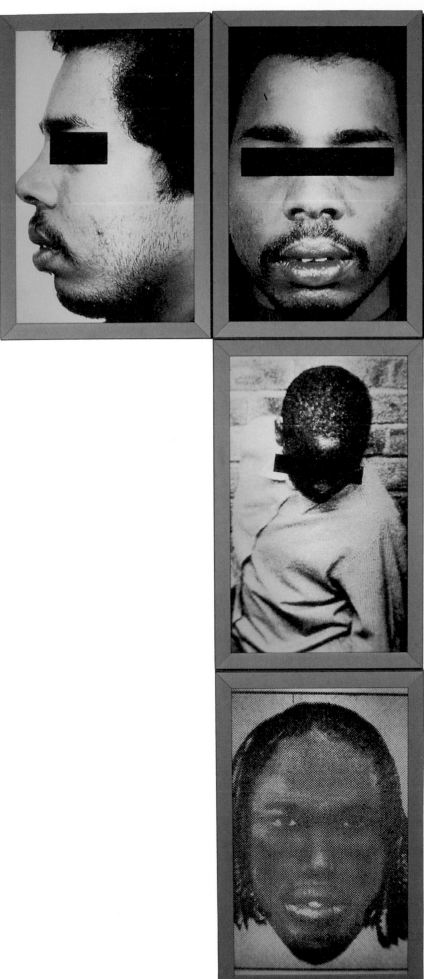

left

NICK KNIGHT

Catherine

Published by *Dazed & Confused*,
1998. Photography Nick Knight,
art direction Alexander McQueen,
styling Katy England
Courtesy Nick Knight

inserted a young albino model into black family photographs borrowed from friends. The work demonstrates Walter Benjamin's description of the city as both a dream world and a catastrophe.[7] *Family* alludes to a utopian resolution while at the same time demonstrating the difficulty of achieving it. While style magazines have explored in detail the intricacies of race in Britain, this is not a subject often examined by fine artists unless they themselves are black. In Donald Rodney's *Self-Portrait 'Black Men Public Enemy'* (1990), images of young black males, their eyes blanked out like criminals, form the shape of a crucifix. Rodney's work articulates the fear and prejudice that dominate the representation of black males. It alludes to an inability to see them as individuals, as victims rather than perpetrators, as people rather than as threats. The work predates yet sadly anticipates the reaction of police to the murder of the black South London teenager, Stephen Lawrence, where police failed to treat the crime with the seriousness it deserved. Rodney's ironic self-portrait is a sad witness to denigration and prejudice.

While mainstream media and institutions continue to either ignore or misrepresent significant minorities, photographers, stylists and designers use magazines as a radical site for experiment. The 1990s magazine *Dazed and Confused*, which set out to blur the boundaries between art and fashion, continues a radical publishing agenda. Alexander McQueen's *Access-able* series in Issue 46 (1998) (photography by Nick Knight and styled by Katy England) and the subsequent catwalk show, were designed specifically for disabled models. These striking images have expanded our definitions of style and beauty, and redrawn the map of the human body.

Graphic design in the 1990s has similarly taken inspiration from London's streets and its citizens. The designer Paul Elliman uses the city, its people and its objects in the construction of his typefaces, illustrating Henri Lefevbre's reading of the city as a found object created by its citizens. Elliman's work also exposes the relationship between the city and language. In *Philosophical Investigations* Wittgenstein uses the city as a metaphor for the growth of language: 'language is a labyrinth of paths. You approach from one side and know your way about, from the other you are lost.'[8] In 1991–2 Elliman created a 'performed alphabet' for the typography journal *FUSE*. Elliman got twenty-six friends to enter a photo booth and perform letters of the alphabet. The result, which uses the human body in an elemental way as the source of basic signs, is humorous and inventive, simple and yet profound. At times the letters being performed are obscure or

right

PAUL ELLIMAN

Alphabet 1991/92 (detail)

Twenty-six photobooth
photographs, each 5 × 4
Courtesy Paul Elliman

even absent. Elliman embraces the agency of chance in his work, retaining those 'letters' which are illegible, in favour of an organic work that expresses the patina of an event, with all the randomness that that entails. Elliman says: 'I wanted to begin by establishing a very open relationship with different forms of language: figurative, expressive, associative.' Elliman's alphabet is fascinating in terms of what it represents accidentally: a richly associative mix of clothes, body language, races and histories. In 1995 Elliman constructed a typeface called *Bits* from pieces of detritus found by the roadside. He scanned them into a computer, thereby adding another element to the process which is beyond his control. The designer's role has become one of editor rather than creator. In a sense Elliman's work acts as an allegory for Walter Benjamin's shifts of meaning, relativities, and plethora of commodities that are symptomatic of the city. The type specimen *City Man Saves 2 in Fireball Smash* articulates two distinct layers: one is the meaning of the text itself, the other is the story of the objects from which the font is made. Elliman says: '*Bits* says something about cities, their relationship with our own language and writing systems. In a material sense it could exist simply as a collection of industrial samples: "pieces of die-cast metals, heat resistant plastics." As a functional character set I wanted it to somehow defy being regularised into a "proper" typeface. Perhaps – although I have little control over this – it defies being used, as if it came from a depressed but still beautiful part of the city.'[9] Following Henri Lefevbre's description of the city as 'the perpetual oeuvre of the inhabitants, themselves mobile and mobilized for and by the oeuvre',[10] Elliman's work demonstrates a seamless interweaving between the

PAUL ELLIMAN

BITS 1995

Colour photograph 24 × 30.5

Courtesy Paul Elliman and Nigel Shafran

right

TORD BOONTJE

Rough-and-Ready Table, Chair,

Shelves, Light 1998–2000

Blanket, straps, wood

Dimensions variable

The Artist

next page

JUERGEN TELLER

Go-Sees: March 1999 (detail)

From *Go-Sees* series

C-prints mounted on board and

framed 107.3 × 149.2 x 2.5

The Artist and Lehmann Maupin,

New York

citizen, the city and creativity itself.

Proximity to the material fabric of the city and the desire to incorporate and transform it, is a characteristic shared by many designers in London. The act of salvaging and recycling materials has profound political repercussions, not simply in environmental terms, but also in the way it suggests freedom from the monopolies of large retail corporations, and in the sense of a re-engagement with the basic necessities and establishing control over one's own life. Tord Boontje follows in a long line of London-based designers who have made recycling central to their work. They include Ron Arad, whose *Rover Chair* celebrates the eponymous car's upholstery, to Tom Dixon and his welded plastics; or more recently the design group Jam and their use of washing-machine inner drums as storage boxes. Boontje issues free, easy-to-follow instructions for his own designs, encouraging people to make their own low cost/no cost furniture from wood and other materials found in skips. What is unusual about Boontje is his drive to turn consumers into creators, to make producers of us all.

Boontje's practice acts as a satire on the pseudo-DIY masquerade of IKEA's self-assembly philosophy; but it also challenges us to reconnect with our own needs and to develop self-sufficiency skills that have been eroded by the spectre of rampant consumerism. The work also raises questions about the ownership of the street and its rubbish. Artists and designers dramatise the city as a site for the negotiation of our civil liberties. Lefevbre comments: 'In the urban the use comprises the customs and gives to the custom a priority with regards to the contract. The utilisation of urban objects (this sidewalk, this street, this passage, this illumination etc.) is a usage and it is not contractually fixed and determined by the state.'[11]

A London street is the setting for the fashion photographer Juergen Teller's *Go-Sees* – a visual diary of all the aspirant models who turned up uninvited on his doorstep in the course of one year. The series accidentally becomes a record of the street outside his studio, of the sameness of London's weather, of the ordinariness of the girls themselves and their casual approach to selling themselves to the world of high fashion. Teller is fascinated by the oscillation between ordinary and extraordinary that is the stuff of the fashion industry. Would these girls present themselves like this if they were in Paris or New York? The work suggests the myth of the 'undiscovered' beauty found on the city

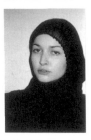
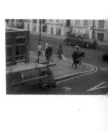

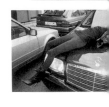

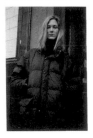

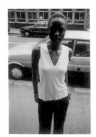
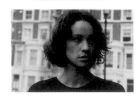

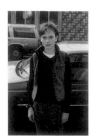

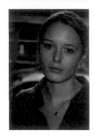

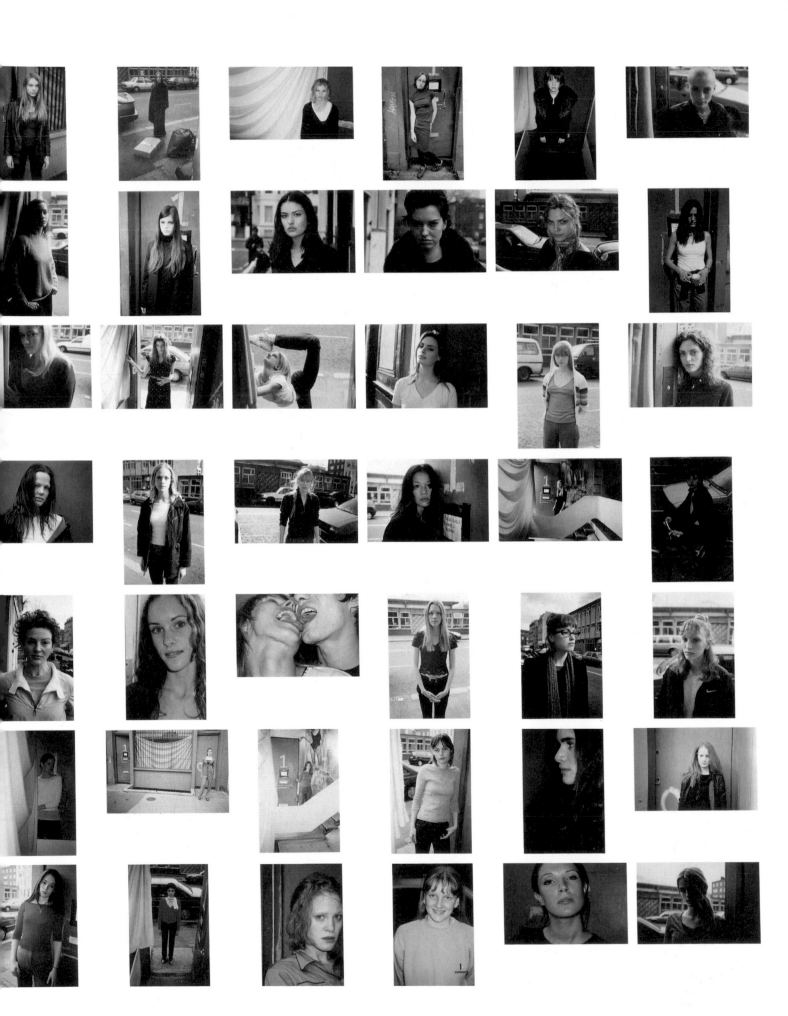

streets, a raw material waiting to be transformed. There is also a sense of relentlessness and sadness, as each day more 'wannabes' turn up to sell themselves.

Contemporary artists, intent on seeking new but enlightening experiences, roam the city, making it and its people (thanks to the advent of the video camera) cheaply and easily the subject of their work. The philosopher Heinz Paetzold has commented: 'A politics of strolling does not consist just in walking around, but leads to ever more new images and new readings of the contemporary culture inscribed in ethnographies, reportages, essays, paintings and other cultural works and designs.'[12]

This form of engagement with the city goes back to the concept of the flâneur developed in France during the nineteenth century. The idler, the man of leisure, chose to roam the city in search of experience and sensation. Walter Benjamin spoke of the intoxication of flânerie – leading to a kind of secular illumination.[13] In the same way Jeremy Deller's digital video work *Current Research (videos)* (1998–ongoing) records the artist's passage through the city over the past three years, encountering a range of different 'illuminations'. Through it Deller captures the city as a site of multifarious allegorical meanings, one of the most crucial being its role as a space for dissent. This is illustrated most notably by Deller's record of the anti-capital riots in the City of London known as J18 (June 18 1999). In juxtaposition, we also witness the ritual mechanisms of state at the Remembrance Day celebrations at the Cenotaph. This reveals a fascinating display of society's hierarchies, as female and black heroes wait till last. For their *Documents* series, Henry Bond and Liam Gillick posed as journalists at press and media events, creating as a result a series of photo/text works that are a neat elision of two distinct realms of information gathering and sorting: that of conceptual art and that of the news and publicity industry. *Documents* exposes the codes and rituals involved in news management, but it has also become, with time, an accidental history of our age.

The flâneur in his original milieu (Paris) was by definition male and rich. His existence denoted a class with leisure time to spend, and whose gender allowed unfettered access to high and low class areas of the city. A century later the artist Gillian Wearing could be described as a female flâneur (now women can attain the kind of 'mastery' inherent in

LONDON 1990-2001/EMMA DEXTER

the term). Wearing travels the city using chance encounters with strangers as the starting point for her work. The flâneur experiences the city only through allegorical experiences, creating a modernist subjectivity of the city. In 1995, while walking down a South London street, Wearing glimpsed a woman wearing a bandage mask. The subsequent work, *Homage to the woman with the bandaged face who I saw yesterday down Walworth Road* (1995), recounts the effect of that chance encounter upon the artist, as well as restaging the event with the artist playing the masked woman. Wearing's entry into the scene as masked protagonist symbolises the flâneur's ambivalence in relation to the crowd: fascinated by it and longing to merge with it, he/she is nevertheless always on the outside, always an observer. It also illustrates the situationist theorist Guy Debord's description of the city as site of both encounter and spectacle: the artist acts simultaneously as both observer and observed within the same narrative. The street is the site *par excellence* of a recurring and ever fascinating theatre in which we participate daily, willing or not.

In *Homage* the telling of the tale of a fleeting encounter is symptomatic of the modern and thereby urban condition. In a passage by Walter Benjamin describing a poem by Baudelaire, Benjamin comments on the relationship between the crowd, the observer and the object of desire: 'Far from experiencing the crowd as an opposed, antagonistic element, this very crowd brings to the city dweller the figure that fascinates.' He adds: 'the delight of the urban poet is love – not at first sight but at last sight. It is a farewell forever which coincides in the poem with the moment of enchantment.'[14] Benjamin reveals how at the moment of glimpsing we are already embarked upon the moment of loss. Wearing compensates for that inevitable loss by turning herself into 'the figure that fascinates' and by producing a work which will allow the constant re-playing of that moment of desire.

Wearing's *Homage* acts as an allegory for the experience of the crowd on all city dwellers. By isolating herself from the rest, Wearing dramatises the relationship between the individual and the crowd which is crucial to city life. It also enacts what Georg Simmel identified as one of the prerequisite modes of being for the city dweller: reserve.[15] Reserve or lack of interest is in effect essential for survival for the city dweller, in order to bear the proximity of enormous anonymous crowds. According to Simmel reserve paradoxically furnishes the basis of individual freedom, and provides a form of privacy within the crowd. City dwellers conspire to give each other anonymity. In a sense Wearing's masked protagonist can be seen as an allegory for this process: of simultaneous presence and absence.

MICHAEL LANDY

Costermonger's Stall 1992–97
Wood, gloss paint, tarpaulin,
plastic buckets, electric lights and
flowers 182 × 213 × 213
The Saatchi Gallery, London

MELANCHOLY OBJECTS A sense of melancholy is engendered too when artists recycle objects and materials that embody a lost or vanishing history. Michael Landy's work over the past decade has dealt with expendability of both materials and people. It has also explicitly addressed the swerving economic conditions of the period, and does not shy away from an overtly political content. Landy's appropriated market stalls, such as *Costermonger's Stall* (1992–97), made from brightly painted wood, are double-edged. On the one hand there is a nostalgic value: the word 'Costermonger' evokes ancient trades and practices now dying out. On the other hand the stall symbolises the market and its attractions real and false: its gawdy brightness attracts, but there is always a sting. The flowers on the stall need constant replacement and fresh water to avoid rotting. Landy says: 'I left college in 1988, near the end of the art market boom. There seemed to be so much money about and I remember thinking, this won't last.'[16]

'Twelve filing cabinets lined up. Each bottom drawer is open, revealing a roll of carpet and a level of water. The work appeared in two configurations: facing outwards and

MELANIE COUNSELL

British Art Show 1990 (detail)

Twelve filing cabinets, rolled carpets and water 132 × 563.9 × 61.6

Courtesy of the artist and Matt's Gallery, London

Photograph: Edward Woodman

reversed facing the wall.'[17] This is how Melanie Counsell describes her work *British Art Show 1990* which has been re-presented for this exhibition as *Filing Cabinets (version 3)* (2000). Counsell left a post-graduate course at the Slade in 1988, and proceeded to make a series of works that included film, video, installation and sculpture, each with a strong sense of site-specificity. Counsell's titles denote where the work was shown – works made for gallery locations are usually spin-offs from site-specific pieces. The work created for this exhibition, and the 1990 British Art Show piece to which it refers, are the offspring of a work done almost invisibly and without fanfare in a derelict South London psychiatric hospital in 1989. There Counsell used dripping water to denote an absent body, the passage and drift of time. Counsell's work is almost risible in its un-seductiveness: from the miserable humdrumness of its found and used materials, to its dampness (which even turns to rot eventually), to its turning itself to the wall, denying access to the viewer, keeping its drawers and secrets closed. This work quietly says something about the end of an era – the end of the small workshops and factories that

right

DAMIEN HIRST

The Acquired Inability to

Escape, Inverted 1993

Glass, steel, silicone, MDF table,

chair, ashtray, lighter and

cigarettes 213.4 × 304.8 ×

205.1

Private Collection, Courtesy Jay

Jopling, London

Photograph: Hugo Glendenning

were the mainstay of London's small-scale industrial geography. It is about the end of one way of working or the upgrading of another: the service industries that took its place, the new 'paperless' computerised office and soon-to-be-useless role of ' filing clerks'. It symbolises the pitiable attempts of the British at domestic comfort and the fear of the modern – the rolled-up grotesquely patterned carpet in the bottom drawer. It conjures the repressive metaphor of 'the bottom drawer' – the place for private things in a public world, hidden, obscure. It speaks of what Benjamin calls the 'salutary estrangement between man and his surroundings'. Again, we are confronted not with the utopia of the ideal city, but the locus for catastrophe. Counsell's work conveys a very particular atmosphere, a sense of foreboding, of 'immanence, suspense'.[18]

The early twentieth-century German philosopher Georg Simmel described the city as the site where the crisis of modern culture, 'culture's tragedy', is occurring.[19] He believed urban culture was characterised by a relentless proliferation of objects, with which subjectivity could not keep pace, and was therefore always in a state of impoverishment. The tragedy of modern culture is the splitting of the objective culture of things from the

above left

Front of the artists' run gallery

CITY RACING, Oval, 1988-1998

Courtesy CITY RACING

above right

Big Blue, partial view of

installation, Coins Café,

election night May 1, 1997

Curated by Peter Lewis

Courtesy the Artists

subjective culture of individuals. Damien Hirst's vitrines function as barriers that exclude the viewer from the often banal, yet somehow existential, contents. Hirst's boxes seem to enact Simmel's tragedy. We are always reduced to the window shopper, always looking in, always wanting. *The Acquired Inability to Escape, Inverted* (1993) continues Hirst's existential preoccupations using the most ordinary of materials. For Hirst, even the cigarette represents a perfect miniature life-cycle, while the nondescript office furniture suggests claustrophobia and the 'horror vacui' of the corporate, office-bound life.[20]

Hirst is often credited with inspiring a whole generation of artist entrepreneurs and curators by organising the exhibition *Freeze* in Surrey Quays in 1988. 'I had seen a lot of work at the college that I thought was better than what was in the galleries, but there was no way that those students were all going to get exhibitions in London galleries when they left college. That gave me the incentive to find a building and do it. And if you're going to do something, you might as well try and do it properly.'[21] This can-do attitude, a desire to take control of one's own destiny, was not exclusive to Hirst. During the 1990s many different models developed exploiting the sudden availability of real estate which was

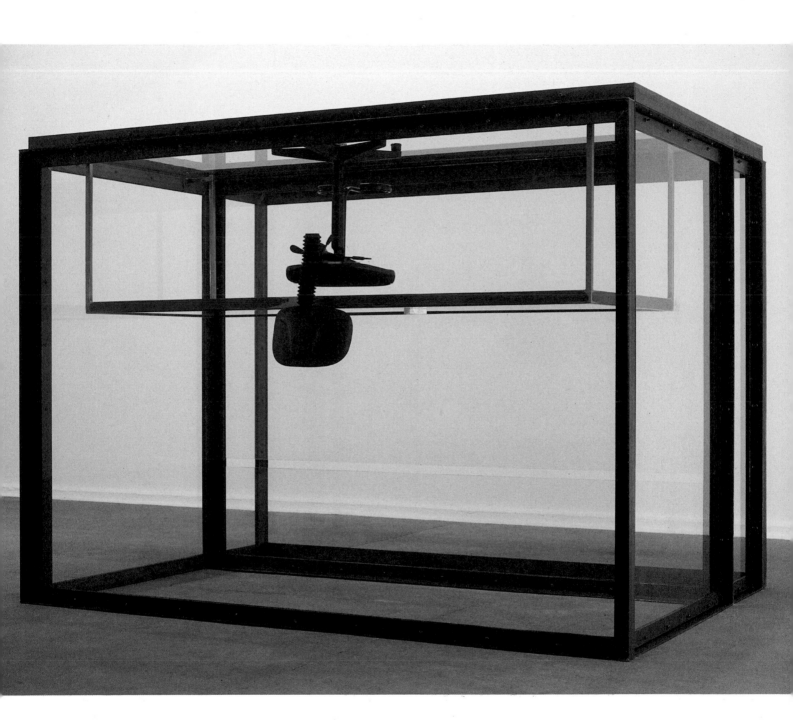

TRACEY EMIN/SARAH LUCAS

THE SHOP 2000

C-print 76.1 × 91.5

Courtesy Jay Jopling and Sadie

Coles HQ, London

Photograph: Carl Freedman

liberated by the advent of the early 1990s recession: From the artist-run gallery City Racing, run from a squatted former betting shop in Vauxhall, to Bank's heavily curated group shows in which the works of invited artists often played second fiddle to the total work of art that was the exhibition itself.[22] Other artists chose a more mobile approach to the city: choosing to move from abandoned site to site: Peter Lewis's curatorial project *Flag*, for example, or the group Space Explorations, have continued the genre of site-specific installations which rarely feature in the big surveys of 1990s British Art.

In 1993, instead of getting a studio, Tracey Emin and Sarah Lucas opened a shop in Bethnal Green. They made all the merchandise themselves: T-shirts with slogans like 'I'm so fucky', 'Have you wanked over me yet?' and 'She's kebab'. Other merchandise included Damien Hirst ashtrays, hats, clothes, ornaments, penis sculptures, tiny blankets the size of handkerchiefs. Emin speaks movingly and energetically about the experience, and the profound yet simple pleasure to be derived from obtaining cash in exchange for goods. The proceeds funded their living costs for the period. Is there an underlying feminism in this insertion of a cottage industry into a late capitalist art world? The artists certainly never advertised or promoted their enterprise conventionally, allowing the grapevine to spread the word, hosting an open house every Saturday night. There is an important contrast between the scale and type of hand-sewn and drawn products found in the Emin/Lucas shop, and the physically dominating works of Damien Hirst's shark or Rachel Whiteread's *House*, produced in the same year. Emin, with her love of needlework, has shown a new generation of artists that the decorative and the feminine have a rightful place within art history, paving the way for the meticulous hand-crafted works of, for example, Enrico David, Michael Raedecker or David Thorpe.

London art of the 1990s straddles both a monumental and a tiny scale. As many key artworks have been made in bedrooms and kitchens as in expensive studios. Sally Barker's *Sally Barker Gallery* (2000) demonstrates the use of fantasy as a means of taking control of one's career. Barker has been working diligently in London as an artist for the past decade, but has yet to achieve celebrity. Her eponymous 'gallery' is a small cardboard and polystyrene model, in which are displayed miniature versions of her oeuvre. Barker also solicits proposals from other artists for shows within the project

SARAH LUCAS

Still Life 1992

Bicycle, C-prints on card, wood

115 × 140 × 56

Courtesy Sadie Coles HQ, London

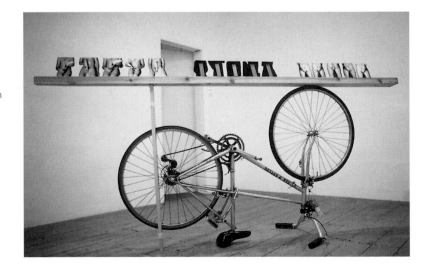

spaces of her museum. Once again a feminist reading is tempting: as a mother, Barker has fewer options than many for self-promotion, networking or curating than others – her gallery provides a home-based mirage of power and agency within the art world.

Gilbert & George are most often cited as the link between two generations of British artists. They transform vernacular language, slang, the East End into the stuff of high art. Yet with this older generation there is always a sense of distance and objectivity, even scientific interest in the vernacular. For artists who have emerged in the 1990s, the use of tabloid culture comes more naturally. Sarah Lucas describes her use of materials as a conscious decision not to intimidate the viewer, by using everyday materials like concrete or fruit in a very direct way. The aesthetic makes a virtue of necessity: using cheap materials the work also connects with the lived experience of many young Londoners, struggling to survive in a gritty, hard and inhospitable city. Lucas's use of found objects such as soiled mattresses, second-hand furniture, combined with market produce or café food, brings the smells, sounds and language of the East End street right into the gallery, in a way that had not happened so literally before in British art. Now a new generation of artists are making the minutiae of London life the subject of their work. Janette Parris's *Skint* (1995) is a small ragdoll of a homeless person begging. It illustrates the conflicted emotions experienced by Londoners in relation to homelessness. The doll is cuddly, yet paradoxically represents those excluded from society; it demonstrates the extreme range of social interplay on our streets, where affluence and poverty exist side by side.

In their use of found materials artists are negotiating processes, re-readings, and

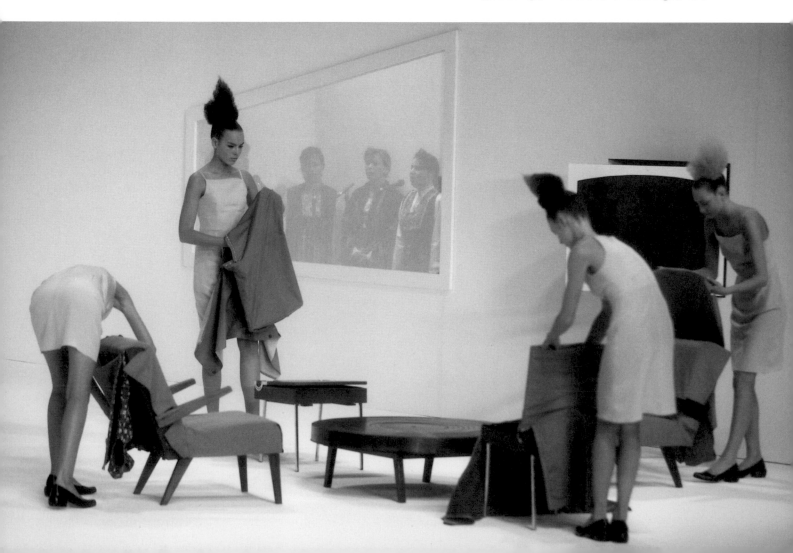

Bite Yer tonGue ©97 J PARRIS.

I once went to an opening of an exhibition, where I met a fellow artist who I had graduated with 5 years earlier. He told me that during these 5 years he had, ① Signed with a top gallery ② Sold out his latest exhibition to the Saatchi's ③ Had a piece of work bought by the Tate ④ A major publisher was in the process of producing a book on him ⑤ Had won the Hamlyn Sculpture prize of £20.000 ⑥ and maybe although he was not certain, he would be short-listed for the Turner prize next year.
I wanted to say... I actually think your work is a pretentious pile of poo and if I ever see it again it would be too soon.... but I didn't I said ... well done you deserve it.
Went home ate 2 plain chocolate Bounty's

discovering new meanings. The fashion designer Hussein Chalayan is changing the grammar of the fashion world. His clothes explore the interface between objects and the body, blurring the distinction between the body and its most familiar surroundings. His aeroplane dress expresses our desire for technology; he has created clothes that incorporate arm rests and head rests – the comforts associated with chairs. In *after words* (2000), inspired by his own personal experience of the partition of Cyprus and the spectacle of the tragic events in Kosovo, Chalayan has created clothes and furniture for people who may be forced to leave their homes within minutes. Slip covers become dresses, a table becomes a skirt, furniture packs up into easily portable segments. Chalayan reunites the split culture of the object and the subject. And perhaps it is the role of art and artists, and designers, to create a link between these two inexorably divergent trends. What is art for? Perhaps this provides some reason for its continued existence long after it has been buried many times over in terms of the avant-garde. Perhaps these definitions miss the importance of the symbolic, allegorical, ritual aspects of the role of art within society, underlining the importance of process over product, of texture and experience over spectacle. So many products proliferate in the city, why make any more? In London, by recycling and salvaging artists and designers don't make anew, they recast and re-align.

In a country that has in some ways been slow to embrace the notion of modernism, we must look for less obvious ways in which our culture has been progressive and at times radical. So it is in the unlikely vehicle of the style magazine that successive editors, stylists and photographers have created features that explore, question and problematise the multiple cultures and tribes that constitute British youth. They have consistently represented a more diverse community than that represented in other mass media. Another unsung vehicle for a progressive culture has been the artist-run spaces or the DIY entrepreneurship of designers. In the face of state apathy in relation to their actions and products, these producers ironically created the very cultural groundswell, eventually inspiring the government marketing tag 'Cool Britannia'. Perhaps the mass political disaffection that developed during the Conservative party's eighteen-year reign, has led to the leakage of a soft political consciousness into a much wider area of cultural activity. As the grocer's daughter from Grantham faded from the scene, a self-confident city of shopkeepers who have developed a powerful sense of agency in their low-fi produce have taken over. Culture is becoming flatter and the old hierarchies of high and low are finally disappearing. The cross-fertilisation between art and advertising, design and fashion is now seamless and runs in both directions.

Notes

1 Quoted in Heinz Paetzold's essay 'The Philosophical Notion of the City', in *City Cultures Reader*, ed. M. Miles, T. Hall and Iain Borden, London 2000, p.217.
2 See the essay by Sharon Zukin, pp.258-65.
3 e.g. Clove, Building One, City Racing, Chisenhale Gallery, Milch, Bank, Malania Basarab, East Country Yard show at Surrey Quays, The Tannery, Cabinet, Bipasha Ghosh. While

many were in former East End or docklands areas others such as IAS (Independent Art Space), Milch or the Woodstock Street, W1, shop used by Damien Hirst for his *In and Out of Love* exhibition were in prime central locations.
4 Exhibitions such as *Brilliant!* and *Sensation*, have focused on the YBA phenomenon. For a survey of this literature see the bibliography at the back of this book.
5 'The delight of the urban poet

is love - not at first sight, but at last sight.' Walter Benjamin commenting upon Baudelaire's sonnet 'À une passante', in 'On Some Motifs in Baudelaire', *Illuminations*, Fontana 1973, p.171.
6 Quoted in David Mellor, *The Sixties Art Scene in London*, London 1993, p.73.
7 See Heinz Paetzold, op.cit., p.214.
8 Ibid., p.206.
9 Quoted in *The Yale Literary Magazine*, vol.XII, no.1, Spring 2000.

10 Paetzold, op. cit., p. 217.
11 Ibid., p.217.
12 Ibid., p.219.
13 Benjamin, op.cit. pp.174 - 175
14 Ibid. p.171
15 Paetzold, op.cit., p.214
16 Quoted in *Brilliant! New Art From London*, exh. cat., Walker Art Center, Minneapolis 1996, p.59.
17 Melanie Counsell, *Catalogue*, Artangel and Matt's Gallery, London 1998, p.18.
18 Patricia Falquières, 'Nothing Beyond', ibid.
19 Paetzold, op.cit., p214.

20 Douglas Fogle, 'Bad Science', *Brilliant*, op. cit., p.87.
21 Ibid., pp.40-43
22 Matt Hale, Keith Coventry, John Burgess, Paul Noble, Pete Owen. A book surveying the history of City Racing will be published by Black Dog Press in 2001.
23 Paetzold, op.cit. p.214.

1990

MODERN MEDICINE AND *GAMBLER* OPEN AT BUILDING ONE, A FORMER BISCUIT FACTORY IN BERMONDSEY

MARGARET THATCHER RESIGNS, JOHN MAJOR NEW CONSERVATIVE PRIME MINISTER

1991

VIOLENT ANTI-'POLL TAX' RIOTS IN TRAFALGAR SQUARE

BLACK WEDNESDAY: BRITAIN WITHDRAWS FROM THE EXCHANGE RATE MECHANISM, BILLIONS LOST FROM BANK OF ENGLAND RESERVES.

CONSERVATIVES WIN GENERAL ELECTION

HOUSE REPOSSESSIONS AT AN ALL-T

PERSONAL BANKRUPTCIES INCREASE BY 80 PER CENT OVER PREVIOUS YEAR

KATE MOSS EMERGES AS A SUPER-MODEL

LONDON

TRACEY EMIN AND SARAH LUCAS OPEN THE SHOP IN BETHNAL GREEN ROAD

UNEMPLOYMENT REACHES 3 MILLION

1993

ELTHAM SCHOOLBOY STEPHEN LAWRENCE IS MURDERED IN A RACIALLY MOTIVATED ATTACK

IRA BOMB EXPLODES IN T

ALEXANDER MCQUEEN SUCCEEDS JOHN GALLIANO AS DESIGNER FOR GIVENCHY

BRILLIANT! NEW ART FROM LONDON AT THE WALKER ART CENTRE, MINNEAPOLIS, FEATURES 22 YOUNG BRITISH ARTISTS

1996

LIFE/LIVE AT MUSEE D'ART MODERNE DE LA VILLE DE PARIS

PROPOSED SLAUGHTER OF 4.6 MILLION CATTLE OVER 6 YEARS IN BID TO END BSE CRISIS

GENETICISTS ANNOUNCE SUCCESSFUL CLONING OF AN ADULT SHEEP

1997

UPTURN IN LONDON PROPERTY PRICES BEGINS

LABOUR WINS GENERAL ELECTION, ENDING 18 YEARS OF CONSERVATIVE PARTY RULE.

UNEMPLOYMENT FIGURES DROP TO JUST OVER 1 MILLION

HOME SECRETARY JACK STRAW ANNOUNCES A NEW AMENDED RACE RELATIONS BILL

INDEPENDENT CANDIDATE KEN LIVINGSTONE ELECTED MAYOR OF LONDON

2000

TATE MODERN OPENS AT BANKSIDE, WITH 1 MILLION VISITORS DURING FIRST 6 WEEKS

THE MILLENIUM DOME FAILS TO MEET PROJECTED VISITOR NUMBERS. BY OCTOBER IT HAD RECEIVED A TOTAL OF £585 MILLION LOTTERY FUNDING

DAMIEN HIRST INSTALLATION *IN AND OUT OF LOVE*

BANK, AN ARTISTS' CO-OPERATIVE IS FORMED
TO CURATE AND COLLABORATE ON EXHIBITIONS

MINISTRY OF SOUND CLUB OPENS

OPERATION 'DESERT STORM' LAUNCHED

FRIEZE, A GLOSSY CONTEMPORARY ART
AND CULTURE MAGAZINE, LAUNCHED

THE BIG ISSUE MAGAZINE LAUNCHED TO
BE SOLD BY THE HOMELESS, ON BEHALF
OF THE HOMELESS

VIVIENNE WESTWOOD BECOMES
BRITISH DESIGNER OF THE YEAR

YOUNG BRITISH ARTISTS 1 AT THE SAATCHI GALLERY

ARTSCRIBE MAGAZINE CLOSES

1992

SARAH LUCAS'S FIRST SOLO SHOW *PENIS
NAILED TO A BOARD* AT CITY RACING

TATE GALLERY'S TURNER
PRIZE RELAUNCHED

JAY JOPLING OPENS WHITE CUBE GALLERY

CHANNEL TUNNEL OPENS

1994

RACHEL WHITEREAD'S CONCRETE *HOUSE,* IN EAST
LONDON, ATTRACTS WIDE MEDIA ATTENTION AND
IS LATER DEMOLISHED BY THE LOCAL COUNCIL.
WHITEREAD WINS THE TURNER PRIZE

TONY BLAIR BECOMES
LEADER OF LABOUR PARTY

MASS DEMONSTRATIONS AGAINST THE CRIMINAL JUSTICE
BILL, WHICH LIMITED THE RIGHT TO ASSEMBLY

DRUM AND BASS ARTIST GOLDIE
STARTS 'METALHEADZ' SESSIONS
AT BLUE NOTE CLUB, HOXTON

MORE THAN 10,000 PEOPLE
IN BRITAIN HAVE AIDS

1995

OWNERS OF 140,000 LONDON
HOMES FACE NEGATIVE EQUITY

THE NATIONAL LOTTERY IS LAUNCHED

'CASH FOR QUESTIONS' SCANDAL:
MEMBERS OF PARLIAMENT
ACCUSED OF TAKING BRIBES

A MASSIVE RISE OF WOMEN IN THE
HOUSE OF COMMONS, FROM 62 TO 120

REFERENDUMS IN SCOTLAND AND
WALES VOTE TO CREATE WELSH
ASSEMBLY AND SCOTTISH PARLIAMENT

TURNER PRIZE HAS ITS FIRST
ALL-FEMALE SHORTLIST

1998

SENSATION AT THE ROYAL ACADEMY, SELECTED
FROM SAATCHI COLLECTION, IS SEEN BY 300,000
PEOPLE, 80 PER CENT OF WHOM ARE UNDER 30

DRUM AND BASS ARTIST RONI SIZE
WINS THE MERCURY MUSIC PRIZE

DIE YOUNG AND STAY PRETTY, CURATED
BY MARTIN MALONEY AT THE INSTITUTE
OF CONTEMPORARY ARTS

THE HOUSE OF COMMONS VOTES TO
REDUCE THE AGE OF SEXUAL CONSENT
FOR HOMOSEXUALS, FROM 18 TO 16

1999

MACPHERSON REPORT ON POLICE
INVESTIGATION OF THE MURDER OF
STEPHEN LAWRENCE IS PUBLISHED,
ADDRESSING INSTITUTIONALISED
RACISM IN THE METROPOLITAN
POLICE FORCE

BARONESS JAY CALLS FOR REFORM
OF THE HOUSE OF LORDS, INCLUDING
REMOVAL OF HEREDITARY PEERS

GOOD FRIDAY AGREEMENT BETWEEN
BRITAIN AND IRELAND AIMS TO END
NEARLY 30 YEARS OF VIOLENCE

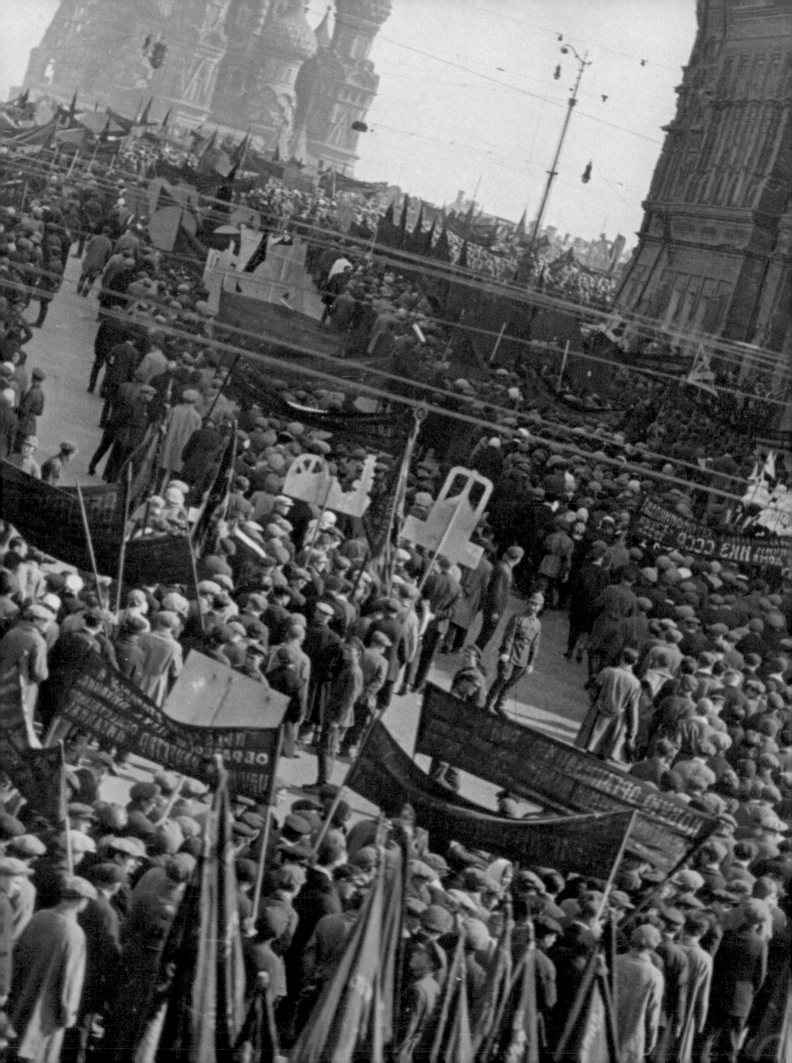

MOSCOW
1916-1930
LUTZ BECKER

previous page
BORIS IGNATOVICH
1 May, Red Square, Moscow
1927
Photograph 24 × 18
Galerie Alex Lachmann, Cologne

below
GUSTAV KLUCIS
Moscow, Spartakiada 1928
Letterpress 15.2 × 11.4
Collection Merrill C. Berman

RED SQUARE + WHITE SQUARE = MOSCOW

Nobody knows what gigantic suns will light up the life that is to come. Perhaps artists clad in hundred-coloured rainbows will transform the gray dust of the cities, perhaps the thunderous music of volcanoes turned into flutes will sound ceaselessly from the mountaintops, perhaps we will make the Ocean waves pluck at strings stretched from Europe to America. One thing we know clearly – we have opened the first page of the history of art of our day.[1]
Vladimir Mayakovsky 'Open Letter to the Workers' (1918)

The feudal order of tsarist Russia was shattered in October 1917 by Lenin's Revolution. In the open forum of the streets and city squares, Lenin and his men won over the urban proletariat for their cause and gained widespread support for the Bolshevik Party. Two immediate measures were decisive for the lasting popularity of the Revolution: the Decree of Peace, which ended the war with Germany, and the Decree of Land, which started the redistribution of farmland. A wave of enthusiasm swept the

MOSCOW 1916–1930/LUTZ BECKER

SOLOMON TELINGATER

Untitled

Photocollage 47.9 × 37.8

Collection Merrill C. Berman

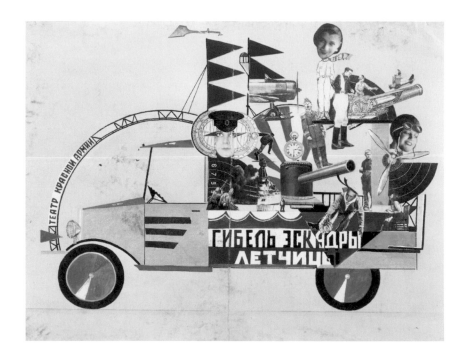

country. The Bolsheviks quickly realised the need for modern means of communication and its value for education and propaganda. A flood of newspapers, posters and pamphlets engulfed the cities. The party papers, *Pravda* and *Isvestia,* were produced in massive editions and the Russian Telegraph Agency (ROSTA) filled bleak streets and empty shop windows with colourful posters and strip cartoons, created by such artists as Vladimir Mayakovsky, Nikolai Cheremnykh and Vladimir Lebedev. Mayakovsky declared: 'The streets shall be our brushes – the squares our palettes.'[2] Young artists started to create for new needs, seizing the opportunity to give their work social relevance. In order to communicate with a mostly illiterate population, their language and imagery had to be basic and simple. In this atmosphere, unprecedented advances were made in all the arts.

As the government of the newly-established Soviet Union made Moscow its capital, the city became not only the political centre and focal point of the Socialist project, but also the catalyst for new developments in the visual arts and literature, experimental theatre and cinema, architecture and avant-garde lifestyle. To break away from the old bourgeois order, its prejudices and social restrictions, the pioneers of Socialism believed that the new society had to be built in conjunction with the modernisation of the cities, electrification and a programme of industrialisation. The living conditions of the urban population changed rapidly – the speed of life took on the momentum of the machine and radio communication. The optimistic vision of the industrialised city found its expression in a new functional architecture. Communal housing, workers' clubs, schools, power stations and factories changed the face of the city; they seemed to transport the Soviet citizen without transition into the Communist future. The constructed environment itself became a tool of social transformation. The art critic Nikolai Chuzhak proclaimed: 'The futurist is not the one who builds day after day and in accordance with today's problems a bridge to the coming future. A futurist is the one who is the most realistic of all realists

SOLOMON TELINGATER

Untitled

Photocollage 24.5 × 31.8

Collection Merrill C. Berman

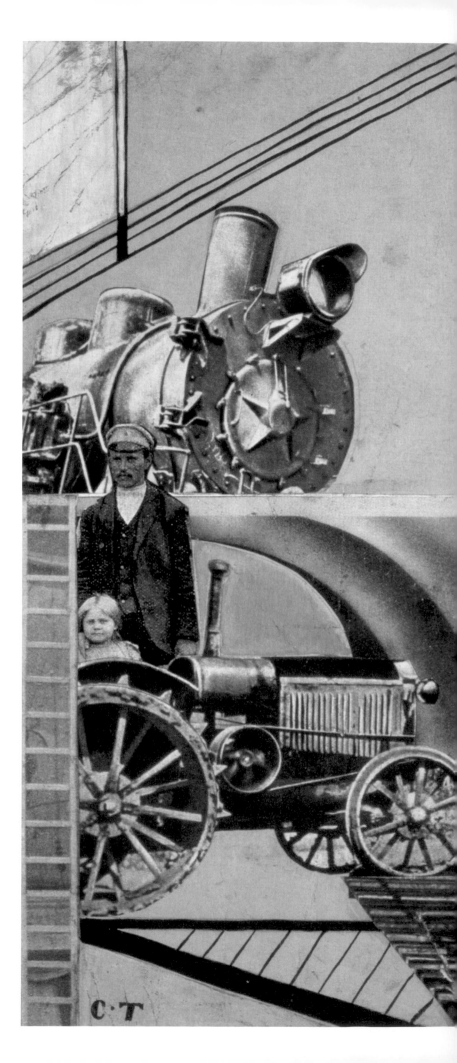

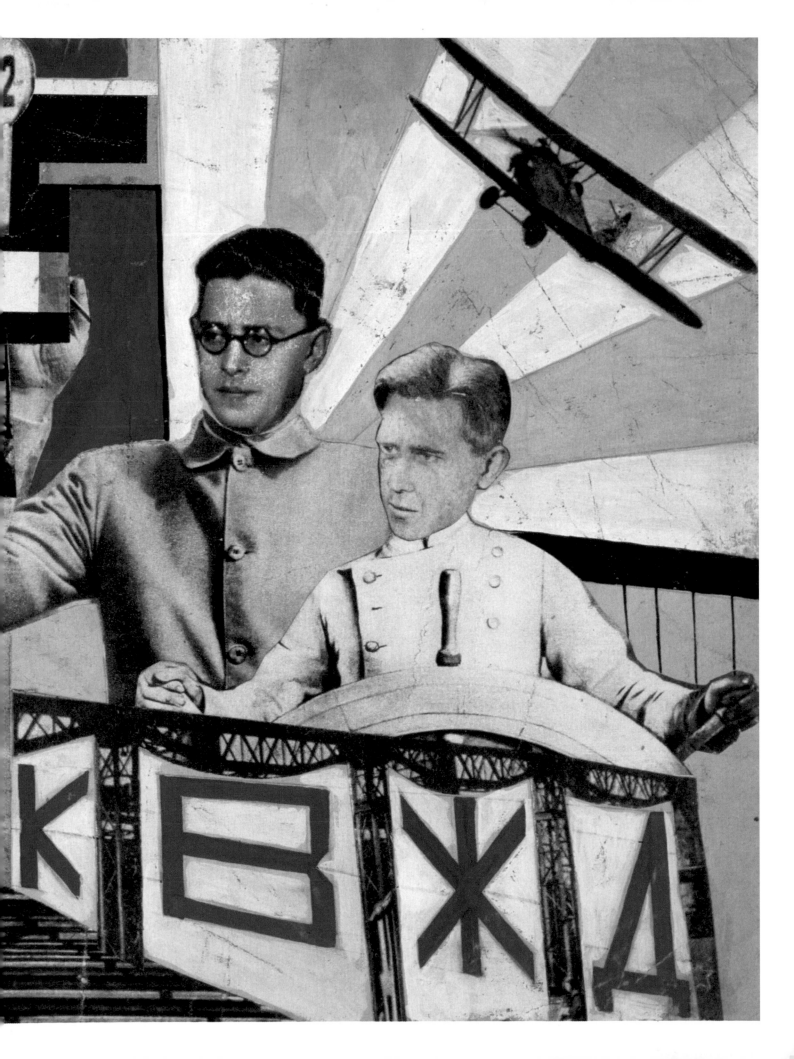

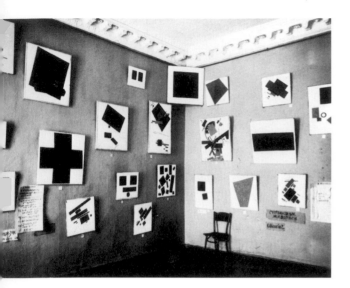

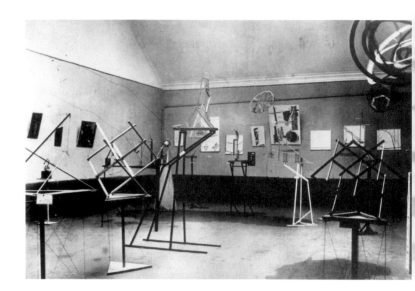

above left

Last Futurist Exhibition *0.10*

Petrograd 1915-16

above right

Second *Obmokhu* **exhibition,**

Moscow 1921

right

EL LISSITZKY

Tatlin Working on the

Monument for the Third

International 1921/22

Gouache and Collage

29.2 × 22.9

Private Collection

of today, he builds dialectical models directly for the future.'[3] That lack of evolutionary calm, that sense of shock, was intended. It prepared the masses for the rapid political and psychological changes that lay ahead.

The signal for change came from the Constructivists, whose artistic visions were linked with the socio-political aims of the Revolution. Their radical aims also connected them with the rising Modern Movement in Western Europe. The Constructivists perceived the creative act as an act of organisation of material and technical capacities, liberated by Communism and industrialisation. Confident of their historical mission they embraced the notion of progress and politicised the role of the artist, who was to take 'art to the people', 'art into life', and finally would take 'art into production', on to a new level of collective purpose.[4]

Vladimir Tatlin's *Monument to the Third International*, planned in 1920, was conceived as a steel tower intended to rise to a height of 1,200 feet. Its ascending double spirals became the emblem of Constructivism, and symbolised energy of action, a metaphor for the process of Communist government. Suspended in this structure were three kinetic architectural elements: at the bottom a large cube, which would rotate once a year, containing an assembly hall for the Communist International; a pyramid-shaped hall for the Party executive committee, which would rotate once a month; a cylindrical space containing propaganda offices, which would rotate once a day; and at the very top a hemisphere containing radio communications, which would rotate once every hour. In this tower project Tatlin identified the collectivist notions of the Soviet State with his own cosmic and spiritual vision. Victor Shklovsky commented: 'This monument is made of iron, glass and Revolution.'[5]

The exploration of the new dimensions of space and time, of powered flight, and the magic of radio waves became a preoccupation of Constructivist artists and architects. The sculptural wire webs of aerials on top of telegraph stations and the erection of radio towers signified the triumph of electrification and the revolutionary embrace of earth and ether. Radio transmitters broadcast Lenin's (and later Stalin's) voice from the Kremlin all over the Soviet Union – a land mass that covered one sixth of the earth. Aleksandr

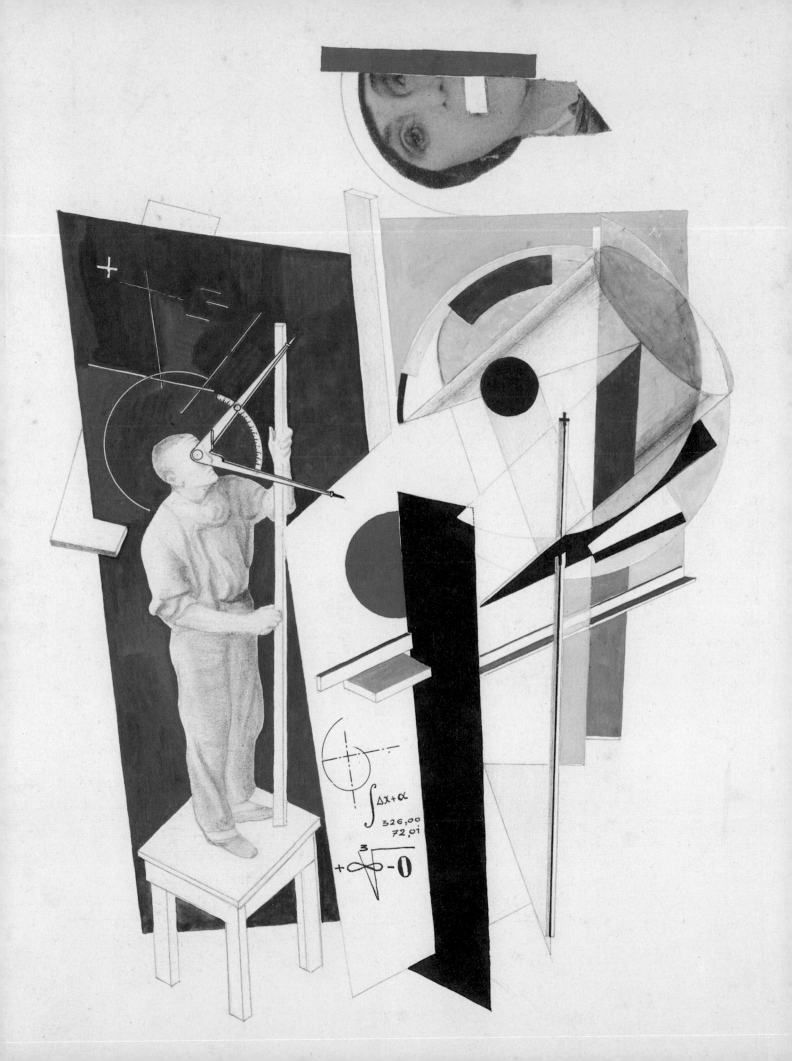

left

KAZIMIR MALEVICH

Suprematist Composition

*c.*1915/16

Oil on canvas 49 × 44

Wilhelm-Hack-Museum,

Ludwigshafen am Rhein

right

ALEKSANDRA EKSTER

Coloured Dynamics 1916/17

Oil on canvas 89 × 54

Museum Ludwig, Cologne

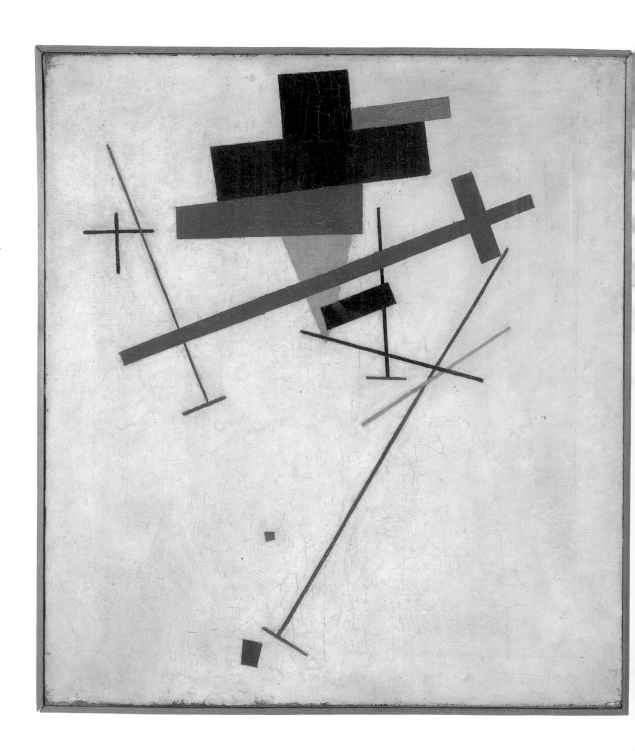

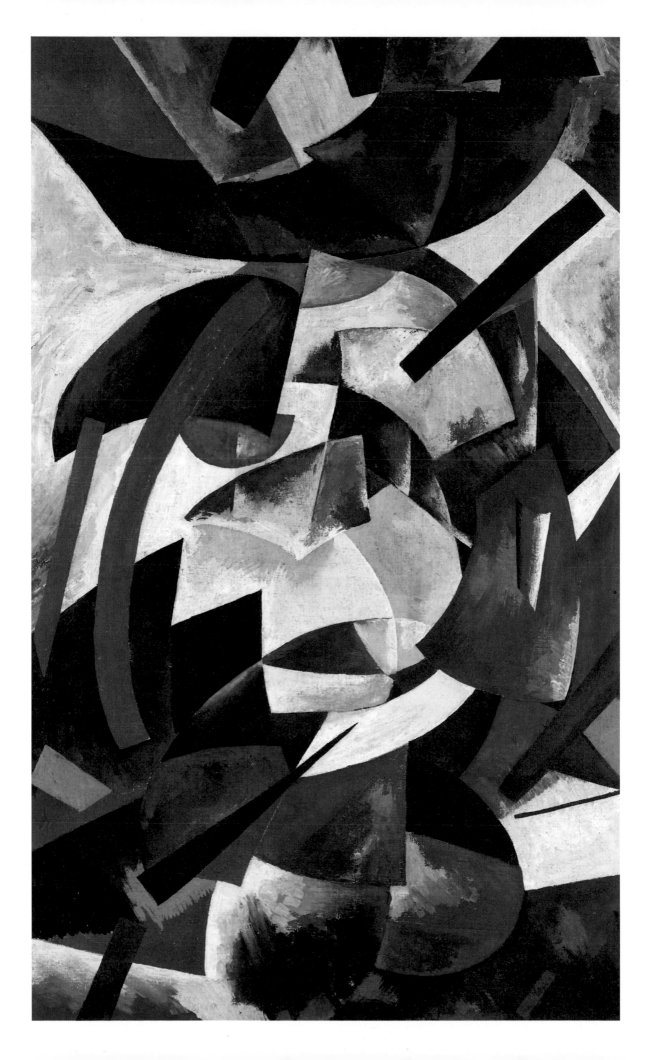

above left

ALEKSANDR VESNIN

Cover of exhibition catalogue

5 × 5 = 25 1921

22 × 12.6

Shchusev State Research

Museum of Architecture, Moscow

above right

VARVARA STEPANOVA

Sketch for *Study the Old but*

Create the New c.1919

Gouache on paper 26.2 × 22.5

Gallery Gmurzynska, Cologne

Shukhov's radio tower in Moscow symbolised power and the romanticism of early radio. In its material and technical solution it too represented the poetics of pure engineering. Kasimir Malevich had held a central position in the art of the Russian avant-garde since 1915. His Suprematist paintings and architectural concepts set him apart from the utilitarian attitude of his contemporaries. In his search for the geometrical and spiritual essence of the new art he arrived at the secular icon, painting constructed of pure form and colour. Influenced by Futurism, Malevich laid the foundations for a new artistic language, which internalised the spirit of the machine age. 'I transformed myself in the zero of form and emerged from nothing to creation, that is to Suprematism, to the new realism in painting – to non-objective creation.[6] Malevich described Suprematism as the pure art of painting as opposed to art imitating nature. Painting for him was an act of renewal, of the transformation of spirit into matter. 'The artist can be a creator only when forms in his picture have nothing in common with nature, for art is the ability to construct, not on the interrelation of form and colour, and not on the basis of beauty and composition, but on the basis of weight, speed and the direction of movement.'[7] Tatlin and Malevich provided the conceptual prototypes, the moral authority and the inspiration for a whole generation of fellow artists, such as El Lissitzky, Aleksandr Rodchenko, Varvara Stepanova, Liubov Popova, Nikolai Suetin, Ivan Kliun, Aleksandra Ekster, and

many others who set out to transform themselves and society through a new art.[8]

The Bolshevik government recognised art as a vital component in its educational and political strategies. In 1918 the Commissar for Education, Anatoli Lunacharsky, proposed that all artists should come under the control of his commissariat, the NARKOMPROS. In 1920 he inaugurated two new institutions with the intention to unify and reorganise all artists' associations and to enable the formation of a system for the training of young artists: the Institute for Artistic Culture (INKhUK), and the Higher State and Artistic Workshops (VKhUTEMAS).

INKhUK, 1920–7, originally envisaged to replace the Academy, was established as a research institute by its first chairman, the artist Wassily Kandinsky. Its aim was to investigate the applications, aesthetics and material properties of abstract and non-objective art. INKhUK received its Constructivist slant through the young members of the 'First Working Group of Constructivists' led by Aleksei Gan. As most of them eventually became teachers at VKhUTEMAS, their ethos had a profound effect on art education. Their aim was to make art accessible to the masses and to improve the quality of industrial and architectural design. Five members of INKhUK organised *5 x 5 = 25*, an exhibition of Constructivist prototype paintings. It was held at the Club of the All Russian Union of Poets in Autumn 1921 and was followed by a sequel dedicated to graphics and architectural and industrial design. The participating artists were Varvara Stepanova, Aleksandr Vesnin, Aleksandr Rodchenko, Liubov Popova and Aleksandra Ekster. Stepanova declared in the exhibition catalogue: 'Technology and industry have made art face the problem of Construction, not as contemplative representation, but as living action.'[9]

In the ten years of its existence from 1920 until 1930, VKhUTEMAS was the most important art school in the Soviet Union, the Soviet Bauhaus; it assembled the leaders of the avant-garde in its teaching staff and gave them unprecedented status and influence. As an institution it was a repository of experimental energy, where artists could test their ideas under laboratory conditions. The division of art and production was at last eliminated, as the painter David Shterenberg declared: 'art has to penetrate production'.[10]

Productivist concepts and advanced technical solutions were handed on to an emerging generation of' 'artist-constructors'. Tatlin's slogan 'Not the Old, not the New, but the necessary!'[11] and the motto 'Artists! Remember – your constructive idea can fertilise industry' expressed the school's ethos.[12] VKhUTEMAS had an average of 1,500 students. The didactic plan provided for seven independent faculties dealing with aspects of architecture, painting, sculpture, metal and woodwork. To enable untrained factory workers to enter the school, Aleksei Babichev founded the Workers' Preparatory Faculty (RabFak).

The integrating element of VKhUTEMAS was the Basic Course, the equivalent of the *Vorkurs* at the Bauhaus, which was organised around the principles of Constructivism: 'Space' was taught by Nikolai Ladovsky and Vladimir Krinsky, 'Volume' by Anton Lavinsky and Boris Korolev, 'Graphics' by Rodchenko and 'Colour' by Popova. The prospectus stated that the Basic Course was to provide students with a 'general artistic and practical, scientific, theoretical, social and political education, and to provide a system of

knowledge essential for the specific faculties'.[13] The production faculties were led by personalities like Tatlin and Lavinsky, and other members of INKhUK – Lissitzky, Rodchenko, Stepanova, Gan, Konstantin Medunetsky, Karl Yoganson, Aleksandr Drevin, Gustav Klucis and Nadeshda Udaltsova, and the brothers Leonid and Aleksandr Vesnin, who successfully converted their subjective discoveries in art into design, theory and systematic practice. As a centre of art education and a forum of ideological debate, VKhUTEMAS was exposed to fierce controversies and to constant structural changes, while factions and faculties struggled for dominance. The implementation of Constructivist concepts was a slow and arduous process. A report on the institution published in *LEF* stated: 'The position of the Constructivists is extraordinarily complicated. On the one hand they have to fight the purists to defend the productionist line. On the other they have to put pressure on the applied artists in an attempt to revolutionise their artistic consciousness.'[14] In fact, a permanent dispute raged between artists on the left, who were pursuing abstraction and construction as objective disciplines, and the proponents of easel painting. These tensions increased with the foundation of the Association of Artists of Revolutionary Russia (AkhRR), whose members hankered after the return of nineteenth-century realism in painting and sculpture, and promoted the notion of Heroic Realism in art and Red Classicism in architecture. This opposition eventually lead to the Stalinist denunciation of the avant-garde as formalist and socially remote; and to the introduction of Socialist Realism. The 'First Discussional Exhibition of Organisations of Active Revolutionary Art' of 1924 showed signs of crisis and polarisation, but tried to unite artists from opposite positions within the common cultural purpose of the Revolution. The 'leftists' were represented with abstract paintings, photography and Constructivist architectural and theatre designs; the 'rightists' showed representational academic paintings and sculptures, some of them in a particular populist vein.

To mark the end of the Civil War, Lenin inaugurated the New Economic Policy (NEP) in March 1921, a form of state-controlled Capitalism, which was to stabilise the Soviet economy and speed up industrialisation. This compromise measure, which affected the development of the Soviet Union for the next decade, was hotly debated and criticised by the left. NEP reintroduced a limited amount of private enterprise and legalised foreign trade. Economic stability brought rising living standards, which enabled social mobility and a popular interest in the new art. The Agit-Prop culture of previous years gained substance. More money was made available for the realisation of art projects and public works. These developments affected the ideological and creative identity of the artists, their loyalties and associations. The need to discuss differing theoretical perspectives, stimulated an intellectual climate in which a wide range of papers and magazines could flourish. Many of these publications were short-lived, but their contribution to defining the shifting role of art in society, and exploring the relationship between art practice and theory, was considerable. Practitioners in all fields explored ideological differences in search of the common purpose of Socialist art. The *Journal of the Left Front of the Arts* (LEF), edited by Mayakovsky and Osip Brik, became most important for the discussion of leftist tendencies in art and the self-definition of the left. Published from 1923 to 1925, the journal reappeared from 1927 to 1928 as *Novy LEF*. It became the forum for artists,

ALEKSANDR RODCHENKO

Four of the ten covers of the serial novel *Mess Mend or a Yankee in Petrograd* by Jim Dollar 1924

1 The Mask of Revenge. 2 The Mystery of the Sign. 8 The Police Genius. 9 The Yankees Are Coming

Letterpress Each 17.8 × 12.7

Collection Merrill C. Berman

writers and theoreticians with Constructivist and Formalist affiliations, such as Brik, Gan, Lavinsky, Boris Kushner, Boris Arvatov, Victor Shklovsky and Nikolai Tarabukin. The bold typography and photomontage covers designed by Rodchenko were representative of *LEF*'s revolutionary programme and intellectual attitude.

Newspaper kiosks around Moscow sold a great variety of popular publications including film magazines and serialised crime novels, poetry and propaganda, which shared a powerful graphic style. The architecture of the printed page was equal to the daring architecture of steel and concrete being erected everywhere. The new city, dynamic and fragmented, was experienced like an exciting montage.

The research groups of INKhUK and the laboratory workshops of VKhUTEMAS promoted inter-disciplinary co-operation between artists and architects. Ladovsky had formed the first VKhUTEMAS research group in 1921, to systematically investigate the perception of form and spatial relationships, material properties of surface, volume, and interior space as well as aspects of proportion, rhythm and composition. His

combination of craft-oriented architecture with mathematical rationalism influenced his colleagues and students alike. In 1923 Ladovsky, Krinsky, Nikolai Dokuchaiev, Aleksandr Efimov, Grigori Barkhin and others, founded the Association of New Architects (ASNOVA), which was dedicated to the application of scientific methods and rationalist aesthetics to architecture and urban planning. They were joined by Lissitzky and Konstantin Melnikov. The latter built the Soviet pavilion for the 1925 *Exposition Internationale des Arts Decoratifs et Industriels Modernes* in Paris, a strikingly elegant wooden construction for which Rodchenko did the interior design, notably the model reading-room for a workers' club. Melnikov was the architect of six Socialist workers' clubs in Moscow, a new type of recreational and educational facility designed to function as 'social condenser', of which the Russakov Club was the most famous. Ladovsky established himself as town planner. In 1927 he drew up a plan for Kostino, an industrial satellite town for 25,000 inhabitants near Moscow. His schemes for a 'Green City' at the periphery of the capital, and his urban development plan for Moscow laid out as a parabola, though rejected at the time

were to influence the way Moscow's expansion was rationalised by a later generation.

Lissitzky, who had strong ties with Germany, acted as mediator between the Soviet avant-garde and the West. Together with the writer Ilya Ehrenburg he edited the trilingual magazine *Veshch/Gegenstand/Objet* which was published in Berlin and Moscow. Together with Shterenberg he organised the *Erste Russische Kunstausstellung,* the first exhibition of Russian art in Western Europe, at the Galerie van Diemen in Berlin in 1922. The exhibition marked a decisive breakthrough in the international recognition of the Soviet avant-garde. Lissitzky was a multi-talented pioneer of Constructivist painting, typography, photomontage and exhibition design. His spatial constructions *Prouns* were situated between graphic design and architecture. With titles such as *Bridge*, *Town*, *Arch*, and even *Moscow*, his designs alluded to architecture but remained unrealisable ideograms. His *Wolkenbügel* (Sky-Hooks), planned as elevated city gates above the intersections of Moscow's ring road, were the Socialist answer to, or horizontal inversions of, the American skyscraper.

The 1922 competition for a Palace of Labour in Moscow was the first major architectural contest after the Revolution. The project submitted by the Vesnin brothers was a visionary structure. The Vesnins insisted on the clear separation of the main functions of the building which would consist of three volumetric forms: a vast oval assembly hall which dominated the building complex, intended for use by the World Congress of Socialism; a bridge building housing the chamber of the Moscow Soviet; and

left

EL LISSITZKY

Proun 93 (Spiral) 1923

Pencil, Indian ink, ink, gouache

and coloured pencil on paper

36.5 × 48.4

Staatliche Galerie Moritzburg

Halle, Landeskunstmuseum

Sachsen-Anhalt

right

ILYA CHASHNIK

Suprematist Spatial

Dimensions No.II 1926

Oil on wood and glass

82.8 × 62.3

Thyssen-Bornemisza Collection,

Lugano

MOSCOW 1916–1930/LUTZ BECKER

BORIS IGNATOVITCH

New Building 1930

Photograph 45 × 27.2

Galerie Alex Lachmann, Cologne

a sixteen-storey tower which would contain the Museum and Library of Socialist Learning. The roof was to hold the central radio station for the Moscow region. Despite the fact that the building was not realised, its value as a prototype was widely recognised. The Vesnin brothers provided further stimulating proposals for the Moscow offices of the *Leningrad Pravda* in 1924 and the new genre of department store for Moscow, the Mostorg of 1926 and the Krasnaya Presna of 1927. Aleksandr Vesnin commented: 'The contemporary engineer has created objects of genius: the bridge, the steam locomotive, the aeroplane, the crane – the contemporary artist must create objects that are equal to these in force, tension and potential with respect to their psychological and physiological effect on the human consciousness as an organising principle.'[15]

In 1925 a group gathered around the architect and theoretician Moisei Ginzburg who formed the Association of Contemporary Architects (OSA). Its most prominent members were the Vesnin Brothers, Iakov Kornfeld, Andrei Burov, Mikhail Barshch, Pantelemon Golosov and Ivan Leonidov. Ginzburg edited the magazine *Sovremennaya Arkhitektura* (Contemporary Architecture), which connected the Soviet architects with the debates of Modernism in Germany, Holland and France; and with the architects Bruno Taut, Walter Gropius, J.J.P. Oud and Le Corbusier. OSA aimed to redefine the architect's profession by extending his responsibilities beyond the known areas of design and engineering into sociology and politics.

OSA addressed the problem of housing, considered 'the most important question in the material life of the workers', with a great sense of urgency.[16] No new housing had been built since before the First World War. Due to the influx of people seeking work in the capital's new industries and administrations, Moscow's population was growing rapidly, driving the housing shortage up to a catastrophic level. In collaboration with fellow architects Ignati Milenis, Boris Venderov and Ivan Sobolev, Ginzburg developed new types of apartment buildings for communal living, with shared living spaces and facilities such as a kitchen, canteen, laundry, day nursery, library, gymnasium and roof garden. Architecture was to play a vital role in social engineering: the collective existence was intended to lead to new kinds of human relationship, which would eventually replace the traditional family. The gradual abolition of the private sphere was proposed to enable new kinds of human contact. The collective would create new ties and responsibilities; the altered social and urban context would end segregation and isolation of the individual. With the experience of hindsight, however, social planners and architects, including Ginzburg himself, were to concede that communal housing as a building type could not be imposed upon the population, and that a building could only 'stimulate but not dictate' its residents' mode of living.

The notion of the city as the focal point of collective energy, and society as the engine of progress, found living expression in Soviet theatre, which was considered to be the synthesis of all the arts. Here artists and architects collaborated with the great reformers of the stage: Vsevolod Meyerhold, Aleksandr Tairov and Nikolai Foregger. Enactments of revolutionary events and new plays written by Mayakovsky, Sergei Tretjakov and others provided entertainment and stimulus for politically-aware audiences. For many years the Meyerhold Theatre was one of Moscow's cultural centres, attracting the intelligentsia, artists and students from VKhUTEMAS, ready to experience

MOSCOW 1916-1930/LUTZ BECKER

the new and the unexpected. The 1922 production of *The Magnanimous Cuckold* by Fernand Crommelynck, was seen as the epitome of Constructivist stagecraft, with its kinetic set and 'biomechanic' action. Popova, its designer, held courses on 'material stage design' at Meyerhold's Higher State Theatre Workshop (GVTM). The concepts developed on the stage and in the workshops had a great impact on the future of Soviet theatre and cinema. Meyerhold's system of 'biomechanics', a kind of Taylorism applied to the theatre, was an important component in the training of his actors.[17] Through a rigorous regime of physical and mental exercises, 'unproductive' motions and emotions were replaced by an economy of gesture and expression. The system was influenced by circus acrobatics; the actors achieved a high degree of self-control, and their precise body language gave them a versatile unsentimental stage presence.

The production of *The Magnanimous Cuckold* was a collaboration between the Meyerhold Theatre and GVTM. Students, among them the future film director Sergei Eisenstein, worked with their masters on an equal basis. Crommelynck's play portrays a jealous husband who offers his wife as sexual bait to his friends and neighbours, in order to confirm suspicions of her infidelity. This adaptation turned the play into a contemporary farce depicting the sexual promiscuity of the new society, in which the monogamous morality of the bourgeois marriage was defunct. In its surprising conclusion the hero is shown as truly magnanimous, donating his wife to the common good. The set was conceived as a mobile stage construction, representing a windmill, with its grinding mechanism in permanent rotation. Meyerhold's programme was made palpable: 'there must be no pauses, no psychology, no conventional emotions.' On a brightly lit stage, action full of infectious enthusiasm and unlaboured creativity unfolded. Athletic actors wore blue overalls, 'production clothing' designed by Popova, which defined them as workers, subservient to the machine. The production combined Meyerhold's theatrical technique and the industrial situation, illustrating the Socialist transformation of labour into pleasure: 'labour is no longer regarded as a curse but as a joyful, vital necessity'.[18]

Tarelkin's Death, a comedy by Sukhovo-Kobylin, was updated to satirise petty NEP capitalism. Stepanova's scenography did not repeat Popova's machine stage, but instead introduced individual 'acting instruments', wooden constructions which were easily shifted into a number of scenic configurations. These play elements were an integral part of the action; at times co-operative or obstinate, they provoked a burlesque pantomimic action. Meyerhold's direction created 'the mechanics of an all-Russian fistfight', a fairground filled with noise and eccentricity.[19]

Meyerhold used Constructivism to engage his theatre with the masses, but he did not think of it as an ageless style. He collaborated with Popova again on an open-air production of Tretjakov's *The Earth in Turmoil*, a montage of dialogues, slogans and images propagandising the building of Socialist society. It was first performed in September 1923 under the auspices of Leon Trotsky and the Red Army who participated in dramatic battle scenes in front of ten thousand spectators. Popova had built a portable wooden construction on which banners, slogans and a cinema screen were mounted. A mobile army kitchen, field telephones, machine guns and a combine harvester were the props. Battle scenes, agitatory speeches, and the projection of newsreels resulted in a vast Agit-Prop experience. When the event was repeated the

following year on the Lenin Hills on the outskirts of the city, it mobilised an audience of 25,000. There was enough money collected during the performances to finance a military aircraft that later bore the name 'Meyerhold'. The theatre had stepped out of its historical confinements – the audience became part of the 'corporate creative act of the performance'.[20]

In his unrealised scheme for Tretjakov's play *I Want a Child* of 1929, Lissitzky explored the idea of a 'total theatre' which would allow the transfer of the mass spectacle into an interior space. His design abolished the proscenium, uniting stage and auditorium in a single flexible structure. Theatre had become the most accessible art form, a truly urban form of entertainment. Artists such as Georgi Yakulov, Sergei Wachtangov, the Stenberg brothers and Aleksandr Vesnin attracted a large audience to Tairov's Kamerny Theatre, next door to the fortress of convention, the Bolshoi Theatre.

In 1923 Vesnin designed *The Man Who Was Thursday*, a dramatisation of a novel by G.K. Chesterton, for Tariov. His three-towered theatre machine, comprising platforms, conveyor belts, escalators, cranes, film projections and kinetic light elements, filled the entire stage. The set represented a romanticised vision of the Western City. The

MOSCOW 1916-1930/LUTZ BECKER

production was full of fashionable Americanisms informed by cinema: leaps in time and continuity, actions and attractions montaged in dazzling speed. The director found himself in the role of an engineer who organised the functions of the stage mechanism and choreographed the actors accordingly.

Tairov's speedy style, his 'theatre without boundaries'[21], was successfully employed in productions of popular cabaret-revues and operettas, often incorporating dance ensembles, trained by Foregger in his MASTFOR studio. In their impeccably synchronised machine dances, the performers enacted the robotic rhythms of engines, imitating the clutter of motors and conveyor-belts, the movements of pistons, exploding valves and the rotation of wheels. These performances celebrated progress. Born partly from the imitation of industrial reality, and partly from the pure enjoyment of abstract movement, they symbolised collective fantasies invested in the Socialist dream combined with a longing for a popular culture, American-style.

With the spread of electrification came the emergence of the new Soviet cinema. Directors such as Dsiga Vertov, Esfir Shub, Sergei Eisenstein, Vsevolod Pudovkin, Aleksandr Dovshenko and Lev Kuleshov, all young revolutionaries, worked to redefine the language of film in accordance with the dynamics of Soviet society. Man had become the master of the machine, the scientifically oriented man, the explorer and researcher, the athletic, omnipresent, critical cameraman. Vertov famously identified himself with his camera:

I am an eye, I am a mechanical eye. I, the machine, show you the world the way only I can see it. I free myself for today and forever from human immobility I am in constant movement I approach and pull away from objects I creep under them ... I cut into a crowd in full speed ... I soar with an aeroplane ...This is I, the machine, manoeuvring in the chaos of movements recording one movement after another in most complex combinations ... My way leads towards the creation of a fresh perception of the world.[22]

The hunger for film was great. Recognising its propagandistic value, Lenin nationalised the film industry in 1919, declaring: 'the art of film is for us the most important of all the arts'. The introduction of NEP and the licensing of free enterprise provided a sustainable economic basis for the recovery of the film industry. Between 1922 and 1923 ninety cinemas sprang into existence in Moscow alone; thirty-five of them were privately owned, forty-five were leased from the state and ten were operated by political organisations. Of the films exhibited only a few were new Russian productions. Approximately eighty per cent of the repertoire was imported from abroad, mostly from Germany and the USA. Favourites were German adventure films starring the stunt-actor Harry Piel and Hollywood's swashbuckling films with Douglas Fairbanks. Epics by D.W. Griffith and Fritz Lang had a great effect in forming standards and feeding audience expectation. The best of the graphic designers, Rodchenko, Lavinsky, Nikolai Prusakov, Konstantin Vialov and the Stenberg brothers produced powerful cinema posters, which were pasted in repeat on walls and hoardings all over the capital. These designers showed virtuoso control of lithograph printing processes, and, echoing filmic fragmentation, made use of photomontage elements, primary colours and bold typography.

GUSTAV KLUCIS

Plan for the Socialist Offensive

in 1929-30 1929

Photomaquette 48.5 × 35

Collection Merrill C. Berman

To boost Soviet cinema, a government film monopoly GOSKINO was set up in 1922. It was renamed and reorganised two years later as SOVKINO which, with its six subsidiaries, took charge of the finance, production and distribution of film chronicles (newsreels and documentaries), educational and scientific films, and feature films.

Vertov was pre-eminent in the development of the Soviet documentary. He had started as director-editor of the first Soviet newsreels, *Kino Nedelya* (1918–19) and *Kino Pravda* (1922–5). These film chronicles were not simply records of current events, but also their poetic reflection. Through the use of well-constructed camera angles, close-ups and intricate editing devices, he achieved both a subjective point of view as well as the rhetoric of political agitation. The inter-titles of these news films, slogans and informative headlines were designed by Rodchenko, to be integrated in the rhythmical order of the sequences. In 1924 Vertov founded the 'Kinoki' team, which included the film editor Elizaveta Svilova and the cameraman Mikhail Kaufman. Together they produced six *Kino Glas* (Film Eye) shorts. In 1926 Vertov made *Forward Soviet* and *One Sixth of the Earth*, two poetic films in which he extended the documentary genre towards a scientific materialist construction of life. The old and the new in everyday life were transformed into a filmic conflict, which opened the eye to the vision of the future. *The Man with a Movie Camera* (1929), a 'cross-section' film describing a day in the life of the people of Moscow, is the purest example of Constructivist cinema; as well as giving a powerful evocation of the city, the camera, the cameraman, the film editor, and indeed film itself, are the subject.

Shub, a close collaborator of Vertov, extended the genre of the documentary with her invention of the compilation film. Based solely on archival footage, such films as *The End of the Romanov Dynasty* (1926), *The Great Road* (1927) and *Today* (1930) achieved a revolutionary view of history through careful research and montage.

Eisenstein's theory of 'The Montage of Attractions', based on his experience of working at Meyerhold's theatre appeared in the same issue of *LEF* as Vertov's manifesto 'Kinosk Revolution'. For Eisenstein the theatre and the cinema were 'instruments of social proclamation'.[23] In 1923, with members of the Proletcult theatre, his assistant Grigori Aleksandrov and cameraman Eduard Tisse, he made *Strike*, his first feature film. This was followed by *Battleship Potemkin* (1925), which marked the twentieth anniversary of the abortive Revolution of 1905. Eisenstein enlarged the historical episode of a mutiny in the Imperial Fleet and turned it into a metaphor for Revolution. The climax of the film, which shows police repression against the revolutionaries on the Odessa steps, is a classic example of montage, with its juxtaposition of close-ups and long shots, clashes of contrast and rhythm. Eisenstein, an excellent teacher and theoretician, had a tremendous influence on the future of Soviet film-making through his classes on film-directing held at the State Technical School for Cinematography (GTK). Here he worked with Kuleshov who ran the course on film acting. Kuleshov had made *The Strange Adventures of Mr West in the Land of the Bolsheviks* (1923) and *By the Law* (1926), co-scripted with Shklovsky. Despite theoretical and methodological differences, Vertov, Eisenstein and Kuleshov shared a commitment to the principle of montage as a means of film construction and ideological synthesis.

In 1927 Eisenstein made *October*, the filmic icon of the 1917 Revolution, shot in and

MOSCOW 1916-1930/LUTZ BECKER

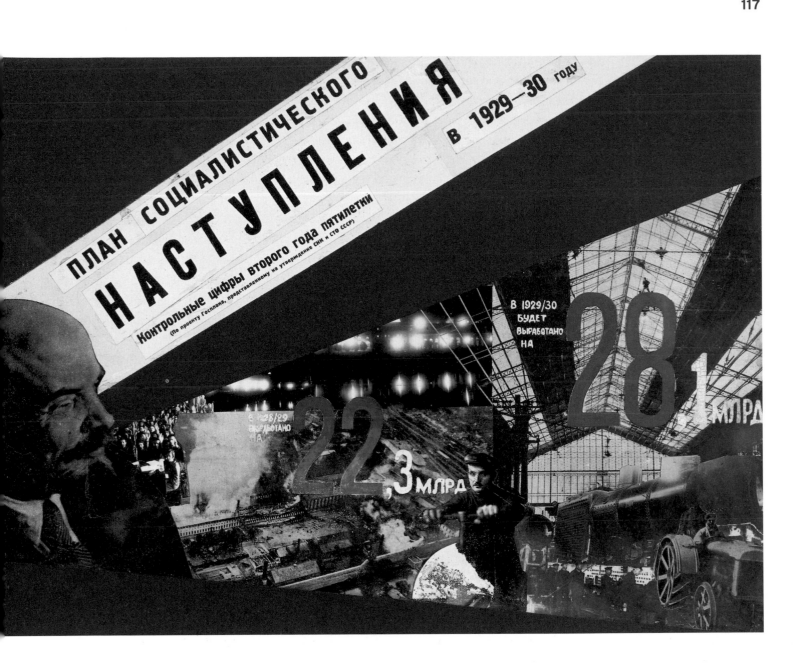

around the Winter Palace. In his montage he succeeded in associating and extrapolating images, like thoughts, and created a narrative flow by elevating fragments of individual actions onto the level of the collective experience. Characters chosen from the population of Leningrad represented psychological and social types; they served the ideological generalisations of the 1917 myth. *The General Line* (1928/9), made to promote the collectivisation of Soviet agriculture, was the director's last silent film. Its homage to modernity displeased Stalin to such a degree that it had to be re-edited several times. Meanwhile directors such as Pudovkin and Dovshenko developed a less controversial narrative cinema. Using 'reliable' literary sources and cultivating an epic acting style based on the Stanislavsky method, their films came closer to the officially condoned realism.

At the end of the decade the avant-garde came under attack from all sides. Defiantly, Gan, Klucis, Rodchenko, and Lissitzky founded the OCTYBR group, and were joined by Ginzburg, the Vesnin brothers, Eisenstein and Shub. Their manifesto published in *Pravda*

asserted that art should serve the working people through ideological education and the 'production and direct organisation of the collective way of life'.[24] Mayakovsky and Brik gathered their followers in the Revolutionary Front of Art (REF). The architects of OSA strengthened their defences by joining forces with other independent associations in an initiative to renew the spirit of Socialist architecture.

The Sixteenth Congress of the Communist Party of 1929 inaugurated Stalin's first Five Year Plan, which decreed the forced collectivisation of agriculture and the construction of Soviet heavy industry. Reverting back to the pre-NEP policies the party expelled eleven per cent of its membership for reasons of ideological unreliability. The great supporter of the avant-garde within the Party hierarchy, the NARCOMPROS commissar Lunacharsky, was replaced by Andrei Bubonov, a former Red Army bureaucrat. Communist Party sponsorship enabled AkhRR to increase its membership and set up a journal, *Art to the Masses*, to promote traditional values and representational art. At the same time a new Union of Proletarian Architects (VOPRA) was set up as a forum against experimental, 'theorising' architecture.

The hard necessities of building the economic basis for Socialism became an excuse for the introduction of mechanisms of repression and censorship. Mayakovsky's suicide and Malevich's three-month imprisonment as a suspected spy in 1930 were for many a

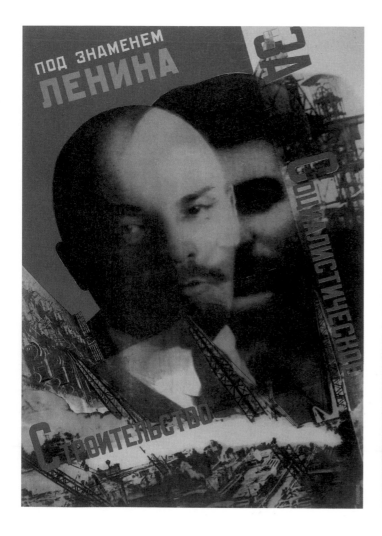

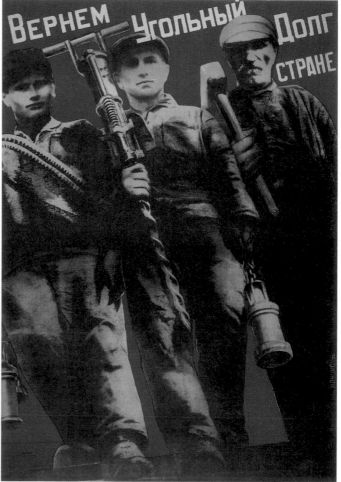

MOSCOW 1916–1930/LUTZ BECKER

signal of the beginning of Stalin's terror. Throughout the 1920s artists had contributed to the new society voluntarily and with enthusiasm, with a minimum of Party interference. Their language, abstract and autonomous, had been a declaration of freedom. Confronted by contemporary needs they had defined their own creative strategies. From now on the Party determined form and content of future tasks. In April 1932, *Pravda* published the Party directive 'On the reorganisation of all existing literary and artistic groups and the formation of a single Union of Soviet Artists'. The new Union would 'unite all those who support the Soviet regime and are striving to take part in the building of Socialism'.[25] AkhRR had finally succeeded in establishing their concept of 'official art', the cultural dogma of Socialist Realism.

During the period of the Five Year Plan the map of Moscow changed rapidly. Old quarters were demolished and wide boulevards were cut through the city. Miners requisitioned from Siberia dug tunnels for the great Metro system deep underground. Tatlin converted the bell tower of the desecrated monastery Novodevichy into an 'Experimental Scientific Research Laboratory' where he studied the economic uses of materials and organic construction with a group of former VKhUTEMAS students. The result was the 'Letatlin',[26] a man-powered flying machine reminiscent of Leonardo da Vinci's glider. Its exhibition at the Moscow Museum of Fine Arts as part of the 1932 retrospective *Work of the Honoured Artist V.E. Tatlin* was both a sign of idealistic determination and a symbol for the end of Constructivism.

By 1932 the first Five Year Plan was completed ahead of time; by the end of the Second Plan in 1937 the USSR had become the third largest industrial power after the USA and Germany. The New Moscow and monumental building projects like the Donbas hydro-electric dam, the Belamorsk and Wolga-Don canal, and the construction of heavy industry seemed to be the realisation of the Socialist dream. Rodchenko, Stepanova, Klucis and El Lissitzky avoided marginalisation; they found new applications for their photography, photomontage and typography by working for the magazine *SSSR na Stroike* (USSR in Construction), a dramatic visual chronicle of its time.[27] Published in several languages, it projected an optimistic propagandistic image of the Soviet Union into the World, an image that was more pervasive than any news of Stalin's show trials and labour camps.

Notes

1 Vladimir Mayakovsky, 'Polnoe sobranie sochinenij v 3 tt', *GIKhL*, Moscow 1955-66, in *Art into Life*, New York 1990, trans. James West.

2 Herbert Marshall, *Mayakovsky*, London 1965.

3 Nikolai Chuzhak, 'Pod znamenem zhiznestroenja (Opyt osoznanja iskusstvadnia)', *LEF*, no.1, 1923.

4 David Shterenberg, 'Pora poniat' in 'Iskusstvo v proizvodstve' (Art in Production), *IZO Narkompros*, Moscow 1921.

5 *Zhizn Iskusstva*, no.650/52, 1921.

6 Kazimir Malevich, 'From Cubism and Futurism to Suprematism' (1916) in Troels Anderson (ed.), *Essays on Art Vol.1*, London 1968.

7 Kazimir Malevich, 'On New Systems in Art', 1919, in Anderson 1968.

8 In 1920 Malevich left Moscow and founded the group UNOVIS (Utverditeli Novogo Iskussta) in Vitebsk. These 'Affirmers of New Art' were an association of followers of Suprematism. The members were the teachers Lissitzky, Jermolajeva, Kogan, and the students Chashnik, Chikedel, Sujetin and Judin. Malevich's dialogue with the Moscow Constructivists continued during the years 1923-7 when he was the head of the Leningrad branch of INKhUK.

9 *Vystavka zhivopisi 5 x 5 = 25*, exh. cat., Moscow 1921.

10 See note 4.

11 'V. Tatlin Moscow 1920', text on a hand painted banner held at the A. Bakhrushin Central State Theatre Museum, Moscow.

12 V. Pertsov, 'Za novoe iskusstvo', Moscow 1925.

13 A.B. Abramova, 'VKhUTEMAS - VkhUTEIN, 1918-1930', in N.Z. Bykov 'Moskovskoe vysshee...', Moscow 1965.

14 'Razval VKhUTEMASa. Dokladnaya zapiska o polozhenij vysshikh khudozhestvenno-tekhicheskikh masterskikh', *LEF*, no.4, 1923.

15 Aleksandr Vesnin, 'Credo', April 1922. Paper in the collection of Selim O. Kahn-Magomedov.

16 Moisei Ginzburg, 'Problemy tipizatsii zhilja RSFSR', *S.A. Sovremennaja Arkhitektura* no.1, 1929.

17 System of scientific management of labour and production proposed in 1911 by the American engineer Frederick W. Taylor.

18 Report of a speech given by V. Meyerhold on 31 October 1920 to the company of the RSFS Theatre, trans. Edward Braun, in Ian Christie and John Gillett (ed.), *Futurism-Formalism FEKS*, London 1987.

19 Ibid.

20 Ibid.

21 Alexandr Tairov, *Das entfesselte Theater*, Potsdam 1923.

22 Dziga Vertov, 'Kinosk: A Revolution', *LEF*, no.3, 1923, in 'Art in Revolution', London 1971, trans. Lutz Becker.

23 Sergei Eisenstein, 'The Problem of the Materialist Approach to Form', 1925, in Richard Taylor (ed.), *S.M. Eisenstein - Selected Works, vol.1*, London 1987.

24 Boris Arvatov, 'Agit i proiskusstvo', Moscow 1930.

25 *Pravda* 12, April 1932.

26 The name 'Letatlin' was a combination of the artist's name and the verb *letat*, to fly. Tatlin dreamed of the 'air-bicycle' which would one day be available to everybody.

27 *SSSR na Stroike* was published from 1930 to 1941 in Russian, English, German and French. Its advanced graphic style and print quality made it the most lavishly produced propaganda magazine of the period.

1916

MANIFESTO *FROM CUBISM AND FUTURISM TO SUPREMATISM* BY KAZIMIR MALEVICH

1917

OCTOBER REVOLUTION; LENIN AND THE BOLSHEVIK RED GUARDS OVERTHROW THE PROVISIONAL GOVERNMENT IN PETROGRAD

FEBRUARY REVOLUTION IN PETROGRAD; END OF ROMANOV DYNASTY

ESTABLISHMENT OF NARKOMPROS (THE PEOPLE'S COMMISSARI OF ENLIGHTENMENT)

REALISTIC MANIFESTO PUBLISHED BY NAUM GABO AND ANTOINE PEVSNER

ESTABLISHMENT OF INKHUK (INSTITUTE OF ARTISTIC CULTURE) UNITING AVANT-GARDE ARTISTS

1920

1921

VLADIMIR TATLIN EXHIBITS HIS MODEL FOR THE *MONUMENT TO THE THIRD INTERNATIONAL* IN PETROGRAD AND MOSCOW

ESTABLISHMENT OF VKHUTEMAS (HIGHER STATE ARTISTIC-TECHNICAL WORKSHOPS), MOSCOW'S LEADING ART SCHOOL

LENIN INAUGURATES NEP, THE NEW ECONOMIC POLICY; PARTIAL RESTORATION OF PRIVATE ENTERPRISE

THE SLOGAN *ART INTO LIFE* IS COINED, MARKING THE BEGINNING OF THE PRODUCTIVIST PHASE OF CONSTRUCTIVISM

1922

END OF CIVIL WAR; FAMINE KILLS HUNDREDS OF THOUSANDS OF RUSSIANS

EXHIBITION *5 X 5 = 25* OPENS IN MOSCOW

MOSCOW

THE MASS SPECTACLE *THE EARTH TURMOIL* BY TRETJAKOV IS PROD MEYERHOLD BASED ON DESIGNS B POPOVA; IT ATTRACTS 25,000 VIS

SOCIETY OF EASEL PAINTERS OSL FOUNDED

1925

TEACHERS AND STUDENTS OF VKHUTEMAS PARTICIPATE IN THE *EXPOSITION INTERNATIONALE DES ARTS DÉCORATIFS ET INDUSTRIELS MODERNE* IN PARIS

OSA (ASSOCIATION OF CONTEMPORARY ARCHITECTS) FOUNDED BY GINZBURG AND THE VESNIN BROTHERS

RELEASE OF SERGEI EISENTSEIN'S FILM *THE BATTLESHIP POTEMKIN* IN BERLIN AND MOSCOW

SCREENING OF THE F *THE END OF THE RO DYNASTY* BY SHUB

1926

MOSTORG, THE FIRST MOSCOW DEPARTMENT STORE, DESIGNED BY THE VESNIN BROTHERS OPENS

KAZIMIR MALEVICH IS IMPRISONED FOR THREE MONTHS

MOSCOW VKHUTEMAS IS REORGANISED, THEN DISSOLVED

1930

THE CENTRAL COMMITTEE OF THE PARTY DEMANDS THE 'LIQUIDATION' OF THE KULAK AS A CLASS; START OF COLLECTIVISATION OF SOVIET AGRICULTURE

MAYAKOVSKY COMMITS SUICIDE; HUGE CROWDS MOURN HIS DEATH

TKULT SET UP IN MANY
TO ENCOURAGE
TARIAN PARTICIPATION
NEW CULTURE

LENIN LAUNCHES HIS PLAN FOR
MONUMENTAL PROPAGANDA

THE BOLSHEVIK PARTY IS RENAMED
THE COMMUNIST PARTY

1918

PEACE OF BREST-LITOWSK BETWEEN
RUSSIA AND CENTRAL POWERS

FIRST POSTER DEPICTING LENIN ISSUED

RUSSIA'S CAPITAL MOVES FROM
PETROGRAD TO MOSCOW

APPOINTMENT OF LEON TROTSKY
AS COMMISSAR OF WAR

CREATION OF THE POLITBURO

1919

ALISATION OF FILM INDUSTRY

THE GREGORIAN CALENDAR IS ADOPTED IN RUSSIA

NATIONALISATION OF ALL
INDUSTRIAL AND ECONOMIC ASSETS

FORMAL ESTABLISHMENT OF THE UNION OF SOVIET
SOCIALIST REPUBLICS (USSR), WITH 22.4 MILLION
SQUARE KILOMETRES, MAKING IT THE LARGEST
COUNTRY IN THE WORLD

OPENING OF THE *FIRST RUSSIAN
ART EXHIBITION* IN BERLIN

1923

IN IS ELECTED GENERAL SECRETARY OF THE
'RAL COMMITTEE OF THE COMMUNIST PARTY

THE MEYERHOLD THEATRE PRODUCES *THE
MAGNANIMOUS CUCKOLD* BY FERNAND
CROMMELYNCK DESIGNED BY LIUBOV
POPOVA AND *THE DEATH OF TARELKIN*
DESIGNED BY VARVARA STEPANOVA

AKHRR (ASSOCIATION OF ARTISTS OF
REVOLUTIONARY RUSSIA) IS FORMED,
ESPOUSING TRADITIONAL REALISM

FIRST PUBLICATION OF THE MAGAZINE *LEF*, EDITED
BY VLADIMIR MAYAKOVSKY AND OSIP BRIK

THE MAN WHO WAS THURSDAY BY G.K. CHESTERTON
WITH DESIGNS BY ALEXANDER VESNIN IS PRODUCED
AT TAIROV'S KAMERNY THEATRE

DEATH OF LENIN

1924

:NIN'S MAUSOLEUM IS DESIGNED BY
.EKSEI SHCHUSEV AND ITS FIRST WOODEN
ERSION IS ERECTED AT THE RED SQUARE

WITHIN A YEAR, 90 CINEMAS OPEN IN MOSCOW

*FIRST ALL-RUSSIAN EXHIBITION OF
ART AND PRODUCTION* OPENS

EL LISSITZKY DESIGNS USSR
PAVILION AT THE *INTERNATIONAL
PRESS EXHIBITION* IN COLOGNE

TROTSKY IS EXPELLED FROM THE COMMUNIST PARTY

1927

1928

THE MOSCOW SECTION OF INKHUK (INSTITUTE
OF ARTISTIC CULTURE) IS CLOSED

NOVYI LEF REPLACES *LEF*,
WITH ALEXANDER RODCHENKO
TAKING A LEADING ROLE

FOUNDING OF THE OCTOBER GROUP

NIKOLAI BUKHARIN IS REMOVED
FROM THE POLITBURO LEAVING
STALIN WITHOUT RIVALS

INAUGURATION OF FIRST
FIVE-YEAR PLAN BY STALIN

1929

TOLI LUNACHARSKI, MINISTER OF
URE, IS REMOVED FROM OFFICE

RELEASE OF THE FILM *THE MAN WITH A
MOVIE CAMERA* BY DZIGA VERTOV

TRETYAKOV GALLERY STARTS LABELLING
EXHIBITS ACCORDING TO THEIR CLASS ORIGIN

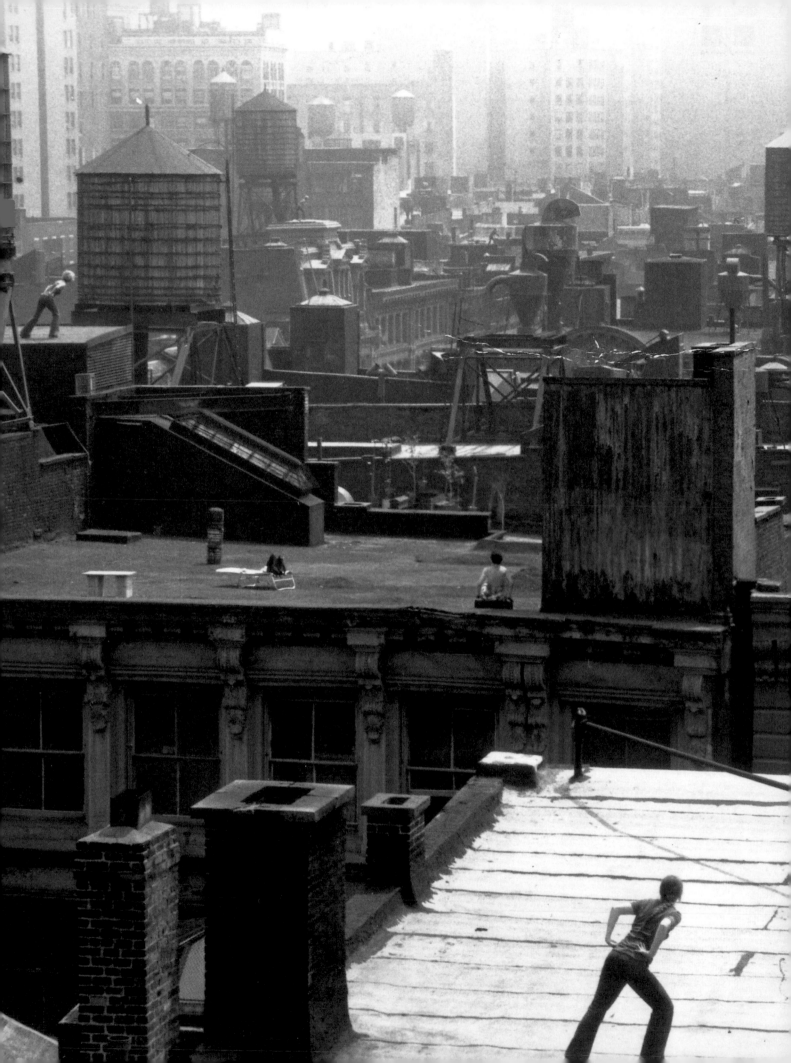

NEW YORK
1969-1974

DONNA DE SALVO

THE URBAN STAGE: NEW YORK CITY 1969-1974

The great purpose of the city is to permit, indeed to encourage and incite, the greatest number of meetings, encounters, challenges, between all persons, classes and groups, providing as it were, a stage upon which the drama of social life may be enacted, with the actors taking their turn as spectators and the spectators as actors.[1]
Lewis Mumford

Anyone who has lived within and travelled outside it knows that New York City is not like the rest of the United States. More than any other American city, New York offers the open stage that Mumford describes as urban. Considered an archetypal modern city, New York continues to attract innovators in the fields of culture and capital. Given this extraordinary history, it might seem odd to be concentrating on developments in art and culture during the dark, gritty years between 1969 and 1974, a time when New York was on the verge of bankruptcy. Yet within a period many would write off, some of the most radical experimentations in art, lifestyle and politics were to unfold. With its streets, lofts, basements, bars and rooftops, the urban environment, and especially SoHo, an area south of Houston Street, became an arena in which to challenge all kinds of received notions – the self, the feminine, the masculine, race, public and private space.

Many of the cultural changes that were to take place during the 1970s were produced as a direct response to the huge upheavals of the 1960s. The cultural theorist Frederick Jameson has argued: 'the sixties did not end in an instant but extended until around 1972–1974'.[2] Both essay and exhibition take 1969 as a starting date. 1969 marks the fortieth birthday of the Museum of Modern Art, the three-day festival at Woodstock and Neil Armstrong's moon walk – three events that give some indication of changing frontiers and institutions. But by 1974, the year of Richard Nixon's resignation as President of the United States, New York City discovered itself on the brink of fiscal collapse and had to look to the federal government for help. The *Daily News* printed its version of Washington's negative response in a now classic headline, 'Ford to City: Drop Dead'. By the end of the decade, the critic Calvin Tompkins was writing in the *New Yorker* that no major new artists emerged in America during the 1970s.[3]

This essay challenges the typically negative appraisal of the 1970s. Among other things, it is an effort to locate some of the predominant forces and individuals that fuelled New York City's cultural crucible and marked the transformation from the 1960s to the 1970s. In the visual arts, it focuses largely on sculpture, performance, video and photography – media whose immediacy was perfectly suited to the experiments, solo and collaborative, of artists, dancers and musicians. For various reasons, I have chosen to limit both exhibition and essay quite radically, for example, excluding developments in painting in favour of media that relate to the cultural and structural mechanics of the space of the city. The essay places particular emphasis on developments that might be inconceivable any place other than an urban environment and which carry with them the special signature of New York City. Clearly, it is impossible to discuss the numerous individuals working during this period; it is a story too full and complex to recount within the space of this essay and exhibition. However, by looking at some of these

NEW YORK 1969-1974/DONNA DE SALVO

developments, something may be revealed about a time we are just beginning to understand.

Unlike the 1950s and 1960s, which were characterised by post-war prosperity and a successive string of dominant artistic styles – Abstract Expressionism, Pop and Minimalism – the 1970s cannot be so easily labelled. Retrospectively, the time has been called 'pluralist', 'post-movement', and 'post-modern', the latter term first coined by the architect Charles Jencks in his attack on the International school and Modernist tradition. Fuelled by Conceptualism and its dematerialisation of the object, visual artists and others were operating without the safety net offered by 'isms', and many regarded this as a good thing. Modernism was being recognised as just another plank in the establishment platform. As the critic Kim Levin wrote, 'Something did happen, something so momentous that it was ignored in disbelief: modernity had gone out of style.'[4]

Fundamental to the art and cultural production of the time was a re-evaluation of the prevailing structures of institutional power, the emergence of grass-roots movements (especially among women and African-Americans) and the establishment of alternative spaces and activist organisations. Traditional gender roles – both male and female – were being scrutinised, inspired by the women's movement, the aftermath of the civil rights initiatives and the riots at Stonewall. The idyllic family paradigm was changing. *Archie Bunker*, based on *Till Death Us Do Part*, a UK television comedy, portrayed a working-class 'bigot' living in Queens with his long-haired, hippie revolutionary son-in-law who attended college. By 1972 the New York Dolls, a proto-punk group, were experimenting with sexual identity à la Andy Warhol, in what was to become known as

SOME LIVING AMERICAN WOMEN ARTISTS

NEW YORK 1969–1974/DONNA DE SALVO

'glitter rock'. A scene from Sidney Lumet's 1975 film, *Dog Day Afternoon*, which recreates the real-life events of one hot summer in 1972, gives some indication of the mood of this milieu. Two petty thieves, portrayed by Al Pacino and John Cazales, staged a robbery at a Brooklyn bank to finance the sex-reassignment surgery of Pacino's male lover. In a botched attempt, the two wind up taking employees and customers hostage. Yet, during the ensuing negotiations with the police and cheered on by crowds of cop-hating Brooklynites standing vigil outside, they emerge an unlikely pair of folk heroes. What was once confined largely to the underground – as exemplified by the parody films of Warhol and Jack Smith – was beginning to be absorbed into the mainstream.

During the early 1970s the political, social and cultural climate of New York City reflected events taking place on both national and international levels. There was trouble at home. 1968, a year made infamous by violence and tragedy, saw student riots in Paris and on the campus of Columbia University. On 18 May 1970 more than 1,500 members of the art community convened at the Loeb Student Center at New York University to protest at the US invasion of Cambodia and the killing of students by National Guardsmen at Kent State and Jackson State Universities. This sparked a series of other actions; ten days later the New York art strike took place, with more than 500 artists staging a sit-in outside the Metropolitan Museum of Art and other major institutions. The strategies employed by the anti-war movement had now been pressed into service by the art world. In New York, the Art Workers' Coalition, an association of activist artists, was founded in 1969, and out of this came Women Artists in Revolution (WAR), founded with the express purpose of addressing the inequities faced by women in the art world. *Harlem On My Mind 1900–68*, a highly controversial exhibition organised by the Metropolitan Museum of Modern Art, initiated the emergence of the Black Emergency Cultural Coalition.

In the visual arts, the bodily references in Eva Hesse's last sculptures, a house split in half by Gordon Matta-Clark, and the videotaped choreography of Joan Jonas's works using New York as a stage set, all show an increasing urgency on the part of artists to reconnect with the world. Moving out of the studio, visual artists sought to reinsert the subjective and biographical content Minimalism had earlier sought to expunge. The

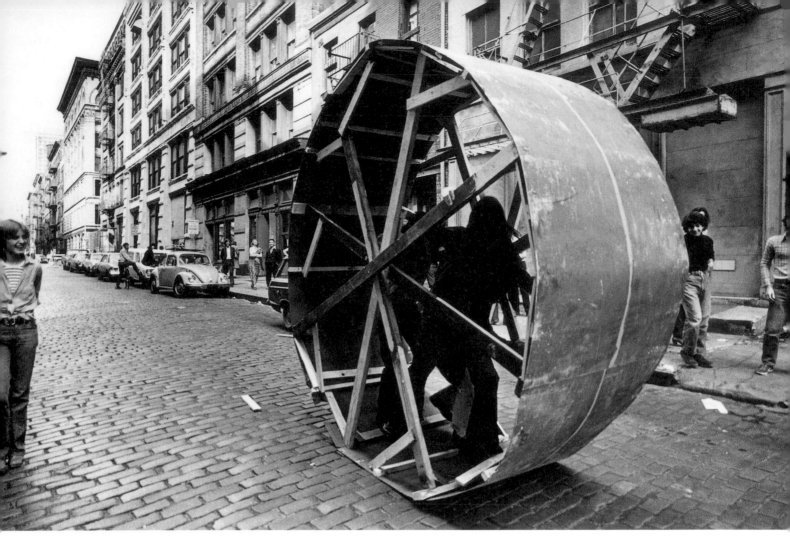

boundaries of the 1960s had been largely defined by formal devices – by 1968 Richard Serra was already throwing molten lead against the walls and floor of a warehouse, making cuts in rubber; Barry Le Va was scattering bits of felt onto the floor; and Sol LeWitt was producing drawings directly upon the surface of walls. In the 1970s works of art were now starting to be thought of as things in the real world. Photography played an essential role at this time, blurring the boundaries between everyday life and art and becoming a surrogate for the actual lived event; the time-based aspects of video also offered startlingly new possibilities. By using their bodies as objects, artists were able to explore the self as a shifting rather than finite concept.

Although it is impossible to fix a finite location in which culture is made, SoHo became, for a while, an important centre for vanguard artists, writers, poets, musicians, choreographers, dancers, film and video makers. In 1976, even Berlin's Akademie der Künste staged an exhibition, *SoHo: Downtown Manhattan*, proclaiming, 'There is no other word for it – SoHo is a phenomenon.'[5] For those who trawl the streets of SoHo today, with its tacky boutiques and crowds of tourists, it is hard to imagine just how bleak and desolate it had once been. 'SoHo has become a case history in the legend of urban pioneers,' writes Lucy Lippard, 'the forerunner of a larger nationwide movement. When middle-class people had left the cities for the suburbs in the seventies, they "repossessed" working class and industrial neighborhoods, ineluctably changing the city's geography and economy.'[6]

NEW YORK 1969-1974/DONNA DE SALVO

left

GEORGE MACIUNAS AND

TAKAKO SAITO

Flux-Treadmill from Flux Game

Fest, May 19, 1973, SoHo, New

York 1973

Photograph 15 × 22.7

Photograph: Peter Moore © The

Estate of Peter Moore

Courtesy of Barbara Moore

below left

Still from *Film about a Woman*

***Who...* (1974) by Yvonne Rainer**

Photograph: Babette Mangolte

below right

RICHARD FOREMAN

Hotel China 1971–2

Photograph: Babette Mangolte

The flight to the suburbs that so characterised urban centres towards the end of the 1960s, coupled with the loss of light manufacturing, created favourable conditions for those in need of large and cheap spaces for working and living. In 1967 the Fluxus artist George Maciunas established the first of the artists' cooperatives that were to flourish in SoHo. One year later, Paula Cooper and Richard Feigen relocated their galleries to SoHo, Cooper opening at 96–100 Prince Street. Her gallery was to be both exhibition space and forum where artists could explore a variety of media. Cooper hosted film showings by Stan Brakhage, Hollis Frampton, Michael Snow, Yvonne Rainer and Richard Serra; performances by Deborah Hay, Mabou Mines, Dan Graham and Vito Acconci; as well as a programme of concerts and poetry readings. The spirit of collaboration that had informed both the anti-war and women's movement now led to the establishment of alternative spaces, including 98 Greene Street (1969), run by Horace and Holly Solomon, Artist's Space (1973) and 112 Workshop also known as 112 Greene Street.

Opened in September 1970, and run largely by the artist Jeffrey Lew, 112 Greene Street provided a space where artists could pursue work often considered as unsaleable in uptown galleries; a perfect space in which to challenge the formalist notion of an art object. Artists willingly embraced its experimental atmosphere. Here they could make cuts in the floor, paint directly on the wall, and generally produce what was not easily definable. Sculptor Jene Highstein characterised the space as 'the funkiest place in the world – so beautiful and impossible at the same time'.[7] The space had a multiple existence: used as a meeting space, studio, and dance floor, it brought together artists from numerous disciplines. Dancers were attracted to the size of the space, although it had a 'treacherously uneven floor', and artist installations often provided ready-made sets. Grand Union dance company (Yvonne Rainer, Steve Paxton, Mary Overly and others) and Mabou Mines theatre rehearsed and gave performances there. The latter incorporated one of the sculptures from an installation by Tina Girouard into their production, *B Beaver Animation*.

Over the course of its eight-year existence, hundreds of artists used the 33 x 110 x 16 foot space. An inspiration for it had come from the sculptor Alan Saret who had been presenting events at his loft on Spring Street, and whose process sculptures, made of

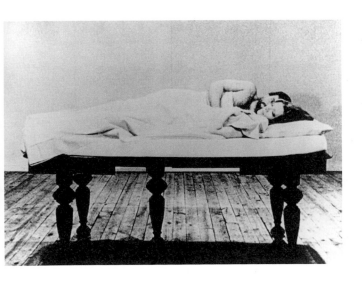

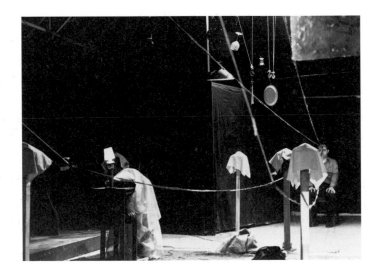

chicken wire and building debris, exemplified the urban landscape. An open-minded attitude extended to the organisation of exhibitions (often chosen by whoever was there at the moment). Tina Girouard remembered: 'trucks would pull up from everywhere and there'd be ten shows laid out on the floor and Jeffrey would try to convince us – you know the dialogue that goes on – "throw that out, Jeffrey ... yes, that's good, leave it" so there'd be this grand edit which was the show and it was exciting'.[8]

As its reputation grew and more artists were attracted to the space, 112 Greene Street sought funding from other sources. An enlightened Brian O'Doherty, of the National Endowment for the Arts, understood the significance of these new alternative spaces, as did the New York State Council on the Arts, and provided essential funding.

The Kitchen, also initially located in SoHo, was another institution key to the development of the vanguard. Founded in 1971 by the video artists Steina and Vasulka, virtually all major video practitioners working in New York passed through its doors. Housed on Mercer Street, it shared company with other performance spaces in the building. It was at this site that the New York Dolls held their first concerts. Precursors of punk, the Dolls were one of several groups who emerged in reaction to the increasing commercialisation of rock, 'championing trash, androgyny, old-fashioned rock'n'roll, drugs and fun'.[9]

Ironically, the fall of the dollar that occurred during the early 1970s made New York economically attractive for several European dealers, including René Block, Reinhard Onnasch and Heiner Friedrich. At their galleries, along with those of Castelli, Sonnabend and Weber, the works of key European artists were brought to the United States, some for the first time. Gerhard Richter, Blinky Palermo, Hanne Darboven, Gilbert & George and Mario Merz were just a few of the artists whose works were shown. In 1974 Joseph Beuys made his first and only trip to the United States for an exhibition at the René Block Gallery, entitled *I Like America and America Likes Me*. Beuys even dismantled the gallery walls and shipped them to Dusseldorf, where they became part of an installation work, *Aus Berlin: Neues vom Kojoten*. Several artists, including Sigmar Polke and Daniel Buren, lived in New York during the period and thus fostered an important exchange of information between the two places. Vito Acconci, Dan Graham and Lawrence Weiner, in turn, were just a few of many artists who began to increasingly exhibit their work primarily in Europe.

The women's movement, which arose towards the end of the 1960s and really gathered momentum in the early 1970s, created a context in which to consider the problematic nature of the feminine subject. There existed various levels of debate among female artists on the topic of subject matter and whether a feminine sensibility could be defined. Some advocated imagery that was quite specific, referencing issues such as childbirth, women's bodies and housework. Others distanced themselves from these more literal interpretations by producing abstract work and viewing the very act of making art as a feminist one. These activities were taking place against a background of events happening around the country. A 'No More Miss America!' protest, for instance, had taken place in Atlantic City and was televised nationally. Kate Millett's *Sexual Politics* was published in 1970, and a portrait of the author painted by Alice Neel appeared on the cover of *Time* magazine. One year later, in an article for *Art News*, Linda Nochlin was

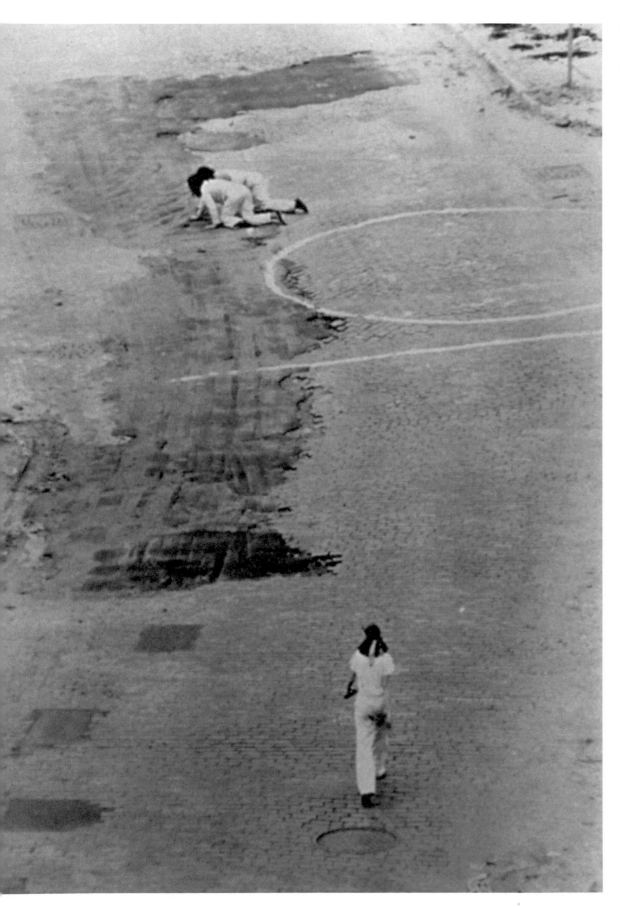

asking the question, 'Why Have There Been No Great Women Artists?'[10]

Early artistic inquiries into feminism had been taking place on the West Coast, where Miriam Shapiro and Judy Chicago had established Womanhouse. In New York, similar activities got under way and included the establishment of several women's collectives, including 55 Mercer Street and AIR (Artist in Residence). The exhibition *Women Choose Women* presented the work of 109 artists at The New York Cultural Center. It was the largest exhibition of its kind ever held at a New York museum. The work was selected by three members of Women in the Arts, along with Linda Nochlin, Elizabeth C. Baker and Laura Adler. Lucy Lippard's text *Six Years:The Dematerialization of the Art Object from 1966 to 1972*, published in 1973, had provided an essential summation of Conceptualism's assault on the Modernist object. Lippard had curated an early exhibition of the work of Eva Hesse; however, with the publication of her collected essays, *From the Center* (1976), she began to establish a critical framework for work produced by women.

The fledgling medium of video offered something especially vital to many artists, and in particular women. Ann Sargent-Wooster observed: 'access to video (as to performance, photography and installation art also emerging in the 1970s) allowed women and others – until then marginalized by the mainstream – to have an equal

voice'.[11] Their work furthered the attack on Modernism by 'transforming the predominantly male monoliths of minimalism into the cluttered, chatty, often messy objects of post-minimalism and postmodernism, with a concomitant destruction of the boundaries between high and low art, fine and applied art, fine art and media production'.[12] In 1969 the landmark exhibition *TV As A Creative Medium* was organised by the Howard Wise Gallery; however, it comprised mostly male artists. In fact, few women had access to professional broadcast quality equipment, such as that at WNET's Television Lab in New York. As new equipment came onto the market, there was an attendant increase in video production and exhibition, including the First Annual Women's Video Festival held at The Kitchen in 1972.

Nancy Holt recalls the immediacy offered by video:

> The first time I had contact with video was in 1969 when Peter Campus rented a video camera and came over. There was a tremendous sense of discovery because it was so accessible and so Bob [Smithson] and I immediately did a work of art. We invited a large group of people over to our loft that night including Richard Serra, Michael Heizer, Nancy Graves, and Keith Sonnier to see it. It was very unusual [to] discover a medium, make a work of art, and show it in the same day. That broke the ice and gave me a sense of what it was about – what were film ideas and what were video ideas.[13]

EVA HESSE

Addendum 1967

Painted papier mâché, wood and
cord 12.4 × 302.9 × 20.6

Tate. Purchased 1979

Video produced by women during this period consisted of a diversity of topics and approaches. In *Art Herstory* (1974) Hermine Freed offered an electronic recreation of a woman's version of the history of painting. Nancy Holt's *Underscan* (1974) employed the underscan button of the video monitor to compress the edges of the image and make them part of the subject matter, coupled with photographs of her aunt's home and an audio track of the artist reading letters written to her. In 1970 Shigeko Kubota began a diaristic chronicle of her life, recording the people she met in various places. Joan Jonas was an important figure in performance art in the 1960s. In the 1970s, she used video to examine and record its phenomenological properties. Three legendary works of this period include *Vertical Roll* (1972), *Organic Honey's Visual Telepathy* (1972) and *Songdelay* (1973).

Eva Hesse was one of only two women (the other being Lynda Benglis) included in New York exhibitions of Process Art, the most important of which was the Whitney Museum's *Anti-Illusion: Procedures/Materials* (1969). Hesse's work was of critical importance to many women artists who emerged during this period. She came to assume mythical status after her death in 1970. Throughout the 1960s Hesse had been experimenting with latex and other industrial materials. By 1968 the majority of her sculptures comprised 'unfixed elements that have to be brought together into some kind of temporary whole during the process of installation'.[14] These sculptures assume a different character each time they are installed, their latex-covered string infiltrating the world like so many tentacles.

When Lynda Benglis began pouring latex directly onto the floor in 1969, she continued an interest in painting shown in her earlier wax-and-pigment lozenge-shaped works. These sensuous poured pieces, with their sparkled knots and Pop colours, were

completely different from the more subdued tones of her Process art contemporaries. Klaus Kertess has observed that her images 'openly declare a very strong female personality'. Works such as *Contraband* went beyond the confines of the canvas to aggressively assert their presence in the gallery space. In 1970, for her first solo show in New York, Benglis poured urethane foam directly into the corners of the Paula Cooper Gallery. In what is usually characterised as a male gesture, it might even be argued that she was marking her territory.

During the early 1970s Benglis also began to use video to examine relationships between individuals, and explore the traditional notions of the feminine and masculine. Reflecting the sexual self-consciousness of the period, *Female Sensibility* (1973) portrays two women engaged in a sensuous exchange. Music from a radio station plays loudly in the background as they tenderly caress and kiss one another; this combination heightens the irony of the scene, especially as both women are made to appear androgynous. Benglis was fascinated by the way she was perceived by the media and made the exploration of her public personae the subject of a series of advertisements

and exhibition announcements.

Along with other women artists of the period – Carolee Schneemann, Hannah Wilke, Eleanor Antin, Dottie Attie, Martha Rosler and others – Benglis created roles for herself to play. In the late 1960s and early 1970s, artists such as Wilke and Benglis produced advertisements that were, in effect, performances. None was more provocative than Benglis's 1974 advertisement in *Artforum*. Photographed by Annie Leibowitz, Benglis appeared oiled, toned, naked, and holding an enormous dildo. It was produced in response to a poster announcing an exhibition of Robert Morris at the Castelli-Sonnabend Gallery in New York, featuring a photograph of the artist nude from the waist up and wearing a metal dog collar, chains and helmet. At the time, Benglis's advertisement caused several of the editors at *Artforum* to publicly distance themselves from it, claiming: 'In the specific context of this journal it exists as an object of extreme vulgarity … [it] reads as a shabby mockery of the aims of … [the women's] movement.'[15] Benglis had collaborated with Morris on her video *Mumble* (1972). Her powerful send-up of the macho male artist fuelled the debates among women artists and others as to what

HANNAH WILKE

Super T-Art 1974

Black-and-white photographs

112 × 92

Mustad Collection, Sweden

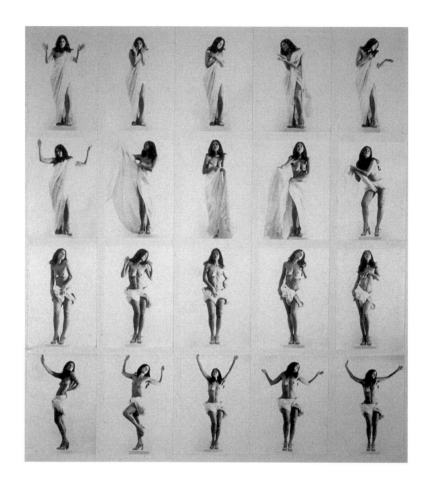

constituted 'women's art'.[16]

In 1974 Hannah Wilke staged a performance at The Kitchen, in which she stripped and photographically documented her actions, to make the work *Super T-Art*. Over a series of images, Wilke transforms herself from a pose suggesting the draped figure of Mary Magdalene to one of a crucified Christ, her arms extended outwards. Wilke's eroticised use of her own naked body is a powerful part of her statement, or as she put it, 'Female nudity painted by men gets documented and when women create this ideology as their own it gets obliterated.'[17] Since 1960 Wilke had been working with abstract forms in an attempt to create 'a formal imagery that is specifically female'.[18] After her mother's mastectomy in 1970, she began performing and having herself photographed. The *S.O.S. Scarficiation* series features the chewing-gum sculptures for which Wilke was well known. Parodying the kinds of poses that were to be found in fashion magazines, Wilke placed small sculpted pieces of chewing gum – metaphors for scars – over her body and especially on her face and breasts, problematising an interpretation of her as victim.

There are certain works of art that might never have been created were it not for the mechanics of city life. As part of a series of performances entitled *Streetworks*, organised in 1969 by the critic John Perreault, artist Marjorie Strider and visual poet Hannah Weiner, Vito Acconci entered the private realm of a different person each day. Following strangers as they conducted their daily chores, Acconci recorded his activities

NEW YORK 1969-1974/DONNA DE SALVO

and mailed these to various members of the art community. Five performances were organised as part of this series, the last sponsored by the Architectural League and, in keeping with the collaborative spirit of the period, with the exception of the last, were open to all. Each event brought artists and performers into direct contact with their audience, dissolving boundaries between maker and spectator. The goal, according to Lucy Lippard, was not aesthetics but communication: 'If the art has no effect on the audience, and the audience has no effect on the art, the street work is not successful, and is hardly deserving of the name.' Over the course of the series, participants included the organisers, as well as Acconci, Laurie Anderson, Jacki Apple, Arakawa, Scott Burton, Meredith Monk, Anne Waldman, Les Levine, Lucy Lippard, Adrian Piper, Charles Simonds, Minoru Yoshida and Martha Wilson.

Before he became a visual artist, Acconci, who was born in New York, was a writer and a poet who approached the space of the page as 'a model space, a performance area in miniature or abstract form'.[19] During the late 1960s, artists such as Lawrence Weiner, Joseph Kosuth, Douglas Huebler and Robert Barry were exhibiting works that featured language, both with and without images. Acconci also chose to situate his work within an art context. Acconci has written: 'going out into the street was a way of literally breaking the margin, breaking out of the house and leaving the paper behind'.[20] In *Seedbed* (1972), which many have considered one of the most notorious works of the early 1970s, Acconci hid beneath a low wooden ramp in the Sonnabend Gallery, masturbating as he engaged in verbal exchanges with visitors walking above. Acconci's fantasies, and his imagined relationship with the anonymous visitor, were broadcast over

above

VITO ACCONCI

Following Piece 1969

Photograph 76.9 × 102.3

Sandra and Stephen Abramson

right

VITO ACCONCI

Seedbed 1972

Photograph 66.1 × 177.9

Barbara Gladstone Gallery, New York

loudspeakers; the spectator plays an active role in the completion of the work. Objectifying the self became a way of analysing it, or as Dennis Oppenheim proclaimed, 'It ain't what you make, it's what makes you do it.'

After the political events of the early 1970s, Adrian Piper felt she could no longer work within what she perceived as an aesthetic vacuum. Maurice Berger writes, 'She could no longer reconcile the socially removed, elitist mind games of Minimalist and Conceptual art with the fact that as an African American woman she faced constant discrimination both within and outside the art world.'[21] Piper's works of the late 1960s often mapped locations around Manhattan. In 1970 she chose to 'become an art object'. She saturated her clothes with cod-liver oil, vinegar, eggs and paint; she stuffed her mouth with wet towels. She moved through the spaces of Manhattan subways, buses, bookstores, Macy's department store, the lobby of the Plaza Hotel, her offensive dress provoking responses. Her actions were recorded photographically and written in a notebook as part of her *Catalysis* series. At the heart of her project was the reality of racial prejudice in contemporary society. In 1971 Piper also staged a private performance in her loft, entitled *Food for Thought,* in which she photographed herself in a mirror, the image reasserting her sense of self. She performed similar events at places throughout New York, including the legendary Abstract Expressionist enclave, Max's Kansas City.

In his 1967 article 'Towards the Development of an Air Terminal Site', Robert Smithson discussed his methodology of the investigation of a specific site as 'a matter of extracting concepts out of existing sense-data through direct perceptions. Perception is prior to conception, when it comes to site selection or definition. One does not impose,

NEW YORK 1969-1974/DONNA DE SALVO

but rather exposes the site, be it interior or exterior.'[22] Growing up in Rutherford, New Jersey, Smithson was influenced by the post-industrial landscape of the metropolitan area. His interventions with the land occurred both within and outside the gallery, most notably his *Tour of the Monuments of Passaic, New Jersey*, published in 1968 in *Artforum*. A series of black-and-white snapshots of the Passaic river documented what Smithson saw as 'ruins in reverse', industrial pipes discharging their waste into the water. In 1970 Smithson made his first major earthwork, *Spiral Jetty*. His engagement with the industrial landscape and use of photographs as surrogates for his non-sites were of critical importance to numerous artists exploring the space outside the gallery.

Gordon Matta-Clark was equally attracted to the post-industrial landscape and chose to work directly in the urban context. He first met Robert Smithson at Cornell University in Ithaca, New York; Matta-Clark was studying architecture and Smithson participating in *Earth Art*, an early exhibition on the topic. Matta-Clark often investigated how materials such as garbage, food and buildings could be transformed. His experiments with cooking and mixing processes were sparked by an interest in alchemy. In his loft on Chrystie Street, he created *Photo-Fry* (1969), literally frying a photograph to see how heat would affect the image.

In 1971 he participated in an event under the Brooklyn Bridge organised by Alanna Heiss, creating a wall of garbage gathered from the site. 'If Matta-Clark is fascinated by garbage dumps, junk heaps, waste and debris, it is because this is the humble substance of the underground, the very gutterspace of society, where its foundations exist.'[23] In May 1972, a garbage dumpster he had moved and placed between 98 and 112 Greene Street became *Open House*. In the steel structure he created rooms and constructed a 'roof' using umbrellas. On opening day, performances were given by many

of the artists, performers and poets also involved in 112 Greene Street and Food.

Food was a space, a restaurant, a meeting place, a gallery, designed by Matta-Clark and built by all its collaborators – a kind of *gesemkunstwerk*. Caroline Gooden had wanted to create a meeting place for the community of artists living in SoHo. Bread was provided by the Madbrook Farm in Vermont, run by two former urban dwellers. 'I designed the menus, the receipes,' recalled Matta-Clark. 'Richard Peck made music while washing dishes. Barbara Dailey designed scrumptious salads during the day and danced at night. Rachel, Tina, Joanne Akalaitis, Joel Shapiro, Ned Smythe, Bob Kushner, and I cooked. Bob Kushner became my "right hand man" in management.'[24]

There was a different cook each Sunday – Mark di Suvero proposed using a crane to serve meals through the restaurant's window. Only fresh and natural foods were served, and it eventually lost money. However, Matta-Clark had intended the restaurant to be an art event rather than a commercial venture, and Food went a long way in subsidising many of the artists who ate there. After this project, Matta-Clark began investigating other building sites, but with a somewhat different purpose in mind.

left
GORDON MATTA-CLARK
Food Restaurant, August
1971–June 1972, New York City

right
GORDON MATTA-CLARK
Graffiti Truck, 1973

Matta-Clark's attacks on the practice of architecture stemmed from his intense interest in it. He began working with buildings located in the Bronx, Manhattan and Brooklyn that were abandoned or to be demolished, and generally situated in areas riddled by urban decay. He objected to the inhumane conditions of these neighbours as well as the public housing projects – looming tower blocks crowded with tenants – that were the city's solutions to overcrowding. In 1971 he cut through all the floors in an abandoned building in the Bronx to reveal its internal structure. He removed essential parts of the building only to discover it did not collapse, subverting the logic of the structure as well as the practice of architecture itself. In this work, and in *Bingo* (1974), he was more concerned with the gaps left behind and what they signified. 'The very real nature of my work with buildings takes issue with the functionalist attitude to the extent that this kind of self-righteous vocational responsibility has failed to question or re-examine the quality of life being served.'[25] To pursue these ideas, Matta-Clark formed the Anarchitecture Group, which met at Food. Its members included Jene Highstein, Laurie Anderson, Richard Nonas, Richard Landry, Tina Girouard and others.

Because of the economic recession, few buildings were constructed in New York
during the early 1970s, the exception being the World Trade Center designed by Minoru
Yamasaki (though planned years earlier), foreshadowing New York's eventual reassertion
as a global financial capital. In fact, most of the projects realised at this time were driven
by urban renewal schemes to provide limited-income housing. Completed projects
included Riverbend Houses (1969), a series of high-rise towers on the Harlem River
designed by Brody Davis; and Exodus House (1969), a drug rehabilitation centre in East
Harlem designed by Smotrich & Platt. Many architects became increasingly disaffected
by the limitations imposed by these urban renewal projects, which they saw as placing
architecture at the service of public programmes. A 1969 conference held at the
Museum of Modern Art focused on whether it was possible for the modernist project to
respond to social needs, and concluded that architects required a greater autonomy. The
proceedings were published as *Five Architects*, in 1972, and included work by John
Hejduk, Richard Meier, Michael Graves, Charles Gwathmey and Peter Eisenman, a group
that became known as 'The New York Five'.[26] In 1967 Eisenman had established the
Institute for Architecture and Urban Studies, and eventually invited Matta-Clark to join.
Eisenman and his group wished to determine whether a critical project could be
undertaken within architecture, in order to prevent it from being merely a tool of authority.
Matta-Clark, on the other hand, felt it was impossible to separate architecture from
societal structures, and chose instead to subvert it through destruction. In 1976, he
used an airgun to shatter the windows of Eisenman's Institute, replacing each pane with
photographs of the shattered windows from the Bronx housing projects. This was his
submission to the exhibition *Idea as Model*; it was however never seen. Eisenman viewed
the act as one of aggression, filed a complaint with the police and had the windows
replaced before the exhibition opened.

NEW YORK 1969-1974/DONNA DE SALVO

Mary Miss and Gordon Matta-Clark each shared an interest in the architecture of space, but their work functioned in decidedly different spheres. While Matta-Clark embarked on his collaborative projects, Miss spent several years making work in virtual isolation in a tiny basement studio. She recalls: 'there was very little interest in my work. I was under no pressure to do things that pleased anyone else, and the isolation allowed time for the work to develop.' Influenced by Minimalist concerns with the relationship between body and object, Miss pursued a 'highly individual engagement with rather than a monolithic mark upon space', declaring, 'It's not about the monument for me.' Referencing images such as fences and ladders, Miss was fascinated with boundaries. 'You can drive for hours through the Western landscape without hitting a town. There's nothing to follow but a beautiful ribbon of fence which never dominates the landscape, just a subtle structure marching off into the distance.'[27] Using the simplest of materials, mostly wood, in 1970 Miss constructed works such as *Stake Fence* and *Ladders and Hurdles* in her basement. Although they refer to outdoor spaces, it can be argued that Miss's work could only have evolved because of its existence within an urban setting; the sense of beyond, and certainly of wide-open spaces, must always be imagined.

In the winter of 1973, Miss moved outside to erect a series of five heavy plank walls in downtown Manhattan. Arranged one behind the other at approximately fifty-foot intervals, each had a circular cut-out of varying configurations that could be viewed from various viewpoints. Lucy Lippard described it as follows: 'This piece happens when you

NEW YORK 1969-1974/DONNA DE SALVO

MARY MISS

Untitled (Battery Park Landfill)

1973

Photograph 28 x 35.5

The Artist

get there and stand in front of it. Its identity changes abruptly ... The experience is telescopic ... The plank fences, only false facades nailed to supporting posts on the back, become what they are – not the sculpture but the vehicle for the experience of the sculpture, which in fact exists in thin air, or rather in distance crystallized.'

The scenes of a lawless New York depicted in *Dog Day Afternoon*, *The Conversation*, *French Connection*, *Mean Streets*, and numerous other films made in the early part of the decade, might seem less plausible towards its end, when Woody Allen's *Manhattan* suggested a more sophisticated and cosmopolitan New York. The club crowd wearing Fiorucci designer denims and going to Studio 54 were beginning to give way to the Ralph Lauren look of *Annie Hall*. History, however, is cumulative, as are the layers in the life of the city. Thinking about New York today inevitably means looking at what has been and can still become; New York has an extraordinary capacity for reinvention.

The conditions that produced vanguard art and culture in the early 1970s are considerably changed, technology having had a profound effect upon how we live our lives and use our streets. These arenas for self-expression have changed with them. The suburbs where people once fled have now infiltrated the city, bringing with them the urban equivalent of the suburban mall: supermarkets and mega-stores. Most of the bars, coffee shops, rooftops and lofts that were a part of the early 1970s have been exchanged for places that are self-conscious, even packaged. Where in 1970 a 'greasy spoon' on Lafayette Street offered just coffee, customers now devote much of their creative energy deciding between latte and cappuccino in an array of flavours. Perhaps, as in the early 1970s when individuals, not movements, were perceived as a defining force, this is just another kind of self-expression. Only time and the city will tell.

Notes

1 Quoted in Jane Jacobs, *The Death and Life of Great American Cities*, London 1962, p.211.
2 Quoted in Dick Hebdige, *Hiding in the Light*, London 1988, p.21.
3 Quoted in Jonathan Fineberg, *Contemporary Art Since 1945*, New York 1998, p.368.
4 Corinne Robins, *The Pluralist Era: American Art, 1968-1981*, New York 1984, p.1. Other essential assessements of this period are to be found in Rosalind Krauss, 'Video: The Aesthetics of Narcissim,' *October*, no. 1, Spring 1976, and Alan Sondheim, *Individuals: Post Movement Art in America*, New York 1977.
5 *New York: Downtown Manhattan SoHo*, exh. cat., Akademie der Künste, Berlin 1976, p.7. René Block offers an excellent overview of the evolution and emergence of SoHo as a centre for artistic activity. See also *De Europa*, exh. cat., John Weber Gallery, New York 1972.
6 Lucy R. Lippard, *The Lure of the local: Senses of place in a multicentered society*, New York 1997.

7 Robyn Brentano with Mark Savitt (eds.), *112 Workshop/112 Greene Street*, New York 1981, p.ii.
8 Ibid.
9 Ben Edwards, quoted in Shelton Waldup (ed.), *The Seventies: The Age of Glitter in Popular Culture*, New York and London 2000.
10 See various feminist texts on this period, including Rozsika Parker and Griselda Pollock, *Framing Feminism: Art and the Women's Movement 1970-1985*, London 1992.
11 JoAnn Hanley, *The First generation: women and video, 1970-75*, exh. cat., Independent Curators, Inc., New York 1993, p.11.
12 Ibid., p.22.
13 Ibid., p.24.
14 Bill Barrette, *Eva Hesse: Sculpture: catalogue raisonne*, New York 1989, p.16.
15 'Postfeminism, Feminist Pleasures and embodied theories of art', in Joanna Frueh et. al, *New Feminist Criticism: Art, Identity, Action*, New York 1994, p.34.
16 Cindy Sherman has noted the influence of the photographic advertisements of Benglis, Morris and Antin on her work.
17 Thomas H. Kochheiser (ed.), *Hannah Wilke, A*

Retrospective, Columbia 1989, p.41.
18 Ibid, p.44
19 Kate Linker, *Vito Acconci*, New York 1994, p.15.
20 Ibid., p.16.
21 Maurice Berger, *Adrian Piper: A Retrospective*, exh. cat., Fine Arts Gallery, University of Maryland 1999, p.16.
22 Nancy Holt (ed.), *Robert Smithson: Collected Writings*, New York 1979, p.47.
23 Corinne Diserens, *Gordon Matta-Clark*, exh. cat., IVAM Centre Julio Gonzalez, Valencia 1993, p.364.
24 Ibid., p.370.
25 Ibid., p.371.
26 See *Five Architects: Eisenman, Graves, Gwathmey, Hejduk, Meier*, New York 1972.
27 *Mary Miss projects 1966-1987*, exh. cat., Architectural Association, London 1987 p.11.
28 Hugh Davies, *Sitings: Alice Aycock, Richard Fleischner, Mary Miss, George Trakas*, exh. cat., La Jolla Museum of Contemporary Art 1986, p.71.

1969

HARLEM ON MY MIND, METROPOLITAN MUSEUM, NYC. *BLACK EMERGENCY CULTURAL COALITION* ESTABLISHED

NEIL ARMSTRONG WALKS ON THE MOON. APPROXIMATELY 720 MILLION PEOPLE WORLDWIDE WATCH THE EVENT LIVE

WHITNEY MUSEUM ANNUAL ONLY 5 PER CENT OF ARTIST WOMEN. FORMATION OF *WOM ARTISTS IN REVOLUTION*

ART WORKERS' COALITION FORMED

NEW YORK MAYOR, JOHN LINDSAY, INAUGURATES THE 'LINDSAY PLAN' TO DEVELOP MANHATTAN'S BUSINESS DISTRICT

*M*A*S*H*, FILM DIRECTED BY ROBERT ALTMAN

US GOVERNMENT ESTABLISHES ENVIRONMENTAL PROTECTION AGENCY

NEW YORK STATE LEGALISES ABORTION SUBJECT TO TIGHT RESTRICTIONS

MONDAY NIGHT FOOTBALL DEBUTS ON ABC

WHITNEY SCULPTURE OPEN. REPRESENTATION OF WOMEN ARTISTS HAS RISEN TO 22 PER CENT

MASTERS AND JOHNSON PUBLISH *HUMAN SEXUAL INADEQUACY*

THE NEW YORK TIMES STARTS PUBLISHING THE LEAKED *PENTAGON PAPERS*, A HIGHLY CLASSIFIED GOVERNMENT ACCOUNT OF THE VIETNAM WAR. NIXON'S ADMINISTRATION FAIL IN THEIR ATTEMPT TO STOP PUBLICATION

1971

NEW YORK WORLD TRADE CENTER BECOMES WORLD'S TALLEST BUILDING

SOHO DISTRICT RESIDENTIA RESTRICTIONS COMPLETELY

NEW YORK

MS MAGAZINE FOUNDED BY GLORIA STEINEM

1973

NIXON MEETS BREZHNEV FOR SALT (STRATEGIC ARMS LIMITATION TALKS)

WOMEN CHOOSE WOMEN EXHIBITION, THE NEW YORK CULTURAL CENTER, 109 WOMEN ARTISTS REPRESENTED

AGREEMENT TO END VIETNAM WAR SIGNED IN PARIS

PICTURES OF JUPITER TAKEN FROM PIONEER 10 ARE TELEVISED

SENATE WATERGATE HEARINGS SHOWN LIVE ON DAYTIME TELEVISION

THOMAS PYNCHON'S *GRAVITY'S RAINBOW* PUBLISHED

WOODSTOCK MUSIC FESTIVAL

AFRO AMERICAN ARTISTS: BOSTON & NY
EXHIBITION, MUSEUM OF THE NATIONAL
CENTER OF AFRO-AMERICAN ARTISTS, NYC

1970

EASY RIDER, FILM DIRECTED BY DENNIS HOPPER

HELLO, DOLLY! CLOSES ON BROADWAY
AFTER 2,844 PERFORMANCES

US TROOPS SENT INTO CAMBODIA

AD HOC COMMITTEE OF THE
ARTWORKERS COALITION IS FORMED,
FOLLOWED BY *WOMEN STUDENTS AND
ARTISTS FOR BLACK ART LIBERATION*

*NEW YORK ART STRIKE AGAINST WAR,
RACISM, FASCISM, SEXISM AND REPRESSION*
ESTABLISHED FOLLOWING 1,500 STRONG
MEETING OF ARTISTS AND DEALERS

SEXUAL POLITICS BY KATE MILLETT PUBLISHED

THOUSANDS MARCH TO CELEBRATE FIFTIETH
ANNIVERSARY OF NINTH (WOMEN'S
SUFFRAGE) AMENDMENT TO US CONSTITUTION

APPROXIMATELY 500 PEOPLE PARTICIPATE IN
ARTIST-STAGED SIT-INS AT THE METROPOLITAN,
WHITNEY AND GUGGENHEIM MUSEUMS

AT KENT STATE UNIVERSITY, OHIO, NATIONAL
GUARDSMEN SHOOT AND KILL FOUR STUDENTS
PROTESTING AGAINST CAMBODIAN INVASION

*CONTEMPORARY BLACK ARTISTS
IN AMERICA*, WHITNEY MUSEUM
OF AMERICAN ART, NYC

POPULAR TV SITCOM *ALL IN THE FAMILY* DEBUTS

THE US CENSUS COUNTS
208 MILLION AMERICANS

THE KITCHEN, THE FIRST DEDICATED FILM
AND VIDEO EXHIBITION SPACE, OPENS

WALT DISNEY WORLD
OPENS IN FLORIDA

THE GODFATHER, FILM DIRECTED
BY FRANCIS FORD COPPOLA

BREAK-IN AT DEMOCRATIC HEADQUARTERS
TRIGGERS THE WATERGATE SCANDAL

1972

EQUAL RIGHTS AMENDMENT
APPROVED BY SENATE

JACKSON POLLOCK PAINTING SOLD FOR
$2 MILLION, RECORD FOR AMERICAN WORK

VICE PRESIDENT SPIRO T. AGNEW RESIGNS
FOLLOWING ACCUSATIONS OF TAKING BRIBES
AND INCOME TAX EVASION

THE CLEAN AIR ACT IS PASSED

99 PER CENT OF GAS STATIONS ACROSS US CLOSE
TO SAVE FUEL DURING ARAB OIL EMBARGO

THE ENDANGERED
SPECIES ACT IS PASSED

1974

WOODWARD AND BERNSTEIN
WRITE *ALL THE PRESIDENT'S MEN*

FIRST ISSUE OF
PEOPLE MAGAZINE

HAPPY DAYS FIRST
BROADCAST ON ABC

ROBERT PIRSIG PUBLISHES *ZEN AND THE
ART OF MOTORCYCLE MAINTENANCE*

FOLLOWING WATERGATE HEARINGS, NIXON RESIGNS.
VICE PRESIDENT GERALD FORD SWORN IN

PARIS
1905-1915
SERGE FAUCHEREAU

'Paris is changing!' Baudelaire wrote in 1860 to Victor Hugo in exile. In the second half of the century, the vast programme of urban renovation initiated by Baron Haussmann rapidly changed the appearance of Paris. The French capital was transformed from a medieval city into a modern metropolis. 'Old Paris is no more,' insisted Baudelaire, and he was to be one of the first to formulate an aesthetic system more in keeping with this changing world. In fact, the entire occidental world was becoming more built up and the industrial metropolises were turning into 'tentacular cities', in the words of the Belgian poet Emile Verhaeren. Paris was overtaken by a great desire for reform: the city spread, swallowing up the surrounding villages, the 'grands boulevards' were built, facilitating circulation. The cityscape was altered by new buildings like the Sacré-Coeur and metal structures became an increasingly common sight: the Gare du Nord, the Bibliothèque Nationale, the Bon Marché department store. In 1889, Gustave Eiffel erected an iron tower whose innovative design created a sensation: the general public and intellectuals protested; the painter Georges Seurat and the poet Stéphane Mallarmé were among the few who approved of it. The boldness of its iron structure excited interest internationally. By contrast with the Art Nouveau style, which flourished in Paris as in all the major urban centres, and was responsible for an impressive array of scrolls and convoluted decorative elements in architecture and the applied arts, this enormous and useless iron construction was like a forerunning symbol of a new era.

Paris did not assume its true status as a modern capital until it finally acquired a metropolitan railway in 1900, long after London. By enabling people to cross Paris in less than an hour, the Métro singularly speeded up the pace of life in the city and enhanced the importance of its suburbs, which were now within easy reach. Electricity also made underground lighting possible. Although the Avenue de l'Opéra had become the first electrically lighted thoroughfare in 1879, gas street lighting was not replaced until several years later. Despite its numerous excessively ornate Art Nouveau palaces, the Universal Exhibition of Paris in 1900 dedicated a Palais de l'éléctricité to this power source that appeared destined for a great future. The 1890s saw a large number of remarkable technical advances which were to have a considerable impact on everyday life: the motor car, the diesel engine, the cinema, the aeroplane all increased the speed of communication. In 1891, France and England were linked by the first undersea telephone cable; in 1899, Guglielmo Marconi established a wireless station which enabled the two countries to communicate with each other. Only a few pessimists, like H. G. Wells, doubted the state of bliss promised by this great scientific and technological development, mocked by Alfred Jarry in *Ubu Enchained* (1900): 'I no longer have any time for the umbrella, it's too hard to manoeuvre, I should sooner have used my knowledge of physics to stop the rain falling!'

In actual fact, speed and electric lighting had a profound effect on people's perception of the world. Artists were the first to take account of it, all the more so because photography, now part of everyday life, had freed some of them from their continuing preoccupation with similitude. It is debatable whether the harsh colours and formal simplifications of Fauvism would have been imaginable without electric lighting. Robert Delaunay's simultanism could be seen as dependent on his vision of a speeded-up world and on the cinema. The Futurist manifesto of F. T. Marinetti, published in Milan

PARIS 1905–1915/SERGE FAUCHEREAU

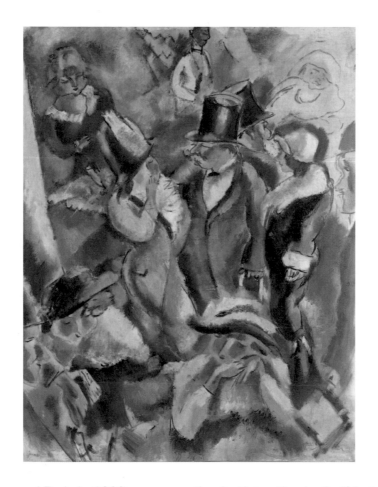

and Paris in 1909, was an enthusiastic synthesis glorifying speed, express trains, cars, aeroplanes, electricity, machines, industrial crowds and even, unfortunately, violence and war. The same spirit radiates from the frenetic dancers, trains and metros of Gino Severini, an Italian Futurist living in Paris, the fighting athletes of Raymond Duchamp-Villon, the simultaneous sights of a train journey in the *Prose on the Trans-Siberian Railway* by Blaise Cendrars and Sonia Delaunay and even from the disjointed contortions of the sculptor Henri Laurens's *Clown*. Artists were keen to tackle anything that thrilled the masses: Delaunay painted athletes and the Cardiff football team; the Cubists regularly painted scenes from the circus while the Fauves and Futurists preferred dances and the music hall. It was in this spirit that Igor Stravinsky included a folk song ('She Had a Wooden Leg') and a waltz by Lanner in *Petrushka* (1911), that Claude Debussy composed *Jeux* (1913) and that Erik Satie wrote his *Sports et Divertissements* suite (1914).

Around 1900, concepts that had been deemed self-evident and unshakeable were overturned by various scientific and para-scientific investigations and discoveries: the exploration of the interplanetary macrocosm and the molecular microcosm using increasingly sophisticated resources made it possible to carry out an in-depth examination of the physical substance of our world as perceived by our primitive senses; discoveries made in the fields of physics and chemistry (radioactivity, for example) as well as speculation about mathematics and paranormal communication challenged perceptible space and raised questions about the true nature of life and death. In 1905,

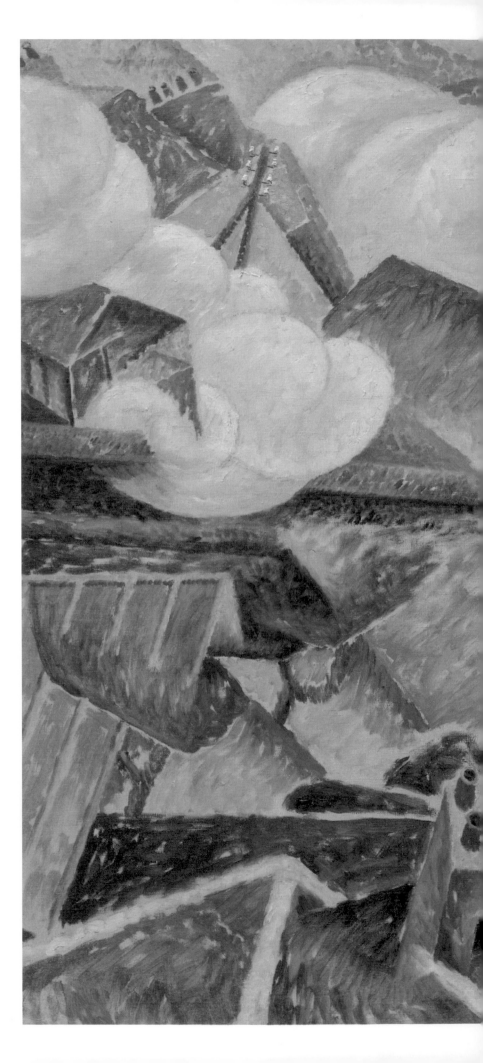

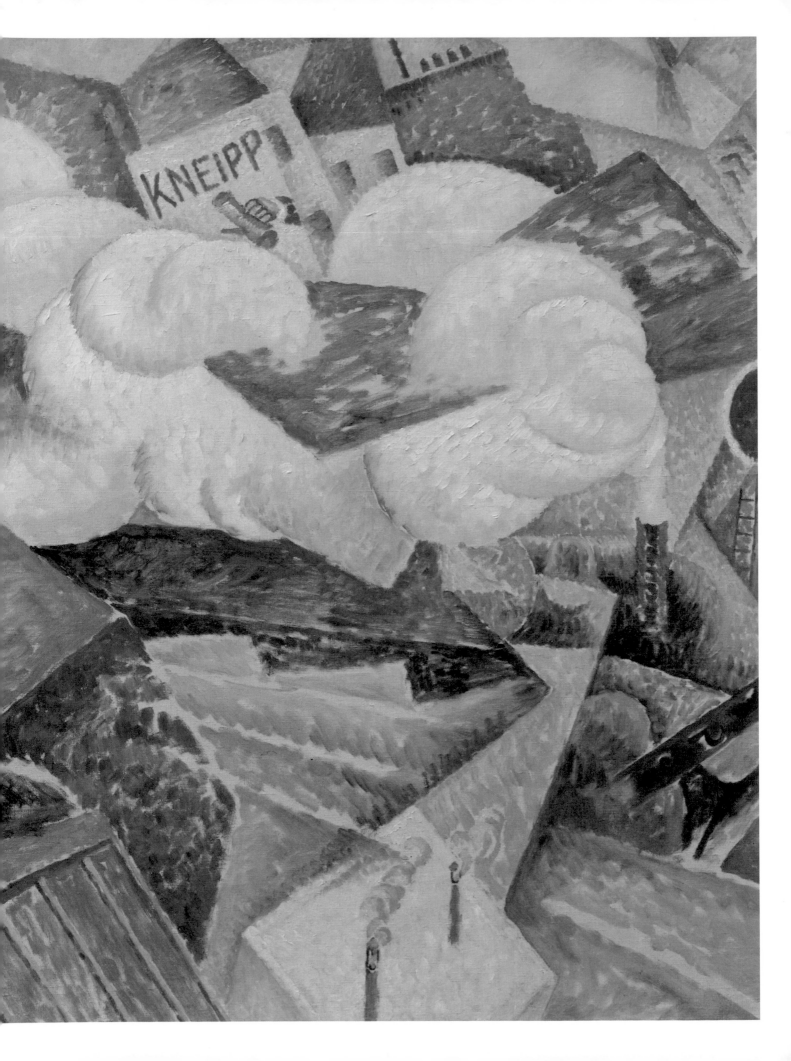

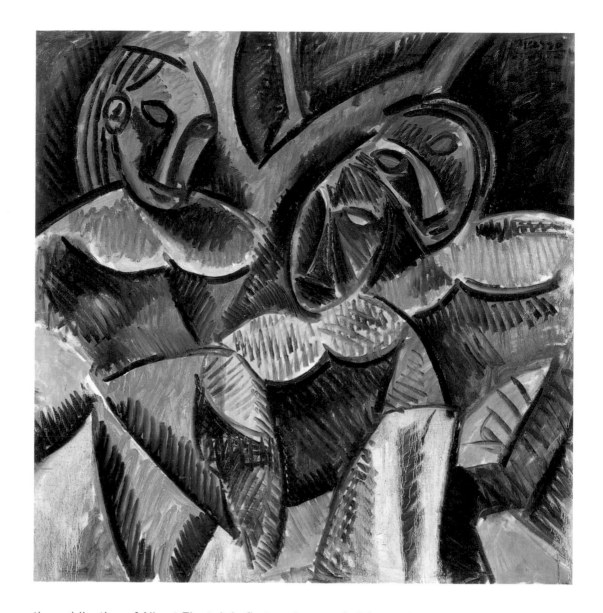

the publication of Albert Einstein's first works on relativity marked a watershed in the concept of space and time. The same year, *Three Essays on the Theory of Sexuality* by Sigmund Freud suggested a fundamentally new depth to human psychology. Artists from all fields realised that they had to incorporate this new vision into their aesthetic systems. This can be seen in the words of the poet Blaise Cendrars:

During these six or seven years, from 1907 or 8 to 1914, a wealth of patience, analysis, investigation and erudition was brought into play in the studios of young painters in Paris and the world had never seen such an intense bonfire of intelligence! The painters scrutinised everything, the art of their contemporaries, the styles of every period, the plastic expression of every nation, the theories of every era. Never before had so many young painters visited the museums to examine, study and confront the techniques of the great masters. They assimilated the creations of savages and primitive peoples as well as the aesthetic vestiges of prehistoric man. They also considered closely the latest scientific theories about electrochemistry, biology, experimental psychology and applied physics.[1]

PARIS 1905–1915/SERGE FAUCHEREAU

left

PABLO PICASSO

Three Figures under a Tree

1907

Oil on canvas 99 × 90

Musée Picasso, Paris

below

LÉOPOLD SURVAGE

Twelve Coloured Rhythms 1913

(detail)

Watercolour 26 × 35

Collection Cinémathèque

française, Paris

In Paris, as in other cities, this spirit of enquiry was to influence classical perspective and the theory of colour in the visual arts, syntax and poetics in literature, and tonality in music.

At the moment when the first ethnologists were displaying their collections in Paris, urban artists wanted to find innocence and freshness wherever it came from. To take just one example, the influence of primitive art (at the time it was called, rather incorrectly, 'Negro art') mentioned by Cendrars on Fauvism and particularly Cubism, has often been seen as a result of a few African masks and statuettes collected by Matisse or Picasso, although its impact can be overestimated. But the importance of other primitive arts, as well as the unusual and inspired paintings by Henri Rousseau (who was no more a naïve painter than he was a customs officer), should be taken into consideration. A certain amount of primitivism is evident in the early Cubist paintings to varying degrees (see *Three Figures under a Tree*, 1907, by Picasso) and in sculptures by Constantin Brancusi, Amedeo Modigliani and Ossip Zadkine, as well as in the overtly barbaric rhythms of Stravinsky's *Rite of Spring* or in Satie's penchant for using humorous quotations of children's songs in his works.

In the decade prior to the First World War, the world of art had seen the gap between folk culture and 'highbrow' culture narrowing. Max Jacob, Guillaume Apollinaire and Picasso loved the circus, André Derain and Georges Braque were keen boxers, Robert Delaunay was fascinated by pioneers of flight, Kees Van Dongen was as fond of nightclubs as he was of society 'soirées', Cendrars and Fernand Léger revelled in the delights of advertising, Braque enjoyed playing popular songs on the accordion and Stravinsky himself had a great love of the mechanical piano. And they were all excited by the most popular art form of all: the cinema. There they delighted in the phantasmagorias of Georges Méliès, the hilarious misfortunes of Max Linder or the thrilling cinematic serials of Louis Feuillade, such as *Les Vampires* or *Fantômas*. Ah, Fantômas! The sinister bandit who terrorised Paris was to prompt the magazine *Les Soirées de Paris* to announce the foundation of the SAF, or Société des Amis de Fantômas. Poets like Apollinaire, Max Jacob, Cendrars, André Salmon and artists like Picasso, Braque and Juan Gris were all members of the SAF. More seriously, *Les Soirées de Paris* also supported the experiments of Leopold Survage, a painter of Finnish origin who, way ahead of his time, had understood some of the potential offered by cinema and had painted scores of coloured rhythms in 1914 in preparation for the first abstract colour film which, due to the war and technical hitches, was never made.

Paris had been established as an international art scene building up momentum through the nineteenth century. From 1905 to 1915, the entire avant-garde challenged the official art and sculpture that filled the many fine arts salons of the period. As Hemingway was to write many years later, Paris was a 'moving feast'. Artists from all over the world were drawn by the legendary freedoms of Parisian art life; this avant-garde was extremely cosmopolitan. A certain number of artists were French, of course, but those who stayed in Paris for a year, two years, ten years, twenty years or more also left their stamp on the cultural landscape. There was a substantial contingent from Russia (Alexander Archipenko, Marc Chagall, Sonia Delaunay, Ossip Zadkine, to mention only a few) and from the Iberian peninsula (Agero, Pablo Gargallo, Gris, Picasso, Souza-

this page

ALEXANDER ARCHIPENKO

Woman Combing Her Hair 1915

Bronze 35.6 × 8.6 × 8.3

Tate. Purchased 1960

right (above)

HANS PURRMANN

Factory Landscape in Corsica

1912

Oil on canvas 50 × 60

Wilhelm Lehmbruck Museum,

Duisburg

right (below)

Café du Dome, Paris

Cardoso) but there were also many Italians (Giorgio De Chirico, Modigliani, Severini, Soffici), Scandinavians (Per Krohg, Axel Revold, Sigrid Hjerten, Nils Dardel, Henrik Sørensen, etc) and Germans (Otto Freundlich, Wilhelm Lehmbruck, Hans Purrmann). Brancusi came from Romania, Van Dongen and Piet Mondrian from Holland, Jacques Lipchitz from Lithuania, and Diego Rivera from Mexico. There were also the art lovers and shrewd art dealers: Americans Gertrude and Leo Stein, the Polish Leopold Zborowski, the Germans Wilhelm Uhde and Daniel Henri Kahnweiler, whose gallery was to stand the test of time. The whole world was in Paris and the city had rarely been so dynamic. Of course, there were specific groups, affinities and enmities; lively discussions abounded in the studios and particularly in the cafes: there were those for and against Matisse or Picasso, Survage's invention of an abstract film was discussed, some even came to blows over the possibility of a fourth dimension in painting. However, if a challenge came from outside, they immediately presented a common front. This is what happened over the scandal caused by Jacob Epstein's monument to Oscar Wilde in the Père Lachaise cemetery. Believing it to be a fine achievement after several years of hard work, various writers and artists from all backgrounds rallied round to support their English colleague

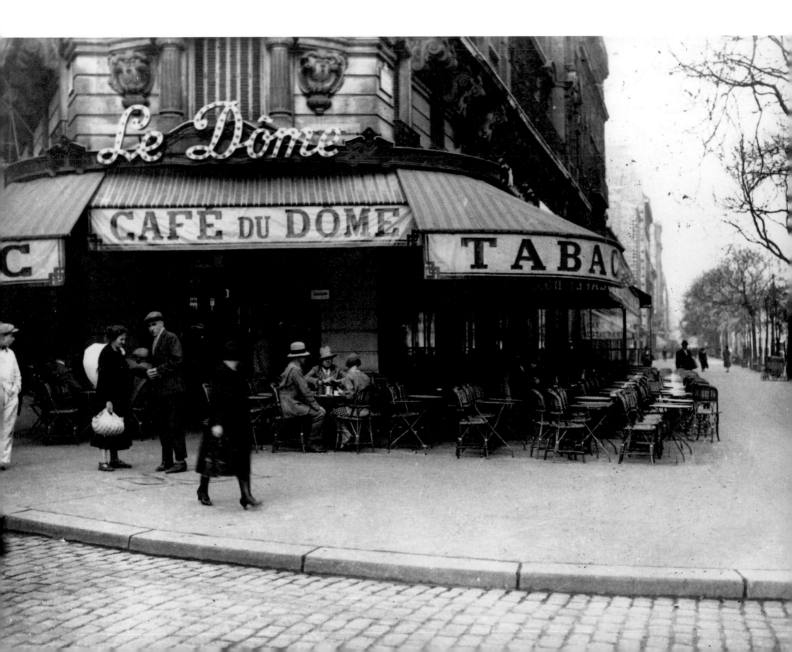

against the attacks made by a prudish public egged on by the academic establishment. Epstein was to remember bitterly that Auguste Rodin refused to support him, which proves that, at the time, a generation gap existed between the artists. The great older generation, Rodin, Medardo Rosso, Claude Monet, Auguste Renoir, Emile-Antoine Bourdelle, Pierre Bonnard, who had nevertheless suffered the same humiliations in their time, kept themselves aloof from the discussions: the latest art trends had passed them by.

The split between academic art and avant-garde art, which appeared at the time of Gustave Courbet and Edouard Manet, only widened with time. Even before 1900, a mutual feeling of contempt reigned between the Nabis and the Neo-Impressionists on the one hand and the academic artists and socialites on the other. When reminiscing about his first stay in Paris in 1902, Epstein wrote:

The time that I was in Paris was a most interesting one artistically. The rebels were just beginning to gain recognition at the expense of the Academicians, but the victory, which was soon to be absolute, was by no means complete yet. I well remember the veteran Bouguereau, who was symbolical of Academic art to such an extent that Cézanne, in his lamentations, referred to 'le salon de Bouguereau', being helped by two admiring pupils, almost overcome with the honour, into a chair when he came to Julian's to criticise the drawings. The time that I was in Paris saw the first and the finest Salon d'Automne, and introduced Gauguin and Van Gogh to a wider circle.[2]

Bouguereau, the master 'pompier', died in 1905 and Cézanne, his antithesis, followed him several months later; but, while the Neo-Impressionists began to be accepted, the salons drew larger crowds than ever. This phenomenon was of inestimable importance. The walls of entire rooms were densely hung with pictures from floor to ceiling (the practice of giving paintings space to breathe is fairly recent) and packed with members of the public, art lovers and journalists.

It was against this backdrop that the Salon d'Automne of 1905 ushered in a revolution. Several paintings hanging next to each other on the wall fairly seethed with

PARIS 1905–1915/SERGE FAUCHEREAU

colour. A journalist ironically dubbed them Fauves (wild beasts). This was not a flattering description but the artists so designated eventually appropriated it. The poets who were shortly after to champion the most innovative styles of art were still too young to have a platform: in any case, their voices would have done little against the negative publicity directed at these artists by hundreds of thousands of copies of *L'Illustration*. The affair was important because *L'Illustration* was one of the publications that dictated public opinion in Paris, the provinces and beyond. On 4 November 1905, the magazine, which claimed not to be taking sides, reproduced several paintings from the Salon d'Automne with extracts from the press. Readers were therefore faced with a page of painters considered to be acceptable (Cézanne, Vuillard, the not-so-audacious Charles Guérin and Alcide Le Beau and finally, with a touch of irony, Henri Rousseau) and a page of 'Fauves': Matisse ('who had strayed with others into brightly coloured eccentricity'), Derain ('virulent imagery', 'facile juxtaposition of complementary colours', 'an intentionally puerile style of art'), Rouault ('the soul of a Catholic and a misogynist dreamer', 'a caricaturist's window') as well as those treated less severely, Louis Valtat, Henri Manguin and Jean Puy whose Fauvism was more moderate. Marquet, Dufy, Camoin or Van Dongen were not even deemed worthy of mention. In fact Fauvism was more a question of atmosphere than distinctive individual characteristics.

It was not long before the journalists discovered an even more 'puerile', more 'virulent' and more 'eccentric' genre of art: what they were to call disparagingly Cubism, as well as several independent artists who could not easily be categorised: François Kupka, Marc Chagall, Jules Pascin, Modigliani and sculptors like Brancusi, Gargallo, Lehmbruck and Zadkine. This time, public opinion was less outraged because the confrontation developed gradually in private galleries rather than in the salons (the galleries of Vollard or Kahnweiler, for example) and particularly because the artists were now backed by articles written by fervent supporters like Apollinaire and André Salmon. So, whereas the Fauves did not deign to explain themselves, the Cubist generation who

were more cerebral in their approach made much use of articles and seminars; this included Léger, Delaunay, Duchamp-Villon, André Lhote and, of course, Albert Gleizes and Jean Metzinger who published *Du Cubisme* in 1912 — printed by the same Editions Figuière run by their friend Jacques Nayral that published Apollinaire's *Les Peintres cubistes* the following year.

Cubism was initiated in Pablo Picasso's studio in 1907, and then in that of his friend Georges Braque. It was in part a reaction against Fauvism, which was a lyrical movement, glorifying a liberal style of drawing and use of colour. By contrast, there is an austerity about Picasso and Braque's Cubism, where the emphasis is placed on the structure of the painting, and the decomposition of the subject into a multitude of planes which reject traditional perspective. 'An object has no absolute form,' proclaimed *Du Cubisme*, so 'the act of moving round an object to capture it from several successive aspects which, combined to form a single image, recreate it in lived time, will no longer incense rationalists'. That the painting exists in 'lived time' is a reference to Henri

Bergson who stated in *L'Evolution créatrice* (1907): 'Lived time will prove to be what it is, continual creation, the uninterrupted outpouring of novelty.' But *Du Cubisme* was primarily referring to non-Euclidean geometry. In *Les Peintres cubistes*, Apollinaire was to push the argument even further by suggesting a fourth dimension. Although the issue did not interest Picasso and Braque, it was debated with gusto in the home of the Duchamp-Villon brothers and by the friends of Severini and Rivera. But the first person to capitalise on it, on the margins of Cubism, was Kupka. After years of research into various domains such as political illustration, Fauvist colour, mathematics, astronomy, the physical and natural sciences, Kupka had decomposed the space of the painting in order to give it a specific duration. As H. G. Wells's illustrator from 1905, it is possible that he may have regarded time, like the mathematician Hermann Minkowski, as a fourth dimension and hence the painting as a time machine. Whatever the case, he was the first artist to present two radically abstract paintings entitled *Amorpha* at the Salon d'Automne of 1912. Sub-titled *Fugue*, they suggested a musical or colour chromaticism; but again

PARIS 1905–1915/SERGE FAUCHEREAU

below

FRANÇOIS KUPKA

Fugue à deux couleurs et pour

Amorpha, chromatique chaude

1911

Oil on canvas 85 × 128

Centre Georges Pompidou, Paris.

Musée national d'art moderne.

Don de Eugénie Kupka

right

PABLO PICASSO

Bottle on the Table 1912

Charcoal and newspaper on paper

62 × 47.5

Fondation Beyeler, Riehen/Basel

these developments were ridiculed by the general public.

With Cubism, the painting was no longer a window onto the real world, but a world in its own right, an object. On that basis, the use of pasted paper and the collages of Braque and Picasso were inevitable. This was a major invention which attracted artists like Juan Gris, Gino Severini and Henri Laurens, who with either a sparing rigour or baroque profusion used materials chosen deliberately for their humble origins: pieces of cardboard, wallpaper, newspapers, cigarette packets or any other item salvaged from urban life.

Like Fauvism, Cubism was not an organised movement. No one was compelled to follow Braque and Picasso. Roger de La Fresnaye, Souza-Cardoso, Auguste Herbin or Mondrian were certainly Cubists but essentially independent in their approach and rather solitary artists. Léger and Delaunay regarded colour as an element of research whose importance equalled that of the painting's structure and Delaunay called his own brand of dissidence simultanism. With Severini and Soffici, who lived in Paris, Italian Futurism represented more than a splinter movement which found dynamic expression in its consideration of the ideal. Above all, it is important to consider to what extent sculpture was challenged by the painters Matisse, Derain and Picasso, who produced pieces themselves, as well as by the great sculptors. Archipenko, Csaky, Duchamp-Villon, Lipchitz, Laurens, Zadkine and perhaps Freundlich can easily be linked to Cubism; but, even if they did not ignore the movement, Brancusi, Gargallo or Lehmbruck were hard to

PARIS 1905–1915/SERGE FAUCHEREAU

JUAN GRIS

Bottle of Rosé Wine 1914

Mixed media on canvas

44.5 × 26

Private Collection

PARIS 1905–1915/SERGE FAUCHEREAU

GINO SEVERINI

Still Life with the Newspaper

'Lacerba' 1913

Paper, gouache, crayon, charcoal,

chalk and Indian ink 72.3 × 57.5

Musée d'Art Moderne, Saint-

Étienne. Dépôt F.N.A.C. Paris

categorise. The same might be said of the distinctive paintings by Modigliani, Pascin or Chagall.

Picasso, Van Dongen, Gris, Salmon, Herbin, Freundlich lived together or one after the other at the 'Bateau-Lavoir' in Montmartre, in the north of Paris. The tenants at 'La Ruche' (The Beehive), a complex in Montparnasse were Léger, Chagall, Archipenko, Lipchitz, Modigliani and Zadkine. Cendrars, Léger and Metzinger used to meet at the house of Robert and Sonia Delaunay. The Duchamp-Villon brothers (Jacques, Raymond and Marcel) and their neighbour Kupka invited friends to their suburb of Puteaux: Gleizes, Marcoussis, La Fresnaye, Reverdy… and so on. Personal affinities were much stronger than mother tongues and native cultures, much more binding than artistic concepts even if they were new. And innovation was largely synonymous with the rejection of academicism. The common denominator linking artists as dissimilar as Léger and Pascin, Rouault and Herbin, Chagall and Marquet, was their rejection of all the genres that delighted the pillars of society: the classical genre, historical painting, allegory, society portraiture, traditional religious subjects, in other words all the conventional styles of art that can still be seen at the Musée d'Orsay. Not all genres were blacklisted, however. These artists were merely rejecting grandiloquence and pathos. It would have been a tragedy indeed to see Matisse or Braque turn their back on still lifes; with *Musical Instruments and Skull* (1914), Picasso composed a traditional vanity – the war, obviously, was imminent. They did not neglect the human figure either. In search of something other than photographic similitude, Fauves and Cubists produced many

striking portraits, as did Modigliani or Chagall and the sculptors; good examples are the masks by Gargallo or by the lesser known Agero. Whether it appeared in the work of Picasso or Chagall, the nude was a study in form, devoid of the genre's conventional use of flattery. When there was a certain eroticism involved, such as *La Toilette* by Pascin, this was done with candour. A re-examination of the art of this period shows clearly that it turned a keen eye on its milieu without attempting to idealise it.

This milieu had changed since the time of Corot and Courbet and even Manet. There was no longer anything bucolic about the landscape. Certainly, artists still painted the countryside, the areas around Paris and the villages where Parisian artists liked to take holidays – Céret, Collioure, L'Estaque, Senlis, Chatou, etc. – but they were more interested in views of ports (Raoul Dufy, Braque and Othon Friesz were raised in Le

PABLO PICASSO

Musical Instruments and Skull

1914

Oil on canvas 43.8 × 61.8

Donation Geneviève et Jean

Masurel, Musée d'art moderne de

Lille Métropole Villeneuve d'Ascq

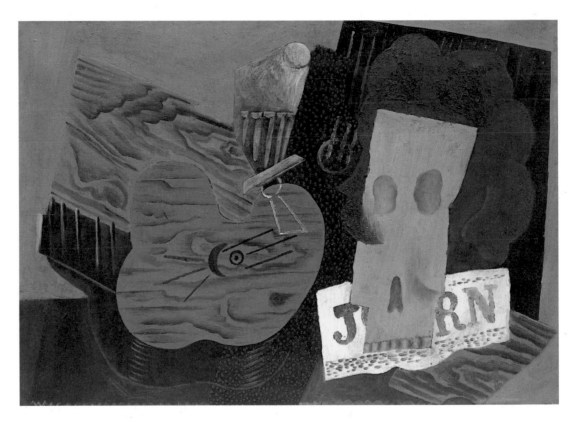

Havre), views of factories, bridges and crowded streets, canals and industrial quays where boats inspired dreams of distant lands and colonies. They obviously had other loves than Paris and it is significant that several of them, like Derain, were very enthusiastic about London, but Parisian life, the Parisian milieu served as a unifying thread. Their works provide a glimpse of their inexpensive pastimes (the clowns and tumblers of the circus, the musicians and dancers of the music hall, sport) and particularly the cafés, which are the symbol of Paris: bottles and glasses, tobacco, newspapers, advertisements, card games, musical instruments, even the traditional dish 'Pigeon and peas' in a painting by Picasso! The actual city is still there, the Eiffel Tower looms through a window by Delaunay or in the corner of a cityscape by Marquet; and even Braque, of all the Cubists the least interested in picturing the urban landscape,

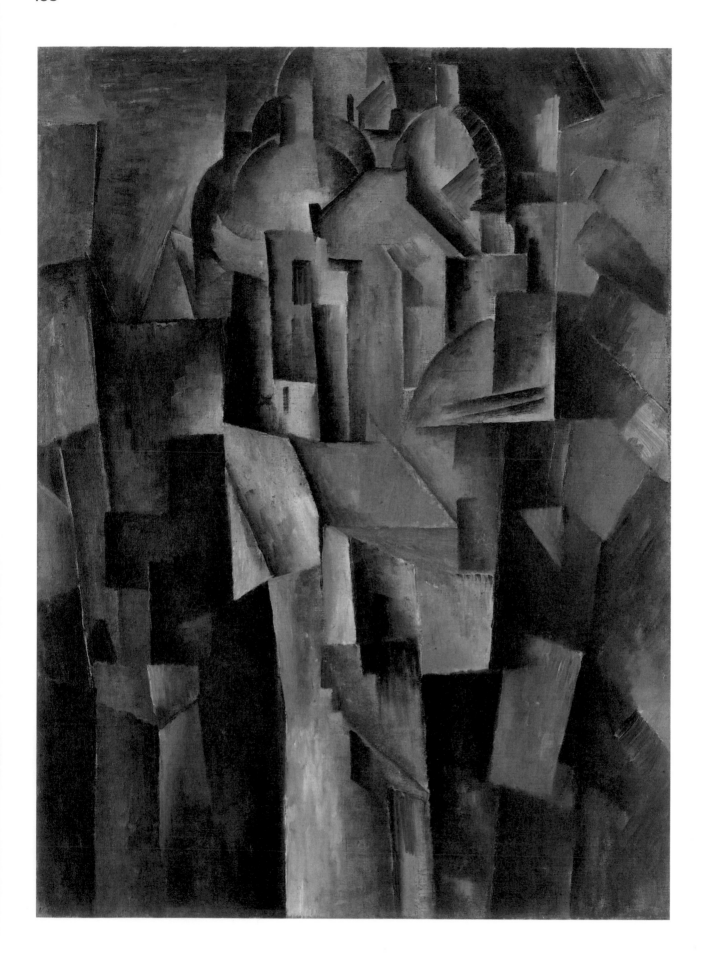

PARIS 1905-1915/SERGE FAUCHEREAU

the Sacré-Coeur.

The young artists were sociable. Convinced that the cafés and studios did not provide a sufficient forum for their ideas, the most organised among them suggested to the oldest member of the Parisian avant-garde, Matisse, that he start a small academy. This Matisse Academy operated informally from 1907 to 1911, but its historical importance was huge because it influenced an entire generation: Hans Purrmann and Oskar Moll came from Germany, Patrick Henry Bruce from the United States, Jon Stefansson from Iceland and a large number of Swedish and Norwegian artists from the Scandinavian peninsula: Nils Dardel, Isaac Grünewald, Sigrid Hjerten, Einar Jolin and Per Krohg, Henrik Sorensen, Jean Heiberg, Ludwig Karsten, Axel Revold. All these painters took something of Matisse's, even Picasso's, Paris back to their own countries.

One of the few revolutionary events in the field of architecture and decoration in Paris at the time was a collaboration between some twelve friends. Unfortunately only a few vestiges remain of the Cubist house exhibited to great derision at the Salon d'Automne of 1912. The architectural project was the work of the sculptor Duchamp-Villon and the decorator André Mare. Hostility was mainly directed at Duchamp-Villon's highly Cubist façade and decorative elements. For the remainder, so far as can be seen from the few surviving photographs, the furniture by Mare, the décor by La Fresnaye and Maurice Marinot, the tea set by Jacques Villon and particularly the paintings by Marie Laurencin were fairly restrained. It was not until after the war that architects like Mallet-Stevens applied the lessons learned from this project.

Not all these collaborative ventures were rejected by the public, as can be seen by the impresario Sergey Diaghilev's Ballets Russes company, which was formed in Paris in 1909 – even if performances included such *succès de scandale* as Debussy's *L'Après-midi d'une faune* in 1912 and Stravinsky's *Rite of Spring* in 1913. Paris was swiftly won over by the expertise of dancers and choreographers like Nijinsky and Fokine and the novelty of the costumes and stage sets of Léon Bakst and Alexandre Benois. The most successful productions included *The Firebird* (1910) and *Petrushka* (1911) to music by Stravinsky, and *Daphnis et Chloé* (1912) to music by Maurice Ravel. The arrival of Natalia

Gontcharova and Mikhail Larionov gave a new lease of life to productions that included *The Golden Cockerel* (1914) and *Midnight Sun* (1915) to music by Nikolai Rimsky-Korsakov.

Among the elements that gave Parisian intellectual life its dynamic thrust and brilliance were several magazines which played a crucial role. First and foremost was *Les Soirées de Paris* (1912–14), founded by Apollinaire and his friends, which, as well as including poems by Max Jacob and Blaise Cendrars, reproduced and defended a variety of works by Léger and Maurice de Vlaminck, Archipenko and Rouault. Rivalry with the painters prompted F. T. Marinetti to write his 'mots en liberté' (words in freedom) and Apollinaire his 'calligrammes'. At the same time, several collaborations resulted in books where the combination of typography and illustration, and the combination of the texts themselves, render them masterpieces of the artistic book: Apollinaire with Dufy or Derain, Max Jacob with Picasso, Cendrars with Sonia Delaunay, Reverdy with Gris and Laurens.

This brings us to a phenomenon which has been largely neglected by the history of art to date: the number of illustrated periodicals, which were already numerous in the late nineteenth century, soared during the first years of the new century. They were very diverse: although the *Courrier français* or *Cocorico* were ironical and critical in tone, most of them owed their success to their French-style light-heartedness: *Le Rire*, *Fantasio*, *Le Frou-Frou*, *La Vie parisienne*, *Le Cri de Paris*, *Le Sourire*, *L'Indiscret*, etc. The *Bonnet Rouge* delivered biting satire while *L'Assiette au beurre* and the *Canard sauvage* could be overtly anarchist when the text was by Alfred Jarry, say, and the illustration was by Kupka. Many artists, motivated occasionally by conviction but more often by sheer enjoyment and financial consideration, provided these magazines with drawings; indeed this was how some of the great future engravers like Jacques Villon, Louis Marcoussis or J. E. Laboureur developed their practice. A glance at the list of regular contributors to L'Assiette au beurre is impressive: special editions were produced entirely by Kupka, Van Dongen, Villon, Soffici, Juan Gris, Valloton, Marcoussis. Marcel Duchamp offered his drawings, on the other hand, to *Le Rire* or *Le Courrier français*. There were even several illustrations by Picasso in *Le Frou-Frou*.

Although Marcel Duchamp and Francis Picabia are usually associated with Dada and Surrealism these tendencies are already nascent in this period. Before 1914 Duchamp produced a small number of more or less Fauvist or cautiously Cubo-Futurist canvases. Picabia, a painter who was on the contrary very prolific, having worked his way through Neo-Impressionism, Fauvism and Cubism, also became one of the major exponents of Dada, with which his name continues to be linked. Similarly Giorgio De Chirico, at the time only admired by Apollinaire, whose disturbing representational style was already Surrealist in spirit. Whatever the case, the three latter artists, in 1915, left France, like Diaghilev and his ballet company. The illustrations and texts published in the magazines were controlled by the censors. Most of the painters and writers were also called up for active service or had voluntarily enlisted on one side or another in a war which we now know was to last for a very long time.

Perhaps partly as a reaction against the 'grand machines' of academic paintings, the Fauves and the Cubists deliberately did not paint large canvases, with the exception of

PARIS 1905–1915/SERGE FAUCHEREAU

the elderly Matisse. One canvas therefore worth noting here, because of its size and its
subject is The *City of Paris* (1910–12) by Delaunay. This painting is an explicit tribute to
Paris in the guise of three naked women, three graces who were moreover taken from a
Pompeian fresco, a copy of which was owned by the artist. There is no eroticism in the
painting, as the faces are as harsh as those of Picasso's 'Negro' period and the bodies
are decomposed into various planes and masses. Although he wanted to use the theme
of the Three Graces to establish a link with tradition, this modern painter was above all
keen to bring in the real world; he therefore surrounded his Parisian graces with
recognisable signs, like a summary of his previous works: to the right, stands the city
and its beloved Eiffel Tower refracted in the light and, on the left, are various buildings
and Notre Dame near the Seine. A boat lies alongside the quay, and for those in the
know, this boat was an exact copy of the one which features in a self-portrait by his friend
Henri Rousseau. There is, of course, a boat in the coat of arms of Paris: *Fluctuat nec
mergitur...* The old city sails on.

Notes

1 Blaise Cendrars, 'La Tour
 Eiffel', in *Aujourd'hui*, Paris
 1931, p.138.
2 Jacob Epstein, *The Sculptor
 Speaks*, London 1931, p.15.

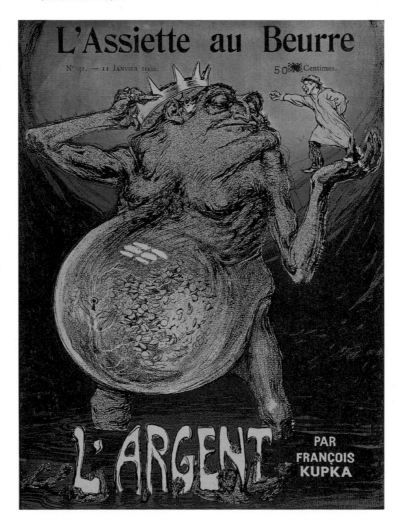

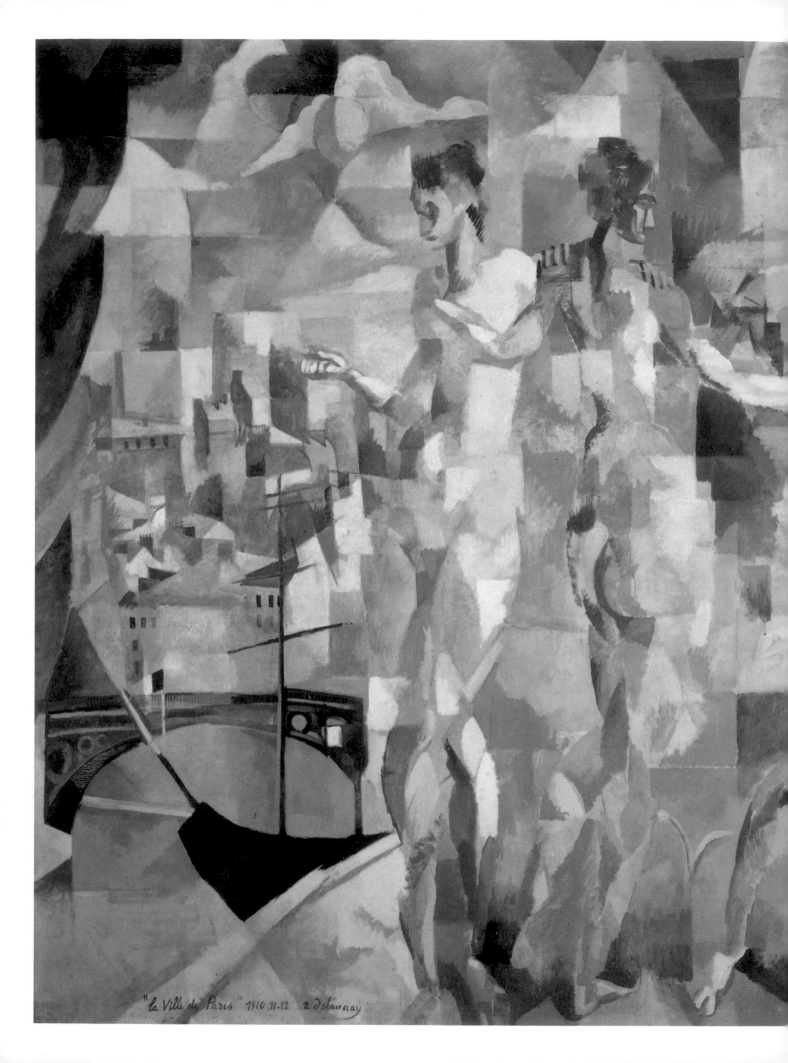

"La Ville de Paris" 1910-11-12 R. Delaunay

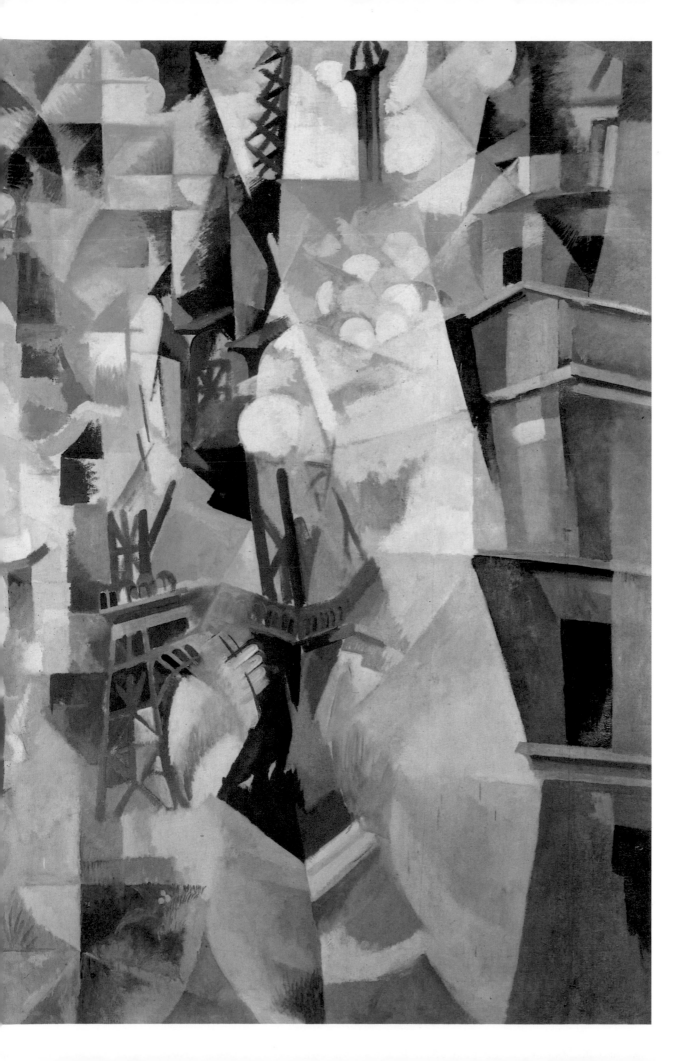

1905

THIRD *SALON D'AUTOMNE* EXHIBITION AT THE GRAND PALAIS, WHERE THE TERM *LES FAUVES* (WILD BEASTS) IS COINED

ALBERT EINSTEIN PUBLISHES HIS SPECIAL THEORY OF RELATIVITY

1906

THREE ESSAYS ON THE THEORY OF SEXUALITY BY SIGMUND FREUD

LAW OF SEPARATION OF CHURCH AND STATE PASSED

DANIEL-HEN KAHNWEILER GEORGES BR CUBIST PAIN REJECTED B *SALON D'AU*

HENRI MATISSE PUBLISHES *NOTES OF A PAINTER*

1909

FUTURIST MANIFESTO PUBLISHED IN MILAN AND PARIS BY FILIPPO MARINETTI

GEORGES SOREL PUBLISHES *REFLECTIONS ON VIOLENCE*

SERGEI DIAGHILEV FOUNDS THE BALLETS RUSSES

CLEMENCEAU'S GOVERNMENT REPLACED BY ARISTIDE BRIAND'S

CATASTROPHIC FLOOD

1910

LOUIS BLÉRIOT FLIES ACROSS THE CHANNEL

WILHELM UHDE SHOWS PICASSO'S WORK IN HIS GALLERY

PARIS

CONSTRUCTION OF THE SACRÉ-COEUR IS COMPLETED (BEGUN IN 1874)

DU CUBISME PUBLISHED BY JEAN METZINGER AND ALBERT GLEIZES

CUBISTS AT SALC SECTION

FIRST ISSUE OF THE MAGAZINE *LES SOIRÉES DE PARIS*

THE FUTURISTS EXHIBIT IN PARIS AT BERNHEIM-JEUNE

PUBLICATION OF *TIDINGS BROUGHT TO MARY* BY PAUL CLAUDEL

ALEXIS CARREL RECEIVES THE NOBEL PRIZE FOR DEVELOPING A METHOD OF SUTURING BLOOD VESSELS

1913

BALLETS RUSSES PERFORM *PRELUDE TO THE AFTERNOON OF A FAUN* BY DEBUSSY

GUILLAUME APOLLINAIRE PUBLISHES *ZONE*

GENERAL JOSEPH JOFFRE MADE COMMANDER-IN-CHIEF IN MILITARY SHAKE-UP

DUCHAMP AND FRANCIS PICABIA LEAVE FOR NEW YORK

ROMAIN ROLLAND IS AWARDED THE NOBEL PRIZE FOR LITERATURE

ON OUTBREAK OF WAR VIVANI FORMS NATIONA UNITY GOVERNMENT

1915

FOUNDATION OF THE FRENCH INSTITUTE OF PSYCHOANALYSIS BY MARIE BONAPARTE

BATTLE OF THE MARNE HALTS GERMAN ADVANCE ON PARIS

RETROSPECTIVE OF PAUL GAUGUIN'S WORK

ALFRED DREYFUS VINDICATED BY
A CIVILIAN COURT OF APPEAL AND
AWARDED LEGION D'HONEUR

RETROSPECTIVE OF CÉZANNE'S
WORK AT THE SALON D'AUTOMNE

1907

DEATH OF PAUL CÉZANNE

GOVERNMENT OF THE RADICAL
GEORGES CLEMENCEAU

PABLO PICASSO PAINTS *LES
DEMOISELLES D'AVIGNON*

TRIPLE ENTENTE BETWEEN
FRANCE, BRITAIN AND RUSSIA

AUGUSTE AND LOUIS
LUMIÈRE INVENT A SYSTEM
OF COLOUR PHOTOGRAPHY

1908

FIRST LONG
DISTANCE
WIRELESS
MESSAGE SENT
FROM THE
EIFFEL TOWER

CREATIVE EVOLUTION
PUBLISHED BY HENRI BERGSON

FIRST FLIGHTS OF
LOUIS BLÉRIOT AND
OF HENRI FARMAN

CUBIST PAINTINGS ARE
EXHIBITED AT THE *SALON
DES INDEPENDENTS*

REVOLT IN AGADIR SPARKS
MOROCCAN CRISIS

BRIAND RESIGNS

1911

GOVERNMENT OF JOSEPH CAILLAUX

BALLETS RUSSES
PERFORM *PETRUSHKA*
BY IGOR STRAVINSKY

MONA LISA IS STOLEN FROM THE LOUVRE

MARIE CURIE RECEIVES
SECOND NOBEL PRIZE FOR
CHEMISTRY FOR ISOLATION
OF PURE RADIUM

BRAQUE DEVELOPS HIS *PAPIER
COLLÉS*

1912

JACOB EPSTEIN'S MONUMENT
FOR OSCAR WILDE CREATES A
SCANDAL IN PARIS

GOVERNMENT OF
RAYMOND POINCARÉ

ANTI-SEMITIC DEMONSTRATION
AT THE COMEDIE FRANÇAISE

SOLO SHOWS BY METZINGER,
GLEIZES AND FERNAND LÉGER
AT BERTHE WEILL'S GALLERY

FIRST VOLUME OF *REMEMBRANCE OF
THINGS PAST* BY MARCEL PROUST

CUBIST PAINTERS BY
APOLLINAIRE PUBLISHED

BALLETS RUSSES PREMIERE
THE RITE OF SPRING BY IGOR
STRAVINSKY IN THE THÉÂTRE
DES CHAMPS-ELYSÉES

FIRST READY-MADE BY MARCEL
DUCHAMP, TITLED *BICYCLE WHEEL*

KEES VAN DONGEN STARTS GIVING
COSTUME BALLS IN HIS STUDIO

FANTÔMAS MASTER OF TERROR
ESTABLISHES THE POPULARITY OF
MOTION-PICTURE DIRECTOR LOUIS
FEUILLADE

AS A GERMAN, KAHNWEILER
HAS HIS GALLERY CLOSED
AND HIS STOCK CONFISCATED

GERMAN DECLARATION
OF WAR AGAINST FRANCE

1914

PARLIAMENTARY ELECTIONS IN FRANCE
SEE A NARROW VICTORY FOR THE LEFT

BRAQUE, DERAIN AND MANY
OTHER ARTISTS ARE DRAFTED
FOR WAR

PREMIERSHIP OF
GASTON DOUMERGUE

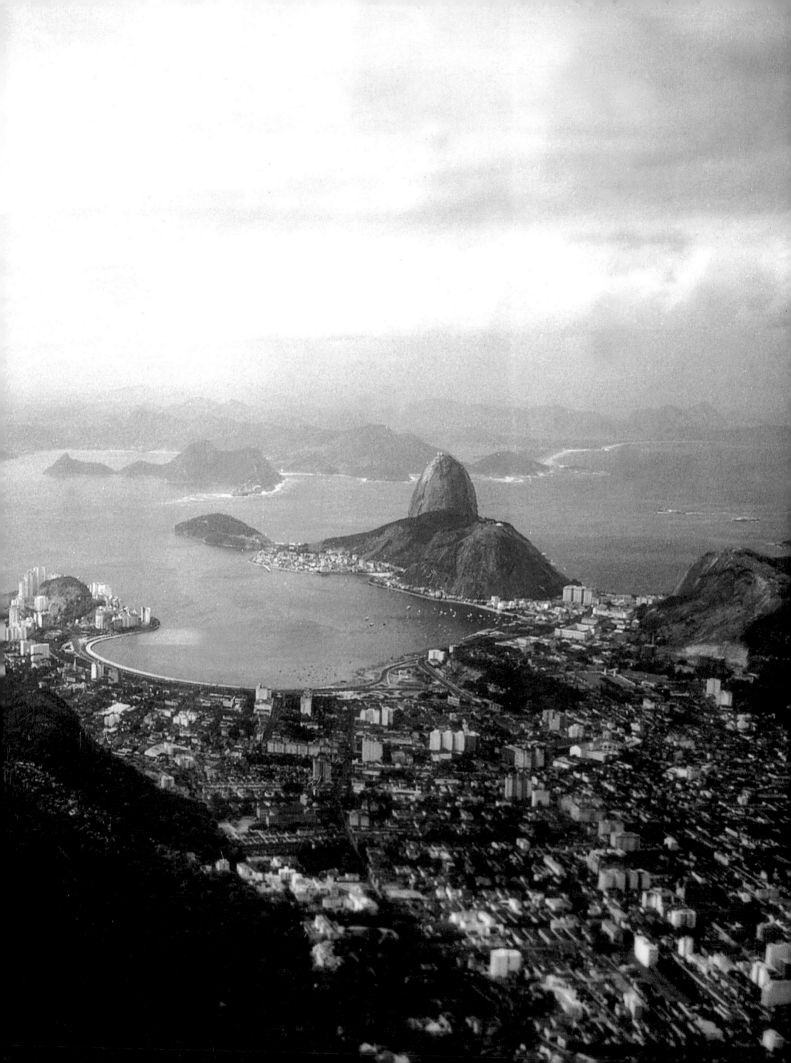

RIO DE JANEIRO
1950-1964

PAULO VENANCIO FILHO

previous page

**A view of the bay and Sugar
Loaf Mountain** *c.*1960

Collection Instituto Moreira Salles

Photograph: Marcel Gautherot

At first, there was only a landscape. A strangely beautiful landscape, characterised by three
unmistakable cliffs: on the sea coast, Gávea Mountain; at the entrance of the bay, Sugar Loaf
Mountain; and, on the cove, Mount Corcovado.
Lúcio Costa

Freshly arrived from Europe in 1919, the fourteen-year-old Lúcio Costa – who would later
pioneer Brazilian modern architecture, and in 1957 design Brasília, the country's new
capital – so described the unique landscape of Rio de Janeiro. Though Rio was to change
considerably in the ensuing decades, the horizontal curves of its beaches and the
vertical lines of its mountains continued to pervade Costa's vision. Decades later, the
architect expressed the city's 'definitive confrontation, the permanent tension which,
viewed from the top of Sugar Loaf Mountain or Corcovado, is sometimes suffused with a
dramatic beauty: the overlapping of two profiles, one man-made and one natural'. This
fundamental relationship, in which the construction of the urban environment follows the
form of – and increasingly prevails over – the natural environment, identifies and
characterises the city as a unique urban milieu.

The natural environment still determines one's first impressions of the city and
influences the behaviour of its inhabitants. Along the coast, dented by the bay and
surrounded by a natural barrier of mountains, Rio immediately impressed those who
arrived by ship and saw, right at the bay's entrance, the huge blocks of sheer granite of
contrasting sizes that the anthropologist Claude Lévi-Strauss compared to a toothless
mouth. As the city grew, from a colonial sugar cane plantation to a busy nineteenth-
century trading post, and into a metropolis with 2.5 million inhabitants in the 1950s, it
followed the contours of the natural environment, expanding along the beaches and
crawling up the mountainsides, blending into the curves of the land. The presence of the
sea, the activities of the port and the beach resort, and the line of the horizon in the
distance have always been integral parts of the lives of the inhabitants of a city with the
characteristics of the Portuguese colonisers, who, like crabs, never ventured very far into
the hinterland; the inhabitant of Rio is by nature a seasider.

right

AMÍLCAR DE CASTRO

Untitled *c.*1960

Iron 101 × 136 × 128

Museu de Arte Moderna do Rio de
Janeiro

Photograph: Pedro Franciosi

far right

LYGIA CLARK

Beast *c.*1963

Aluminium 100 × 100 × 45

Eugênio Pacelli Pires dos Santos

RIO DE JANEIRO 1950–1964/PAULO VENANCIO FILHO

The city's natural environment may be considered a structural element in the formation of its various social milieux. Whether one lives near or far from the beach, high in the hills, in a favela, a working-class suburb, or a middle-class district, each specific location implies a given kind of urban experience, all of which are non-exclusive and complementary. This makes Rio a porous city, inimical to formalities, marked by capillarity and transversal mobility, and by somewhat flexible social hierarchies. The natural environment of the city offers itself to everyone indiscriminately and suffuses the inner urban experience of its inhabitants. This determines a characteristic form of coexistence, as if the adaptability between the man-made and the natural were extended onto the social plane, implying easygoing relations between races, classes and cultures, with nature acting as an amiable mediator between individuals. Carnival, Rio's major popular feast, is a momentous inversion of social hierarchies. Rio, as Brazil's capital, is the stage of social and political tensions, yet social violence has never established itself as a permanent conflict. Violence in the 1950s was more encapsulated by popular renegades like Micuçu whose tragic life inspired a poem ('The Burglar of Babylon' – Babylon a famous favela in Copacabana) by the American poet Elizabeth Bishop who lived in Brazil in the 1950s, and Cara de Cavalo to whom Hélio Oiticica dedicated a famous work.

Since becoming the capital of Portuguese Brazil in 1763, Rio has been Brazil's most cosmopolitan city – economically, culturally and socially. In the 1950s Rio was the site of the country's adaptation to modern conditions of existence in the post-war world. The modification of traditional conduct and customs, and the liberation of new energies, meant that, within a short period of time, city life was affected in a way that, paradoxically, both modified and reinforced Rio's urban characteristics. The intense and

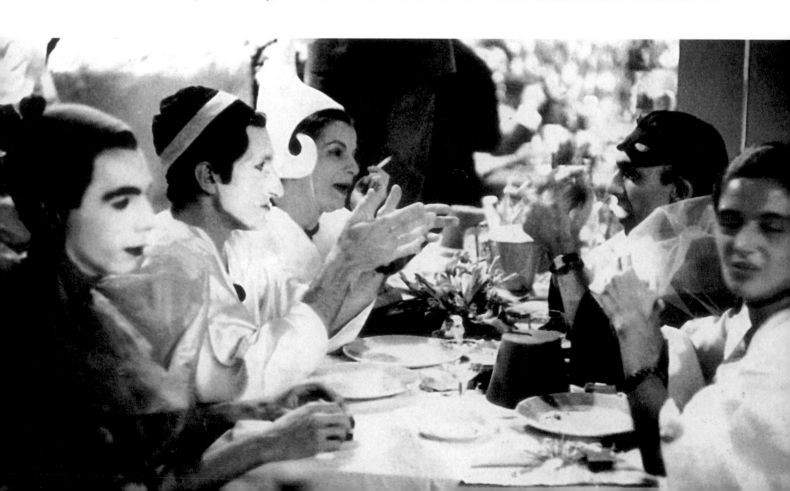

constant contact with the sea was gradually transformed and intensified; the turning point came in 1950s, when a new way of being, open, vivid and spontaneous, replaced the sober and melancholy culture of Europeans exiled in America, to whom the ocean was not something to be lived with but rather an allegorical and physical obstacle to civilisation and culture. Brazil was finally leaving behind the colonial mentality, the slaveholding past, the atavistic patriarchalism and the rural lyricism, and metamorphosing into a modern society, anxious to overcome its contradictions and backwardness. With this open, self-confident, optimistic spirit Rio became a world metropolis, and the arena for a cultural and artistic explosion.

The period of development that began during the Second World War radically changed the identity of Brazil. People flocked to the cities, particularly to Rio and São Paulo, and within a few years what had long been an agricultural country became urbanised and industrialised. The state led the way in this process: the extremely popular President Juscelino Kubitschek (1956–61), who was called 'President Bossa Nova', launched his famous quinquennial plans which set out to achieve in five years what usually took fifty. With its slogan 'Energy and transport', his government initiated important infrastructure projects – roads, hydro-electric plants and, most daring and controversial of all, the building of a new capital, Brasília. For the first time, modernity and innovation became concrete and visible.

A new spirit of optimism manifested itself in Rio de Janeiro in the 1950s. For the first time in Brazilian history, life was led by, and for, young people. The neighbourhood of Copacabana, and its world famous beach, became the symbol of this new lifestyle. The sun, the beach and the tropical enviroment were seen through a more liberal ideology that gave urban experience a new meaning. Copacabana, with its bars, nightclubs, hotels and theatres, became Rio's social and cultural centre; and, with its Hollywood glamour, it became the tropical town Europeans and North Americans had dreamed of. Brazil's first ever World Cup victory in 1958 was equally important as a boost to national self-esteem. In this championship, Pelé – the all-time greatest football star, only seventeen years old at the time – became world famous. This major conquest gave Brazilians the sense of self-confidence that comes with world-class major sports feats in modern times.

Hélio Oiticica, Jean Boghici, Lygia Clark, Ferreira Gullar and Tereza Aragão, Carnival 1961
Ferreira Gullar personal archives

During the 1950s an enlightened and anti-provincial cultural spirit was irreversibly established in Brazil. This manifested itself in what was called the 'constructive will', meaning the use of modern technical, scientific and artistic procedures to solve the problems of an underdeveloped country, which emphasised the importance of planning and designing for the future. Emancipated from the Positivist belief in science, the 1950s saw the maturation of an intellectual consciousness quite different from the one that had prevailed since colonial times, founded on belles-lettres and legal knowledge. The authority of technical knowledge, autonomous and socially recognised, became disseminated in Brazil, replacing the old-style culture responsible for a type that had dominated the country for so long: the pompous man of letters (a category which included engineers and doctors).

Brazil wanted to be a new country for a new kind of man, as the sociologist Sérgio Buarque de Hollanda expressed in his book *Raízes do Brasil* (Roots of Brazil) published in 1936: the 'cordial man', who is open, thoughtful, imaginative and affable, friendly

LE CORBUSIER

Ministry of Education and Health 1936

Pencil on paper 30 × 78

Collection Fondation Le Corbusier, Paris

far right

Ministry of Education and Culture *c.*1960

Collection Instituto Moreira Salles

Photograph: Marcel Gautherot

without being sentimental, rational without being mechanical, who avoids formalities, shrinks from harshness and conflict, and prefers to conciliate – the Brazilian fully emancipated from a patriarchal and enslaved past. It was for this new man that Brazilian artists created new architecture, painting and sculpture, literature, music and cinema. The keyword in the names of all the artistic movements of the day was 'new': Neoconcretism in art, Bossa Nova (new wave) in music, and Cinema Novo. The visual arts, popular music, cinema and architecture displayed characteristics that became uniquely Brazilian: economy of means, simplicity of form, emphasis on construction, and the recovery and transformation of the autochthonous past (colonial architecture, baroque art and samba, the popular urban music of Rio).

The past, until then rejected as shameful, now became the object of study and analysis, as well as a source of inspiration. What had, since Brazil's independence from Portugal, been seen as a liability was transformed into a vital asset. Architectural elements characteristic of the colonial period – the cobogó, the muxarábi, the veranda – were combined with the ideas of such architects as Le Corbusier and Mies van der Rohe. Brazil's artistic heritage, dating back to the eighteenth century, was reinvented even as it

was being rediscovered and preserved.

Urban life was transformed by pioneering modern architecture. The invention of reinforced concrete made new construction techniques possible and allowed for the daring structures that characterise the buildings of this period. The city was liberated from the 'parasitic' architectural styles that had previously deformed the sense of a full-blown modernity. The architect was now seen as both artist and technician – a tropical humanist, as one might classify such an extraordinary figure as Lúcio Costa.

The definitive turning point for Brazilian modernity and its later development in Rio de Janeiro was the construction of the Education and Health Ministry building. Designed by Le Corbusier in 1936 and developed by a team of young Brazilian architects led by Lúcio Costa, this building, completed in 1943, was the first example of modern architecture in the Americas. It served as a public assertion of the new spirit in art and the precursor of all that was to come in other spheres of culture. Le Corbusier's association with Rio had begun years earlier: Rio was one of the cities – which also included Buenos Aires, Algiers and Paris – for which he designed large-scale urban projects. On his first visit to the country in 1929 Le Corbusier designed a huge, winding structure, topped by a highway,

RIO DE JANEIRO 1950–1964/PAULO VENANCIO FILHO

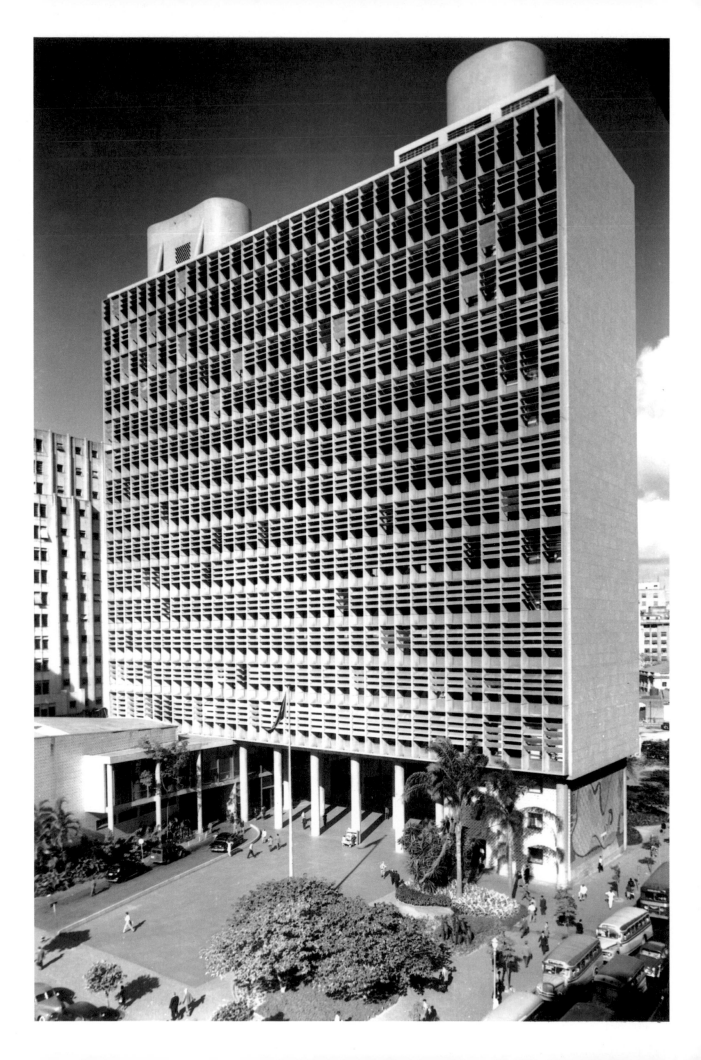

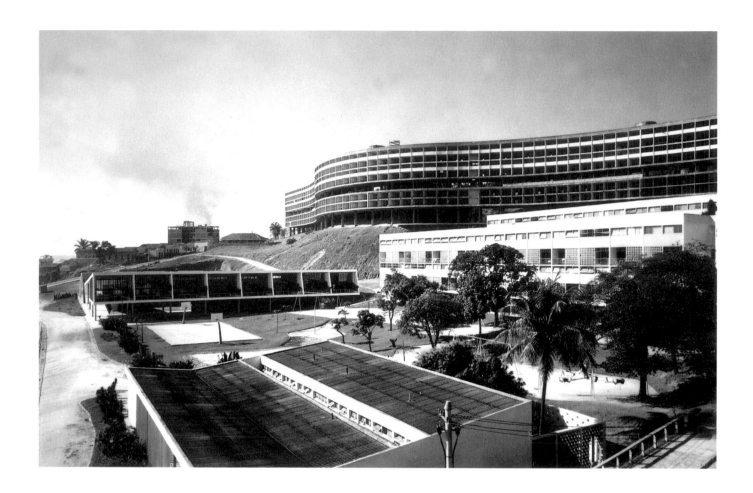

Affonso Eduardo Reidy's

Pedregulho Housing Complex

*c.*1960

Collection Instituto Moreira Salles

Photograph: Marcel Gautherot

that was to follow the contour of Rio's hills and cross the bay all the way to Niterói. The sinuous line of the building captured the symbiosis of landscape and built environment that characterises Rio.

The opening of the Ministry building in 1945 consolidated a series of initiatives, which had to overcome resistance on political, ideological and artistic grounds – nationalism in politics, populism in ideology and academicism in art. Occupying an entire block in the city centre the Ministry building included the basic principles of Le Corbusier's architecture: pillars, brise-soleils, a garden terrace on the roof, a façade free of ornamentation and an open floor plan. The fact that such resources were being employed for the first time in the seat of a government agency was underlined by Lúcio Costa in a letter to Education and Health Minister Gustavo Capanema, an enthusiastic supporter of the project:

> In fact, so far no public building has been built in Europe, in America or in the East with the characteristics of this one now being finished ... in this particular case we are not imitating what has already been done somewhere else, nor are we improvising. We are simply applying, quite consciously, the principles acknowledged by modern architects around the world as fundamental to the new construction technique, even though no government has yet officially adopted them in a project of such magnitude.
>
> Thus we are dealing with an undertaking that will have international repercussion and earn

a place in the history of contemporary architecture. And it was our country that took this definitive step. This is one more significant indicator that our initiatives are no longer dependent on foreign approval.

The Education and Health Ministry Building became the symbol of modern Brazilian architecture that was to spearhead a political effort for change and social emancipation. Soon Rio was transformed by innovative architectural projects: Affonso Eduardo Reidy's bold Pedregulho Housing Complex (1947–58); Lúcio Costa's Parque Guinle (1948–54), an upper-middle-class apartment-building complex employed traditional Brazilian architectural elements in an inventive manner; and Oscar Niemeyer's Canoas House (1953), remarkable for its integration of architecture with the natural setting – the house combines organic shapes with the hills and surrounding tropical vegetation. The Aterro do Flamengo (1962–4), designed by Reidy and the painter and landscape designer Burle Marx, transformed a long stretch of landfill to create what was then the biggest urban park in the world.

In a developing and changing country, the architect's task is to devise housing solutions for entire populations; to give a modern and democratic face not only to public, official architecture but also to private construction; and in Brazil's case to design a new capital for the country – Brasília. Its design, initiated in 1959, is the most significant representative of the great architectural and urban projects of the period. With Chandigarh, designed by Le Corbusier in 1951, Brasília is one of two capitals designed following the principles of modern architecture. Costa designed Brasília as a 'city

Oscar Niemeyer's Canoas House (with the architect in the foreground) *c.*1960
Collection Instituto Moreira Salles
Photograph: Marcel Gautherot

planned for the ordained and efficient labor, as well as a living and pleasant place to be, open to dreams and intellectual speculation, that in time could be not only the country's centre of power and administration, but a meaningful and lucid focus of culture'. However, it is important to understand that Brasília was, above all, the result of concepts, ideas and tendencies generated in Rio.

Cinema Novo, influenced by Italian Neo-Realism and the French nouvelle vague, presented a new view of Brazilian urban life and revisited regional themes with a critical perspective. Nelson Pereira dos Santos's films *Rio, 40 graus* (1955) and *Rio, Zona Norte* (1957) showed everyday life in suburban Rio, and showed personalities like the samba composer in a realistic and lyrical way for the first time. The spontaneous aesthetic of Cinema Novo was best expressed by its slogan: 'A camera in the hands, an idea in the mind.' Made by young, middle-class urban film-makers – most of them from or based in Rio – Cinema Novo was directed at a young, urban, politically-committed audience. Endowed with a violent visual aesthetic, its libertarian ideology captured the imagination of those who confronted the military government which took over after the 1964 coup. Glauber Rocha's film *Terra em Transe* (1967), in which a young poet is tormented by the conflict between freedom of expression and the ideological compromises he must face as an individual fighting injustice and oppression, represents the allegoric and agonist trance of the political ideals of the period torn between reformist populism and revolutionary action.

The radical musical style Bossa Nova consisted of a new kind of syncopation and

above

Brasília, capital of Brazil

*c.*1960

Collection Instituto Moreira Salles

Photograph: Marcel Gautherot

right

Tom Jobim at the piano

Jobim Music Archives

RIO DE JANEIRO 1950–1964/PAULO VENANCIO FILHO

beat, and a natural, unaffected, understated singing style that hardly rose above a spoken whisper. Influenced by samba (the traditional music of Rio de Janeiro) Bossa Nova was a fusion of Brazilian rhythms, cool jazz, and the music of Debussy and the French Impressionists. It resulted in a completely different sound, which required a new kind of auditory perception. Bossa Nova introduced a novel conception of melody, rhythm and harmony that in its clarity, transparency and essentialism represented a musical parallel to Neoconcretist artworks. Tom Jobim's songs 'One note samba', 'Quiet Nights', 'Desafinado', 'How Insensitive' and 'The Girl from Ipanema' proposed a new musical landscape (indeed, they often mentioned Rio's landscape hallmarks). The lyrics of 'Quiet Nights' describe the composer playing his guitar and looking for inspiration in the Corcovado hill he sees outside his window. 'The Girl from Ipanema' was composed by Jobim at a bar where he glimpsed the graceful walk of a girl on her way to the beach. Lyrical and dispassionate, discreet and subtle, almost monochromatic, these songs were the musical equivalents of abstract paintings. One might almost say that Jobim's sambas were not meant to be danced to, and were hardly meant to be heard at all. On João Gilberto's record 'Chega de Saudade' released in 1959 (with songs arranged by Tom Jobim), the artist's syncopated guitar playing and his soft and whispery singing carried the ideal of a constructivist vocalisation to extremes and demanded the most attentive form of listening. Years later, in 1967, when Frank Sinatra recorded an album of Jobim compositions he joked: 'I haven't sung so soft since I had laryngitis.'

In the visual arts an opposition had come to a head in the 1940s, between realism and abstraction. From the ideologically driven perspective of the realists, abstraction appeared evasive and inconsequential; from the traditional standpoint of the Academy on the other hand, abstract art was dismissed as being without artistic merit. These oppositions reflected the nationalist politics of culture in Latin America, whereby art was posited as a vehicle for the enlightenment of the masses; and the power of a cultural tradition whereby mimetic realism still held artistic authority.

The earliest manifestations of abstract art – the Frente group in Rio and the Ruptura group in São Paulo – must be seen in the context of the transformation of the country's economic, social and artistic conditions. The polarisation between Rio and São Paulo, Brazil's two major cities, was heightened in the early 1950s, as São Paulo, attracting manpower from all over the country, became the epitome of the Latin American industrial metropolis.

In 1922 São Paulo had been the stage for the first manifestation of Brazilian modernism, the Semana de Arte Moderna (Modern Art Week) and whose artistic ideology was to be summarised by the poet and writer Oswald de Andrade in the 'Anthropophagic Manifesto' (1928): 'Only anthropophagy unites us. Socially. Economically. Philosophically.' Anthropophagy (literally, 'cannibalism') dictated that Brazil's cultural mission was to devour Europeans, just as the Indians had reputedly dispatched their colonisers. Tarsila do Amaral, the quintessential Anthropophagic painter studied under Albert Gleizes and frequented Léger's studio and went through what she described as the 'military service' of a Cubist phase. Her work portrayed Brazil in an unprecedented way: the lyrical use of the colours used by the poor to paint their houses – pale roses, blues and greens – was structured in her paintings according to Cubist logic,

below

HÉLIO OITICICA

Equal Bilateral (698) 1960

Oil on board. Five pieces, each

54 × 54 × 2

Projeto Hélio Oiticica

right

HÉLIO OITICICA

Fireball Box 9 1964

Oil on wood 55.5 × 24 × 67

Projeto Hélio Oiticica

far right

HÉLIO OITICICA

Bilateral 1959

Oil on wood 112 × 172 × 2

Projeto Hélio Oiticica

so that the contrast between the archaic and the modern in Brazil was expressed in a new visual language. This pictorial formulation was an example of Brazil's modern cultural task. The search for an identity dictated the need to devour the cultural heritage of European civilisation. In 1928 Tarsila painted the fantastic figure of 'Abaporu', a deformed creature, alone and naked, under a glaring sun, surrounded by tropical foliage, who was to become the emblem of the Anthropophagic ideology.

The modernism of 1922 was anarchical and avant-garde, precocious and stormy, tropical and Parisian. Its purpose was to shock modern art in Brazil into existence. But Anthropophagy could not possibly present a long-term solution; cannibalism as a metaphor had limits that were clearly set by the very gesture of abandoning a provincial attitude and facing a conscious modern autonomous destiny.

The creation of the São Paulo Biennial in 1951 was a decisive step towards a more cosmopolitan attitude in art. The Biennial was the first organised attempt to bridge the gap between local artistic endeavours and contemporary trends in European and North American art. It was to have a stimulating effect. The first Biennal sculpture prize was awarded to the Swiss artist Max Bill for his sculpture *Tripartite Unity* (1947/8) and six years later in the fourth Biennal the same prize was awarded to the Spanish sculptor Jorge de Oteiza. This reaffirmed the local abstractionist and geometrical tendencies and

underlined the affinity between the work of Brazilian and European artists. It was also the catalyst for the Constructivist trend represented in Rio by the Frente group – Hélio Oiticica, Lygia Pape, Aloísio Carvão – and in São Paulo by the Ruptura group – Waldemar Cordeiro, Geraldo de Barros, Lothar Charroux and Luís Sacilotto. Formed in 1952, these groups were the first two organised manifestations of non-representational, geometrical art in Brazil. The names Ruptura (Rupture) and Frente (Front) represented the radical nature of the artists' approach.

Athough the Concretists from São Paulo were inspired by the utopian, chaotic and literary nature of the 1922 modernists, their own ideas were set out in the strict programme of the Ruptura Manifesto in which they emphatically declared: 'There is no Continuity!' They established a sharp boundary between 'those who create forms from old principles' and 'those who create forms from new principles'. Once again, the idea of the 'new' was the fundamental issue in question.

Inspired by New York's Museum of Modern Art, a group of bankers, newspaper owners, entrepreneurs and politicians founded the Museum of Modern Art of Rio de Janeiro in 1949. Initially occupying the headquarters of a bank, the museum was moved, most appropriately, to the MES building in 1952. By 1958 the museum finally had its own building, designed by Affonso Eduardo Reidy, in the newly urbanised area of the Aterro do Flamengo. MAM, as the museum has been called ever since, represented the cultural discernment of Rio's progressive elite in providing the city with an institution dedicated exclusively to modern art (which at the time was mostly identified with abstract art). The museum was understood not only as a repository of works of art, but as a living space where discussion and creativity could flourish. It also contained an Art School and a Film Department. The building remained a dynamic meeting place until it was destroyed by fire in 1978; after it was rebuilt it never recovered its influential role in the artistic life of the city.

Soon the divergence between the São Paulo and the Rio Concretists increased and became irreconcilable. The orthodox and dogmatic constructivistic principles adopted by the São Paulo group was rejected, and the inevitable schism gave rise to Neoconcretism in Rio. Marking their definitive rupture with the Concretists, the Neoconcretists organised the first Neoconcrete exhibition at MAM, which had become their headquarters, in 1959. The Sunday supplement of the Rio daily newspaper, *Jornal do Brasíl*, designed by the

sculptor Amílcar de Castro, became the vehicle for Neoconcrete ideas. It was there that the poet and art critic Ferreira Gullar's 'Neoconcrete Manifesto' (1959) and 'Theory of Non-Object' (1959) were published. Early in 1954 Gullar had already published a book entitled *Luta Corporal* (Body Fight) where he renovated Brazilian poetics in a very similar way that Neoconcretism was to renovate Brazilian visual language.

Neoconcretism, a Brazilian reinterpretation of Constructivism, was the country's first fully modern contribution to a universal visual language. Artists Lygia Clark, Hélio Oiticica, Amílcar de Castro, Sérgio Camargo, Milton Dacosta, Franz Weissmann and Lygia Pape were the pioneers of Brazilian constructivism. Reacting against the orthodoxy of Concretism, the group emphasised experimentation and speculation, and the work's active relation to the viewer. This led to the sensorial and participatory creations of Hélio Oiticica and Lygia Clark, praised by the critic Mário Pedrosa as 'an experimental exercise of freedom'.

The Neoconcrete Manifesto opens: 'The term 'Neoconcrete' designates a particular stand taken in relation to 'geometrical' nonrepresentational art (Neoplasticism,

Constructivism, Suprematism, Ulm School) and particularly to Concrete art carried to a dangerous extreme of rationalist exacerbation.' The text also states that 'it must be made clear that in the language of art so-called geometrical forms lose the objective character of geometry and become vehicles for the imagination'. In addition, it discusses what probably is the fundamental issue that concerned the Neoconcrete innovative artistic experience – the problem of space and the spatialisation of the work:

> the phenomenon that dissolves space and form as causally determined realities and turns them into time – into spatialization of the work. By spatialization of the work we mean that the work is constantly making itself present, constantly restarting the impulse that generated it and of which it was the origin. And if this description leads us also to the initial – and full – experience of reality, it is because the intention of Neoconcrete art is precisely to reignite this experience. Neoconcrete art establishes a new expressive space.

While the Concretists cited the Ulm School and Gestalt psychology among their

RIO DE JANEIRO 1950–1964/PAULO VENANCIO FILHO

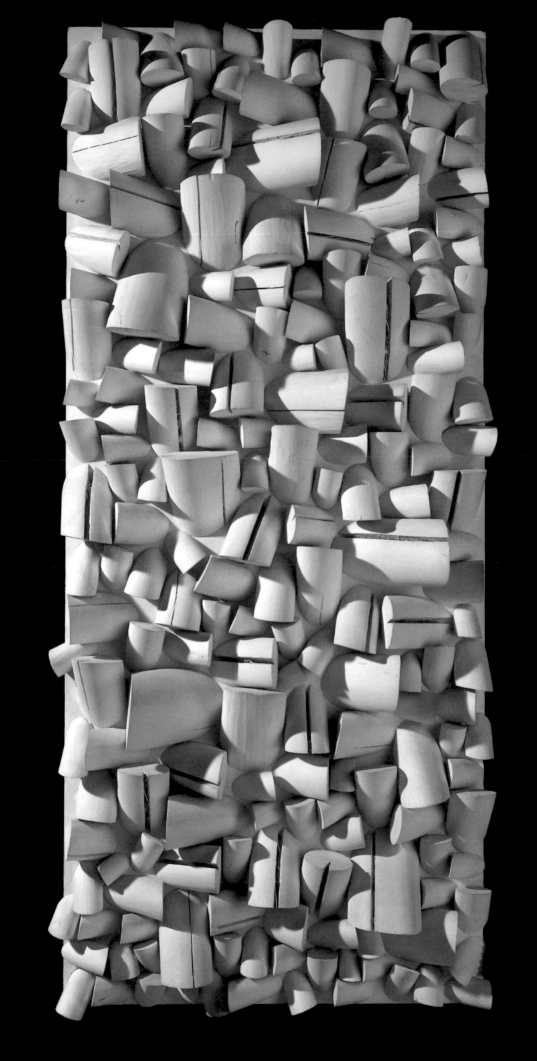

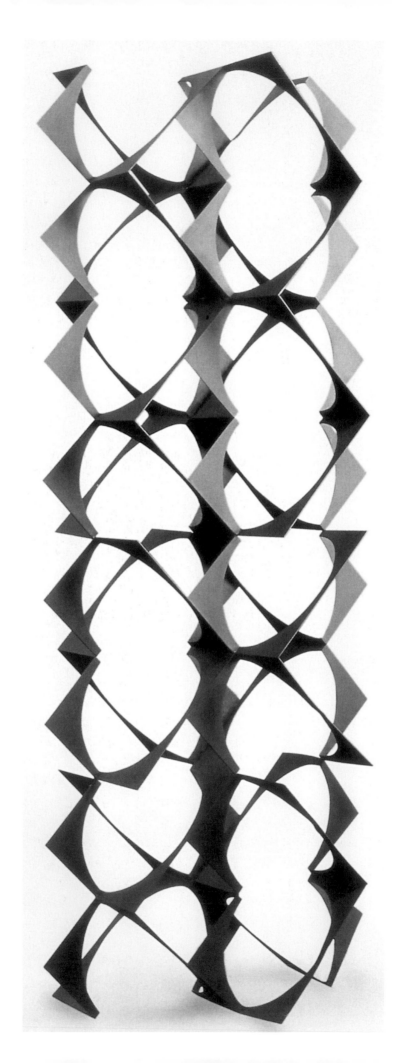

influences, the Neoconcretists were influenced by the theories of the philosophers Merleau-Ponty, Ernst Cassirer and Susanne Langer. While the Concretists stressed the functionalist and socially integrated condition of the work as a product, the Neoconcretists emphasised the process of working itself. This philosophical shift expressed the Neoconcrete emphasis on the phenomenological condition of the work of art, its presence as an existential moment that could not be entirely rational and technically deduced nor integrated as an industrial object. The Neoconcrete work wanted to be at one with space. Every interposition between work and space should be eliminated. The picture breaks with the frame and the sculpture with the base. The Neoconcrete artists' intention was to burst open the isolation of the art work. No longer a representantion of the world, the work became an active part of the world. Surpassing every traditional categorisation, the Neoconcrete work realised its purpose of appearing to the viewer as a pure and original presence.

This understanding of the work as a process characterises Neoconcretism's

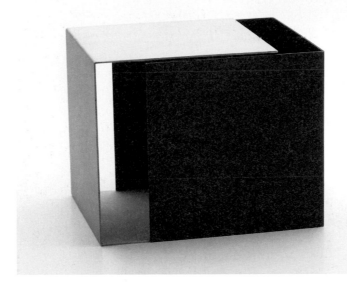

receptiveness to free experimentation. The transforming spirit of the times is evident in the apparently contradictory simultaneity between geometrical universality and the irreducible singularity of its manifestation in the work that is mobilised by the Neoconcrete experience. Milton Dacosta's paintings, Sérgio Camargo's relief, Lygia Clark's counter-relief, Hélio Oiticica's spatial relief, Franz Weissmann's Neoconcrete column, Lygia Pape's *Tecelares*, Amílcar de Castro's sculptures or a photograph by José Oiticica Filho – take on the condition of what Ferreira Gullar called the 'non-object':

> The expression 'non-object' does not intend to describe a negative object nor any other thing which may be opposed to material objects. The non-object is not an anti-object but a special object through which a synthesis of sensorial and mental experiences is intended to take place. It is a transparent body in terms of phenomenological knowledge: while being entirely perceptible it leaves no trace. It is a pure appearance.

This 'pure appearance' identified by Gullar, expresses an anti-materialist

understanding of the work that is oriented in its multiple relations with the world and the viewer. Colour, form, space and time are interchangeable, non-hierarchical components, made to overlap through the subjective experience of the work. The viewer experiences the work and passes on leaving no trace of the exchange, of the mutual relation of consumption. In this way these works represent a manifestation of the elemental and enduring nature of existence.

It is possible to follow the continuity of this artistic process through individual works. A painting by Milton Dacosta of pure blocks of colour suggests a spatialisation that anticipates Hélio Oiticica's boxes of pigment, or *Fireballs* (1963), or his *Monochromatics* (1959). This same sense of spatial expansiveness is also reiterated in Lygia Clark's *Unity* (1959). Weissmann's structures and Lygia Pape's woodcuts, the *Tecelares* (1955), represent a search for transparency; while the emphatic planar dimensions of sculpture can be seen not only in Weissmann's *Neoconcrete Column No.1* (1958) and Oiticica's *Spatial Reliefs* (1959) and *Bilaterals* (1959), but also in works such as Amílcar de Castro's large planar iron structure of 1960. Sérgio Camargo's reliefs express the kinetics of light just as Lygia Clark's *Beasts* (*c.*1963) express the dynamic variability of form. Thus through the individual works of every artist, Neoconcretism proposed its own

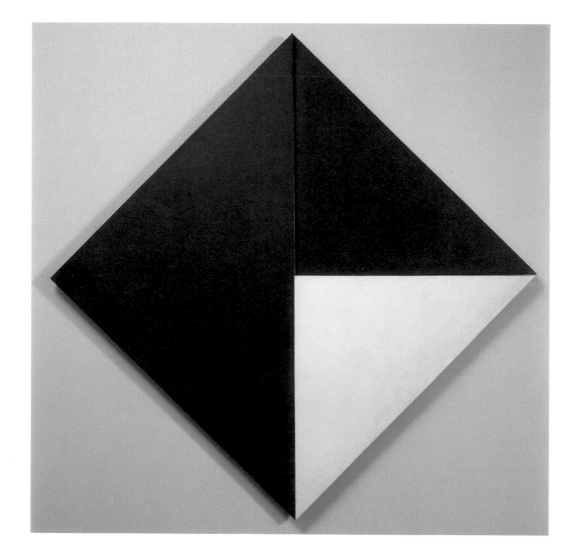

RIO DE JANEIRO 1950–1964/PAULO VENANCIO FILHO

unique system of sensitive co-ordinates for grasping the modern artistic experience.

Transcending movements, groups, manifestos or theories, a modern spirit characterised Rio and Brazilian culture in the 1950s which was inspired by the urban experience, gained expression through a particular poetics and determined an entire world-view. In an era of cosmopolitanism, Brazilians seemed wholly at ease with the modern world, having made their own statement about modernity – the ability of a society to co-exist with the city built in the tropics was the manifestation of a modern mindset and modern conditions. Having overcome the colonial condition characterised by Europeans banished from the West and transplanted to America, Brazilians created an articulate and legitimate self-image – though it was to be shortlived. The military coup of 1964 was soon to eclipse this young, promising and self-confident modernity.

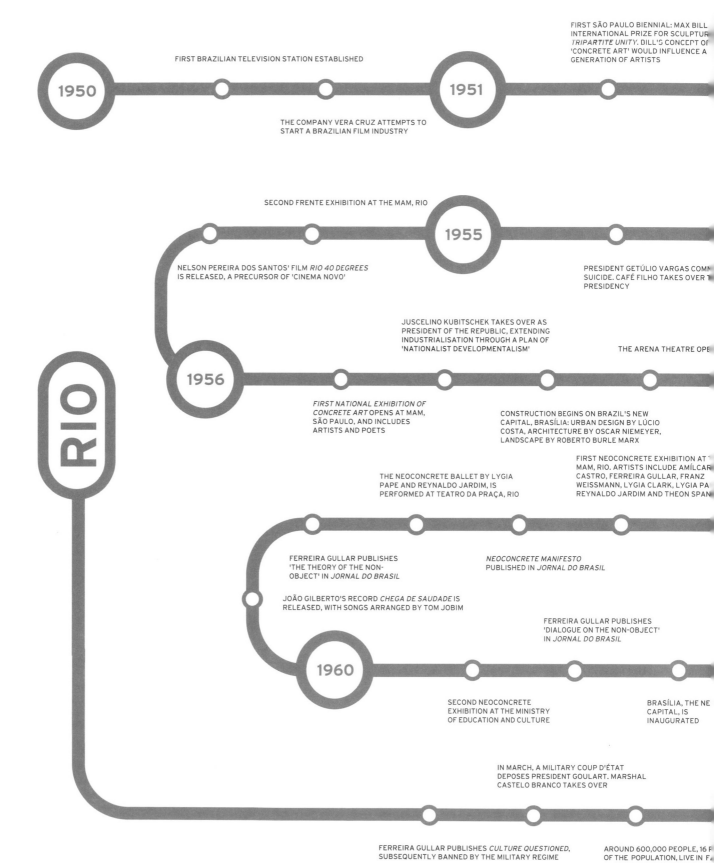

1950

FIRST BRAZILIAN TELEVISION STATION ESTABLISHED

THE COMPANY VERA CRUZ ATTEMPTS TO START A BRAZILIAN FILM INDUSTRY

1951

FIRST SÃO PAULO BIENNIAL: MAX BILL INTERNATIONAL PRIZE FOR SCULPTURE *TRIPARTITE UNITY*. BILL'S CONCEPT OF 'CONCRETE ART' WOULD INFLUENCE A GENERATION OF ARTISTS

SECOND FRENTE EXHIBITION AT THE MAM, RIO

1955

NELSON PEREIRA DOS SANTOS' FILM *RIO 40 DEGREES* IS RELEASED, A PRECURSOR OF 'CINEMA NOVO'

PRESIDENT GETÚLIO VARGAS COMM SUICIDE. CAFÉ FILHO TAKES OVER T PRESIDENCY

JUSCELINO KUBITSCHEK TAKES OVER AS PRESIDENT OF THE REPUBLIC, EXTENDING INDUSTRIALISATION THROUGH A PLAN OF 'NATIONALIST DEVELOPMENTALISM'

THE ARENA THEATRE OPE

1956

FIRST NATIONAL EXHIBITION OF *CONCRETE ART* OPENS AT MAM, SÃO PAULO, AND INCLUDES ARTISTS AND POETS

CONSTRUCTION BEGINS ON BRAZIL'S NEW CAPITAL, BRASÍLIA: URBAN DESIGN BY LÚCIO COSTA, ARCHITECTURE BY OSCAR NIEMEYER, LANDSCAPE BY ROBERTO BURLE MARX

THE NEOCONCRETE BALLET BY LYGIA PAPE AND REYNALDO JARDIM, IS PERFORMED AT TEATRO DA PRAÇA, RIO

FIRST NEOCONCRETE EXHIBITION AT MAM, RIO. ARTISTS INCLUDE AMÍLCAR CASTRO, FERREIRA GULLAR, FRANZ WEISSMANN, LYGIA CLARK, LYGIA PA REYNALDO JARDIM AND THEON SPAN

RIO

FERREIRA GULLAR PUBLISHES 'THE THEORY OF THE NON-OBJECT' IN *JORNAL DO BRASIL*

NEOCONCRETE MANIFESTO PUBLISHED IN *JORNAL DO BRASIL*

JOÃO GILBERTO'S RECORD *CHEGA DE SAUDADE* IS RELEASED, WITH SONGS ARRANGED BY TOM JOBIM

FERREIRA GULLAR PUBLISHES 'DIALOGUE ON THE NON-OBJECT' IN *JORNAL DO BRASIL*

1960

SECOND NEOCONCRETE EXHIBITION AT THE MINISTRY OF EDUCATION AND CULTURE

BRASÍLIA, THE NE CAPITAL, IS INAUGURATED

IN MARCH, A MILITARY COUP D'ÉTAT DEPOSES PRESIDENT GOULART. MARSHAL CASTELO BRANCO TAKES OVER

FERREIRA GULLAR PUBLISHES *CULTURE QUESTIONED*, SUBSEQUENTLY BANNED BY THE MILITARY REGIME

AROUND 600,000 PEOPLE, 16 F OF THE POPULATION, LIVE IN F

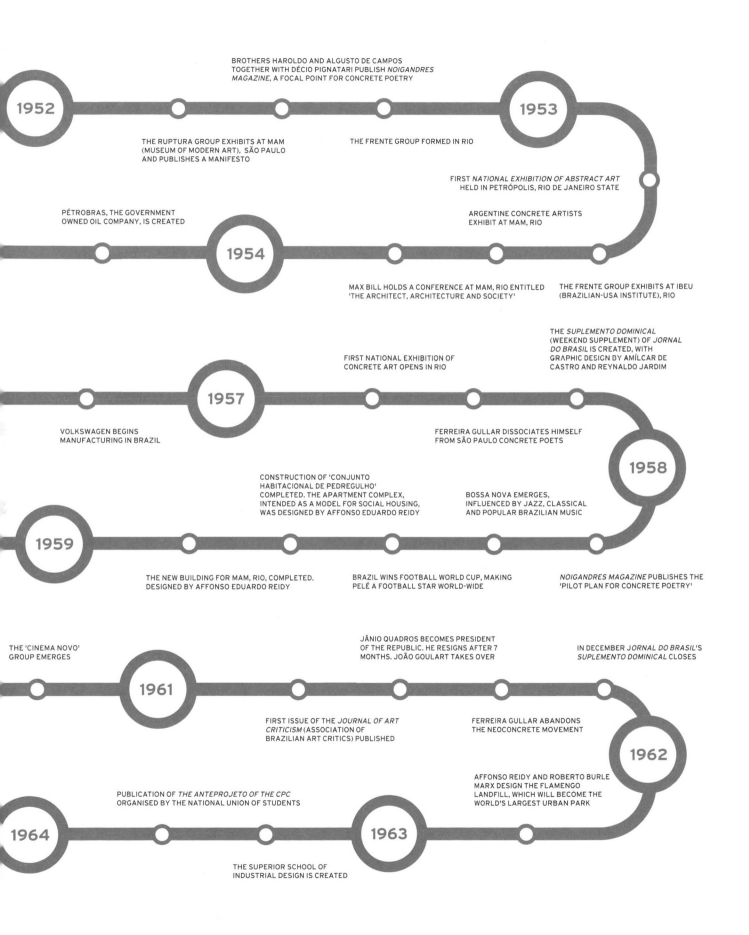

1952

BROTHERS HAROLDO AND ALGUSTO DE CAMPOS TOGETHER WITH DÉCIO PIGNATARI PUBLISH *NOIGANDRES MAGAZINE*, A FOCAL POINT FOR CONCRETE POETRY

1953

THE RUPTURA GROUP EXHIBITS AT MAM (MUSEUM OF MODERN ART), SÃO PAULO AND PUBLISHES A MANIFESTO

THE FRENTE GROUP FORMED IN RIO

FIRST *NATIONAL EXHIBITION OF ABSTRACT ART* HELD IN PETRÓPOLIS, RIO DE JANEIRO STATE

PÉTROBRAS, THE GOVERNMENT OWNED OIL COMPANY, IS CREATED

ARGENTINE CONCRETE ARTISTS EXHIBIT AT MAM, RIO

1954

MAX BILL HOLDS A CONFERENCE AT MAM, RIO ENTITLED 'THE ARCHITECT, ARCHITECTURE AND SOCIETY'

THE FRENTE GROUP EXHIBITS AT IBEU (BRAZILIAN-USA INSTITUTE), RIO

THE *SUPLEMENTO DOMINICAL* (WEEKEND SUPPLEMENT) OF *JORNAL DO BRASIL* IS CREATED, WITH GRAPHIC DESIGN BY AMÍLCAR DE CASTRO AND REYNALDO JARDIM

FIRST NATIONAL EXHIBITION OF CONCRETE ART OPENS IN RIO

1957

VOLKSWAGEN BEGINS MANUFACTURING IN BRAZIL

FERREIRA GULLAR DISSOCIATES HIMSELF FROM SÃO PAULO CONCRETE POETS

1958

CONSTRUCTION OF 'CONJUNTO HABITACIONAL DE PEDREGULHO' COMPLETED. THE APARTMENT COMPLEX, INTENDED AS A MODEL FOR SOCIAL HOUSING, WAS DESIGNED BY AFFONSO EDUARDO REIDY

BOSSA NOVA EMERGES, INFLUENCED BY JAZZ, CLASSICAL AND POPULAR BRAZILIAN MUSIC

1959

THE NEW BUILDING FOR MAM, RIO, COMPLETED. DESIGNED BY AFFONSO EDUARDO REIDY

BRAZIL WINS FOOTBALL WORLD CUP, MAKING PELÉ A FOOTBALL STAR WORLD-WIDE

NOIGANDRES MAGAZINE PUBLISHES THE 'PILOT PLAN FOR CONCRETE POETRY'

THE 'CINEMA NOVO' GROUP EMERGES

JÂNIO QUADROS BECOMES PRESIDENT OF THE REPUBLIC. HE RESIGNS AFTER 7 MONTHS. JOÃO GOULART TAKES OVER

IN DECEMBER *JORNAL DO BRASIL*'S *SUPLEMENTO DOMINICAL* CLOSES

1961

FIRST ISSUE OF THE *JOURNAL OF ART CRITICISM* (ASSOCIATION OF BRAZILIAN ART CRITICS) PUBLISHED

FERREIRA GULLAR ABANDONS THE NEOCONCRETE MOVEMENT

1962

PUBLICATION OF *THE ANTEPROJETO OF THE CPC* ORGANISED BY THE NATIONAL UNION OF STUDENTS

AFFONSO REIDY AND ROBERTO BURLE MARX DESIGN THE FLAMENGO LANDFILL, WHICH WILL BECOME THE WORLD'S LARGEST URBAN PARK

1964

1963

THE SUPERIOR SCHOOL OF INDUSTRIAL DESIGN IS CREATED

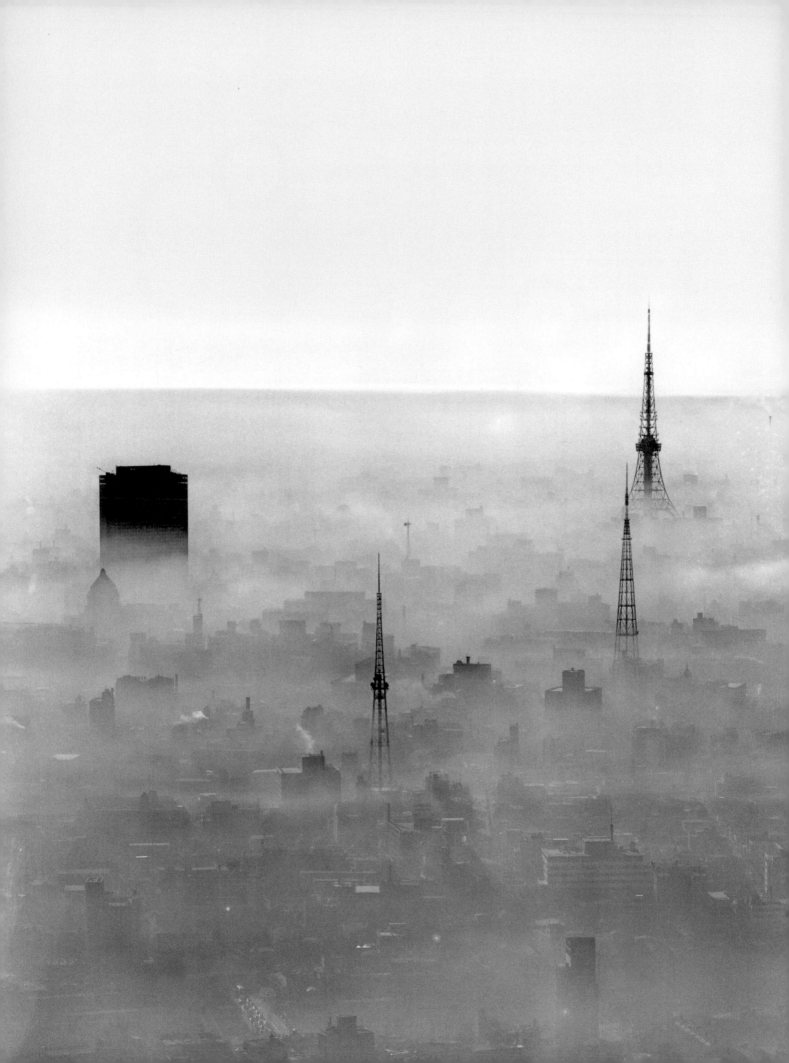

TOKYO
1967-1973

REIKO TOMII

THOUGHT PROVOKED: TEN VIEWS OF TOKYO, CIRCA 1970

In the years surrounding 1970, Tokyo experienced a period of unease. The capital of Japan endured enormous turmoil, when all received values were questioned and defied, while the nation boasted a phenomenal economic success a quarter century after its devastating defeat in the Second World War. This conflicting and conflicted milieu makes 'Tokyo, Circa 1970' a fascinating subject. The state of art and culture was so multifarious that it cannot be captured in a single sweeping narrative. How, then, shall we study the art and culture that inhabited Tokyo around 1970?

One strategy is offered by Hiroshige, the nineteenth-century woodblock master who codified old Tokyo (Edo) in a compendium of 100 scenic views.[1] Echoing his approach that at once contextualised and epitomised each Edo locale, this essay selects ten views of Tokyo in order to introduce aspects of the vast artistic and cultural activities taking place around 1970. Emphasis is placed upon those practitioners whose works reveal a significant degree of intensity of thought – on art, culture and society – provoked by the spirit of the time. The period in question centres on the year 1970 when the emblematic events of Anpo '70 and *Expo '70* occurred. This study begins in 1967, when Governor Minobe was elected, and concludes in 1973, when the so-called 'Oil Shock', precipitated by the international oil crisis, put an end to Japan's economic boom.

A LANDSCAPE OF PROSPERITY In the course of the twentieth century, Tokyo twice experienced a change of extraordinary magnitude. The first occurred in 1923, in the wake of the Great Kantō earthquake; the second in 1945, when American B-29s fire-bombed downtown Tokyo at the end of the Second World War. Both times, the Japanese capital had to be rebuilt from catastrophic destruction. The metropolis underwent yet a third fundamental change in the early 1960s: a retooling of the city in the name of modernisation (*kindaika*), which eventually resulted in the skyline of Tokyo as we know it today. Its driving force was neither nature nor war, but prosperity fed by ruthless development and industrialisation. Initially propelled by high economic growth, this process continued even after the Japanese economy nose-dived in 1973.

The most conspicuous early sign of this retooling was the 36-storey, 147-metre-high Kasumigaseki Building completed in 1968. This modernist box that rose in the heart of the government district was a direct result of the 1963 revision of the building codes, in which the height restriction, previously set at 31 metres, was removed. Though not an architectural distinction, this landmark building was a triumph of quake-proof and other construction technology. It was followed by other soaring towers, especially in the Shinjuku district, newly redeveloped as the capital's sub-centre. The constructions in Tokyo around 1970 set precedents for what was to come.[2] Big projects in urban areas tended to be monopolised by the design departments of construction companies and by large architectural offices.[3] The kind of city planning that preoccupied progressive architects earlier in the 1960s found little place, although important works – ranging in style from modernism and metabolism to hybrid-Japanism and postmodernism – were individually created. Notable examples include Tange Kenzō's Shizuoka Newspaper-Broadcasting Building (1968), Takeyama Minoru's Ichibankan (1969) and Kurokawa Kishō's Nakagin Capsule Tower (1972).

AZUMA TAKAMITSU
Tower House 1967
Photograph: Franck Robichon,
2000

HIKOSAKA NAOYOSHI

Repetition/Reversal (Hanpuku)

1974

Book 19.5 × 13.5 × 2.5

Jacket design: Kimura Tsunehisa

The Artist

Construction of the new was inevitably accompanied by destruction of the old. A case in point was the Imperial Hotel designed by Frank Lloyd Wright in the 1910s. The structure that had withstood the 1923 earthquake could not resist the tide of modernisation some forty years later. It was demolished in 1967, despite much opposition and efforts to preserve it, and was replaced in 1970 by the current hotel equipped with more rooms and contemporary facilities. Wright's facade and lobby were transferred to the Meiji Village museum near Nagoya.

Prosperity also wrought destruction of a different order, such as environmental pollution and the so-called 'traffic wars'. Tokyo's afflictions were aggravated by overpopulation – by 1962 the city was home to some ten million people, one tenth of the nation's whole population. In response, some architects proposed diverse experimental solutions in residential architecture. For example, Azuma Takamitsu's strong desire to live within the city resulted in the ingenious *Tower House* (1967), standing on a twenty-square-metre lot, to accommodate his family of three. Maki Fumihiko's Hillside Terrace complex consists of commercial and residential structures, designed and built in stages from 1969 to 1998. The coherent and pleasing streetscape it has achieved is testimony to the remarkable degree of architect–client collaboration nurtured in the often cold reality of urban architecture.[4]

SPECTACLES OF DISCONTENT Towards 1970, the strain of the bulldozing economic drive was mounting. Residents did not sit idly by. Community- and grassroots-based groups increasingly gave voice to local and urban issues, and, with their support, Socialist–Communist coalitions elected liberal mayors and governors. The 1967 victory of the Marxist economist Minobe Ryōkichi in Tokyo's governor race served a clear notice to the national government, pushing urban concerns to the top of the national agenda.

A decisive expression of disapproval, however, came from university students. The campus conflicts of 1968–70, which originated in Tokyo, represented first and foremost the moral crisis of post-war Japanese society. Although the student radicals of Zenkyōto (All-Campus Joint-Struggle Councils) began their rebellion by fighting campus-specific issues, they soon extended their critique to the educational, economic and social systems. Significantly, these so-called 'non-sect radicals', who were independent of sectionalised party ideologies, went beyond traditional anti-war and anti-state opposition. Making 'self-negation' their central thesis, they put on trial their 'criminality' and 'fallacy' that stemmed from their own implicated existence in the system.[5] The struggles they led involved over 100 schools nationwide in 1968, more than half of them barricaded by students.

Tokyo was not alone in witnessing the student revolt. 1968 was dubbed 'the year of the barricades'; cities around the world were in turmoil, against the backdrop of the Vietnam War – from Paris to Chicago, from London to Prague. The moral revolt caused by disillusionment with dominant values, which took place in a time of material prosperity and cultural tolerance, left mixed legacies.[6] Obvious international correspondences notwithstanding, the historical, political and cultural conditions particular to each city moulded each insurgence. In Tokyo, the student movement converged with the left's 'Anpo '70' campaign. This protest against the US–Japan Security Treaty (Anpo) was timed to coincide with the treaty's expiry. Initially signed in 1951, Anpo allowed American troops to station in Japan, turning the island nation into a key front base for America's Asian operations. The previous renewal of Anpo in 1960 had incited fierce opposition, and the state was determined to remove any obstacles to its extension in 1970. Thus the fall of the student-occupied Yasuda Lecture Hall at the prestigious national University of Tokyo in January 1969 was more than symbolic. A brutal attack by riot police signalled the beginning of the end of the student movement and leftist activism on the whole. Into the 1970s, the futility of street demonstration led some radicals to terrorism; Japanese Red Army factions achieved notoriety through a series of hijacking and shooting incidents.

Political destruction was also directed at architectural space. At Shinjuku Station, in order to outlaw anti-war folk-song gatherings, the police redefined the outdoor plaza as a 'passageway' in July 1969. This suppression of a spontaneously emerging public sphere makes a striking contrast to the officially sanctioned 'pedestrian paradises' created in 1970, whereby cars were shut out of Tokyo's main streets in the Ginza and Shinjuku districts on Sundays.

SITES OF RADICALISM In this season of politics, art and culture could not be indifferent. Art and design schools had their share of campus conflicts. For instance, students at the

Yasuda Lecture Hall, University of Tokyo, under attack by riot police, 18 January 1969

University of Tokyo architecture school's city planning section were active in the Zenkyōtō movement.[7] And the group Bikyōtō (Artists Joint-Struggle Council) was founded in July 1969 at the private Tama Art University. In one of the group's early agitational flyers, Bikyōtō members identified their 'battlefield' as artists, rather than as students, calling to arms on the platform, 'Dismantle the Power Machine of Art!'[8]

Radical students and younger professionals, often forming inter-group alliances, attempted to disrupt select exhibitions and events in 1969. They were successful on a few occasions, managing to force the cancellation of the annual poster exhibition of Nissenbi (Japan Advertising Artists Club) and Film Art Festival Tokyo '69 at Sōgetsu Art Center.[9]

However, *1970 Japan World Exposition*, commonly known as *Expo '70*, offered the radicals by far the largest target in the cultural sphere. Held in Osaka, the first world's fair in Asia was a pageant of technology and art that mobilised a roster of leading Tokyo avant-gardists in architecture, design and art. Leftist practitioners claimed that the state- and corporate-orchestrated festival, with its theme 'Progress and Harmony of Mankind', was at once a diversion scheme for Anpo '70 and an arrogant display of the nation's economic might gained in the 1960s.[10] Taki Kōji, a member of the photographers' collective Provoke, observed far more sinister consequences: in his view, *Expo '70* was a means for 'power', in a presciently Foucaultian sense, to co-opt art and culture into the 'network' of power that operated invisibly.[11] In a sense, the logic of anti-*Expo '70* was

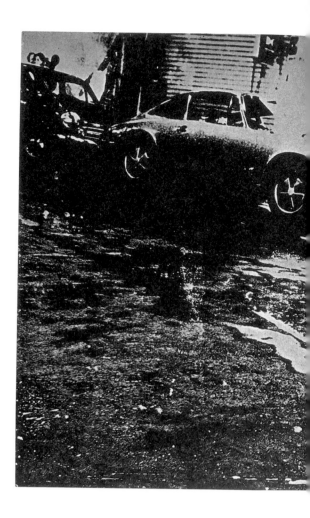

left

MORIYAMA DAIDŌ

Photograph from *Provoke* no. 2

1969

Magazine 24.2 × 18

Kaneko Ryuichi

centre

NAKAHIRA TAKUMA

Photograph from *Provoke* no. 3

1969

Magazine 23.9 × 18.5

Kaneko Ryuichi

right

TAKANASHI YUTAKA

Photograph from *Provoke* no. 2

1969

Magazine 24.2 × 18

Kaneko Ryuichi

intimately related to doubts about the morality of designing within a mass consumerist society, which increasingly exerted pressure to produce not so much a culture of form as an apparatus of desire.

Ultimately, cultural practice itself was suspect. Or, rather, the social and intellectual premises of 'design' proved to be untenable, as the dismantling (*kaitai*) of modern design or architecture became a theoretical issue.[12] It is in this context that the architect Isozaki Arata wrote a series of articles, 'The Dismantling of Architecture', for the magazine *Bijutsu techō* (Art Notebook), published in ten instalments between 1969 and 1973.[13] The chief producer of the Festival Plaza of *Expo '70*, Isozaki had personally witnessed the student revolt at the Milan Triennale in 1968. Stirred by this experience, and disheartened by the tyranny of technocracy rampant at *Expo '70*, he turned to the study of his contemporaries (such as Hans Hollein, Archigram and Superstudio) who frequently worked in 'visionary architecture', or architecture on paper. His survey constituted an extensive introduction to the work of these architects, who were not yet well known in Japan, and helped him reflect on his own work and examine the state of architecture.[14] Of especial interest today are the last chapters, which discuss the 'symptoms' of the dismantling of architecture – apathy, the alien, the *ad hoc*, ambiguity and absence – in a distinctly postmodern exercise, before postmodernism entered the international discourse. The final chapter reads:

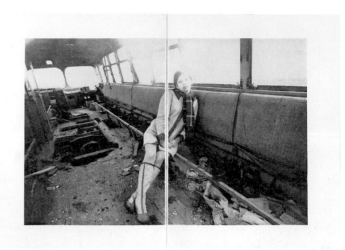

When I say 'dismantling of architecture', what I mean by 'architecture' is the concept of 'modern architecture' ... When [the architect] hits a limit as he individually develops visual language through technology, the technocrat takes over the initiative of development. Architecture is then assimilated into the social production system by way of mass production, mass construction, and mass consumption ... In this situation, the architects discussed in *The Dismantling of Architecture* ... have begun a probe, simultaneously dismantling the systems of their own work and the received notion of architecture ... [I]f the architect wants to evade a net of mass consumption cast by the technocrat and not abandon design, he has but to keep an ambivalent relationship with reality, which then will be often ironical and paradoxical.[15]

A WORLD WITHOUT CERTAINTY No other artist or group expressed the urgency of Tokyo in this period more eloquently than Provoke. Active between 1968 and 1970, the group consisted of four photographers (Nakahira Takuma, Takanashi Yutaka and Taki Kōji, with Moriyama Daidō joining from the second issue) and the poet–art critic Okada Takahiko. Their journal *Provoke* was more than a photography magazine; through both language and images, it aspired to present, as its subtitle stated, 'material to provoke thought [*shisō*]'. The preface to the first issue proclaimed:

Image of and in itself does not constitute thought. It lacks a totality of idea, and it is not a convertible sign like language. Yet, with its nonreversible materiality – a reality cut out by

TAKI KŌJI

Photograph from *Provoke* no. 1

1968

Magazine 21 × 21

Kaneko Ryuichi

the camera – it exists in a world on the reverse side of language. It thus sometimes provokes the world of idea and language. Language will then transcend its self that has become a fixed concept, transforming into a new language, that is, a new thought.

Now, at this very moment when language loses its material foundation, that is, reality, and floats in the air, what we the photographers can do is to capture with our own eyes fragments of the reality that cannot be grasped by the received words, and actively present some materials to language, to thought. That is why we gave *Provoke* the subtitle 'material to provoke thought', in spite of some embarrassment on our part.

Taki, a thinker by profession, summarised the state of affairs in society and culture as a 'degeneration of Intellect' in an essay published in the first issue of the magazine.[16] He argued that this crisis of Intellect most characteristically manifested itself in the campus conflicts and in *Expo '70*, in which the crux of the problems lay in the lack of 'thought' on culture. Taki's call for 'Intellect', or 'an effort towards a theory that comprehends the totality of the world and humanity', pointed to a horizon beyond the total self-negation embraced by Zenkyōtō students.

The Provoke photographers exercised their radicalism against the established principles of modernist photography. They deployed the vision of *are/bure/boke* (grainy/blurred/out-of-focus qualities) to create, according to the photography critic Iizawa Kōtarō, 'pathetic images, as if capturing the sight of a world struggling out of the darkness'.[17] The poet-member Okada expressed a similarly primordial vision in his poem 'Endure a Spread-Eagle of Your Legs and Wander' (1969), published in the second issue.[18] Nakahira's intense, mobile gaze at desolate scenery and nocturnal Shinjuku streets, and Taki's portrayals of 'disquiet everywhere', characterise this tendency.[19] Moriyama, already recognised as a practitioner of the *bure/boke* style, contributed his probes of languid sex life in the city and commodity culture in the spirit of 'turning everything my eye sees into photography'.[20] Takanashi, who had captured the city of the high-growth era in a series of perceptive snapshots called *Tokyo People* (1966), turned his lens to the subject of fashion, a domain in which he often worked as a commercial

OYOBE KATSUHITO

Communication Plan No. 1 1969

Poster for Theater Center 68/69

(Black Tent) 79.1 × 54.7

Musashino Art University Museum

and Library, Tokyo.

YOKOO TADANORI

John Silver: Love in Shinjuku

1967

Poster for The Situation Theatre

(Red Tent) 103.4 × 74.6

Musashino Art University Museum

and Library, Tokyo

photographer.

Aside from the vision of *are/bure*, a style widely copied by young photographers and amateurs alike, Provoke's place in Japanese photography has been debated.[21] If their language and photography were raw and underdeveloped, their 'expressions', that is, 'activities of [their] whole beings', testify to their existential attempt at what Taki described as a 'contradictory act – knowing that we can but see the world only in fragments and simultaneously question the meaning of the whole world'.[22] To do so, they had to 'first abandon the world of certainty', as the title of their 1970 book commanded.

THEATRE INTO THE STREETS Tokyo's urban space was a stage for the 'small theatre' movement – popularly known as 'Angura' (an abbreviation for 'underground') – which emerged in the 1960s, in refutation of modern theatre. Angura troupes included, most notably, Kara Jurō's The Situation Theatre (Jōkyō Gekijō), Waseda Small Theatre (Waseda Shōgekijō), Terayama Shuji's Tenjō Sajiki (gallery tier) and Theater Center 68/69 (Engeki Sentā).

These troupes liberated their plays from the confines of traditional theatre spaces, which the poet–playwright Terayama called the 'prison to theatre'.[23] The city offered them three primary venues.[24] First, as well as appropriating such spaces as coffee shops and cinemas, many troupes created their own small-capacity theatres, often with only dozens of seats, such as Tenjō Sajiki-kan, which opened in Shibuya in 1969. Second, vacant grounds, like parks, were ideal for the temporary space of 'tent theatre'. Troubles with the local authorities that regulated these spaces are part of the colourful history of tent theatre. The indisputable pioneer was Kara's Red Tent, first set up in 1967 in the precincts of Hanazono Shrine in Shinjuku. If the Red Tent recalled the vulgar energy and giddy ambience of circuses and freak shows, Theater Center 68/70's Black Tent, inaugurated in 1970, reflected the politically oriented company's desire to develop a closer communication with society. Third, the streets presented an open opportunity, which Terayama ingeniously exploited in his 'street theatre'. His works in this vein, such as *Man-Powered Airplane Solomon* (1970) and *Knock* (1975), represented his voracious experimentation with all kinds of space to agitate the mundane consciousness.

Graphic design played an integral role in shaping the street identity of the Angura troupes.[25] Yokoo Tadanori's posters for The Situation Theatre were a blend of pre-modern Japanese imagery and contemporary Pop sensibility; this amalgamation fitted Kara's taste for the vernacular and the native, which had been eliminated from Japanese modern theatre. The designer Oyobe Katsuhito's choice of the wall-newspaper format embodied Theater Center's call for 'theatre as revolution' and 'theatre as movement'.

However, these posters were more than simply aesthetic translations of the plays: they were the troupes' symbolic banners. They became, as Yokoo recalled, 'part of theatre, for theatre begins at the moment the poster is put up in the streets, or even before that'.[26] The enthusiasm designers brought to Angura theatre graphics can also be felt in the deployment of 'full-sheet' paper, measuring approximately 105 × 75 cm – too large to be posted in cafés and other underground meeting places. These oversized posters were first produced by Yokoo in 1966, and were quickly adopted as the Angura standard. The solidarity designers felt with troupe leaders (who had little money to pay

them) was unusual in the designer–client relationship, and helped transform their products into independent forms of expression – even 'theatre' in their own right.

TOKYO BIENNALE '70 Art in Tokyo during this period was characterised by the shift from Anti-Art (*Han-geijutsu*), the chief concern around 1960, to Non-Art (*Hi-geijutsu*) around 1970. The innocence of the avant-garde and their iconoclasm was forever lost, especially after 1967 when the Anti-Art master Akasegawa Genpei was found criminally guilty for his mechanically reproduced money, in his work *Model 1,000-Yen Note Incident* (1963–73).[27] The trial exposed the critical shortcoming of Anti-Art: Anti-Art's subversive gesture might be sanctioned only within the sphere of art; Anti-Art was after all still Art, with a capital 'A'. The avant-garde dream of merging art and life was prolonged by Environment art, which frequently employed technology and media, but it would quickly lose momentum after *Expo '70*. By 1970, the collapse of the paradigm of 'modern' (*kindai*) put forth by the critic Miyakawa Atsushi in the mid-1960s[28] was no longer a theoretical abstraction, as 'contemporary art' (*gendai bijutsu*) replaced the avant-garde – a typically modernist concept. Among the pioneers in this new territory were artists of Mono-ha (literally, 'thing-school') and Conceptualism, who engaged in 'not making'.

Of all the exhibitions that inform this shift, *Tokyo Biennale '70* was the most iconic. By presenting Euro-American examples of Minimal, Post-Minimal, Conceptual art and Arte Povera together with Japanese works, the exhibition demonstrated what the critic Haryu Ichirō called the 'international contemporaneity' (*kokusaiteki dōjisei*)[29] in the tendency of 'not making' – or playing an end game of modernism. If *Expo '70* was the emblem of 'prosperity' built on obsessive 'making', *Tokyo Biennale '70* represented the

above

Exhibition catalogue for *Tokyo Biennale '70: Between Man and Matter* 1970
Book 23.5 × 25
Cover design: Nakahira Takuma

right

LEE UFAN

From Line 1973
Mineral pigment on canvas
127 × 182
Museum of Contemporary Art, Tokyo

TOKYO/1967–1973/REIKO TOMII

SEKINE NOBUO

Phase of Nothingness:

Oilclay 1969

2.6 tons of oilclay. Dimensions

variable

Installation at Tokyo Gallery

next page

KOSHIMIZU SUSUMU

From Surface to Surface 1971

Wood. Fourteen parts,

each 250 × 30 × 6. Lost

Installation at Tamura Gallery

seeming 'poverty' in art effected by the strategies of 'not making'.

Yet, as implied by the Provoke member Nakahira Takuma's photograph on the catalogue cover, an expanse of rased ground that may apparently offer little to see can in itself be a compelling image. This desolate sight, indeed, invokes a challenging question that concerned both artists and their audience around 1970: What can you see here – in this place where everything has been taken down?

A WORLD REVEALED The direction of 'not making' was consciously affirmed by Mono-ha artists who dealt with *mono* ('thing' or 'matter') while invariably exploring the issue of perception in order to bring in an additional dimension to their works.[30] Sekine Nobuo, one of the originators of the Mono-ha movement, declared: 'First we must stop creating, and start seeing.'[31] In his mind, the history of modern art, which had unfolded as a chain of styles, was now over. For him, Nakahira's urban wasteland would have symbolised 'a horizon where it all ended'.[32] Metaphorically speaking, that is where Sekine's *Phase: Earth* (1968), a 2.7-metre-high tower of dirt and an identically shaped hole in the ground, would stand, its sheer monumentality defeating mere words.

While *Phase: Earth* was, in the words of Sekine's then assistant Koshimizu Susumu, the 'big bang'[33] that set Mono-ha in motion, the involvement of the Korean artist–theorist Lee Ufan added a crucial theoretical depth. Above all, Lee saw Sekine's work as an embodiment of his own anti-modernism, whereas Lee's command of philosophy quenched the hunger Sekine felt for language – Sekine was then rather disenchanted by the critics' inability to penetrate the surface of his work. Sekine first met Lee shortly after presenting *Phase: Earth* at an outdoor exhibition near Kōbe, and thereafter the two conversed almost every day at a Shinjuku coffee shop. Sekine brought his junior colleagues, including Koshimizu, to these meetings, and this group formed the core of Mono-ha in its origin.

Sekine and Lee's symbiotic relationship can be observed in Lee's seminal text 'World and Structure' (1969), as read against Sekine's often-quoted vision of 'the world that exists vividly as it is'.[34] In this text, clearly positioning himself in the lineage of the critic Miyakawa Atsushi, Lee observed the collapse of the modern paradigm in the loss of man's privilege of representation – to 'make things' – which had once validated his supremacy in the world, but was now nullified by technology (i.e. things that make things). Therefore, Lee asked, what possibilities were left for art today? His proposed solution was: 'Man will have to learn to see everything as it is, the world as it is, without objectifying the world through man-imposed representation.' Adding an Eastern twist, he then echoed Sekine's belief: 'Because, since time immemorial, everything is realised and the world is revealed as it is, what world can we newly make and where?'[35]

In 'On Sekine Nobuo', Lee further explored how the thesis of 'seeing the world as it is' could be put into practice, examining, among other works, Sekine's *Phase of Nothingness: Oilclay* (1969). This text elegantly infused literature into art criticism. His quiet theoretical exegeses are interpolated by the narration of the artist's 'act' (*shigusa*) – the repetition of piling and shifting – until he has an 'encounter' (*deai*) with the world.[36]

However, the alliance between Lee and Sekine was short-lived. By 1971, although Mono-ha artists had grown in number, Sekine had become more interested in the social

function of art.[37] Koshimizu, who around 1970 developed a distinct Mono-ha approach to materiality, turned to a more deliberately sculptural manner. In 1972, Lee himself added two series of paintings to his Mono-ha repertoire, *From Line* and *From Point*.[38] This was a move quite courageous at a time when the death of painting was widely perceived.

MAIL IS IN For Japanese conceptualists, whose practices are varyingly grounded in institutional critique,[39] Nakahira's vacant land would have represented society, of which art is an integral part. That was their world, quite unlike Mono-ha's metaphysical world, in which they could operate in an interventional mode. To this end, artists such as Akasegawa Genpei, Matsuzawa Yutaka and Horikawa Michio employed the vehicle of mail around 1970.

For Akasegawa, money was an introduction to a world governed by the state. His first confrontation with the state, in the ongoing saga of the *Model 1,000-Yen Note Incident* (1963–73), ended in defeat, when the lower court found him guilty in 1967. Learning from this setback, Akasegawa conceived the parodic, 'law-abiding'[40] *Greater Japan Zero-Yen Note* (1967). To distribute his zero-value (thus not illegal) money, Akasegawa utilised the state-provided postal service. As he advertised in a poster and in magazine articles, interested parties could send him three *real* 100-yen notes, via the post office's cash mailer, in exchange for one of his *authentic* zero-yen notes. His goal was to put the state's currency out of circulation, by gradually replacing it with his own. Akasegawa's

subversive spirit, in the fashion of Chairman Mao, whose doctrine 'rebel with a cause' was quoted in the note's border design, anticipated the battle cry of Zenkyōtō students who made Mao's little red book their bible.

Matsuzawa and Horikawa, who both lived outside Tokyo, deployed the postal service to reduce their distance from the capital's art world. Since 1964, when he denounced material objects in favour of immaterial language, mail art became part of Matsuzawa's Conceptualist strategy, together with flyers, installations and performances. His goal, however, in whatever medium he worked, was to promote examples of 'non-sensory painting', 'psi art', 'final art' and 'catastrophe art', which could be visualised in the recipient/viewer's mind in the forms of 'nothingness' and 'void'. His hanging panels *My Own Death*, shown at *Tokyo Biennale '70*, were yet another example of his dematerialised practices. The accompanying text, 'Some Dilations', provides a mystical

TOKYO/1967-1973/REIKO TOMII

私 の 死

（時間の中にのみ存在する絵画）

あなたがこの部屋をしづかによぎる時あなたの心に一瞬
私の死をよぎらせよそれは未来の正真正銘の私の死であ
るがあなたの死ともまた過去の何千億の人間の死とも未
来の何万兆の人間の死とも似ているあれなのだよ松沢宥

MY OWN DEATH

(Paintings existing only in time)

When you go calmly across this room, go my own death across your mind in
a flash of lightning, that is my future genuine death and is similar
not only to your own future death but to past hundred hundred millions of
human beings' deaths and also to future thousand trillions of human beings'

explication of his idea: 'Therein I have presented my own death. I have presented the future. It exists in an infinite number, as many as the number of minds that contemplate it. It exists only in time. It is my death and your death and ... the Nirvana that neither increases nor decreases nor comes nor goes.'[41]

Matsuzawa's dire premonition of 'death' and the 'end of civilisation' was informed by his abiding interest in cosmology and the spiritual. Thus, towards 1970, in an age of prosperity-induced destruction, the godfather of 'not making' saw his advocacy for 'anti-civilisation' gain an enthusiastic following among a group of younger artists, who were collectively called 'Nirvana school'.[42]

Matsuzawa's cosmic awareness and Akasegawa's critique of power structures saw a synthesis in Horikawa's *Mail Art by Sending Stones* series (1969–1972). On the one hand, the collection of 'stones on the Earth' for *The Shinano River Plan 11* was an operation parallel to the gathering of lunar samples during the Apollo 11 mission (both projects were executed simultaneously). On the other hand, these stones, delivered to eleven denizens of the art world, could have been a political statement of sorts – not unlike the stones thrown at the police by student radicals – prompting the recipients to think of earthly matters. Horikawa wrote: 'Nothing changes in the universe if humanity stood on the moon and brought back the stones. What does change is humanity and his thinking.'[43] At the end of the tumultuous year 1969, the stone Horikawa sent to President Nixon as a Christmas present was the artist's lone anti-war message.[44] In an amazing coincidence, Horikawa's stones were included in *Tokyo Biennale '70*, while Apollo 11's rocks were on view at *Expo '70*.

'EMPTY CENTER' Tokyo has been the home of modern emperors since 1968, when the country's capital was relocated from Kyoto. In his book *Empire of Signs* (1970), the French philosopher Roland Barthes posited the imperial palace as Tokyo's 'empty center', where the emperor lives, in his characterisation, unseen and unknown by the surrounding world.[45] Still, the emperor, or more precisely the 'emperor system' (*tennōsei*), is far from an empty signifier – although it is an invisible one. Since 1945, when the post-war Constitution redefined the emperor as the symbolic head of a democratic country, Emperor Shōwa's responsibility in the Second World War remained unresolved and unmentionable. Invisibility thus constructed does not equal indifference on the part of the Japanese people.

In the 1970s, the painter Yamashita Kikuji probed the issue of the emperor system in his work.[46] As an army veteran, he was still haunted by the wartime memories of acting as a reluctant victimiser. He experimented with photographic images in his *Anti-Militarism Collages* (1970) and in a series later called the *Anti-Emperor* paintings (1971). This series, as exemplified by *Encounter*, bridges the present and the past by juxtaposing a contemporary image of Emperor Shōwa (from his first post-war trip to Europe that year) and historical photographs of European and Asian victims: Jews under Hitler and subjects of Japanese atrocities. The *Anti-Emperor* series points to the internalised continuation of the imperialism once indoctrinated in 'the emperor's babies' – the familiar wartime appellation for the Japanese people – that hardly ceased to exist in a new Japan. The suicide of the right-wing novelist Mishima Yukio after a failed coup attempt in 1970 was but a reminder of it.

The women's liberation movement in Japan arose from the barricades in 1970. It was another critique of the emperor system, which fundamentally shaped the 'family' system,

right

YAMASHITA KIKUJI

Encounter 1971

Oil on canvas 112 × 162.1

Gallery Nippon

far right

YOKO ONO

Cheers to Women on Top 1973

45 rpm record, jacket, lyric card,

CD transfer. Jacket: 18.2 × 18.2

The Artist © Yoko Ono

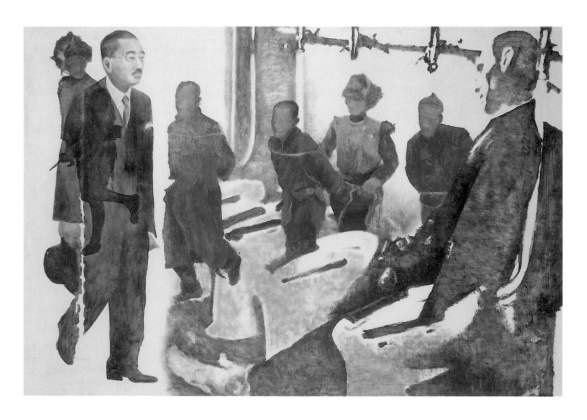

TOKYO/1967-1973/REIKO TOMII

CHEERS TO WOMEN ON TOP 1973
YOKO ONO

One thousand years of male society
Smog covers the land of Japan
History shows how incompetent they are
Time has come for all men to resign

It's time to show women's true nature
Let us open a new age
With women's soul and women's power
With women's soul and women's power

One thousand years of male society
Mahjongg rattles in the land of Japan
History shows how powerless they are
Time has come for women on top

It's time to exercise women's gift
Let us build a new age
With women's soul and women's power
With women's soul and women's power

One thousand years of male society
Corrupt politics in the land of Japan
History shows how reckless they are
Time has come for women's solidarity

It's time to sing women's mind
Let us create a new age
With women's soul and women's power
With women's soul and women's power

[chorus]
Cheers to women on top! Cheers to women
on top!

Cheers to women on top! Cheers to women
on top!

*Translated from the Japanese by Reiko
Tomii; © Yoko Ono 2000*

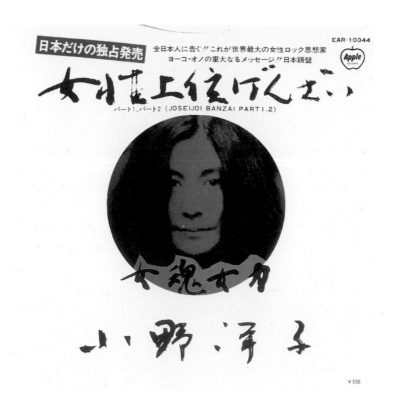

which in turn determined women's place in society.[47] Female students took their cause to the streets and, together with concerned housewives and working women, organised themselves into groups. Most notorious of all was Chupiren (an abbreviation of women's liberation union that objects to the Abortion Prohibition Law and demands free access to contraceptive pills), who asked the renowned feminist artist Yoko Ono, living in New York, to compose their theme song. Ono responded with 'Cheers to Women on Top' (*Josei jōi banzai*), which celebrated women's 'positive force to change the world'.[48] The same year, Ono also contributed a satirical text on male–female role reversal, 'Japanese Men Sinking', to the women's magazine *Fujin kōron* (Women's Public Discourse).

Kusama Yayoi, also a resident of New York in the 1960s, returned to Japan in early 1973. With the exception of her elongated, crawling sculpture *Snake* (1974),[49] Kusama's oeuvre in the mid-1970s consisted primarily of poetry and small but intense works on paper. If the artist's New York work – especially the whirlwind of performances and Happenings staged in opposition to the Vietnam War and male-dominant society in 1967–70[50] – was what she calls her 'front side', her Tokyo works from this period represent her 'reverse side', or a more 'lyrical frame of mind', which was impossible to maintain in New York's harsh reality.[51] The hundreds of collages Kusama created in 1975, in a room of the mental hospital she checked into that year, reveal a penetrating gaze cast on the spiritual world and human mortality.

ESCAPE ROUTES In 1970, radical politics was at the crossroads: the Anpo treaty was automatically extended and the student movement was in disarray. Bikyōtō, too, languished during what the member Hikosaka Naoyoshi called the 'period of strategic retreat',[52] after the administration of Tama Art University introduced riot police to remove

Now that you've died

Your soul is gone forever

Fading away over the cloud of cotton roses

Covered with the powder of a rainbow light

Yet, you and I

Parted our ways

Having never met again

After the endless strife

Of love and hatred

I was born a child to the world of humanity

Parting is like a quietude

Of footprints in the path of flowers

And it is soundlessly silent

Beyond the sunset clouds

Poem by Kusama Yayoi inscribed on the
back of the collage (left); translated from
the Japanese by Reiko Tomii

TOKYO/1967–1973/REIKO TOMII

left

KUSAMA YAYOI

Now That You've Died 1975

Collage 54 × 39

Setagaya Art Museum

below

HORI KOSAI

Revolution: Ceiling, Wall, Floor

1971

Documentary photograph of

installation event 15.4 × 24

The Artist

below right

YAMANAKA NOBUO

Projecting a Film of a River

onto the River 1971

Documentary photograph of

projection event 20.3 × 25.4

Tochigi Prefectural Museum of

Fine Arts

the students from its campus in October 1969. The group's political life was over. However, it was no simple matter to return to the 'battlefield' of artists – the group's ultimate concern as declared in its founding announcement – given the state of art dominated by the strategies of 'not making'. To break the impasse, Bikyōtō members Hikosaka, Hori Kosai and Yamanaka Nobuo, with a handful others, reorganised the group into a cluster of collectives,[53] with a tactic to wage a battle on two fronts: theory and practice.

On the theory front, the battle began with Hikosaka's critique of the Mono-ha ideologue Lee Ufan, in late 1970.[54] While still drawing on leftist logic, the young artist, in essence, denounced Lee for his ahistoricism (being 'so uncritically immersed in the historical condition that is the collapse of the modern') and his 'mystical naturalism' (embracing the 'encounter' with the world that was 'fleeting' and 'so immense as to lack even a history of being and nothingness'). From 1971 onwards, his and other members' discursive works unfolded in their journals _Bijutsu shihyō_ (Art History and Criticism) and _Kirokutai_ (Document Zone). In particular, Hikosaka – together with his senior colleague and Fluxus artist Yasunao Tone – pursued the reassessment of 1960s art as well as the whole history of the Japanese avant-garde on the pages of the leading contemporary art magazine _Bijutsu techō_.

This revitalisation explored through language paralleled artistic practice. One of the Bikyōtō collectives, the first Bikyōtō Revolution Committee, produced a series of members' solo exhibitions outside of the institutional spaces in 1971, in order to scrutinise what they called the 'internal museum'. Theoretical implications aside,[55] the works presented by Hori, Hikosaka and Yamanaka revealed their keen awareness of formal and otherwise expressive elements, which was, more often than not, lacking in Nirvana-school Conceptualism. These were all primary, signature works, which they soon developed into new stages within a few years. From his installation at an underground theatre, Hori took the question of discourse rendered in disparate systems of signification, and recast it in a series of performances entitled _Reading Affairs_.[56] After an

HIKOSAKA NAOYOSHI
Floor Event (invitation postcard) 1971
Silkscreen and offset 10 × 14.5
The Artist

initial performance of *Floor Event* in his room, Hikosaka executed the act of latex-pouring in various settings, in the way a composer would work on the variations of a theme. One such example is *Carpet Music*, performed at Lunami Gallery in 1972. Yamanaka's projection of a film of the Tama River onto the same river taught the artist to deconstruct 'seeing' through the dialectics of filmed-projected imagery, which led to an inventive use of the pinhole camera.[57] The evolution of these artists was so swift and so significant that in 1973, when they formed the second Bikyōtō Revolution Committee and entered into an agreement of 'nonactivity' during 1974, the decision of 'not making' was more drastic than it initially appeared. Still, putting this distinct concern of circa 1970 into literal practice, Bikyōtō signalled the end of an era consumed by the conundrum of modernism in its final stage.

The years surrounding 1970 in Tokyo were a sober time. Despite the 'international contemporaneity' that marked this period, the overall mood was introspective, with local, rather than global, issues demanding more attention of the nation and individuals alike. It was not until well into the 1980s that the art and culture of Tokyo seized the international stage, buoyed by the country's 'bubble economy'. In the meantime, 'making', and even 'painting', which were presumed dead around 1970, were resurrected towards the end of the 1970s. Art and culture from 'Tokyo, Circa 1970' stand in stark contrast to the developments of the ensuing decades, illuminating their singular creativity and imagination that resonated in the voices of the era.

Notes

In this essay, Japanese and Korean names are presented in the traditional fashion, with the family name first, followed by the given name. Exceptions are made for those who primarily reside outside their native countries and have adopted the Western system (e.g., Yoko Ono).

Unless otherwise noted, all translations from Japanese material are by the author.

1 See Henry D. Smith and Amy G. Poster, *One Hundred Famous Views of Edo/Hiroshige*, New York 1986.
2 Suzuki 1999, p.386.
3 Suzuki 1984, pp.9-10.
4 See Azuma 1988 and Maki 1995.
5 Takagi Masayuki, *Zengakuren to Zenkyōtō* (All-Federation of Student Self-Governing Councils and All-Campus Joint Struggle Councils), Tokyo 1985, pp.124-5.
6 David Caute, *The Year of the Barricades: A Journey Through 1968*, New York 1988), pp.xi-xii. It should be noted that Caute gives little attention to the Zenkyōtō movement. For the pictorial accounts of 1968, see *1968-nen* 1998.
7 Suzuki 1999, pp.374-77.
8 For Bikyōtō, see Reiko Tomii, 'Concerning the Institution of Art', *Global Conceptualism* 1999, p. 23, especially Text 5.
9 See *Nissenbi 20-nen/JAAC 1951-70*, exh. cat., Ginza Graphic Gallery, Tokyo 2000 and *Sōgetsu to sono jidai, 1945-1970* (Sōgetsu and its era), exh. cat., Ashiya City Museum of Art and History, Ashiya 1998.
10 For anti-*Expo '70*, see Haryū 1969 and *KEN* 1970.
11 Taki Kōji, 'Oboegaki 1: Chi no taihai' (Memorandum 1: Degeneration of Intellect), *Provoke*, no. 1, November 1968, pp.67-68 and 'Banpaku hantai-ron' (Counter-discourse on Expo '70) in Haryū 1969, pp.34-35. For critical assessment of *Expo '70* in recent years, see Yoshimi Shun'ya, *Hakurankai no seijigaku: Manazashi no kindai* (Politics of expositions: Modernity in gaze), Tokyo 1992, pp.220-40. For Foucault's concept of 'power', see *The History of Sexuality: An Introduction, Volume 1 (1976)*, New York 1990, pp.93-97.
12 For example, see Yasunao Tone, 'Modan dezain no kaitai' (Dismantling of modern design), *Design*, December 1969; reprinted in *Gendai geijutsu no isō: Geijutsu wa shisō tariuruka* (Phases of contemporary art: Can art be thought?), Tokyo 1970, pp.162-83.
13 In 1975, these articles were made into a book, *Kenchiku no kaitai* (The dismantling of architecture), by Bijutsu Shuppansha.
14 Isozaki Arata, preface to *Kenchiku no kaitai*, facsimile edition, Tokyo 1997, p. iv.
15 Isozaki, 'V Abusensu – jo ni kaete' (Absence – or in place of postscript) in ibid., pp.397-98.
16 Taki Kōji, 'Oboegaki 1', pp.63-68.
17 Iizuka Kōtarō, '"Provoke" no shissō' (Provoke sprints), *11-nin* 1989, p. 152.
18 Okada Takahiko, 'ōmata biraki ni taete samayoe' (Endure a Spread-Eagle of Your Legs and Wander), *Provoke*, no. 2, March 1969, p. 103.
19 Taki Kōji, untitled statement, *Provoke* no. 1, November 1968, p. 15.
20 Moriyama Daidō (1972), quoted in Kaneko Ryūichi, 'VIVO igo' (After VIVO) in *11-nin* no 1965-76 1989, p. 141.
21 See, for example, deja-vu 1993 and Nishii Kazuo, *Naze imada "Purovōku" ka* (Why still Provoke?), Tokyo 1996.
22 Taki Kōji, "Shashin ni nani ga kanō ka: Jo ni kaete" (What is possible for photography?: In place of preface) in *Mazu tashikarashisa no sekai o suteo: Shashin to gengo no shisō* (First abandon the world of certainty: Thought by photography and language), Tokyo 1970, pp.6-11.
23 Terayama Shūji, *Chika sōzōryoku* (Underground imagination, 1971), quoted in Senda Akihiko, *Gekiteki runessansu: Gendai engeki wa kataru* (Dramatic renaissance: Contemporary theatre speaks up), Tokyo 1983, p. 15.
24 Senda, *Gekiteki runessansu*, pp.438-45. This paragraph draws on Senda's discussion.
25 See David G. Goodman, introduction to Goodman 1999, pp.8-10; Senda, 'Gekiteki bijutsu no nijūnen: Shōgekijō posutā no sekai' (20 years of theatre art: Posters of little theatres) in *Gendai engeki* 1988, unpag.
26 Yokoo Tadanori (1978), quoted in Senda 1988, unpag.
27 For Akasegawa's *Model 1,000-Yen Note Incident*, see Tomii, *Global Conceptualism*, pp.20-22.
28 For the collapse of 'modern', see Tomii, *Global Conceptualism*, pp. 17-18.
29 Haryū 1979, pp. 181-82.
30 Okada Kiyoshi, 'Gendai bijutsu eno toi/The Challenge to Contemporary Art' in *1970-nen* 1995, pp. i, 12.
31 Sekine, 'Miru (tsukurukoto, tsukuranukoto)' (To see: making and not making), *Sūgaku seminā* August 1969); reprinted in *Sekine Nobuo/Nobuo Sekine 1968-78*, Tokyo 1978, unpag.
32 Sekine Nobuo, in panel discussion, "'Mono' ga hiraku atarashii sekai" (A World revealed by mono), *Bijutsu techō*, no. 324 (February 1970), pp. 35-36.
33 Koshimizu Susumu, 'Yami no naka e kieteiku mae no yabu no nake e' (Into the thicket before it disappears into darkness), *Bijutsu techō*, no. 706, May 1995, p. 269. This paragraph draws on Koshimizu's text as well as those by Lee Ufan, Yoshida Katsurō, and Sekine, published in 'Shōgen: Mono-ha ga kataru Mono-ha/Testimony: Mono-ha as Explained by the Mono-ha,' special feature, pp.254-63.
34 Sekine, 'Miru'.
35 Lee Ufan, 'Sekai to kōzō: Taishō no gakai (gendai bijutsu ronkō)' (World and Structure: Collapse of the object [theory on contemporary art]), *Dezain hihyō/Design Review*, no. 9, June 1969, pp.121-33.
36 Lee, 'Sonzai to mu o koete: Sekine Nobuo ron' (Beyond being and nothingness: On Sekine Nobuo) in *Deai o motomete: Atarashii geijutsu no hajimari ni* (In search of encounter: At the dawn of new art, Tokyo 1971, pp. 117-173. This is an expanded and revised version of his two texts on Sekine published in *SD*, nos. 74 and 75, December 1970 and January 1971. For excerpt translation, see Munroe 1994, pp.377-78.
37 Sekine, 'Diarōgu 31: Sekine Nobuo, kikite Haryū Ichirō' (Dialogue 31: Haryū Ichirō interviews Sekine Nobuo), *Mizue*, no. 812, October 1972, p. 85.
38 For Lee's painting, see Tomii, 'Infinity Nets: Aspects of Contemporary Japanese Arts' in Munroe 1994, pp. 314-15.
39 For Japanese Conceptualism, see Tomii, *Global Conceptualism*.
40 See Akasegawa's poster for *Greater Japan Zero-Yen Note*.
41 Matsuzawa Yutaka, '"Watashi no shi" ni kansuru jakkan no fuen" (Some Dilations on My Own Death) in *Dai-10 kai Nihon kokusai bijutsu-ten*, exh. cat., unpag.
42 'Nirvana school' was officially launched at *Nirvana: For Final Art*, held at Kyoto Municipal Museum of Art in 1970.
43 Horikawa Michio, '69721115620,' statement dated 26 July pasted on document card for *The Shinano River Plan 11*, 21 July 1969.
44 His 'thoughtfulness in sending [the President] a most unusual Christmas gift' was acknowledged by Tokyo's American Embassy. Documentation of this gift is included in a compilation of multimember Mail art projects, *Seishin Eiseigaku Kenkyūjo* (Mental Hygiene Study Institute), compiled by Ina Ken'ichirō and others in 1970.
45 Roland Barthes, *L'Empere des Signes* (1970); *Empire of Signs*, trans. Richard Howard, New York 1982, pp. 30-32.
46 For Yamashita's works from the 1950s, see *Reconstructions* 1986, pp. 17-18, 36-37; for his wrenching confession of his wartime experiences, see 'Sabetsu o nozoku ana' (The hole through which to see discrimination), *Me* (Eye), no. 4, July 1970.
47 See for example *Sei/ai/kazoku: Nihon josei no rekishi* (Sexuality/love/family: History of Japanese women), Tokyo 1992, pp. 181-91. For the women's liberation movement, see *Zenkyōtō kara ribu e* (From Zenkyōtō to women's lib), (Tokyo: Impact Shuppankai, 1996).
48 Yoko Ono, 'The Feminization of Society' (1971); reprinted in Munroe and Hendricks 2000, p. 300.
49 For *Snake*, see Tomii, "Yayoi Kusama, A Snake" in *Warhol/Kusama*, exh. brochure, New York 1997.
50 See Karia 1989.
51 Kusama in 'Interview: Akira Tatehata in conversation with Yayoi Kusama,' trans. Reiko Tomii in *Yayoi Kusama*, London 1999, pp. 25-26.
52 Hikosaka Naoyoshi, 'Senryakuteki kōtai-ki no shūen' (End of the period of strategic retreat) (1971); reprinted in Hikosaka, *Hanpuku (Repetition/Reversal)*, Tokyo 1974.
53 Tomii, *Global Conceptualism*, p. 242.
54 Hikosaka, 'Ri Ūfan hihan: 'Hyōgen' no naiteki kiki toshiteno fashizumu' (Critique of Lee Ufan: Fascism as an internal crisis of 'expression'), *Dezain hihyō/Design Review*, no. 12, November 1970; reprinted in Hanpuku.
55 Tomii, *Global Conceptualism*, pp.22-23, 25-26.
56 See Hori Kosai, *ten: Kaze no me/The Eye of the Wind*, exh. cat., Takaoka Art Museum, 1996.
57 'Pinhole Camera', concept card included in *Eizō hyōgen '72: Mono, ba, jikan, kūkan/Expression in Film '72: Thing, Place, Time, Space - Equivalent Cinema*, exh. cat., Kyoto Municipal Museum of Art, 1972, reveals his formulation. It reads: 'My event *Projecting a Film of a River onto the River* also posed a problem about the camera and the projector. The pinhole camera is an apparatus in which these two functions are not yet separated but unified.'

1967

MARXIST ECONOMIST MINOBE RYŌKICHI
ELECTED TOKYO GOVERNOR

'POLLUTION COUNTERMEASURES
BASIC LAW' ENACTED

USA RETURNS DOCUMENTARY
FILMS OF A-BOMBS TO JAPAN

JAPAN BECOMES LARGEST
PRODUCER OF TELEVISION SETS

1.5 MILLION PEOPLE GATHER
NATIONWIDE ON '10.21 ANTIWAR DAY'

POLICE OUTLAW 'FOLK
GUERRILLA' CONCERTS
OUTSIDE SHINJUKU STATION

ARMY VETERAN ATTACKS
EMPEROR SHŌWA (HIROHITO)

DIET PASSES 'UNIVERSITY ADMINISTRATION
TEMPORARY MEASURES LAW' TO CRACK
DOWN ON THE STUDENT MOVEMENT

8,500 RIOT POLICE MOBILISED
TO RECAPTURE THE STUDENT-
OCCUPIED YASUDA LECTURE
HALL AT UNIVERSITY OF TOKYO

TRAFFIC ACCIDENTS CAUSE
AROUND 1,000 DEATHS A MONTH

1,505 STUDENTS AND ACTIVISTS
ARRESTED ON '10.21 ANTIWAR DAY'

NATIONAL MUSEUM OF MODERN ART,
TOKYO MOVES TO NEW BUILDING
DESIGNED BY TANIGUCHI YOSHIRŌ

NISSENBI'S ANNUAL POSTER COMPETITION AND *FILM ART
FESTIVAL TOKYO '69* (SŌGETSU ART CENTER) DISRUPTED
BY RADICAL STUDENTS AND PRACTITIONERS

JAPAN'S FIRST ATM MACHINES
INSTALLED IN SHINJUKU

BIKYŌTŌ (ARTISTS JOINT-
STRUGGLE COUNCIL) FOUNDED

SECOND AND THIRD ISSUES
OF *PROVOKE* PUBLISHED

TOKYO

FIRST 'BLACK TENT' PRODUCTION
BY THEATER CENTER 68/70

AUGUST 1970, NATIONAL MUSEUM OF MODERN ART,
TOKYO, GATHERS 13 *MONO*-ORIENTED ARTISTS

PROVOKE'S 'FIRST ABANDON THE
WORLD OF CERTAINTY' PUBLISHED

NISSENBI (JAPAN ADVERTISIN
ARTISTS CLUB) DISBANDED

1971

FIRST RESIDENTS MOVE INTO TAMA NEW TOWN

EMPEROR SHŌWA
VISITS EUROPE

'DOLLAR SHOCK'. FIXED DOLLAR-
YEN EXCHANGE RATE ENDS

SEKINE NOBUO FOUND
ENVIRONMENTAL ART

AZUMA TAKAMITSU'S
'TOWER HOUSE' COMPLETED

ANGURA THEATRE TROUPE
TENJŌ SAJIKI FOUNDED. FIRST
'RED TENT' PRODUCTION BY
THE SITUATION THEATRE

OVER 100 UNIVERSITIES NATIONWIDE EXPERIENCE
CAMPUS CONFLICTS THAT EVOLVE INTO A
BROADER BASED 'STUDENT MOVEMENT' WITH
ANTI-ESTABLISHMENT AGENDAS. 734 STUDENTS
AND ACTIVISTS ARRESTED IN SHINJUKU ON '10.21
ANTIWAR DAY'

1968

AKASEGAWA GENPEI FOUND
GUILTY IN CASE BROUGHT
AGAINST HIM FOR HIS WORK
*MODEL 1,000-YEN NOTE
INCIDENT*

IMPERIAL HOTEL
DEMOLISHED

USA RETURNS OGASAWARA ISLANDS
(TOKYO PREFECTURE) TO JAPAN

SEKINE NOBUO'S WORK
PHASE: EARTH LAUNCHES
MONO-HA MOVEMENT

FIRST ISSUE OF
PROVOKE PUBLISHED

1969

TOKYO'S FIRST SKYSCRAPER,
KASUMIGASEKI BUILDING COMPLETED

EXHIBITION *100 YEARS OF PHOTOGRAPHY*
SURVEYS HISTORY OF JAPANESE
PHOTOGRAPHY ORGANISED BY JAPAN
PHOTOGRAPHERS ASSOCIATION AT THE
SEIBU DEPARTMENT STORE

JAPAN'S GNP RANKS SECOND TO
THE USA IN THE WESTERN BLOC

ISOZAKI ARATA'S 'THE DISMANTLING
OF ARCHITECTURE' PUBLISHED IN
BIJUTSU TECHŌ MAGAZINE (-1973)

TENJŌ SAJIKI OPENS
'TENJŌ SAJIKI-KAN'
THEATRE IN SHIBUYA

EXPO '70 HELD IN OSAKA. 64
MILLION VISITORS RECORDED

1970

FIRST PHASE OF MAKI FUMIHIKO'S
HILLSIDE TERRACE COMPLETED

THEATER CENTER
68/69 FOUNDED

JAPAN RED ARMY HIJACKS JAPAN
AIRLINES' *YODO* PLANE

*TOKYO BIENNALE '70: BETWEEN
MAN AND MATTER*, TOKYO
METROPOLITAN ART MUSEUM

WOMEN'S LIB ACTIVISTS
MARCH ON '10.21 ANTIWAR DAY'

770,000 PEACEFULLY DEMONSTRATE
NATIONWIDE AGAINST THE
AUTOMATIC EXTENSION OF ANPO

NOVELIST MISHIMA YUKIO KILLS
HIMSELF AFTER A FAILED COUP

FIRST PHOTO-CHEMICAL SMOG HITS
TOKYO. 5,208 VICTIMS REPORTED

USA RETURNS 155 WAR PAINTINGS TO JAPAN

KEIŌ PLAZA HOTEL
COMPLETED IN SHINJUKU,
TOKYO'S SUB-CENTRE

USA RETURNS OKINAWA TO JAPAN

1972

BIKYŌTŌ REVOLUTION COMMITTEE I
FOUNDED, ORGANISING A SERIES OF
MEMBERS' EXHIBITIONS OUTSIDE
THE MUSEUM/GALLERY SPACE

UNITED RED ARMY HAS
CONFRONTATION WITH POLICE FORCES
IN 'MOUNT ASAMA VILLA INCIDENT'

KUSAMA YAYOI RETURNS TO
TOKYO FROM NEW YORK

MIDDLE EAST CONFLICT LEADS TO 'OIL SHOCK' IN JAPAN.
ELECTRICITY RATIONED AND 'CRAZY PRICES' TRIGGERED

1973

BIKYŌTŌ REVOLUTION
COMMITTEE II FOUNDED

YOKO ONO PUBLISHES
'JAPANESE MEN SINKING'
IN A WOMEN'S MAGAZINE

MERCURY AND PCB POLLUTION
OF FISH BECOMES SERIOUS

VIENNA
1908-1918

RICHARD CALVOCORESSI AND
KEITH HARTLEY

previous page

Viennese Coffee House, *c.*1900

right

EGON SCHIELE

The Self-Seer 1911

Oil on canvas 80.5 × 80

Leopold Museum, Private

Foundation, Vienna

below

EGON SCHIELE

Portrait of Arnold Schoenberg

1917

Pencil, charcoal, coloured chalks

and watercolour on paper

40.5 × 27

By kind permission of the Earl and

Countess of Harewood

TABULA RASA The public debate about postmodernism in the 1970s and 1980s coincided with a growing fascination with the artistic, musical and intellectual life of Vienna in the final two decades of Habsburg rule (1898–1918). Previously overlooked by the majority of Anglo-Saxon historians as a centre of modern culture, *fin-de-siècle* Vienna offered a compelling alternative to the modernist belief in a progressive, utopian, politicised avant-garde – a concept which could perhaps more easily be applied to cities such as Paris, Moscow or Berlin. In Vienna, by contrast, the failure of liberalism and rise of nationalism, coupled with a paralysing bureaucracy and rigid Court hierarchy, produced a climate of exclusion from politics in which, paradoxically, high culture flourished. Many of the issues that have preoccupied artists in the retreat from formalism and other modernist dogmas over the last twenty or thirty years – the limits of language, memory, the body, the self – had their origins in Vienna in the early years of the twentieth century. If ever a city can be said to have suffered a crisis of identity, that city was Vienna.[1]

Our section of *Century City* focuses on the years 1908 to 1918, which saw a growing resistance to aestheticism: specifically, to the decorative mannerisms of the artists of the Vienna Secession and to the total design philosophy of Josef Hoffmann's Wiener Werkstätte. Instead, ideals of honesty and naturalness informed the architecture and theories of Adolf Loos, the satirical journalism of Karl Kraus, the philosophy of Ludwig Wittgenstein, and the paintings and graphic work of Oskar Kokoschka, Egon Schiele and Richard Gerstl. The development of a distinctly psychological form of Expressionism, with its emphasis on uncompromising subject matter and neurotic introspection, can be traced in the visual arts as well as in music (e.g. Arnold Schoenberg) and the theatre (e.g. Arthur Schnitzler), echoing the psychoanalytical discoveries of Sigmund Freud. Our section concludes with the catastrophic impact of the First World War and consequent disintegration of the Austro-Hungarian empire, when Vienna became the overcrowded capital of a tiny Alpine republic.

The empire itself had been breaking up internally since long before the war. A huge, disparate area stretching from Switzerland in the west to Russia in the east, and from Germany in the north to Serbia in the south, Austria–Hungary boasted two capitals, Vienna and Budapest, eleven nationalities speaking fifteen different languages, and a conservative Catholic monarch, Franz Josef, who had been on the throne since 1848. Its prospects of surviving the growing national demands for self-rule in the Austrian half of the empire, not to speak of ethnic and religious divisions, were minimal. The late and hurried introduction of industrialisation only exacerbated these tensions. It is not surprising that Kraus, in July 1914, should have described the empire as an 'experimental station for the end of the world'.[2]

Among minorities, Jews accounted for an increasingly high proportion of the population in the two capital cities – in Vienna at least 10 per cent, more than double that figure in Budapest. Few of the great Jewish intellectuals and artists of late Habsburg Vienna were actually Viennese by birth: for example, Kraus came from Bohemia, Freud from Moravia, reflecting a widespread migration from small provincial towns to the centre. Orthodox Jews from Galicia and the other eastern provinces were often resented by the assimilated westernised Jews of the Viennese bourgeoisie, who included several significant patrons of the avant-garde, as well as many of its practitioners. Between

VIENNA/1908–1918/RICHARD CALVOCORESSI/KEITH HARTLEY

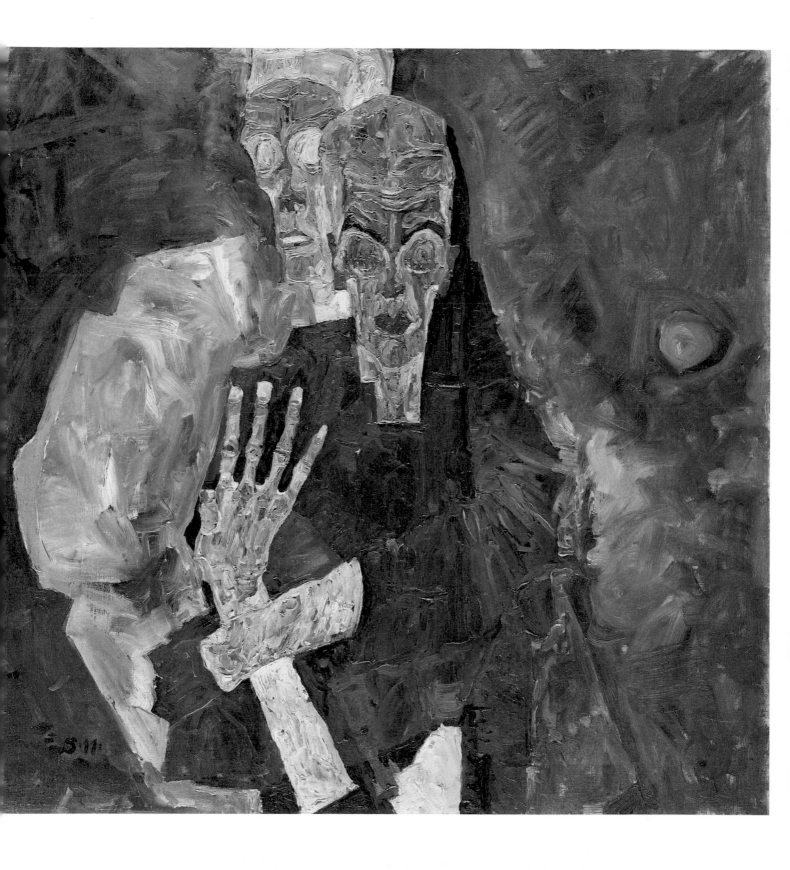

above left

Ringstrasse, Vienna

above right

OTTO WAGNER

Project for an Industrial

Exhibition Hall, Vienna,

Zedlitzgasse 1913

Pencil and indian ink on paper

53.5 × 54.5

Museen der Stadt Wien, Vienna

1880 and 1910, as commercial and industrial opportunities expanded, the population of Vienna trebled, from 700,000 to over two million. Social deprivation and a desperate housing shortage resulted, with working-class unrest soon presenting a serious threat to the prosperous bourgeoisie. In 1897 the Christian Socialist Karl Lueger was elected Mayor, promising to represent the interests of the 'little man' – the shopkeeper, artisan and small employer – caught between the two extremes of large-scale capitalism and organised labour. Lueger initiated a massive programme of municipal improvements but his type of emotive populism exploited anti-Semitic prejudice and provided a fertile model for the young Adolf Hitler, who spent his formative years in the city during the latter part of Lueger's rule.

The physical appearance of Vienna changed dramatically under Franz Josef. On the site of the medieval city walls the emperor built a splendid boulevard, the famous Ringstrasse, which he lined with monumental public buildings and ostentatious apartment blocks in various historical styles – classical, gothic, baroque and so on. Modernisation of the city continued under the great town planner and architect-engineer Otto Wagner, who in 1894 was given responsibility for the construction of a metropolitan railway, the Stadtbahn, and for the regulation of the Danube canal. Here, and in Wagner's Postal Savings Bank (1904–6) and in his numerous projects for public buildings – many of which, such as his Industrial Exhibition Hall, were never built – we can sense a new spirit of functionalism and rationality, allied with a bold use of modern technology, replacing the nineteenth-century love of ornament.

Austria–Hungary before 1914 has been memorably, if idealistically, characterised by Stefan Zweig as 'the Golden Age of Security'. Social life in Vienna was centred on an endless succession of ceremonial parades and festivities, some held to celebrate anniversaries in Franz Josef's 68-year reign, others military or religious. Zweig writes perceptively of the Viennese love of entertainment and dressing up, its obsession with music and the theatre. In 'this wonderfully orchestrated city' public life itself assumed a theatrical dimension.[3]

VIENNA/1908–1918/RICHARD CALVOCORESSI/KEITH HARTLEY

OSKAR KOKOSCHKA

Adolf Loos 1909

Oil on canvas 74 × 91

Staatliche Museen zu Berlin,

Nationalgalerie

The sense of permanence and stability evoked by the 'Golden Age' was, as Zweig and others soon discovered, deceptive. Similarly, behind the aestheticised, pleasure-loving façade of Viennese public life lurked darker conflicts and contradictions. The artists, musicians and writers who probed beneath the surface, often in the face of hostility or indifference from a conservative press and establishment (Kraus called Austria an 'isolation cell in which one is allowed to scream'), met regularly to exchange ideas in the numerous coffee-houses that are such a distinctive feature of Vienna. In his monograph on Kraus, Edward Timms has demonstrated how 'the whole structure of avant-garde culture in Vienna can be pictured as a series of intersecting "circles"', each one with its own favourite café, a dominant personality at its centre and one or more members who were also members of other circles.[4] These inter-relationships not only ensured, as Timms notes, 'a rapid circulation of ideas'; they also strengthened the fundamental interdisciplinary character of artistic and intellectual life in Vienna. The groups around the architect Adolf Loos and the satirist Karl Kraus, for example, included the painter

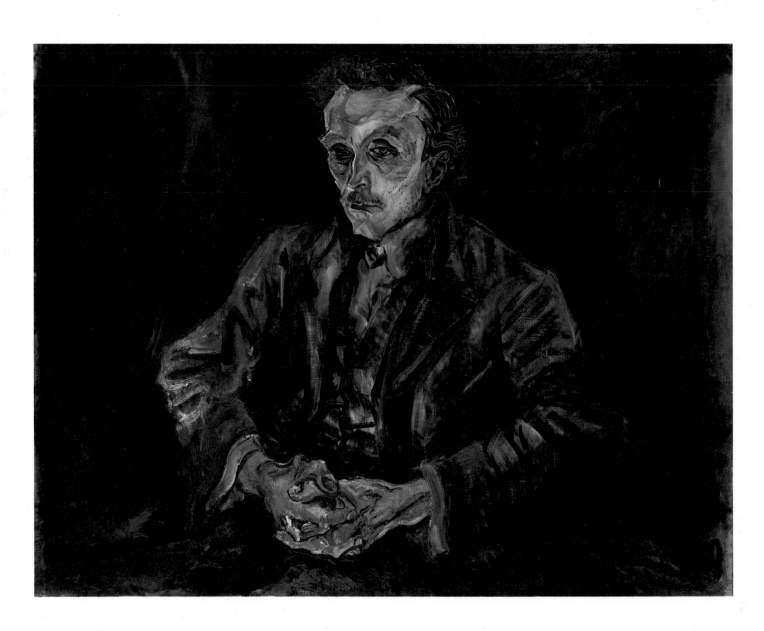

left

ADOLF LOOS

My House on the

Michaelerplatz 1911

Poster for a lecture 80 × 60

Museen der Stadt Wien, Vienna

below

ADOLF LOOS

House on the Michaelerplatz,

1909-11

View from the Hofburg, 1950s

Loos Archive, Albertina, Vienna

Oskar Kokoschka, the poet Peter Altenberg and the young philosopher Ludwig Wittgenstein. It is worth recalling that Kokoschka also wrote plays and stories and that Wittgenstein was later to design a house – just as the composer Schoenberg (who had his own circle) painted expressionist pictures. Crossing the divide between different art forms or disciplines was common at the time, but nowhere more so than in Vienna.

Several themes and approaches emerged in the 1890s but by 1908 they were so pronounced and broadly-based that we can speak of a common avant-garde culture. This was characterised by an overwhelming desire for truthfulness in ideas, words, images and deeds. The hypocrisy and pretentiousness of nineteenth-century Viennese society could no longer be supported. People pretended to live in renaissance palaces on the Ringstrasse but in fact merely had a flat that hid behind a floridly ornamented façade. Prostitutes catered for the sexual appetites of the same respectable, middle-class husbands who publicly attacked the growth of prostitution. Although the visual arts had by the turn of the century largely turned their back on historicism, they had then become enthralled to an aestheticism that concealed the realities of life. However, the reformers were busy at work, criticising the *status quo* and setting out guidelines for how things could be in the future. So thorough and profound were many of these thinkers and artists that what they proposed was nothing short of a blueprint for the twentieth century as a whole – not just for Vienna but for the rest of the world.

Otto Wagner's attempts to create a modern metropolis based on new building materials and techniques were taken up with programmatic zeal by Adolf Loos, not only in his own architecture but in his published writings and lectures. In 1898 he likened the Ringstrasse to a 'Potemkin city', recalling the story that Count Potemkin had had sham villages of canvas and cardboard erected in the Crimea to impress his lover Catherine the Great.[5] Loos was an incisive and witty writer and an unforgettable lecturer on a wide range of cultural and social topics from cooking and underwear to plumbing and typography. His aim was to reform Austrian taste and habits which he considered backward in comparison to the more modern and liberated way of life practised in Anglo-Saxon countries: 'the centre of Western culture is London', he wrote in 1898.[6] In 1903 he published two issues of a paper entitled *Das Andere* (The Other), which he wrote entirely himself; it was ironically subtitled 'a journal for the introduction of western civilization into Austria'.

In 1910 Loos's most controversial building was erected: the department store-cum-apartment block for the gentleman's outfitters Goldman und Salatsch, built on the Michaelerplatz opposite one of the grandiose gates of the Hofburg (Imperial Palace). Today the neutrality of its plastered upper storeys, with their impassive rows of identical and regularly placed window openings, scarcely merits a second glance. Even the free classicism of the green marble columns below, signifying the commercial or public face of the building, seems unremarkable. Yet seen in the context of Habsburg Vienna's love of ornament, whether historicist or Secessionist, the building assumes an ideological charge: as Karl Kraus so succinctly put it, Loos 'has built them an idea'.[7] 1910 was also the year of Loos's much photographed Steiner House, tucked away in a quiet residential suburb, with its flat roof, plain wall surfaces and equally austere geometry. Both buildings proclaim the virtues of impersonality, discretion, the absence of style – the

opposite of the Secessionist or Wiener Werkstätte house. Kraus once again neatly summed it up when he called Loos 'the architect of the *tabula rasa*'.[8]

Loos is probably best remembered for his campaign against unnecessary, time-wasting decoration which he waged in such sardonic essays and pamphlets as 'The Poor Little Rich Man' (1900) and 'Ornament and Crime' (1908). In the latter he places ornament in an anthropological context, arguing that as time has progressed ornament has become less and less of a necessity. In the earliest of times and in primitive cultures people decorated not only all the objects they used but also their bodies, in the form of tattoos. Now, Loos says, only criminals and degenerates tattoo their bodies. Thus, pressing his point in true polemical fashion, he argues that since only criminals use ornament today, ornament is regressive: it is a crime. Setting out what later became the tenets of modernist design, Loos concludes: 'The evolution of culture is synonymous with the removal of ornament from objects of daily use.'[9] The modernists, however, chose to ignore the degree of irony or tongue-in-cheek in much of this: for example, Loos also claimed that 'one can measure the culture of a country by the degree to which its lavatory walls are daubed'.[9]

Loos placed a high value on art, which he saw as having a spiritual role, in contrast to architecture, which should essentially be good honest building. A work of art and a utilitarian object were not to be confused. The concept of the artist-designed, total environment was therefore anathema to him, and he vigorously opposed the artefacts of the Wiener Werkstätte and, later, the Bauhaus. He usually let his clients choose their own furniture, while favouring the comfort, discreet good craftsmanship and practical design which he recognised, for example, in eighteenth-century English chairs; he found similar qualities of practicality and unselfconsciousness in English tailoring. He developed a complex language of materials, mixing different types of wood, marble and stone with glass, mirror glass, leather and brass. Anyone who visits his few surviving interiors will be struck by their colour, warmth and understated elegance.

In many respects Loos's wish to demystify architecture, and certainly his guiding ethos of scrupulous honesty, find a parallel in the work of his close friend the satirist and aphorist Karl Kraus. In 1899 Kraus founded his own periodical *Die Fackel* (The Torch) and

Karl Kraus reading aloud in public, 1921

Photograph: Atelier Joël-Heinzelmann, Berlin

VIENNA/1908–1918/RICHARD CALVOCORESSI/KEITH HARTLEY

from 1911 wrote every issue himself. He led a one-man campaign against the abuse of language for political ends but he also attacked corruption, hypocrisy and injustice wherever he found them. One of Kraus's main targets was the press which, although purporting to be independent and dedicated to the dissemination of truth, was according to Kraus biased towards the *status quo* and unwilling to reveal the dishonesty upon which Austrian society was based. Kraus's venom was saved for the famous *feuilletons*, those sections of the newspapers that 'commented' on current affairs and in particular on the cultural life of the capital. What Kraus found so objectionable about the *feuilletons* was that they embodied a deadly flaw in Austrian life, the inability to distinguish between facts as they are and the way that we interpret them. Their very *raison d'être* was to ignore facts and concentrate on the personality and style of the writers. Their emphasis on subjective impressions reflected one of the dominant philosophical trends of the day, the view propounded by Ernst Mach that reduced all knowledge to sensations rather than the powers of innate reasoning. The trouble with this was that it tended to overemphasise the individual viewpoint and undervalue shared experience.

Kraus's particular method of attacking lies and hypocrisy was to expose the inconsistencies and double standards in what people wrote, said and did. He would use their actual words and juxtapose them with what they had written elsewhere in order to show how they did not match up, that they were in fact based either on fabrication or on unconscious delusions. He used this method to devastating effect in his anti-war documentary drama *The Last Days of Mankind,* where many of the speeches are taken direct from newspapers.

Kraus shared many of the concerns of his fellow reformers. He criticised the sexual hypocrisy of his age, arguing that, provided they did not infringe the civil liberties of others, 'abnormal' sexual practices were no business of the state and should be decriminalised. He argued for equal treatment under the law for women and homosexuals, and, like Freud, defended the prostitute against the police. However, he did believe that women should not follow men into business and other walks of life dominated by men, since that would negate their essential nature, which was sensual rather than intellectual. In this respect Kraus was very much in line with other writers of his age whom he championed, such as Frank Wedekind whose trilogy of plays, *Pandora's Box* (1892–4), shows the destructive effect of a corrupt society on the instinctual life of the main character Lulu; or Otto Weininger, whose book *Sex and Character* (1903) emphasises what he saw as the overwhelming sexual nature of women compared with the duality (spiritual/sexual) of the male personality.

This intense interest in sexuality in turn-of -the-century Vienna was shared by the playwright Arthur Schnitzler who saw it as an all-powerful force affecting all sections of society alike. In his most famous play *Reigen* (1896–7), or *La Ronde*, censored in Vienna for many years and only given its first performance in 1920 in Berlin, ten couples belonging to very different classes of society talk about their feelings before and after sex. However, one half of the first couple makes up the other half of the second and so on, so that in the end the circle is closed and the audience gains an insight into the basic nature of the sex drive linking them together.

Schnitzler had trained as a doctor and was well acquainted with the latest

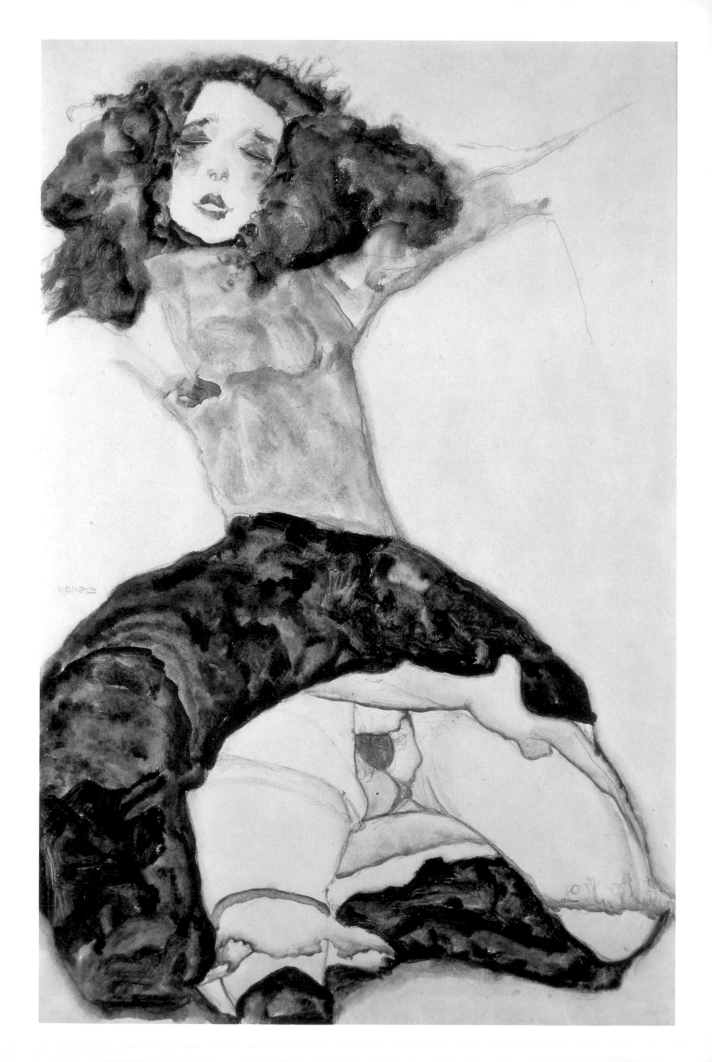

developments in research into sexuality and its role in the human personality. The most significant and far-reaching work in this area was carried out by Sigmund Freud. His 'discovery' of the importance of infantile and childhood sexuality in the development of a fully functioning and well-adjusted adult, and of its obverse, the role that suppression and disruptions in sexual development played in later psychological problems, caused a scandal when it was first elaborated in such works as *The Interpretation of Dreams* (1900) and *Three Essays on the Theory of Sexuality* (1905). What Freud also did was to divorce sexuality from an exclusively genital orientation, centred on reproduction, and to give it a more general significance, involving the whole of the human body and personality. These were taboo subjects in traditional middle-class Vienna, suggesting as they did that much of human behaviour was governed by sexual impulses. One of the most disturbing aspects of *The Interpretation of Dreams* was Freud's revelation of the Oedipus complex – the theory that the very young child unconsciously seeks to possess the parent of the opposite sex while eliminating that of the same sex.

left

EGON SCHIELE

Black-Haired Girl with Raised Skirt 1911

Pencil and gouache on paper

55.9 × 37.8

Leopold Museum, Private Foundation, Vienna

right

Freud's Consulting Room in Vienna, 1938

Photograph: Edmund Engelman

Courtesy Thomas Engelman, Newton

Equally offensive to those who believed in the sovereignty of the will and human reason was Freud's 'demonstration' that beneath our conscious mind was a seething underworld of primitive feelings that had more of an impact on our judgements and actions than we might care to contemplate. As Freud put it, the ego 'is not master in its own house'.[11] This idea proved revolutionary not only in turn-of-the-century Vienna but throughout the twentieth century. If our conscious minds could no longer be certain that our views of the world were rationally based, how could we be certain about anything? The whole scientific, positivist structure of the world was in danger of collapsing. The massive growth of postmodernist relativism and scepticism since the Second World War is in no small part due to the working out of the implications of Freud's theory of the unconscious.

If Freud opened the door to doubt that we could rationally construe the world, his fellow Viennese Ludwig Wittgenstein set limits to what our reason could understand and to what thoughts could be expressed. Building upon the logic of language of Gottlob

below

OSKAR KOKOSCHKA

Standing Nude Girl *c.*1907

Pencil and gouache on paper

43.2 × 29.2

Private Collection, London

right

OSKAR KOKOSCHKA

Poster Design for *Der Sturm*

1910

Tempera on canvas 102 × 70

Szépművészeti Muzeum,

Budapest

Frege and Bertrand Russell, Wittgenstein believed that he had solved the problem of what reason – and the language we use to articulate our thoughts – could explain and what it could not. He believed that it could describe the facts of the world as they present themselves to us, but not what those facts mean to us – their ethical values, in other words. In his famous philosophical work *Tractatus Logico-Philosophicus* (first published in German in 1921 but begun a decade earlier) Wittgenstein drew the boundaries between science on the one hand and ethics/art/religion on the other. He was in no doubt as to which was the most important. He wrote:

> The book's point is an ethical one ... My work consists of two parts: the one presented here plus all that I have *not* written. And it is precisely this second part that is the important one. My book draws limits to the sphere of the ethical from the inside as it were, and I am convinced that this is the ONLY *rigorous* way of drawing those limits. In short, I believe that where *many* others today are just *gassing*, I have managed in my book to put everything firmly into place by being silent about it.[12]

In other words, it is impossible to write logically about ethics (and art); all one can do is to define their territory. Just as Kraus had tried to separate factual writing from art, or as Loos had made a clear distinction between architecture (building) on the one hand and the expressive arts on the other, so Wittgenstein (who was influenced by both) laid down the philosophical foundations of what we can speak about and of what 'we must pass over in silence'.[13]

In the visual arts, the most important figure in the circles around Kraus and Loos was the iconoclastic young painter Oskar Kokoschka. While studying at the School of Applied Arts in Vienna, Kokoschka became an associate of the Wiener Werkstätte. In 1908 he was invited to teach an evening class at the School, where he introduced the practice of sketching naked figures in motion, using as his models children from the streets. With no formal training in painting, Kokoschka's early work is largely graphic (postcards, programme covers, posters etc.), indebted to Klimt and the stylised art of the Vienna Secession. But in 1908 the Wiener Werkstätte published his illustrated 'fairy tale', *The Dreaming Youths*. In Kokoschka's staccato, stream-of-consciousness text and crude, brightly coloured images with their erotic undertones, the Secessionist love of sinuous decoration has been replaced by jagged rhythms and a more distorted figure style. The following year, 1909, saw Kokoschka's total break with ornament in his poster for the second *Kunstschau* (art show), which had replaced the Secession as the principal exhibiting venue for the avant-garde; it was here that Kokoschka's short drama *Murderer, Hope of Women* was first performed. His poster shows a deadly coupling of a man and a woman whose contorted, angular forms reflect the violent body language of the play. With its theme of explicit sexual conflict and its primitive movement and dialogue, *Murderer, Hope of Women* is considered by some to be the first example of expressionist theatre.

Kokoschka left the School of Applied Arts in 1909, and, encouraged by Loos, cut his links with the Wiener Werkstätte. Loos was the first to recognise Kokoschka's genius as a radically new kind of portrait painter, free from Secessionist artificiality. He not only solicited commissions but paid the artist out of his own pocket when a sitter refused to

VIENNA/1908–1918/RICHARD CALVOCORESSI/KEITH HARTLEY

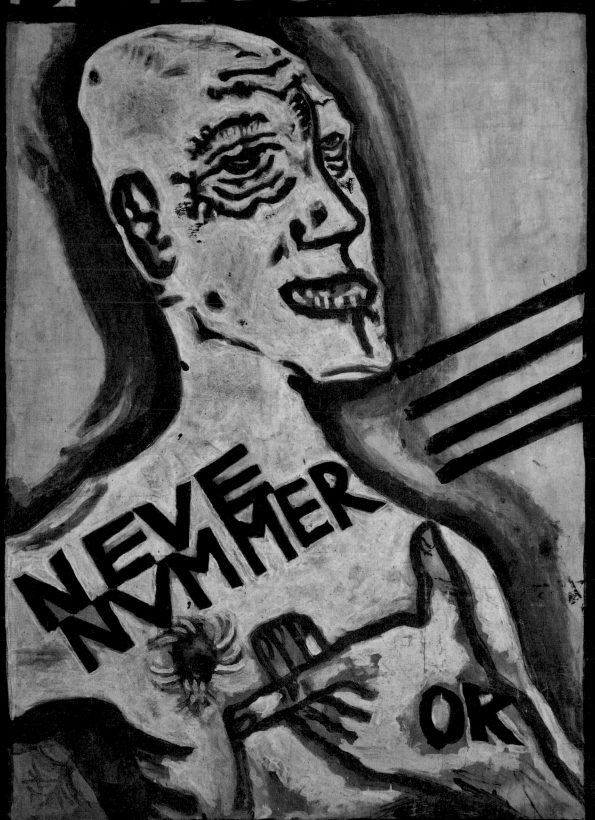

right

OSKAR KOKOSCHKA

Conte Verona 1910

Oil on canvas 70.6 × 58.7

Private Collection, Courtesy
Marlborough International Fine Art

far right

Portrait of Egon Schiele, 1914

Photograph: Anton Josef Trcka

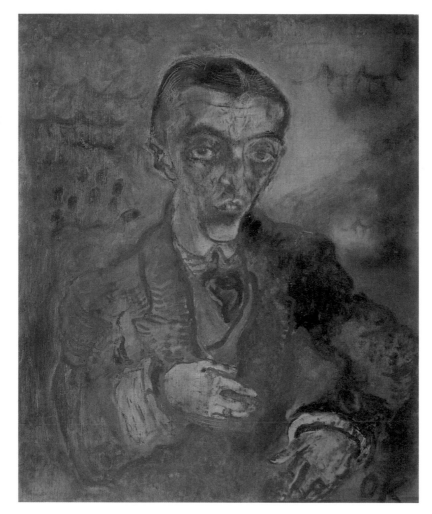

buy his or her likeness, as often happened.

Between 1909 and 1911 Kokoschka painted an extraordinary series of portraits which, in their intense concentration on the psychological condition of his subjects, mark a major contribution to Expressionism. These portraits are characterised above all by rawness, immediacy and a total lack of aesthetic grace. Critics at the time complained of their disgusting colours, their diseased looks, their closeness to caricature. Yet some give the feeling of being barely painted at all, as if the artist had imprinted a photographic negative or X-ray of his subject onto canvas, lending the image a ghostly quality. In reality, Kokoschka would rub and scrape the paint surface with his bare hands or a cloth. Great emphasis is placed on the sitter's face and hands, which seem to twitch and pulsate with life. In these areas Kokoschka often scratched the wet paint with a fingernail or the sharp end of the brush handle, producing a network of tiny lines. In 1910, while living in Berlin, he drew a number of heads for Herwarth Walden's expressionist weekly *Der Sturm* (inspired by *Die Fackel* and partly financed by Kraus), in which such graphic marks play a more descriptive role, suggesting cuts, scars or nervous tics.

Over the next few years Kokoschka's subjects included artists, musicians and intellectuals such as Kraus, Loos, Peter Altenberg, Hans and Erika Tietze, Hermann

VIENNA/1908–1918/RICHARD CALVOCORESSI/KEITH HARTLEY

Schwarzwald, Egon Wellesz, Anton von Webern and Ludwig von Ficker – a veritable portrait gallery of the Austrian avant-garde. Isolated against blank, impersonal backgrounds, they appear rootless and vulnerable. Among Kokoschka's most haunting early portraits are a series depicting tuberculosis patients in a Swiss sanatorium, including the febrile Conte Verona whom the artist described as 'a small Italian who was a passionate skater and often spat blood'.[14] Kokoschka's friend the painter Felix Albrecht Harta wrote: 'His subjects all looked like people possessed by demons or like the Damned souls of Hell. Kokoschka looked behind the cosy façade of the bourgeoisie of his day, as if, like a visionary, he could foresee the catastrophe that was about to engulf it.'[15]

Portraiture, and especially self-portraiture, features prominently in the small oeuvre of the equally precocious Richard Gerstl, who committed suicide in 1908 aged twenty-five. Gerstl has sometimes been called 'the first Austrian Expressionist' although his work was unseen until the 1930s.[16] A difficult, uncompromising person, he does not appear to have mixed with other painters, preferring the company of composers such as Schoenberg, the latter's brother-in-law Alexander Zemlinsky and his pupils Webern and Berg, until they ostracised him as a result of his affair with Schoenberg's wife. Before this he may have given Schoenberg painting lessons, at a time when the composer was engaged in his heroic attempt to compress and purify music after the vast emotional narratives of the later Romantic period. Schoenberg's first atonal compositions, with their exploration of intense inner states, date from 1908, the year of Gerstl's death. Gerstl was familiar with the writings of Freud and of Otto Weininger, who killed himself at the age of twenty-three a few years before Gerstl. The influence of van Gogh can be seen in some of his oils, with their thick, broken brushstrokes and remarkably free handling of paint. In his *Nude Self-Portrait* he exposes himself mercilessly to our uncomfortable gaze, without a trace of either irony or self-pity.

Kokokschka also occasionally portrayed himself naked, in allegorical double-portraits with his lover Alma Mahler, widow of the composer Gustav Mahler. But it is in the work of Egon Schiele that naked self-portraiture moves centre-stage and assumes an explicitly sexual charge.

In Vienna at the beginning of the twentieth century sexuality became one of the dominant themes in the visual arts. As has already been mentioned, this development began in the theatre with the plays of Schnitzler and Wedekind and in the writings of Weininger and Freud. The artist Gustav Klimt took up the theme in his allegorical paintings (*Nuda Veritas* 1899, *The Beethoven Frieze* 1902) and paintings of water spirits, but above all in his drawings. These showed naked couples making love, women blatantly exposing their sexual parts and masturbating. Previously these had been the subject of the backroom trade in pornography. In the new climate encouraged by a more open discussion of sexuality, even an artist as successful and celebrated as Klimt felt that he could push the boundaries of what was socially acceptable.

When Egon Schiele came on the scene in 1909, aged nineteen, he at first consciously modelled himself on Klimt, paraphrasing some of the older artist's paintings and even going so far as to call himself the 'Silver Klimt'. From the first he took as his subject the naked model, including himself. This last was a daring thing to do. Up until then there were few examples of the nude self-portrait in art history. The most famous

VIENNA/1908–1918/RICHARD CALVOCORESSI/KEITH HARTLEY

was Dürer's drawing in Weimar. In the nineteenth century a few German artists had depicted themselves half naked, but it was only relatively recently that an artist had made it an important aspect of her work. Paula Modersohn-Becker's nude self-portraits, particularly the one in which she shows herself pregnant (1906), had caused a storm of protest when they were shown. Schiele's nude self-portraits are part of a series of self-portraits in which the artist examines his whole person, from grimacing facial expressions, through careful gesticulating of the arms and hands, to masturbation. The sexual is but one aspect of the whole. It is as if Schiele were trying to run the gamut of all the emotions, characters, types that he as an individual might assume. They are not so much attempts to capture the fleeting impressions of passing feelings or to plumb the depths of his psyche; rather they are like the roles of an actor or mime (such as his colleague Erwin Osen). Most of the poses are highly contrived and as such look back to the self-portraits of James Ensor (even to some of the more posed paintings of Rubens and Rembrandt) and forward to the polymorphous photographs of Cindy Sherman.

Among the hundreds of nude drawings that Schiele did, there are a large number of children and adolescents. It has been pointed out that, for a fairly impecunious artist, it was much cheaper for him to draw the children of the poor than to hire models; and also that he was only a few years older than many of them. However, this would have been the case with other artists at the time who did not concentrate on portraying children and adolescents, particularly in the nude or semi-nude. The interest seems to have been personal, aided by the general climate of the time. Child prostitution was widespread in Vienna and young girls were the focus of attention for a number of writers, such as the eccentric poet and wit Peter Altenberg who sent provocative postcards to his friends and who had a large collection of such photographs decorating his apartment. Although it is generally agreed that Schiele had not read the works of Freud, he surely could not have escaped the general interest in (not to say scandal caused by) Freud's theories of childhood sexuality. Just as Schiele himself adopted poses and moods for his own drawings, so he got his young models to appear now coy and shy, now provocative and forward. The works were meant to break taboos and go beyond the bounds of what was considered acceptable at the time. They still have the ability to disturb us today.

Schiele felt that as an artist he had the right to freedom of expression, but the authorities of Neulengbach, a small town near Vienna where he was staying in 1912, thought otherwise and had him imprisoned on pornography charges for a few days. During his time in jail he drew some of his most searing self-portraits as a persecuted and outcast individual. Afterwards he turned away from drawing children (at least in the nude) and there is a marked change in the style and mood of his depictions of the nude. Many of them are still explicitly sexual in their content and erotic in their purpose, but they do not have the same raw and tormented quality of the earlier work. In those earlier drawings there was always the feeling of a young immature adult trying to come to terms with his own sexuality and using his art if not as therapy then as an arena for helping to find his own identity. It is this experimental, almost provisional quality of Schiele's work that appeals to us today and why his drawings, often done in a few minutes, have a directness that looks forward to the performance and actionist art of the 1960s and beyond.

below

EGON SCHIELE

Nude Self-Portrait, Squatting

1916

Pencil and gouache on paper

29.5 × 45.8

Graphische Sammlung Albertina,

Vienna

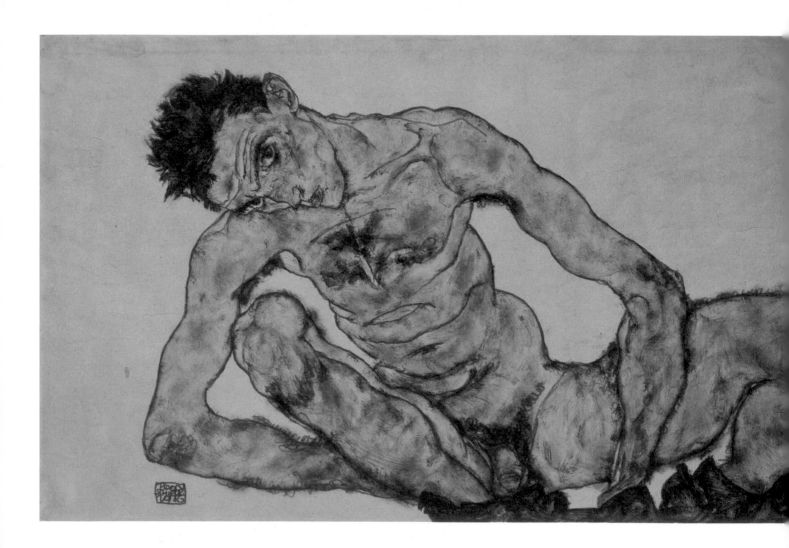

right

EGON SCHIELE

Self-Portrait with Lowered

Head 1912

Oil on wood 42.2 × 33.7

Leopold Museum, Private

Foundation, Vienna

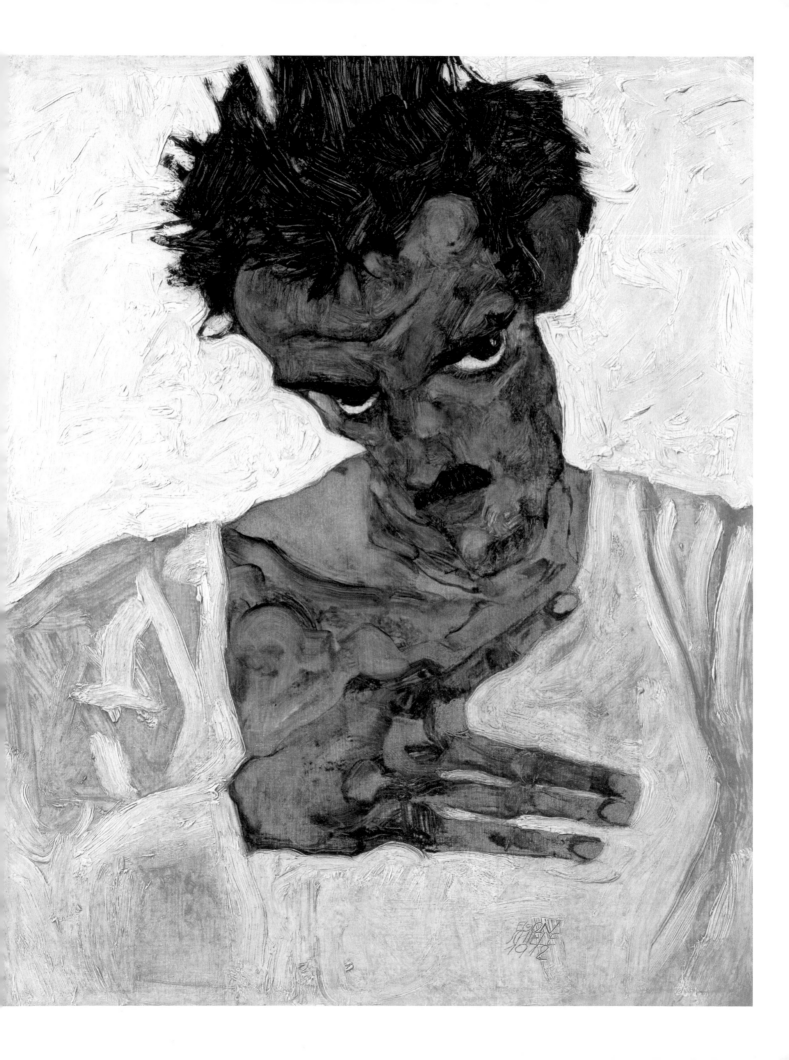

THE LAST DAYS OF MANKIND The bullet which killed Archduke Franz Ferdinand, heir to the Austro-Hungarian throne, at Sarajevo in June 1914 'shattered the world of security and creative reason in which we had been educated, had grown up and been at home', wrote Stefan Zweig.[17] A month later Austria-Hungary, after fifty years of peace, declared war on Serbia. By early August Britain, France and Russia had entered the conflict against the Central Powers (Austria–Hungary and Germany), who were later joined by Turkey. In 1915 Italy also declared war on Austria–Hungary.

Of all the radial thinkers and artists in our period, only Kraus publicly (and Schnitzler silently) opposed the war from the beginning. Even that normally humane and reflective eye-witness Stefan Zweig felt himself caught up in the mood of patriotic fervour sweeping Vienna. Zweig's attitude to the war remained ambiguous but, many years later, he was careful to distance himself from the xenophobia and militant nationalism that had affected the majority of his fellow citizens:

> the pure, beautiful, sacrifical enthusiasm of the opening days became gradually transformed into an orgy of the worst and most stupid impulses. In Vienna … one 'fought' France and England in the Ringstrasse … which was definitely more comfortable. The French and English signs on the shops were made to disappear … Sober merchants stamped or pasted *Gott strafe England* [God punish England] on their letters, and society ladies swore (so they wrote to the newspapers) that never again would they speak a single word of French. Shakespeare was banned from the German stage.[18]

The war brought people together with often unforeseen consequences. In 1916 Wittgenstein, after prolonged service on the Eastern front, was posted to Olmütz in Moravia for retraining. Armed with an introduction from Loos he sought out and

befriended Paul Engelmann, one of Loos's former pupils and a disciple of Kraus. Ten years later, Engelmann helped Wittgenstein on the initial stages of the mansion or 'palais' which the latter designed for his sister Gretl Stonborough-Wittgenstein in Vienna. Superficially reminiscent of Loos in its crisp, cuboid exterior and absence of superfluous detail, to the extent of avoiding all natural and semi-precious materials in favour of the industrially manufactured, the house goes even further than Loos in its precise, logical analysis of the needs of its occupants. As Bernhard Leitner, one of those responsible for saving it from demolition in the early 1970s, has written: 'The interior … is unique in the history of twentieth-century architecture. Everything is re-thought. Nothing in it has been directly transplanted, neither from any building convention nor from any professional avant-garde.'[19]

Wittgenstein had joined up as a gunner in August 1914. He endured five years of hardship and danger, seeing action on the Russian and Italian fronts and ending up as a prisoner of war in Italy. He was decorated four times for bravery and in 1916 was promoted to lieutenant. The sight of mass destruction and waste, and the experience of sharing the suffering of ordinary people, profoundly affected not only his character but his philosophical thoughts, which he wrote down in increasingly aphoristic form in notebooks which he carried around with him; some of them would eventually find their way into the *Tractatus*. The defeat of the Central Powers, about which Wittgenstein never had any illusions, and the break-up of the Austro-Hungarian army into its national groupings, marked the end of an empire which had been inextricably bound up with his own family's prosperity and influence. From now on his life would be deliberately purged of the trappings of privilege.[20]

By 1917 Kokoschka's views about war had moved in the direction of scepticism, if not pacifism. His experience of the front line was briefer than Wittgenstein's but more dramatic. In August 1915 he was wounded by a bullet to the head and a bayonet thrust in the lung in the western Ukraine, where his cavalry regiment was taking part in an advance on the Russian border. On his discharge from hospital in Vienna six months later he was declared temporarily unfit to return to the front. However, in July 1916 he was called up to serve as a liaison officer on the Italian front, in the hills above the river Isonzo (now in Slovenia), where he accompanied a group of war correspondents and artists and was responsible to the local High Command for their work, travel, food, welfare and so on. Although this may have been a gesture on the part of the War Press Headquarters to shield Kokoschka from being sent back as a combatant to the front, he nevertheless witnessed the destruction of villages at close range. In late August 1916 his military career came to an abrupt end when a grenade exploded in front of him as he strayed into no-man's land, causing severe shock and necessitating his return to hospital in Vienna. During the six weeks he spent at the Isonzo front, Kokoschka filled a number of sketchbooks with pastel drawings of gun emplacements, trenches, dugouts and other military subjects, which are unusual for their documentary accuracy. Universalised images of brutality and death began to emerge in his more expressionist works, particularly in his lithographic cycles and dramatic texts.

Egon Schiele spent all of his three years as a soldier inside Austria, apart from basic training in Bohemia. He seems to have been protected by the authorities for at least part

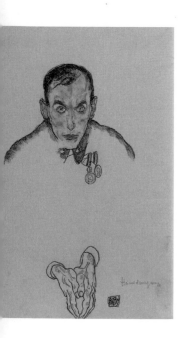

of this time since, unlike Kokoschka, he never saw active service. Instead he guarded Russian prisoners of war, whom he drew in a series of poignant portraits. He also portrayed his fellow soldiers and superior officers. Jane Kallir, the Schiele scholar, detects a 'greater human empathy' in these wartime portraits, with their less stylised, more plastic forms, anticipating Schiele's later oils.[21] In early 1917 Schiele was transferred to the main military Supply Depot in Vienna, where his commanding officer commissioned him to make a record of this and other depots. Like Kokoschka's sketches of military installations along the Isonzo front, Schiele's incisive line drawings are notable for the amount of objective information they convey – a pictorial inventory rather than an expressionist reworking of reality. In October 1917 Schiele applied for a transfer to the Heeresmuseum (Army Museum) in Vienna, which had become something of a refuge for artists under the enlightened directorship of Wilhelm John. Permission to transfer finally came through in April 1918.[22] Six months later Schiele died from the notorious Spanish flu epidemic which had already claimed his young wife.

Karl Kraus began his vast mock-epic drama *The Last Days of Mankind* in 1915 and published it in instalments in *Die Fackel* from 1918 onwards; it did not appear in book form until 1922, although Kraus gave public readings from it during the war. It consists of over 200 scenes and about 500 characters, real and imaginary, beginning with the cry of the newspaper boy on the Ringstrasse in the summer of 1914 and ending apocalyptically with the voice of God echoing over the killing fields four years later.

The anonymity and dehumanising effect of modern mechanised warfare that Kraus so deplored are chillingly captured in the monumental compositions of the Tyrolean painter Albin Egger-Lienz, who served briefly as a war artist on the Italian front. But Kraus's theme is even greater in scope: the collapse of an entire civilisation, as observed by 'the Pessimist' (based partly on Kraus himself) in café conversations throughout the play with his friend 'the Optimist' (a naive patriot). Kraus reserved his most sarcastic contempt for what he saw as the collusion between militarism and journalism, summed up in his punning phrase 'eine wohl uniformierte Presse' (a well uniformed press). Kraus invented very little: the chauvinistic and propaganda speeches were lifted direct from newspaper articles and editorials. He juxtaposes these, without intervention, with the reality of life at the front or in the field hospital. The accumulation of short episodes resembles a collage of music and laughter (Vienna waltzes while millions are slaughtered), shouts, battlefield noises (the increasingly sophisticated military technology was another of Kraus's targets), speeches and dialogue.[23] With each new scene, Kraus constructs a grotesque phantasmagoria of incompetence, hypocrisy, callousness and deceit. His principal message – that insensitive reporting and thoughtless cliché trivialise and conceal the truth about war – has lost none of its relevance in our age of the media conflict.

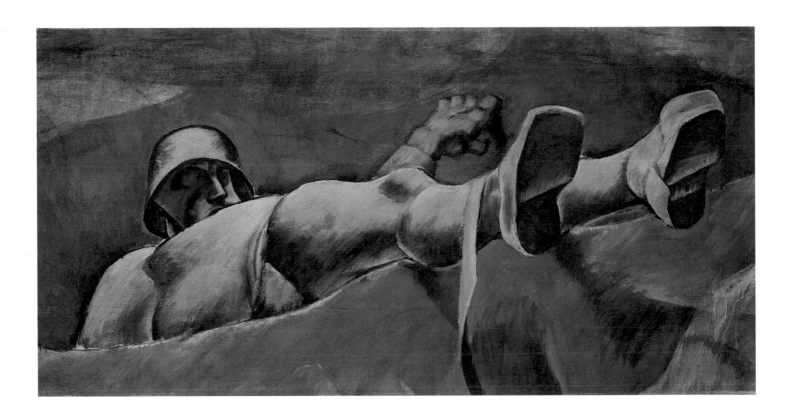

Notes

1　These ideas are explored in much greater depth in Steven Beller, 'Modern Owls fly by Night: Recent Literature on fin de siècle Vienna', *The Historical Journal* 31, 3, 1988, pp.665-683. See also Carl E. Schorske, 'Revolt in Vienna', *The New York Review of Books*, 29 May 1986, pp.24-29.

2　*Die Fackel* no.400-403, 1914, p.2; quoted in Edward Timms, *Karl Kraus: Apocalyptic Satirist*, Newhaven and London 1986, p.10. Timms's opening chapter is an indispensable summary of the social, political and cultural situation in Vienna at the beginning of our period. See also Alan Janik and Stephen Toulmin, *Wittgenstein's Vienna*, London 1973, chapter 2; and Peter Vergo, *Vienna 1900*, exh, cat., National Museum of Antiquities of Scotland, Edinburgh 1983.

3　These phrases come from the first chapter of Zweig's *The World of Yesterday*, London 1943

4　Timms 1986, p.7.

5　Adolf Loos, *Spoken into the Void: Collected Essays 1897-1900*, introduction by Aldo Rossi, Cambridge, Mass. 1982, p.95.

6　Ibid., p.12.

7　'Er hat ihnen dort einen Gedanken hingebaut': from *Die Fackel*, no.313-314,

December 1910, reprinted in Hermann Czech and Wolfgang Mistelbauer, *Das Looshaus*, Vienna 1976, pp.84-5. Loos's illustrated lecture in December 1911 defending the building attracted an audience of 2,700 people (Timms 1986, p.7).

8　*Die Fackel*, no.300, April 1910.

9　*The Architecture of Adolf Loos*, exh. cat., Arts Council of Great Britain, London 1985, p.100.

10　Ibid.

11　'A Difficulty in the Path of Psychoanalysis', *Standard Edition of the Works of Sigmund Freud*, 17, 137, London, p.143.

12　Letter to Ludwig von Ficker, 1919, quoted in Paul Engelmann, *Letters from Ludwig Wittgenstein with a Memoir*, Oxford 1967, pp.143-4. Ficker, editor of the Innsbruck literary review *Der Brenner*, was at the time considering whether to publish the *Tractatus*. Before the war he had distributed money from a trust set up by Wittgenstein to help artists and writers. Among the beneficiaries were Loos, Rilke, Trakl and Kokoschka. It was Ficker who introduced Wittgenstein to Loos, in July 1914.

13　*Tractatus Logico-Philosophicus*, London 1971 edition, p.151.

14　Oskar Kokoschka, *Das schriftliche Werk Vol.II*,

Hamburg 1974, p.85, quoted in Frank Whitford, *Oskar Kokoschka: A Life*, London 1986, p.54.

15　'Zum 70. Geburtstag von O.K.', *Das Kunstwerk* 4, 1955-56, p.16, quoted in Richard Calvocoressi et. al., *Oskar Kokoschka 1886-1980*, exh. cat., Tate Gallery, London 1986, p.300.

16　See Jane Kallir, *Richard Gerstl. Oskar Kokoschka*, exh. cat., Galerie St. Etienne, New York 1992, pp.7-8

17　Zweig, op.cit, 1944 edition, p.166.

18　Ibid. p.181. See Timms 1986, pp.297-300, for Kraus's critique of Zweig's 'pacifism'.

19　*The Architecture of Ludwig Wittgenstein. A Documentation*, London and Halifax, Nova Scotia, 1973, p.11.

20　See Brian McGuinness, *Wittgenstein. A Life: Young Ludwig (1889-1921)*, London 1988, pp.273-4, and also Chapter 7, 'The War 1914-18'.

21　*Egon Schiele: the Complete Works*, New York 1990, p.200.

22　See Ilse Krumpöck, 'Schiele-Skizzen im Heeresgeschichtlichen Museum', *Neues Museum* 3, April 1996, pp.75-81.

23　An ideal medium for the play is radio, as Giles Havergal's recent production for BBC Radio 3 (broadcast 11 and 12 December 1999), demonstrated.

1908

KUNSTSCHAU EXHIBITION ORGANISED BY
CIRCLE OF ARTISTS AROUND GUSTAV KLIMT

ARCHITECT ADOLF LOOS PUBLISHES
ORNAMENT AND CRIME

THIRTIETH EXHIBITION OF THE *SECESSION*
IN HONOUR OF FRANZ JOSEF'S 60 YEARS
AS EMPEROR

KARL KRAUS PUBLISHES ESSAY
COLLECTION *MORALITY AND CRIMINALITY*

ARTIST RICHARD GERSTL
COMMITS SUICIDE

GUSTAV MAHLER DIES

PUBLIC UPROAR OVER FAÇADE OF
LOOS'S HOUSE ON MICHAELERPLATZ

1911

KRAUS BECOMES SOLE WRITER AND EDITOR OF
HIS LITERARY AND POLITICAL REVIEW *DIE FACKEL*

1912

KOKOSCHKA BEGINS AFFAIR
WITH ALMA MAHLER

LUDWIG WITTGENSTEIN BEGINS TO STUDY PHILOSOPHY
AT CAMBRIDGE UNIVERSITY. STARTS WORK ON WHAT
WILL BECOME *TRACTATUS LOGICO-PHILOSOPHICUS*

SCHIELE ARRESTED AND IMPRISONED FOR
24 DAYS FOR THE 'DISPLAY OF AN EROTIC
DRAWING IN ROOM OPEN TO CHILDREN'

FIRST PERFORMANCE OF ARTHUR SCHNITZLER'S
PLAY *LA RONDE* IS BANNED IN BUDAPEST

ALTENBERG COMPILES *SEMMERING*
HE CREATES AN ALBUM OF 259 CAR
AND PHOTOGRAPHS WITH THE SAME

OTTO PRIMAVESI BECOMES MANAGER OF
THE WIENER WERKSTÄTTE AND DAGOBERT
PECHE JOINS IT AS A DESIGNER

SCHIELE MARRIES EDITH
DAYS LATER HE BEGINS

VIENNA

KRAUS BEGINS *THE LAST DAYS OF MANKIND*

JOSEF HOFFMANN DESIGNS THE
SKYWA-PRIMAVESI VILLA

1916

EMPEROR FRANZ JOSEF DIES. SUCCEEDED
BY GRANDNEPHEW, ARCHDUKE KARL

KOKOSCHKA SENT TO ITALIAN FR
AND MAKES SEVERAL DRAWINGS
BEFORE BEING WOUNDED AGAIN

FREUD'S 'INTRODUCTORY
LECTURES ON PSYCHO-ANALYSIS'
AT THE UNIVERSITY OF VIENNA

KRAUS LECTURES AGAINST THE
WAR. *DIE FACKEL* REGULARLY
CONFISCATED BY THE CENSORS

PSYCHOLOGICAL WEDNESDAY EVENING
Y THAT MEETS IN SIGMUND FREUD'S
ND CONSULTING ROOM IS RENAMED
NNA PSYCHO-ANALYTICAL SOCIETY

ARNOLD SCHOENBERG'S *SECOND STRING QUARTET* OPUS 10 VERGES ON ATONALITY. THE PREMIERE CULMINATES IN NEAR RIOT.

FOUNDATION OF *NEUKUNSTGRUPPE* (NEW ART GROUP) BY EGON SCHIELE AND OTHERS

1909

OTTO WAGNER CHAIRS THE EIGHTH INTERNATIONAL CONGRESS OF ARCHITECTS IN VIENNA

AUSTRIA-HUNGARY ANNEXES BOSNIA AND HERZEGOVINA

PERFORMANCE OF KOKOSCHKA'S EXPRESSIONIST DRAMAS *SPHINX AND MAN OF STRAW* AND *MURDERER, HOPE OF WOMEN*

DEATH OF KARL LUEGER, CO-FOUNDER OF THE CHRISTIAN SOCIAL PARTY AND MAYOR OF VIENNA

LOOS'S STEINER HOUSE BUILT IN VIENNA

1910

PETER ALTENBERG BEGINS
TMENT FOR CHRONIC ALCOHOLISM
PSYCHOLOGICAL PROBLEMS

DER STURM, WEEKLY EXPRESSIONIST JOURNAL THAT FREQUENTLY INCLUDES DRAWINGS BY KOKOSCHKA, FOUNDED IN BERLIN BY HERWARTH WALDEN

SCHOENBERG COMPLETES THE MONODRAMA *EXPECTATION* AND *FIVE ORCHESTRAL PIECES*, HIS FIRST FULLY ATONAL WORKS

FIRST PERFORMANCE OF ALBAN BERG'S *ALTENBERG LIEDER*, CONDUCTED BY SCHOENBERG, PROVOKES A RIOT.

GERMANY, AUSTRIA-HUNGARY AND ITALY CONSOLIDATE 'TRIPLE ALLIANCE'

WAR DECLARED IN THE BALKANS

1913

FREUD PUBLISHES *TOTEM AND TABOO*

BALKAN PEACE TREATY SIGNED

1914

KRAUS PUBLISHES ANTI-WAR ESSAY 'IN THIS GREAT TIME'

AUSTRIA DECLARES WAR AGAINST SERBIA, PRECIPITATING OUTBREAK OF THE FIRST WORLD WAR

1915

OSCHKA JOINS DRAGOONS. ON
/E HE PAINTS PORTRAIT OF
WIG VON FICKER. IS LATER
NDED ON THE EASTERN FRONT

WITTGENSTEIN DONATES 100,000 KRONEN TO NEEDY AUSTRIAN ARTISTS. JOINS ARMY AS A VOLUNTEER GUNNER

ASSASSINATION OF ARCHDUKE FRANZ FERDINAND OF AUSTRIA IN SARAJEVO

WITTGENSTEIN RECEIVES SEVERAL CITATIONS AFTER KERENSKY OFFENSIVE ON THE EASTERN FRONT

DEATH OF WAGNER AND KLIMT. SCHIELE DIES IN SPANISH FLU EPIDEMIC

1917

1918

THE USA ENTERS THE WAR

WITTGENSTEIN TRANSFERRED TO ITALIAN FRONT. COMPLETES *TRACTATUS LOGICO-PHILOSOPHICUS*

12 NOVEMBER, DECLARATION OF THE REPUBLIC OF GERMAN-AUSTRIA BY PROVISIONAL NATIONAL ASSEMBLY

28 OCTOBER, PROCLAMATION OF INDEPENDENT CZECHOSLOVAKIA

KRAUS'S *THE LAST DAYS OF MANKIND* PUBLISHED IN INSTALMENTS

11 NOVEMBER, EMPEROR KARL ABDICATES ROLE IN GOVERNMENT

26 OCTOBER, HUNGARIAN PARLIAMENT VOTES TO SECEDE FROM AUSTRIA

HOW URBAN CULTURE WAS SAVED IN THE LEVANT

JOACHIM SCHLÖR

HOW URBAN CULTURE WAS SAVED IN THE LEVANT

JOACHIM SCHLÖR

Looking back at the twentieth century, we are left with an ambivalent image of the Big Cities, the central *sites of modernity*, whose growth began sometime in the 1840s or 1850s, and whose image today, at the beginning of a new millennium, seems to dissolve in suburbia and the 'digital cities'. Our mental archives contain well-known images of a flourishing culture – fin-de-siècle Vienna, Berlin's 'Roaring Twenties', Paris in dark light – but also those of destruction and loss. In the following article I will try to tell the story of how a certain kind of urban culture, of 'urbanity', endangered and restless, survived the turmoils of the past century. Several concepts will be used: the modern debate about an 'elective affinity between Jews and urban culture'[1]; the idea of certain skills needed for living in a Big City; and, finally, the image of the city as a blank canvas on which artists, painters, writers, musicians, would engrave their own, personal comment.

The destruction of cities as symbols of modern civilisation, last exemplified during the siege of Sarajevo, followed a tradition of thought which had been worming its way into people's hearts and minds long before the inferno brought their houses crashing down around them. There is insufficient space here to give a full account of the ideology of hostility to the city – a phenomenon that was anti-modern and yet wholly modern in the forms that it took. I will therefore focus on what seems to me to be a key element in it, namely the identification of the modern Jew as the 'city-dweller *par excellence*'. Our narrative about the displacement of the avant-garde and the search for cultural identity will take us on a journey from the heart of Europe to the coast of the eastern Mediterranean.

I The conditions for the growth of urban settlements into Big Cities varied greatly from one European country to another. There are places like St. Petersburg or Paris where the royal court, government, administrative machinery and military organisation had already been concentrated in a single location, when the effects of urbanisation and industrialisation took shape. Here these effects appeared less dramatic – at least in their indirect manifestations, in literature and the visual arts – than in places where a new centre was created. This second case is typified to some extent by Budapest but more especially by Berlin. One image – the familiar (romanticised) landscape, varying according to region, with a rural population working on the land and living in harmony with nature – is overlaid with another, that of an artificial product, a 'colonialist' city' without tradition and without beauty. Berlin, city of the uprooted. Even in the art that it produced the emerging metropolis revealed, from the outset, a character that was restless, explosive, inwardly at odds with itself. This provided a cue for anti-Semitic propaganda, which 'discovered' a perfect image of the city-dweller, of the 'urban stereotype', in the fictitious figure of the supposedly equally 'rootless', 'homeless', 'wandering' Jew. That for the Jews, as for anyone else, migration to the cities meant breaking with some of their traditions escaped the notice of the anti-Semites,[2] who observed only that this minority, which owned no land and was concentrated in an 'abnormally' narrow range of occupations, was particularly quick, and apparently willing, to move 'from the ghetto to the city'. The ghetto, so the theory went, had prepared the Jews for an urban way of life, so much so that even Jews who lived in rural areas were really 'city-dwellers living in the country'.[3] Among the qualities attributed to the 'city-dweller' were versatility and flexibility, adaptability and a spirit of curiosity. To us these are positive qualities, and they were indeed interpreted as such by contemporaries. The German philosopher Georg Simmel, in his outstanding essay of 1903, 'Die Großstädte und das Geistesleben' (The Metropolis and Mental Life),[4] acknowledged the rapid assimilation of 'inward and outward impressions' as a metropolitan skill, and Willy Hellpach – one of the more interesting unknown writers of the period, who tried create something he called 'Geo-Psychologie', looking for the impact of landscape on mentality – described

1 Emily D. Bilsky, Introduction, in *Berlin Metropolis. Jews and The New Culture*, 1890–1918, exh.cat., The Jewish Museum, New York 1999, p.4.
2 On this point, see Felix Theilhaber, *Der Untergang der deutschen Juden. Eine volkswirtschaftliche Studie*, Berlin 1921, pp.56–72.
3 Peter-Heinz Seraphim, *Das Judentum im osteuropäischen Raum*, Essen 1938, p.427.
4 Georg Simmel, 'Die Großstädte und das Geistesleben', *Jahrbuch der Gehe-Stiftung*, Dresden 1903, pp.185–206; Engl. 'The metropolis and mental life', in P. Kasnitz (ed.), *Metropolis: Centre and Symbol of Our Times*, London, pp.30–45.

the city-dweller's 'sensory alertness' as a virtue.[5] Yet precisely these characteristics (including the readiness to adopt a new attitude to time and different behaviour in relation to space – learning how to move about in what Hellpach calls the 'constriction and crowding' of the city) were seen by the enemies of the big cities as signs of a personality in which something of profound importance had been lost: tradition, roots and affiliation with the land.

Hostility towards the cities was highly compatible with anti-democratic thinking and with the rejection of general social emancipation. But in the argument that the Jews were 'intrinsically' city-dwellers, predestined by character, as it were, for city life, we have before us one of the central discourses of the modern period. Just as Berlin's great shopping boulevard in the city's West End, the Kurfürstendamm, was reviled as the 'Kohnfürstendamm' [a reference to the Kohns, or Cohens], so comparable pamphlets from Hungary and Poland denounce Budapest as 'Judapest' and Warsaw as 'Moischepolis' [from 'Moses']. Whenever any achievement of the modern age was regarded or portrayed as undesirable it was attributed to the Jews, whether it was industrial production destroying the skilled crafts, the department store putting small shops out of business, the press unsettling the people, or art undermining religious faith and patriotism.

II Stereotypes often contain a core of truth, and simply to dismiss them as prejudice does little to advance the debate. The writer Theodor Fontane, who had his own liberating experiences of city life in London rather than Berlin, offers a good example of ambivalent feelings both towards the city and towards Jews. In June 1879 Fontane wrote to an editor on the periodical *Die Gegenwart* (The Present Day) that he had started working on the subject of 'The Jews and Berlin Society'. As a sensitive observer of that society he had realised that something about his city was changing, and he was honest enough to describe this as being, all in all, a change for the better. His essay is, as he writes himself, 'somewhat anti-aristocratic and very philosemitic'; that it was necessary to make a special point of this shows how unusual Fontane himself must have felt his standpoint to be. The aristocratic society which had formerly 'dominated' Berlin had been 'too poor, too provincially blinkered, too uncosmopolitan and too ignorant of everything that creates refinement – the sciences and the arts. They had read little and seen nothing.' By contrast Fontane acknowledged, though with barely-concealed regret, that the ways of the new middle class did represent 'progress', even where that class still displayed 'something of the timidity and lack of self-confidence of the parvenu'. Here 'a new superiority shows itself, and narrowness and provincialism have been discarded. Important issues are debated, people have a wider horizon which takes in the whole world. Their style of life is polished, refined, improved. Especially in matters of taste ... The arts and sciences, which once had to beg or else pay their own way, are made welcome here, observatories are built rather than stables, and instead of ancestral portraits in blue, yellow and red it is the works of our best artists that hang in the salons and galleries. The state may be the loser, but the world has gained by it.'[6]

While an anti-city and specifically anti-Berlin attitude spread more and more widely, from the assertion by the historian Heinrich von Treitschke that 'the Jews are our misfortune' to Adolf Stoecker's Christian Socialist movement, various groupings within the Jewish population came to feel ever more closely associated or even wholly identified with Berlin. This contact, this friction between an artistically and intellectually oriented Jewish avant-garde and German society gave rise, from the 1880s on, but particularly during the democratic experiment that was the Weimar Republic, to outstanding works in the visual arts, literature and music. Collectors like Carl and Felice Bernstein brought Impressionist paintings to Berlin, the 'Berlin Secession would hardly have been possible without the efforts of Max Liebermann and Paul and Bruno Cassirer',[7] Max Reinhardt and Ernst

5 Willy Hellpach, 'Stadtvolk (Über die Dreifalt seines Ursprungs und seiner Erforschung)', in Egon Freiherr von Eichstedt (ed.), *Bevölkerungsbiologie der Großstadt*, Stuttgart 1941, pp.82–94.

6 Theodor Fontane, 'Adel und Judenthum in der Berliner Gesellschaft', published with a commentary in Jost Schillemeit, 'Berlin und die Berliner. Neuaufgefundene Fontane-Manuskripte', *Jahrbuch der Deutschen Schillergesellschaft*, 30 (1986), pp.35–82; here pp.37–38.

7 Bilsky 1999, p. 6.

HOW URBAN CULTURE WAS SAVED IN THE LEVANT/JOACHIM SCHLÖR

Lubitsch can be described as pioneers of the performing arts. Does the fact that they were Jewish, help us understand modern art? Or Judaism? Obviously not. When we touch the 'minefield'of this 'tainted discourse' (Emily Bilsky), we do it in an effort to understand more about the relationship between the self and the city.[8] In this context, works of art, paintings like Ludwig Meidner's street scenes, novels like Alfred Döblin's *Berlin Alexanderplatz*, or - not least - buildings like Erich Mendelsohns Metal Workers' Union in the Kreuzberg district headquarters can be interpreted as instruments of the search for a modern form of identification with modernity's central place, the Big City.

III The debates about the 'Jewish city-dwellers' provided one more basis for the National Socialist ideology of exclusion and for the ensuing persecution and attempted annihilation. Though the Nazis drew no distinctions here, it is important to point out that the desire of the majority of German Jews for identification with 'Berlin' - which stood for both 'modernity' *and* the German cultural tradition - was not shared by all Jews. Not only did the Orthodox Jewish establishment deplore the increasing neglect of Jewish tradition, but the Zionist movement, striving to help Jews to 'return to Judaism before returning to Palestine', made a particular point of criticising the Jews' distorted occupational structure (trade and freelance work being overrepresented compared to agriculture or crafts) as they saw it, and in so doing entered a territory already colonised by the anti-Semites. The city-dwellers, already under attack from anti-Jewish resentment, were told by the Zionists that they should renounce all that they had achieved and take the retrograde step into agriculture just at a time when - at last! - their abilities seemed to be in demand. A remarkable text by Moritz Goldstein (who himself could easily be chosen as the very embodiment of the stereotype: born in Berlin into a family which had moved there from the east; graduate in German studies; journalist) discusses this very question.

Goldstein was born in Berlin on 27 March 1880. Only a short time before his death in 1977, as an émigré in New York, he was still correcting the galley proofs of his memoirs, *Berliner Jahre 1880-1933* (Berlin Years, 1880-1933).[7] Here he recalls, amongst other things, how from the flat which went with his father's job and which was above the 'Kaisergalerie' he could watch everything that went on down below in the shopping arcade situated at Berlin's central crossroads, the intersection of Unter den Linden and Friedrichstrasse.[9] Moritz Goldstein pursued his studies of German literature mainly in Berlin. His own attempts at writing plays met with little success, and after gaining his doctorate he worked from 1907 to 1914 as the editor of 'Bongs Goldene Klassiker-Bibliothek' (Bong's Golden Classics Series). As a student he had experienced anti-Semitic discrimination, and he had not managed to find a positively-based Jewish identity either within his family, who lived as typical assimilated Jews, or in the Zionist organisations to which he conscientiously paid his dues.

And then he wrote his essay, which at first he was unable to get published. Eventually this text, for which Goldstein is still remembered today,[10] appeared in the 'universal fortnightly cultural review' *Der Kunstwart* (The Guardian of the Arts) in March 1912 under the title 'Deutsch-jüdischer Parnaß' (German-Jewish Parnassus). In it the author declares: 'We Jews administer the intellectual property of a nation which does not consider us entitled or competent to do so.' This assertion inevitably caused consternation and prompted reactions from all sides. The city's vigorous artistic life, its dynamism, its characteristic way of expressing itself, all stemmed partly from the contribution made by a committed minority group; would the city accept and absorb this infusion of vigour, or would it reject it?

To talk about a 'Jewish contribution to German culture' could lead us into a trap. There is enough evidence for it,[11] but Peter Gay's 'doubt' concerning the construction of a 'Berlin-Jewish spirit' is still

8 Eberhard Roters and Bernhard Schulz chose a good title for their exhibition: *'Ich und die Stadt'. Mensch und Gross-Stadt in der deutschen Kunst des 20. Jahrhunderts. Berlin*, exh.cat., Berlinische Galerie 1987. The city's statistician, Hermann Schwabe, wrote about the idea of 'Das Ich der Stadt' as early as 1925.

9 Moritz Goldstein, *Berliner Jahre 1880–1933* (Dortmunder Beiträge zur Zeitungsforschung, no. 25), Munich 1977.

10 See Manfred Voigts, 'Moritz Goldstein, der Mann hinter der '*Kunstwart*-Debatte'. Ein Beitrag zur Tragik der Assimilation', in Helmut Koopmann and Peter-Paul Schneider (eds.), *Heinrich-Mann-Jahrbuch*, 13, Lübeck 1996, pp.149–184.

11 Cf. Julius H. Schoeps (ed.), *Juden als Träger büprgerlicher Kultur in Deutschland.* Stuttgart, Bonn 1989.

valid.[12] In a text written in 1938 but never published, Moritz Goldstein, desperately conscious of the impending danger, writes about 'Die Sache der Juden' (The Jewish Cause). He expounds an unusual project. All the schemes to save the Jews, he says, require too much time. This may be partly because they are conceived on too grand a scale. What Goldstein proposes 'is in fact a reduction of Zionism to something less ambitious. It is the changing of the Zionist idea into what is practically possible, it is simply a sober drawing of conclusions from the given circumstances.' His argument is this:

> A country with a settled, rooted population cannot be made. A country has to grow. The conditions for its development may be either more or less favourable, they may promote or inhibit its growth. But all in all it is something that has to be waited for. Growth takes time; a long and undisturbed period of time.

> A city, on the other hand, can be made … Since it takes too long to settle Jews, hundreds of thousands, indeed millions of Jews, on to land, build them a city instead; let them build a city for the time being, as a temporary solution. There is no room anywhere in the world for a large-scale settlement of Jews on the soil. Perhaps there is room, but it all belongs to political states, and those states will not relinquish it. But even if there is no room for a land of the Jews, there may be room for a city of the Jews. Even for a great, cosmopolitan, gigantic city, a city of millions.

Goldstein continued, significantly: 'We hear so many complaints about the Jews' "flawed" occupational structure, from which primary production is almost entirely absent, or was so in the past. I think this is a misguided view. Far from being wrong, that structure was absolutely the right one – given the circumstances in which they were compelled to live - to enable them to live at all. It would be the wrong structure if one were to take the Jews, just as they are now, and set them down in a country where they had to fend for themselves, starting with growing corn and mining coal and minerals. That is after all one of the reasons why Jewish colonisation is proving so difficult. Yet those same Jews, if they were to be transplanted to a city, have exactly the right occupational structure – they have the skills that are needed in a city.'

IV The skills that are needed in a city. Part of the background to Moritz's text is formed by the experiences – or rather the accounts of experiences – emerging from Jewish Palestine. At that time, after all, a city was indeed developing there: Tel Aviv. Its first foundations had been dug into the sands in 1909, and by 1938 its population numbered a good 150,000, a quarter of whom had emigrated there from Germany in the space of barely five years. These German immigrants, for the most part seasoned city-dwellers, particularly Berliners, had brought their urban 'qualities and passions'[13] with them to Palestine, and the modernisation of Tel Aviv by these urban pioneers had been an extraordinary achievement. Against all manner of opposition from within and without they too had done what is 'needed in a city'.

As various travellers observed, Tel Aviv in the mid-1930s was 'the most national, and at the same time, the most international city in the world'. It was 'the most national' because it was envisaged as a 100-per-cent Jewish city, the notional capital of a state which did not yet exist, and the focus for a Jewish nation which was only just beginning to take shape. But it was at the same time 'the most international', because the people whose ideas and work were creating the city came from so many different countries and brought with them such a medley of languages, memories, styles of home life, types of clothing and food, and everyday habits and customs. It was amid this tension between

12 Peter Gay, *The Berlin-Jewish spirit. A Dogma in Search of some Doubt*, Leo Baeck Institute, New York 1972.

13 Gottfried Korff, 'Berliner Nächte. Zum Selbstbild urbaner Eigenschaften und Leidenschaften', in Gerhard Brunn and Jürgen Reilecke (eds.), *Berlin. Blicke auf die deutsche Metropole*, Essen 1989, pp.71–104; cf. Joachim Schlör, *Nights in the Big City*, London 1998.

nationality and internationalism – truly one of the fundamental themes of the past century – that the city came into being, and with it a plurality of forms of artistic expression which felt this tension, embodied it – and made it a central theme.

I am focusing on Tel Aviv because some of the major political and cultural issues of the century and their reflection in the arts are to be found there. Tel Aviv was to have been a place where the past was wiped out, but instead it became a place of preservation. The Zionist programme was concerned with occupational 'restructuring', 'productive labour' and the promotion of agricultural activity; the corollary of this was a rejection of the life of the big cities. The modernisation to which the European Jews had contributed so much had not brought them the emancipation and equality that they longed for. Nowhere in the plans for converting the Zionist programme into reality was the founding of cities envisaged.

Then Tel Aviv happened. There is really no other way to put it. The founding of the new town in April 1909 came about because Jewish inhabitants of the ancient town of Jaffa had had enough of an Arab style of life which they did not understand, and which they found alien. Sixty little houses were built out among the sands. A high school bearing the name of Theodor Herzl, the founder of the Zionist movement, was the first public building. And suddenly, without a conscious decision having been taken, this modest settlement became a city, through the influx of the multitude from elsewhere, who all brought their own small homelands with them from Warsaw, Moscow, Odessa, Berlin, Vienna, Budapest, Damascus and Baghdad. In the overall history of Zionism Tel Aviv represents the neglected story of the liberal, bourgeois (and petty-bourgeois) elements – scorned by the left-wing majority – who built themselves a city. The history of the Diaspora, which was supposed to come to an end here, reveals itself in the diversity of the restaurants, the window displays, the cadences of a Hebrew tinged with Hungarian, German, or Arabic, and in the separation, visible now as ever, into different residential districts which owe their origin to particular waves of immigration.

It was not supposed to become a city, but it did: 'Tel Aviv became Tel Aviv by the vital force of life itself, in marked contrast to what its founders wanted to make of it; if they had really intended it to be what it is today, why did they make its streets so unsuitably narrow for a city?' In Shmuel Yosef Agnon's novel *Gestern, Vorgestern* (Yesterday, the Day Before Yesterday), the immigrant Yizchak Kummer from Galicia witnesses the growth of the tiny settlement towards an uncertain future. The immigrants brought not only a variety of models of everyday living, but also quite disparate experiences of the project of 'modernism'. That these experiences of a break with the past and a new beginning were successfully given a new, shared home is probably due first and foremost to the external structure, the 'shell' which contained them all. It was a matter of architecture, but not merely of architecture *per se*. In terms of form it was indeed the Bauhaus or 'International Style' which gave Tel Aviv its visual character. After a period of eclecticism in the 1920s, when everybody tried to build 'dream houses' inspired by the dreams they had brought from their home countries, the new architecture started with Ze'ev Rechters 'Engel House' on Rothschild Boulevard, the first house to be built on pilotis. This architectural element, together with the grid plan created by Richard Kaufmann and Sir Patrick Geddes, was the symbol for the 'White City' which grew from the sands.[14] The new architecture gave all the city's inhabitants a sense of unity whilst allowing for a variety of ways of living. But the form, which – according to the Bauhaus principle – must follow function, also expresses a content, namely nostalgia for the big city. 'Homesickness for the big city is perhaps the most intense kind of all,'[15] as even Oswald Spengler, a stern critic of modern culture, has commented. The exiles who had been forced to leave the great cities of Europe brought this homesickness with them to the coast

14 Micha Levin, *The White City*, exh. cat., Tel-Aviv Museum of Art, Tel-Aviv 1982; Irmel Kamp-Bandau, *Neues Bauen in Tel-Aviv, 1930–1939*, Institut für Auslandsbeziehungen, Stuttgart 1993.

15 Oswald Spengler, *Der Untergang des Abendlands*, Munich 1983, p.673.

of the Levant, and for these homeless people Tel Aviv became – as far as anywhere could – a home.

In his book *Erfahrungen* (Experiences), the German-Jewish writer Hans Habe describes the situation of the émigré: once turned into a foreigner, a stranger, he never again manages to feel at home. But Habe tempers the sadness intrinsic to such accounts with a surprisingly positive assessment: 'Because yesterday's émigrés are not at home anywhere ... they are at home everywhere; if you have no home, your home is the world; as well as the mark of Cain there is a mark of Abel.' Homelessness itself becomes, perforce – and much against the will of the person who loses his home, who is robbed of it – a place to stay, a dwelling, and with it comes, unexpectedly, a gain in lived experience and a deeper understanding of life. By remaining behind one is denied this gain: 'Those who stayed at home are still strangers in London and Rome and New York, God has touched them with provincialism, whereas yesterday's emigrant is not a stranger even in the desert or the jungle, he eats with chopsticks, he throws a spear and wears a leopard-skin, he dances foreign dances, worships in foreign churches and weeps at foreign funerals. Because he has experienced more he knows more, and because he knows more he *is* more. Because he is nowhere at home, he can nowhere be driven from home. He knows no homesickness.'[16]

The Jewish emigrants from Germany who arrived in Tel Aviv in the years following 1933 created their home there by building the city. Tel Aviv had become Palestine's centre of art and culture already in the mid-1920s when artists like Reuven Rubin and Zaritsky had moved 'down' from Jerusalem where the atmosphere was too heavy with religion and political conflict. Tel-Aviv, for them, was a blank canvas, yet to be painted on. In this unfinished city where the first museum was founded in mayor Dizengoff's house on Rothschild Boulevard in 1936, coffee-houses became the central meeting places for intellectual exchange.[17] Precisely because the city of Tel Aviv preserved and never lost its foreign flavour, it was able to offer a place to those who came as foreigners, a place which could accommodate the dreams of many different people. 'It seems then that the All-Jewish City was the dream of millions. No two dreamed alike. None was too sure even of his own dream.'[18] We might ask what freedom this city offered, and still offers, for people to shape their own lives – and their dreams; what space remains, amid the general tendency towards homogenisation, for the divergent, the special. I maintain that Tel Aviv, by being a *big city*, a big city *in the making*, has offered more scope in this respect than other places: that in this city, which itself must have looked to many like a foreign body, people were better able to convert a place of exile into a home than elsewhere. Many descriptions have been written of Tel Aviv. 'This literature, since its inception, related to Tel Aviv as the "big city". It was considered a grand, open, dynamic metropolis even before this vision became a reality. Tel Aviv already appeared as a Zionist Utopia everywhere a Hebrew city was described ... Clearly it was difficult for these authors, who were for the most part European immigrants, familiar with big cities, to view Tel Aviv as a city in the usual sense, but it fulfilled the *fiction of a city* even before it actually became one.'[19] Tabula rasa: a starting point for modernity.

All kind of demands were made of the little big city. 'Of the many interesting conjectures to which this new 'city of the Jews', Tel-Aviv, gives rise, one may be, will the Jews retain, in their own surroundings and among their own people, the same *civic virtues* with which municipalities all over the world credit their Jewish citizens?'[20] 'Virtues': a striking term to use. And what are '*civic* virtues'? It cannot be just a matter of orderliness and cleanliness, punctuality and discipline. Richard Sennett speaks of 'ingenuity, organizational ability, tolerance and creativity' and a culture of diversity, which is expressed not in abstract ideological precepts but in the *physical character of the city*. He writes of 'people who have had to deal with otherness, with all the differences of age, taste, past lives, and

16 Hans Habe, *Erfahrungen*, Olten 1973, p. 233.
17 Joachim Schlör, 'Kaffee verkehrt. Notate an Tel-Aviver Kaffeehaustischen', in Jakob Hessing and Alfred Bodenheimer (eds.), *Jüdischer Almanach 1999/5759 des Leo Baeck Instituts*, Frankfurt am Main 1998, p.151–158.
18 Dorothy Ruth Kahn, *Spring Up, O Well*, London 1936, pp.121–22.
19 Nurit Govrin, 'Jerusalem and Tel Aviv as metaphors in Hebrew literature', *Modern Hebrew Literature*, New Series, no.2 (Spring 1989), pp.23–27; here pp.24–25.
20 Brian Epstein, 'Palestine's Jewish City', *Egyptian Gazette* (Cairo, 25 March 1922), in *Jerusalem Correspondent 1919–1958*, Jerusalem 1964, p.71.

religious persuasion that are naturally found in concentration in a city ... people who have been stimulated by the variety surrounding them.'[21] Accordingly Tel Aviv could be seen as an expression in stone of the diversity of the people who came to build a new land in Palestine - a diversity which may have been controversial but which can no longer be denied in the face of its self-evident existence. 'This is where the courses of all lives intersect, those that lead into the light, and those that lose themselves somewhere in the depths of wretchedness. Here Jewish destinies are massed together in motley confusion, and the great city, with its splendid façades and its poor districts over towards Jaffa, resounds with the tough, ruthless struggle for survival, with the cries of the despairing and the triumph of the successful.'[22]

Tel Aviv is *all city*, 'drunk with growth, intoxicated with youth, mad with change',[23] and has no wish to be otherwise. 'People drawn from all corners of the earth, with conflicting ideals and ideas, rebirthing a city at a terrific, breath-taking speed'[24] - 'all are hurled together, to make the ugliest and yet, perhaps, the most vital city I have ever seen.'[25] It is 'a place that has sprung up overnight, or an exhibition on the day of the opening'.[26] And its residents are city pioneers. Gideon Ofrat chose as the motto for his essay *Der Chaluz in der israelischen Kunst* (The chalutz in Israeli art) a line from a song: *'Mi jivne bajit be Tel-Aviv - Anachnu ha'chaluzim!'* ('Who will build a house in Tel Aviv? - We, the chalutzim, the pioneers!'). The song was recorded by Bracha Zfira, and the record sleeve shows, beside a picture of her, a photograph of the construction works for the 1934 Levant Fair. The construction of the trading centre and that of the great city of Tel Aviv were pioneering achievements no less important for the building of the country than the work of the agricultural pioneers in the kibbutzim.

While searching for examples of an emerging Israeli art depicting the chalutz, 'who dances the wildest horra, climbs the highest peaks, and makes the very earth subject to him', Ofrat came across one particular picture: 'Let us take a look at Mosche Matusovsky's *Tel Aviv Chalutzim* of 1931! This huge canvas languished, totally forgotten, in the cellars of the Tel Aviv museum, until a long-serving museum official drew attention to it. In this picture the founders and builders of Tel Aviv are shown as nothing less than ... astronauts, floating surrealistically through the air above the city, and the scaffolding structures have become launch ramps, while the houses seem to kneel down in reverence - this is the chalutz as God.'

While we may not choose to take idealisation to such extremes, the fact remains that this city built by the Jews themselves became a reservoir, a gathering-place, indeed a place of rescue for a conception of city life and a modernity that was threatened with destruction. Moreover, as the tradition of the Levant Fairs of 1932 and 1934 reminds us, Tel Aviv stands at the 'crossroads' linking Europe, the Near East and North Africa. Under the 'Law of Return' Israel has opened its doors to immigrants from other regions, and European-style modernity is being complemented - by no means always harmoniously as yet, but in ways that are already starting to be productive - by the experience of people from the Arab lands, the Maghreb, Iran, India and the Asiatic provinces of what is now the Russian Federation. Not only were city-dwellers saved - though how many were not! - but so too was the very idea of the city. If the peace process is allowed to continue, Tel Aviv could become a focal meeting-point for the avant-garde movements of the twenty-first century, while continuing to be a reservoir for our memories of the upheavals of the twentieth.

21 Richard Sennett, *Civitas. Die Großstadt und die Kultur des Unterschieds*, Frankfurt am Main 1991, p.160.
22 Manfred Sturmann, *Palästinensisches Tagebuch. Aufzeichnung einer Reise*, Berlin 1937, p.47.
23 Kahn 1936, p.110.
24 Kahn 1936, p.108.
25 Hector Bolitho, *Beside Galilee. A Diary in Palestine*, London 1933, p.101.
26 Norman Bentwich, *Fulfilment in the Promised Land*, London 1938, p.80.

HOW TO CREATE A CULTURE CAPITAL:
REFLECTIONS ON URBAN MARKETS AND PLACES

SHARON ZUKIN

Two decades ago, shortly after moving into a loft in New York City, I wrote a book about contemporary artists who had also begun to live and work in lofts.[1] Although readers often refer to that book as a 'community study' of SoHo, an artists' district in lower Manhattan, it was actually a case study of a much larger phenomenon. I was interested in documenting how an unlikely space in an almost 'blighted' part of the central city saved itself from demolition and rose, like the phoenix, to spearhead a major urban transformation. I focused on industrial lofts as both the site and symbol of this change. The conversion to a chic lifestyle commodity marked the definitive shift from a city based on manufacturing and material production to a city that advertises itself as 'the culture capital of the world'. Mainly on the strength of New York's example, loft living has become a paradigm for cultural centres in other cities around the world.

Perhaps I was lucky to choose this topic in the late 1970s, before it was clear that New York City would extricate itself from severe fiscal problems, and that anxiety, at least in some quarters, over 'deindustrialisation' in the society at large would yield to euphoria over the 'New Economy'. Twenty years ago, French steelworkers were marching on Paris to save their mills, BBC TV was announcing weekly counts of plant closures, and, since there were no personal computers, the public had not yet heard of Silicon Valley. It would be two years before the Disney Company opened EPCOT and modernised Disney World, the 'themed' amusement park that rapidly became an archetype of public space. It would also be two or three years before most of the middle-class public of art consumers heard about the East Village artists, who blended Conceptual art and music in a new Bohemia of Manhattan that was, for some of them, a fierce battleground against gentrification and, for others, a catapult to commercial success. Four years would pass before Tommy Hilfiger put his logo on a line of jeans, and Michael Jordan signed a contract with Nike to give the most lucrative athlete's endorsement in history.

I mention these landmarks of mass culture to place the emergence of artists' living lofts – as a commodity, a site of production and a symbol of cultural consumption – in a social context. As recently as 1980, it was not at all clear that finance and technology were driving both plant closures and an Internet economy, or that cities would try to reorient themselves not only around business services, but around a symbiosis of finance, media, art and fashion in which Image Rules, and the centre of the city is a Leisure Zone. Like the history of SoHo, the rise of the symbolic economy as an urban economic base is partly a story of unplanned and unexpected developments. But in many cities around the world, this is also a story of deliberate restructuring by large property owners, real estate developers, government officials, and the media, who aim to attract new businesses, increase property values, and make a city grow.[2]

When loft living began in the 1960s, at the height of post-war suburban development, growth was mainly a matter of expanding business services, especially banking, the stock market and law, in the city's geographical core, and appealing to professionals and executives in the middle class to come back to, or stay in, central urban neighbourhoods. Among urban planners, the common strategy was to prepare the built environment for growth by clearing out manufacturing districts and wholesale food markets, demolishing old structures, and building new tower blocks and skyscrapers. These steps were not enough to stem the flight of many corporate headquarters and middle-class families to the green fields of the suburbs. Yet, pragmatically, the planners discovered that some upper-middle-class men and women would brave the congestion, higher crime rates, and declining public services of the city in order to live close to certain cultural amenities. This was not true of all people or all cities, but gradually, in the Baby Boom generation born after the Second World War, a significant change of attitude occurred.[3]

1 Sharon Zukin, *Loft Living: Culture and Capital in Urban Change*, Baltimore 1982, 2nd ed., London 1988.

2 On the 'symbolic economy' and its significance to urban centres, see Sharon Zukin, *The Cultures of Cities*, Cambridge MA and Oxford 1995; Scott Lash and John Urry, *Economies of Signs and Space*, London 1994; and Derek Wynne, (ed.), *The Cultural Industry: The Arts in Urban Regeneration*, Aldershot 1992.

3 While this change has many possible sources, an early, influential manifesto was Jane Jacobs' *The Death and Life of Great American Cities*, New York 1961. Jacobs argued against the planners' mode of operation and against Modernists from Le Corbusier to Lewis Mumford who would reduce or deny the city's density, grittiness and intricate social networks.

Some people rebelled against the conformity suburban living implied. Some actively embraced the cultural diversity big cities offered, at least in the form of theatres, restaurants, and musical performances. It also became possible for more middle-class children of working-class and lower-middle-class parents to construct an urban lifestyle that had formerly distinguished wealthy patricians and starving artists. At any rate, some middle-class people, beginning with rather poor but college-educated artists, began to occupy factories as if they were townhouses or apartments. Aside from their often makeshift sanitary facilities or electrical wiring, the aesthetic virtues of living lofts – the 'authenticity' of old structures and materials, appropriation of obsolescence and spacious proportions of open-floor plans – were, and still are, more appealing to many people than plasterboard construction. The media, especially the new 'lifestyle journalism', lost no time presenting artists' lofts as symbols of the good life. Articles about loft living in glossy magazines and newspapers, and references to artists' lofts in films, attracted the interest of middle-class cultural consumers.

This sort of cultural centre differed greatly from the social-welfare model of the urban planner Hubert Worthington, who, after the Second World War, wanted to develop a multi-purpose cultural centre in Manchester. Worthington envisioned a cultural centre that would include a mixed public of both Bohemian writers and football fans. But what actually developed – initially in New York, and only eventually in Manchester – was an array of urban entertainments, from gourmet food shops and cafés to art galleries and clothing and furniture boutiques, that I later called the 'critical infrastructure' of gentrification.[4]

Between the 1970s and the 1980s, various cultural strategies of urban redevelopment led to an 'Artistic Mode of Production', a set of related economic practices that included (1) revalorising the built environment around cultural consumption and historic preservation, symbolised by the heritage industry, (2) restructuring the labour force by using art work to absorb youth unemployment, and (3) nurturing a new set of cultural meanings that value both urban space and labour for their aesthetic rather than their productive qualities.

Yet while the Artistic Mode of Production described artists' roles in fostering cultural *consumption*, the symbolic economy in fact joined business services and cultural *production*. Much of the work in urban economies these days involves the production of such symbolic goods as information, finance and entertainment. Moreover, promoting both products and cities increasingly relies on creating and marketing images. As I suggested when I wrote about the AMP in 1980, and as Richard Sennett, Mike Featherstone and many other writers have said, visual representations are hegemonic in both our sensual experience of cities and contemporary consumer culture.[5] So it is not surprising that visual artists play a key *productive* role in creating and processing images for the urban economy. This productive role is highlighted by the recent rise of the new media industry. Despite its own financial fluctuations, the new media industry simultaneously offers a new scenario of business growth, increases the size of the urban middle class, and gives some artists the opportunity to use their skills and creativity in a 'day job'.

I didn't really believe, in 1980, that the Artistic Mode of Production would become so widespread. However, the same changes that after 1984 brought Nike, the National Basketball Association, and Michael Jordan to public view on television also brought a closer association between the look of a product and the ability to promote it. This vastly increased the social significance of all sorts of urban cultural producers, whose major task in life is to make images. On the one hand, as they began to say in marketing circles, design adds more 'value' to products than their material components do. On the other hand, consumer products do not just mark consumers' investment in social status, they also

4 Sharon Zukin, *Landscapes of Power: From Detroit to Disney World*, Berkeley and Los Angeles 1991; on Hubert Worthington, see John J. Parkinson-Bailey, *Manchester: An Architectural History*, Manchester 2000.
5 Richard Sennett, *The Conscience of the Eye*, New York 1990; Mike Featherstone, *Consumer Culture and Postmodernism*, London 1991.

SHARON ZUKIN/HOW TO CREATE A CULTURE CAPITAL

mark an emotional investment. This means that loft living's aestheticisation of the industrial age, and the media's aestheticisation of loft living, contributed to a general interest in design and in the marketing of design that coursed through consumer products industries and led to the current preoccupation with 'branding'.[6]

In a city where production focuses on the media, the stock market and frequent changes of design, the medium that creates value is 'buzz'. Buzz is comprised of publicity, gossip and anticipation; it increases the value of anything, and anyone, that can be linked to a critical nexus of creativity and profit. In part, the importance of buzz reflects the priority that has been placed since the late nineteenth century on the commercial applications of technical innovation. Partly, too, buzz reflects the importance of media – newspapers, glossy magazines, cable television, websites and chat rooms – in diffusing knowledge about commodities and celebrities. While these aspects are important to both financial investors and cultural consumers, buzz also plays a key role in the careers of cultural producers. Buzz intensifies the tendency to organise credentials in terms of 'portfolios' that telescope producers' track records for creativity – a tendency that began with visual artists and culture industries in the 1960s. Moreover, buzz is a major medium of communication among the interconnected networks of cultural producers, employers, clients and patrons who circulate among the city's consumption spaces, media spaces and cultural institutions.

The development of the Artistic Mode of Production is made tangible, however, by the increase in working artists and designers of all kinds and by the share of art and design employment in the urban economy.[7] Especially during the summer, the city's business seems based on theatre festivals, restaurants, and playful gatherings at art museums and commercial centres and along the waterfront, creating, at last, a spectacular Fun City, as a former mayor of New York had promised in the 1970s. But even as we, as cultural consumers, flow through this Fun City, we cannot ignore that the entire urban space is comprised of a hierarchical network of places that represent degrees of power in the larger society. These spaces are connected in a 'regional network' of culture industries that link producers and consumers: the gritty urban neighbourhoods where avant-garde artists live because they can afford the rents there, the derelict warehouses along the waterfront that are transformed into Urban Entertainment Destinations or Leisure Zones, the immigrants' neighbourhoods where we can find 'ethnic' restaurants, the commercial theatre district, and the monumental centres of performing arts complexes and major art museums. In New York, this regional industrial network connects the artists' district of SoHo, in lower Manhattan, to Williamsburg, in Brooklyn, and the urban entertainment zone of Times Square, in midtown.

The cultural strategy of redevelopment that was unplanned in SoHo in the 1970s became official government policy in Times Square in the 1990s, when New York State, New York City, and several not-for-profit groups used art installations in the pornographic movie theatres of 42nd Street as a wedge of urban change.[8] As in SoHo, so in Times Square the city government and the financial community planned to tear down old buildings and replace them with new construction – a sports stadium and expressway in lower Manhattan, and office towers in midtown. But when the Times Square plan was blocked, first, by aesthetic opposition and, then, by a stock market collapse in October 1987, the idea of using a cultural strategy occurred simultaneously, and even serendipitously, to several people who were already involved in redeveloping the area. Manhattan's 'indigenous' arts – downtown installation artists and Broadway theatres – were extremely important in 'clearing' the land for redevelopment. They also legitimised the use of massive government power, from confiscating property and evicting tenants to policing the streets and setting up a local court. Nevertheless, in

6 Lash and Urry, *Economy of Signs and Space*; Harvey Molotch, 'L.A. as Design Product: How Art Works in a Regional Economy', in Allen J. Scott and Edward W. Soja, eds., *The City: Los Angeles and Urban Theory at the End of the Twentieth Century*, Berkeley and Los Angeles 1996, pp.225–75; Tom Vanderbilt, *The Sneaker Book*, New York 1998.

7 Andrew Pratt, 'The Cultural Industries Production System: A Case Study of Employment Change in Britain, 1984–91', *Environment and Planning A* 29, 1997; Allen J. Scott, *The Cultural Economy of Cities*, London 2000.

8 Zukin, *Cultures of Cities* and 'Times Square', in Steve Pile and Nigel J. Thrift (eds.), *The City A–Z*, London 2000.

contrast to SoHo and the other major artists' districts that emerged in the 1980s and 1990s – the East Village and Williamsburg – Times Square's redevelopment was based on decisions by giant corporations of the media and entertainment economy to locate their headquarters and large, if not flagship, stores around 42nd Street and Broadway. Just as many centrally located urban districts around the world have been 'SoHo-ised' by encouraging artists to become residents and converting old factories to living lofts, so Times Square has been 'Disneyfied'. But these cultural strategies of redevelopment represent different agents, and degrees, of power in the global economy.

Williamsburg represents a different sort of cultural space. A working-class and manufacturing neighbourhood that is still undergoing significant renovation, Williamsburg has attracted many visual artists since the early 1990s. Like SoHo in the 1970s, and even more so, the East Village in the 1980s, Williamsburg draws large numbers of artists who seem to migrate *en masse* after graduation from art schools around the country.[9] Many of them get temporary jobs in offices, teach, or work in new media to support themselves. Others become entrepreneurs who open art galleries, restaurants and bars, that initially cater to artists but in fact set up the critical infrastructure of cultural consumption that turns the wheels of gentrification. These establishments become grist for the mill of journalists, who bring them to the attention of, and review them for, a broader public. In a three-stage process, the *location* of artists becomes the *place* of gentrification: artists' networks establish proximity, their amenities of galleries and cafes are integrated into the cultural practices of aspiring cultural consumers, and the media enhance the value of the artists' district through buzz.

I originally thought the Artistic Mode of Production would lower the standard of living for young workers. So it is not surprising that, although most artists do not belong to labour unions, the two lengthiest labour strikes in New York City in 2000 involved cultural work. For several months, both film and television actors and employees of the Museum of Modern Art struck to demand fair wages. MoMA's technical and clerical workers, researchers, and workers in the gift shops, all members of a single labour union, also wanted to retain employer-paid health benefits and to have the museum's guarantee they could return to their jobs after the museum reopened following an extensive rebuilding program. Most importantly, they protested the museum's demand they give up union representation – a severely regressive step that would have diminished New York's reputation as a culture capital.[10] While the MoMA strike referred to conditions that have historically been at the heart of labour confrontations, the strike by members of the Screen Actors Guild took labour conflicts into the information era. The actors demanded that residuals – payments for their filmed or taped performances – continue throughout the product's broadcast history, regardless of medium (e.g. video) and technology (e.g. digital). The strike at MoMA affected only about 50 workers, and was settled after five months, but the SAG strike, involving more workers in several different labour unions, lasted longer, and had a greater effect on the city's economy.

Since 1990, in New York alone, there have been thirty strikes, and three averted strikes, by cultural workers. These include three strikes at MoMA, three at television and radio networks, two in the film industry, and five by professional musicians. The American Broadcasting Corporation (ABC) locked out striking television camera operators, editors and technicians for eleven weeks in 1999 over issues similar to MoMA's, as well as over the hiring of temporary workers. Professional athletes in basketball, hockey and baseball, who are unusually well paid but have short careers, have struck seven times since 1990, and have withstood three lockouts by their employers. At a much lower end of the wage scale, film projectionists have accepted wage cuts because the automation of multiplex cinemas reduces the number of jobs.

9 The artist-owner of a bar in Williamsburg says 'half the class' moved to the neighbourhood after graduation from the Rhode Island School of Design; the artist-owner of a restaurant in the neighbourhood says 'half the class' moved there after graduation from the Kansas City Art Institute; and I have heard the same 'fact' from a former administrator at Skowhegan Art School.

10 Aside from senior curators and top managers, who are not unionised, the other employees of the Museum of Modern Art belong to different labour unions. They were not asked to relinquish union representation.

SHARON ZUKIN/HOW TO CREATE A CULTURE CAPITAL

Apart from the prospect of continued labour conflict in media, sports and entertainment industries, the strike at MoMA raises questions about the social inequalities created by a vastly more commercialised system of fine arts production than existed twenty years ago. While there have always been extreme gaps between commercially successful and unsuccessful artists, I think these gaps have grown larger since the 1980s. The mechanisms are typical of the 'winner-take-all' society that has developed in many highly skilled labour markets – notably, that of professional athletes – where those at the top more freely negotiate their rewards. Very high incomes reflect employers' and investors' attempts to insure returns on their investment, and to capture market share, by hiring the 'best' talent.[11]

Despite these inequalities, the Artistic Mode of Production has influenced the changing of work norms. Like artists, workers are now encouraged to take risks, to engage in continuous innovation, and to collaborate in project teams that bring them into close communion with clients. These work norms have been embraced by young urban workers, who are children of both the enterprise culture and the marketing of 'hip' culture fostered during the 1980s. Exemplified by web designers and new media producers, these workers want 'cool' jobs that give them autonomy, flexibility, and a sense of not working in a corporate hierarchy: the epitome of artistic work. Although their job conditions are quite different, these workers have internalised some of the historical values of the avant-garde.[12] They have had an effect, moreover, on artists' districts, which expand, get more expensive, and become subjects of buzz when the richest artists, actors and even fashion models buy housing there.

While I didn't fully realise it at the time, the Artistic Mode of Production also contributes to the globalisation of New York City. Artists whom I interviewed about their activism in the 1960s and early 1970s, when they lobbied the City Council for the right to live legally in buildings zoned for manufacturing, said that articles about SoHo in newspapers and magazines around the world had helped their cause. Later, when tourism in New York City began to increase, many of those tourists came to SoHo, as well as to the monumental art museums and commercial theatre and concert spaces uptown. SoHo art galleries also showed work by young foreign artists, mainly Europeans, some of whom also came to New York to paint, draw or make installations. More Europeans arrived to open galleries, or branches of existing galleries, showing contemporary art. The attraction of cultural producers and consumers from overseas was noted in various media, from the 'lifestyle' and 'weekend' sections of daily newspapers to the international art press and the research reports of local government agencies.[13] Artists in the 1960s and 1970s suspected that they were seen as economically important not only to the patrons who collected their work, but also to far-sighted business and political leaders. By the end of the 1980s, this became the official position of city governments in Europe, Japan, and the United States. Unfortunately for other cities, Mayor Rudolph Giuliani proclaimed New York not only the culture capital of the nation, but the culture capital of the world.[14]

Competition for public and financial support has pushed art museums to follow in the footsteps of for-profit culture industries. In recent years, museums have expanded by making strategic alliances, establishing branches, and hiring directors with experience in financial management. The larger museums commission more spectacular architecture, no longer drawing inspiration from the Acropolis, but from the Mall of America. In the United States, art museums now claim they draw more visitors than major league baseball games. From 1998 to 2000, more than 150 US museums have been built or expanded at a total cost of $4.3 billion.[15] To support their expansion, museums develop profit-based activities that capitalise on their collections, such as the obligatory gift shops and MoMA's joint website with Tate. It is not news that selling art is a profit-making activity or that some

11 Robert Frank and Philip J. Cook, *The Winner-Take-All Society*, New York 1996); c.f. Susan Christopherson, 'Flexibility and Adaptation in Industrial Relations: The Exceptional Case of the U.S. Media Entertainment Industries', in L.S. Gray and R.L. Seeber, (eds.), *Under the Stars: Essays on Labor Relations in the Arts and Entertainment*, Ithaca NY 1996, pp.86–112.

12 Gina Neff, Elizabeth Wissinger and Sharon Zukin, "'Cool' Jobs in 'Hot' Industries: Fashion Models and New Media Workers as Entrepreneurial Labor", unpub. ms., August 2000.

13 Port Authority of New York and New Jersey, *The Arts as an Industry: Their Economic Importance to the New York–New Jersey Metropolitan Region*, 1983, 1993.

14 As in global finance and national politics, however, New York was in competition with London and Los Angeles.

15 Daniel Costello, 'Museum of Modern Art's Ambitious Expansion Plan Faces Trouble', *Wall Street Journal*, June 7, 2000.

artists get rich. But institutionally, the promotion of contemporary artists has gone hand in hand with the expansion of both non-profit fine arts museums and for-profit cultural industries.

These general strategies of redevelopment, both within and around cultural production, have given rise to a more 'spectacular' city than I envisaged twenty years ago. But it's a more decentralised city, also, with artists' districts developing, over the years, in the East Village and Williamsburg, and entertainment zones around Times Square, 57th Street, and Lincoln Center. Even the Brooklyn Academy of Music is the focus of an economic redevelopment district near downtown Brooklyn, that may eventually include some artists' lofts near the Brooklyn and Manhattan bridges, on the East River. This continuum of cultural and entertainment districts expands on the idea SoHo established: the idea that a city could reinvent itself around cultural markets.

In his recent book on cities, Peter Hall asks what conditions make a culture capital.[16] He is thinking about a golden age of great ideas and priceless art rather than about restaurants, property development, or mass cultural consumption. But the business of cities today is to construct a place around culture markets. Whether it is the monumental space of the performing arts complex, or the more modest space of an artists' or a new media district, a cultural quarter is very much like a regional industrial district that produces any product. The cultural quarter specialises in 'culture' rather than in computers or textiles, but just as in a manufacturing district, complementary networks create different parts of the product, from ethnic districts to heritage landmarks, and from art museums to retail shops. In contrast to the insularity of manufacturing districts, where places of socialisation are built around a core industrial activity, consumption spaces in cultural zones bring consumers from outside. As we know, the cost of constant modernisation of a cultural district may lead to higher rents that displace artists in favour of higher-price amenities and chain stores. So, after three decades of cultural development strategies, a DKNY store has replaced the flagship art galleries at 420 West Broadway – those of Leo Castelli, Ileana Sonnabend, John Weber, and Andre Emmerich – that established SoHo as a cultural destination. We get similar commercial profiles in SoHo, in Manhattan, Hoxton Square, in London, and other districts around the world.

The old, imagined city that radiated from a historic centre with old money and old cultural capital has yielded, since loft living began, to a fluid set of urban spaces in which new cultural capital based on innovative art is economically and symbolically important. The continuous growth of cultural institutions and the increase in ethnic diversity have reduced the sense of an unbridgeable gap between monumental spaces and slums. Moreover, the anointing of various cities as culture capitals has occurred along with greater tolerance for different kinds of cultural activities. Today, there are more playful exhibits, more public art, and more recognition of the cultural value of ethnic communities. While this view of fluidity, diversity, and Fun culture acknowledges that the city is now more of a collage than an urban war zone, it gives, nonetheless, a more optimistic picture than we know is true. In the face of continued increases in housing prices and homelessness, environmental crises and ethnic hostility, not even a culture capital can be Utopia.

16 Peter Hall, *Cities in Civilization*, New York 1998.

SHARON ZUKIN/HOW TO CREATE A CULTURE CAPITAL

OTHER CITIES, OTHER FUTURES

ZIAUDDIN SARDAR

Where was the city, the first imagined central place, the settled point from which the metropolis began? In what enclave of human aggregation did the meaning of the city first take shape? Around which bustling, still centre did the world come to turn? Not here in the urban West was the confection created, the sights, smells and sounds of all the world jostling and rubbing shoulders. If first is important, then the first city was at a crossroads, the crossroads was in Asia, and the roads were already worn with travel, trade and time before the city walls were built.[1] Within that protected space, at its centre, art, performance, imagination and identity shaped, expressed, decorated and explained the meaning of the human condition to all who frequented the cosmopolis, the centre where many peoples met. Is the city now or then? Has the city today become a forgetting, a gradual strangulation of potential, a diminution of the cities it has been or could become?

Today the cities of the non-West are a conundrum wherein the themes of art, performance, imagination and identity conflict with their own discrete heritage, challenge Western rationalist definitions of modernity and contend for other futures. And here I mean the West not as a geographical location, but rather as a conceptual, political, economic and cultural entity. The city beyond the West wrestles for repatriation, representation and relocation as it appears to give away all that it is and has been. The city beyond the West is strewn with the detritus of modernity; it is a congealed, corrupted mass of all the uglier and ungainly meanings of modernity. From another perspective, the city beyond the West is a harbinger of other futures, as yet as unstable as its juxtapositions are unbecoming. In such cities the central reality is the exploration of identity, the art of becoming. Art in all its forms is recovering its ancient significance and can remake all our imaginings. Art in the non-West is as complex as the city space; its subject is all the ways of being that the idea of the modern metropolis offers and withholds.

THE DISJUNCTURE OF AMORPHOUS CONURBATIONS The idea of the city has become a monolith. The city is taken as the embodiment of what it is to be modern, the distillation of its meaning that emanates centrifugal forces sucking in all life, forcing it into conformity according to its pattern of complexity. The domination exercised by the Western sense of modernity obscures, when its does not eradicate completely, all histories that have generated and fed the growth of cities around the globe. The twentieth-century Western city defines itself as the singular historical trajectory; all that does not feed its rise, bend to its will, join in its conformity is irrelevant, marginal, peripheral. The modern metropolis is a Western fabrication; the powerhouse whose commingled product is the new phenomenon of globalisation, the extrapolation to all cities of a single, invariant future of the postmodern, post-industrial cyber age. Essential to the nature of the contemporary city are the postmodern themes of eclecticism and cosmopolitanism, expressions of its global potency. It is the marketplace of marketable art, genetrix of the cutting edge, the locale of art as style, taste, fashion and playful expression. Western cities and their art are beyond identity, because all that identifies and defines them is already subsumed in the idea of the modern metropolis.

On every congested corner of the cities of the non-West gather other identities – the products of other definitions, concepts and ideas, histories – that stand in contradistinction to dominant ideas and the idea of dominance. The other histories, concepts and ideas, however inchoate, are the context, subject and subtext of all art in all its non-Western locations. To explore the contemporary art of the non-West intimates and requires plurality of definitions. The non-Western city remains a crossroads, an intersection point of many timelines, many different trajectories. The non-Western city has histories. Its histories refer to and connect with different periodizations, look to other centres, not

1 The conventional literature on the city suggests that it is solely a Western invention! For example, in his Eurocentric treatise *Cities in Civilisation*, London 1998, Peter Hall suggests that cities and civilisation began with Athens in 500–400 BC, and proceeded along a superhighway to Florence in the fifteenth century. The 2,000 or so years in between are nothing but a derelict site not worth bothering with.

only the Western metropolitan colonial ones. Non-Western histories had ancient empires, central seas other than the Mediterranean, global connections of trade, diffusion, and mutual influence before they were subsumed into Western colonialism. Modernity, the product of Western colonial accumulation, has been within the non-West, part of its own acculturation for as long as it has been a function of the West. Cosmopolitanism and globalisation are treated as artefacts newly minted in the modern metropolis, the developed, urban formation of the West. Other histories contain different definitions, experiences and expressions of cosmopolitanism and globalisation.

The plurality of histories and trajectories that congregate in the cities of the non-West are not neat sequences, an ordered succession of phases and eras. Plurality gives qualitatively different implications to cosmopolitanism, the interaction of many cultures and cultural forms in one locale, and to globalisation, the rapid and dense interaction of economic, social and cultural exchange on an international scale. We can look back to the ancient caravanserai cities, the pre-industrial cities of the non-West, which were connection points where local, regional and long-distance trade began cosmopolitanism and globalisation before the entry of the West or inception of modernity. The histories within the continuum display multiple forms of interaction with diverse forms of colonialism and reach on to the megalopolis – the characteristic monster city of the contemporary non-West. The chaotic nature of these amorphous conurbations are seen as all that is untenable, unsustainable and unacceptable in the urban condition. Yet, by another reading the megalopolis, the home of post-colonial art, reveals other meanings. The megalopolis is a site of remembering, a relocation that reconnects to another definition of the city as a genuine cosmopolis. The megalopolis in all its conundrums is indeed unsustainable, but the project of its art, as of all its living, is a search for resolution that will recapture other possibilities. The megalopolis is not product and function of one concept of modernity. It lives with, by reference to, and with respect for the plurality of all its histories. Its cosmopolitanism is not only a pluralistic cultural meeting of times and difference, it is the inherent, lived condition, the interior life and experience of its citizens and artists. The art of the megalopolis reflects the lived experiences of its citizens. It seeks to author a new – modern? postmodern? – identity that searches for universal meaning inherent in non-Western urbanscapes.

The cities of the West, paradoxically, are the places of disjuncture. The modern Western metropolis is the urban arena of *anomie*, as Durkheim dubbed the isolated, anonymous condition of the modern city dweller. The contemporary city surfeits on its own technological capabilities. Imagining itself to death, the Western city dreams its dominance as everyone's nightmare. Its postmodern eclecticism is the anonymous assumption of a pastiche of unimportant identities, mixed and matched to divert the personless personality. Urban space frightens its citizens; their dreams are dreams of decay – the Robocop imagery, the millenarian visions of destruction, disjuncture and the death of meaning. The Western city proclaims the death of history, identity and becoming as all there is. The modern metropolis of the West spawns suburbanisation, leaving its economic heart to fester in all its decayed magnificence or to posture in new architectural monuments dedicated to dreams of globalisation. The globalisation of the modern Western city flickers on computer terminals of stock exchanges. It proliferates in inane pop jingles, superstar icons and movies long on mindless action and short on anything to say. This globalisation is the new promise of subordination of all other futures in the dead grasp of the banal global popular culture of mass merchandising.

The cities of the non-West have lived through slow strangulation – they are practised, past masters at survival without fresh air. They are choked and breathless, yet they breathe. Their life-support system is the freedom of resistance. The dreams of the non-Western city are personalised acts of

OTHER CITIES, OTHER FUTURES/ZIAUDDIN SARDAR

repatriation and relocation that define an alternate cosmopolitanism, re-presentations, new fusions, infused with diversity, at home with difference and a quantum leap beyond the global because inescapably they must also wrestle with the universal. Meaning and identity in the non-Western city is rooted in religion. Religion was the sponsor, subject and glory of the ancient art forms of the non-West. Domestication of home-grown modernity, germinating the seeds of a sustainable future, must strive with ultimate questions. It is just as possible that ultimate answers are assumed, implicit in addressing any question, questions of authority and meaning beyond the sociological, technological, mundane secular world. Meaning and identity shaped by non-fundamentalist religious consciousness look both here at this world and the Hereafter to connect the individual to the whole.

THE COSMOPOLITANISM OF THE COLONISED Modernity began for the non-West as intrusive acts of penetration by arrogant power. Spanish Conquistadors annexed a 'new world', previously unknown only to themselves and demarcated it for their exclusive enrichment. Portuguese adventurers declared the Indian Ocean closed under their sole control, for their exclusive enrichment. So began a slow strangulation, an incremental withering process that decayed cities from within as they were suffocated by outside control. Colonialism had its own art, the nightmare art of Orientalism.[2] The Orient was cast as the dark antithesis of an Enlightened West. Orientalism projected a distorted imagination of the Orient that Europe desired and sought to distance from itself. Think of it as Rudyard Kipling did, and no one expresses it better, if that is the word. The text of the colonial city is inscribed in his 1901 novel *Kim*. And *Kim* begins in Lahore; but it is not my Lahore. *Kim* is the story of an irrational journey of unreason, a lama's quest for spiritual fulfilment, interwoven with a story of the modern reality that has overtaken his quaintly exotic world. The reality to which the eponymous hero Kim discovers he truly belongs, as Kipling himself constantly strove to demonstrate in his life, is the 'Great Game', the stratagems of control and command of the colonisers. The journey sets off down the Great Trunk Road, the great thoroughfare of India. So Kipling sketches, but fails to understand in his portrayal, how this ancient highway is a connective tissue in space and time to the cosmopolitanism of Asia, cultures interlinked, interacting, influencing one another, the world of the Other. What animates the story is not the journey but the subterfuge, the spymaster games of war by proxy between distant powers for control of all the bustling life of those whose destiny is no longer within their own control. The essence of *Kim* is that the new masters of the globe can be natives better than the natives themselves: the complete Orientalist project. The West knows more of the Orient, or the Other, than they do of themselves, yet within the West what is known of the Orient or the Other is subsidiary to real knowledgeable advance and innovation, the defining characteristic that belongs to the West alone. The power to define and the defining characteristic the West legitimates the authority and dominance of the West.

The imposed European mercantile globalisation made modernity by remaking all Indies and Orients. The old connections operated within, by, and for, the non-West were broken; new lines of extraction for the exclusive enrichment of the distant metropolis were enforced. The modern metropolis fabricated in Europe was insular, self-absorbed. The riches of the trading worlds, the old and new colonial, did not make the modern metropolis a centre of connection but one of monolithic dominance. European global Empires and their metropolitan centres were not cosmopolitan, their project was a civilizing mission understood and operated as remaking the Other in the form, ideas and modes of the West. Orientalism is the art of colonialism; it is the art of dissembling and appropriation, an unknowing imaginative creation of what Indies and Orient must be to demarcate their difference

2 For a detailed discussion see Ziauddin Sardar, *Orientalism*, Buckingham 1999.

from the self-identity of the new masters. Colonialism made bizarre, exotic distortions of the older reality. The ancient laws of Hindus and Muslims, for example, were constructively reinvented through scholarly appropriation. In this bastardised form they were then re-imposed to regulate the lives of the natives as if they were real, by colonial officials and their institutions. The entire fabric of the older world, its ideas, art and artistry was ransacked and appropriated. What is a Paisley pattern? Its origin lies in the exuberant designs of Indian textiles. When Kashmiri shawls became the latest fashion in Britain, around 1800, the woollen mills of Paisley in Scotland began turning out their own bland imitations to satisfy demand. What we call a Paisley pattern is a familiar motif of Moghul art. The woollen industry, like the cotton mills of Manchester, got preferentially economic encouragement and so purposefully destroyed the textile industries of India. Textile design was not the only pastiche product manufactured in the industrial cities of the West so that it could be sold back to an impoverished, dependent, constructed colony. The learning of the cosmopolitan world of caravanserai cities was extracted, as deliberately as economic resources, without attribution or acknowledgement and formed to serve the instrumental needs of modernity. Appropriation without attribution, extraction without interchange is not cosmopolitanism. Orientalist art speaks not of fusion but only of the daydreams of the metropolitan centre bent on deluding itself, defining the self by demonising and diminishing the Other.

There is a paradox in this suffocating art of dissembling. Ancient cities remained, but they were peripheral, marginal places, the antithesis of their former selves, redundant in the new global order. Like the old cities of Fez and Tunis they were off centre, exotic labyrinths beyond the rationally laid out new encircling cities built by the new masters of the globe. Metropolitan control did not make its abode in old cities, the ancient caravanserai of land or sea; instead it enveloped them in grand new monuments: French colonial Fez and Tunis, New Delhi in Lutyen's dream of eternal Empire. Old cities were irrelevant to the new order of extraction laid out as rationally as the colonial cities themselves. The Spanish Conquistador Cortes's first action in the New World was to lay out a city on gridlines, and distribute plots of land and so many head of population to his raggle-taggle followers. Everywhere he went he continued the process, overwriting, re-inscribing, renaming, building over native cities or circumventing their reasons for existence so that they could wither to death, lacking reason to survive. But the natives who served the new colonial order had to live somewhere, convenient to the call of the masters but not too close for comfort. So the natives lived on in the old decaying cities, straddling two worlds, two histories – living within plurality.

Colonialism was everywhere resisted, everywhere ingested.[3] Colonialism distorted, diverted, destabilised, everything, everywhere. Colonialism increased the proximity of irreconcilable juxtapositions and by these contradictory means increased the cosmopolitanism that is the reality of the Other. The colonised established a contingent, spontaneous and functional existence of multiple possibilities, and all the arts of which this new existence was capable. They continued, in their own discrete sphere, to master and practice old arts and the culture of knowledge and belief from which they sprang. This ancient learning became the golden glow of the lost golden age of autonomy. The old learning and their arts retained meaning, yet, like the way of life they expressed, only in truncated forms. The meaning was largely potential, not grounded in the retaining walls and foundation of a lived, responsible social order. There was resistance and retention, memory and forgetting, the distortions of idealised hopes of a different future of repossession, of a pre-colonial past in a post-colonial future. Cherishing potential beliefs often ossifies compassion to stiffen resistance; fanaticism and fundamentalism have deep roots, implanted by the impositions of colonialism.

3 On how the process worked see Ashis Nandy *The Intimate Enemy: Loss and Recovery of Self Under Colonialism*, Delhi 1983.

OTHER CITIES, OTHER FUTURES/ZIAUDDIN SARDAR

In the colonial city, survival is resistance. Survival is learning, genuinely seeking to master the new ideas of dominance. Only the colonised had no choice but to accomplish such learning, and that spawned new directions in thought and art. The new repertoire of learning, ideas and art forms acquired by familiarity with Western modernity generated thinkers like Rabindranath Tagore (1861-1941), the Bangali poet, painter and musician; and Muhammad Iqbal (1873-1938), the Indian Muslim poet, philosopher and the spiritual founder of Pakistan. Both were masters of two worlds, cosmopolitan synthesisers, an artistic trope impossible to imagine in Europe. But there was also a consciously created class of functionaries, variously dubbed 'brown sahibs', 'Orientalised Orientals' and 'captured minds'[4], that was selected, recruited and schooled by the colonial masters. Their function was not just to make perfect employees and loyally serve the colonial administration as ideal civil servants. No one so punctiliously learns the manners and mores of the master as does the servant. But neither the synthesiser nor the servant is a simple identity, for the original, the indigenous source of identity and its meaning exists in tension with the new expressions as unreflexive, discrete and disassociated realms or supple and subtle fusions. The palimpsest is overwritten, but the indentations of previous writing are tangible, if not visible; they continue to exist as part of the inherent nature of the vellum. They operate to form and constrain all future writing.

Art, the art of the colonised, expresses the multiple conditions of their being as a constant wrestling with the question of identity, authenticity and the ways of becoming. All artistic expression of the colonised is cosmopolitan because it cannot ignore, evade or overcome the actual fact of colonial dominance. Whether it is art seeking to appropriate modernity and attract the patronage of the metropolitan centre, or art seeking to denounce and renounce its effects, it is cosmopolitan art alive, volatile and dense, fuelled by the animus of colonialism.

4 See V. T. Vittachi, *The Brown Sahib Revisited*, Delhi 1987.

THE MEGALOPOLIS AND POST-COLONIAL FUTURES Colonialism ends and continues, is ever present - because it is ineradicable. Independence is - and is not - the challenge of post-colonial times. The city enfolds the legacy of colonialism; the city manifests a new form - the megalopolis - the congested congregation of contested meaning. The conclusion of 'colonialism' is merely an alphabetical progress from the 'c' word to the 'd' word - the 'development' era. Colonial independence is developmental dependence, a becoming that is unbecoming. The dominant notion of the Western city insists on what development is, and how it should occur. Its locale is the megalopolis, the monster city to which all roads lead, to which all eyes turn, in which all ages, stages and conditions are gathered, where all decisions are made.

Developmental dependence is the densest cosmopolitanism the city in the non-West has known. As a built and lived environment it faithfully expresses the contested meanings and disputed identities of its burgeoning population, accurately representing the conundrum that is their existence. The megalopolis is corrupt, unplanned, deformed, polluted and dirty, swamped by the inadequacies of development. It is gleaming islands of new national monuments, pinnacles of affluence and dreaming spires of incorporation in the new globalised economy. It is also encrusted with the scabs of favellas and cities of the dead - as in Cairo where the teeming living inhabit graveyards, and Manila where the squatters who survive on the rubbish dumps provide the classic photo opportunity. This example of prolific, precarious survival is a tribute to the indomitable spirit of resistance and art - for even in such places art flourishes among the refuse. The arts of the megalopolis feed on such conundrums and juxtapositions.

History, with its plural timelines and trajectories, is more alive in the most vacuous, newly made

city of the non-West than in any city of the West. Identity, the struggle to define exactly where, when, and who they are, engages all the histories, all the different intersections of time, ideas and experience that went into the making of the megalopolis. The question of identity is an imaginative palette of all possibilities expressed and performed in all tropes of art and artistry. The art of identity, the living art of becoming, imagines the future as it embraces, invokes and reassesses the past. In the megalopolis, cosmopolitanism is normality, the kind of cosmopolitanism unimaginable in cities of the West that reluctantly, belatedly and half-heartedly, embrace the rhetoric of multiculturalism. In the megalopolis all stages of multiple acculturation jostle, cheek by jowl. Newly-arrived peasants, products of the remnants of indigenous traditions, live in the shanties or by the roadside. They interact with the government official, the new breed of native international businessman, the local foreign-trained intellectual and dyspeptic academic. The megalopolis attracts the fundamentalists and messianic leaders. They host multiple ethnicities that cannot be comfortably clothed in an invented nationality. The megalopolis echoes with denunciations of the inadequacies of modernity. It abounds with projected alternatives seeking legitimacy by diverse and contradictory strategies: removal from modernity to pure authenticity, revitalisation of authenticity as conceptual synthesis starting from premises other than modernity, synthesised variants of modern ideologies fashioned after imagined re-inventions of indigenous history. The alternatives are ever alert to and aware of metropolitan modernity but wrestle with more than metropolitan modernity can mean. They reflect on globalisation but are neither global nor international because they answer an interior, personal predicament that is intra-national, an expression of home-grown cosmopolitanism.

Above all, the megalopolis seeks independence, identity, and answers to questions of tradition and modernity. But what is independence in a world of inequitable relations, where periphery and centre still exist, and dominate the global economy so that even those who rise in the league table are not quite in the premier division? What constitutes national identity, in a polyglot, multi-racial, multi-cultural, multi-ethnic, multi-religious society, where all history and possibility coexist on the same streets? Questions, the megalopolis resounds to questions and expresses them in art, performance and imagination, the art of becoming.

In Lahore the bullock carts jostle with the limousines, the motorised rickshaw conveys all conditions of humanity through the fumes that are clouds of complex consciousness. In such works as Pakistani artist Amir Malik's *Heera Mandi* (1997), we see how tradition and transformations are inscribed in the art of the megalopolis. Heera Mandi, (diamond market), was once a prestigious quarter of the old city. But today its nobility has been transmuted to become the 'diamond market' of the red light district. The painting is framed as if it were a Moghul miniature and draws on both the realist style of Western art and the naïve style of the paintings of colonial native art. The traditional Moghul border design is presented as a window, not a boundary, and appears to be opened outwards inviting the observer to enter within the experience of the artist. With multiple references to multiple influences, the artist presents an invitation to enter within cosmopolitanism as a lived personal experience. In *Lahore 1997*, another Pakistani artist, Fazullah Ahsan, depicts the route from Lahore International Airport to the city complete with the juxtapositions along the way – ancient monuments, age old mosques, new shopping malls, cinemas and fairgrounds, old pleasure gardens – as a reprise of the ancient maps of caravanserai cities.[5] The representation of physical space in ancient style acknowledges that place exists also in time, history reconnects and art is the connective tissue. There is no art in the megalopolis that does not frame itself in tradition. Without tradition there can be no independent post-colonial identity, only the homelessness of the displaced person who inhabits the

5 For the works of these and other Pakistani artists, see M. Athar Tahir, *Lahore Colours* Lahore 1997.

OTHER CITIES, OTHER FUTURES/ZIAUDDIN SARDAR

delusory existence of metropolitan imaginings, Orientalist, modernist or postmodern.

However, we should not see tradition simply as opposition to modernity. It is in opposition to modernity as constructed by the West. The non-West is engaged in creating and defining its own modernity. Moreover, it is also false to think that art that frames itself within tradition is a conformist, comfortable or slavish replication of tradition. Even the artisan fakers, whose works can be found in every flea market of the non-West, innovate, include whimsy and comment in their artefact, make a dense statement of new modern identity through traditional artistic acumen and its sensibility. The artisan and artist are a false dichotomy, a categorisation formed by Westernised modernity that has no meaning for the megalopolis. Artisan and artist reconnect in interactive tension because both question and extend tradition, in all its meanings, depicting and performing a continuous, living, breathing liberation of potential identity. The art of survival, resistance and the search for resolution that will impregnate the life of the megalopolis, must find connection across all time and space. The megalopolis draws into itself all that was and is, but it is not yet a conduit for an interconnected meaningful order. That is yet to come – for the art of the megalopolis germinates the seeds of other, as yet undefined, futures.

GENERAL

Andreotti, Libero (ed.), *Theory of the Dérive and other Situationist Writings on the City*, New York 1987.

Barley, Nick (ed.), *Breathing Cities: Visualizing Urban Movement*, London 2000.

Burgin, Victor, *Some Cities*, London 1998.

Deutsche, Rosalyn, *Evictions: Art and Spatial Politics*, Cambridge, MA 1996.

Feher, Michel and Kwinter, Sanford (eds.), *Zone 1 / 2*, New York 1986.

Fincher, Ruth and Jacobs, Jane M. (eds.), *Cities of Difference*, Guilford Press, 1998.

Frascina, Francis and Harris, Jonathan, *Art in Modern Culture*, London 1992.

Goodman, D.G. (ed.), *The European Cities and Technology Reader*, London 1999.

Hall, Peter, *Cities in Civilisation*, London and New York 1998.

Hayden, Dolores, *The Power of Place*, Cambridge, MA 1997.

Harrison, Charles, *Modernism* London 1999.

Knechtel, John (ed.), *Alphabet City: Open City*, Toronto 1998.

Le Corbusier, *The City of To-Morrow and its Planning*, trans. Frederick Etchells, repr. London 1987.

Low, Setha M. (ed.), *Theorizing the City: The New Urban Anthropology Reader*, Rutgers 1999.

Massey, Doreen, *City Worlds*, London 1998.

Miles, Malcolm; Hall, Tim; and Borden, Iain (eds.), *The City Cultures Reader*, London 2000.

Mitchell, William J., *e-topia*, Cambridge, MA 1999.

Mumford, Lewis, *The City in History*, Fine Communications, USA, reprinted 1998.

The Power of the City, The City of Power, exh. cat., Whitney Museum of American Art, New York 1992.

Sandercock, Leonie, *Towards Cosmopolis: Planning for Multicultural Cities*, London 1998.

Schlör, Joachim, *Nights in the Big City*, London 1998.

Sennett, Richard, *The Conscious of the Eye*, New York 1990.

Southall, Aidan, *The City in Time and Space*, Cambridge, MA 1999.

Short, John Rennie; Kim, Yeong Hyun, *Globalization and the City*, London 1999.

Simmel, Georg, 'The Metropolis and Mental Life', *Gehe-Stiftung zu Dresden*, winter, 1902–3, trans. Kurt H. Wolff.

Soja, Edward W., *Postmodern Geographies*, London 1989.

Tschumi, Bernard, *Event-cities*, Cambridge, MA 1994.

Zukin, Sharon, *Loft Living: Culture and Capital in Urban Change*, Baltimore 1982.

BOMBAY/MUMBAI

1. Political Contexts:

Dange, Shripad Amrit, *Driving Forces of History: Heroes and Masses*, New Delhi 1969.

Gupta, Dipankar, *Nativism in a Metropolis: The Shiv Sena in Bombay*, New Delhi 1982.

Hansen, Thomas Blom, *The Saffron Wave: Democracy and Hindu Nationalism in Modern India*, Princeton, N.J., 1999.

Katzenstein, Mary Fainsod, *Ethnicity and Equality: the Shiv Sena Party and Preferential Policies in Bombay*, Ithaca NY, 1979.

Omvedt, Gail, *Dalits and the Democratic Revolution: Dr. Ambedkar and the Dalit Movement in Colonial India*, New Delhi, London and Thousand Oaks 1993.

Purandare, Vaibhav, *The Sena Story*, Mumbai 1999.

2. History:

Dossal, Mariam, *Imperial Designs and Indian Realities: The Planning of Bombay City, 1845–1875*, Bombay and New York 1991.

Dwivedi, Sharada and Rahul Mehrotra (eds.), *Anchoring a City Line: the History of the Western Suburban Railway and its Headquarters in Bombay, 1899–1999*, Mumbai 2000.

Dwivedi, Sharada and Mehrotra, Rahul (eds.), *Fort Walks: Around Bombay's Fort Area*, Bombay 1999.

Tindall, Gillian, *City of Gold: The Biography of Bombay*, London 1982.

3. Urban Studies, Architecture, Space:

Correa, Charles, *Housing and Urbanisation*, Mumbai, 1999 and London 2000.

Correa, Charles, *The New Landscape*, Bombay 1985.

Mehrotra, Rahul and Sawanth, Sandhya, *The Fort Precinct in Bombay: A Proposal for Area Conservation*, Bombay 1994.

Mehrotra, Rahul and Nest, Gunter (eds.), *Public Places in Bombay*, Mumbai, 1996.

Rohatgi, Pauline, Pheroza Godrej, and Rahul Mehrotra (ed.), *Bombay to Mumbai: Changing Perspectives*, Mumbai 1997.

Seabrook, Jeremy, *Life and Labour in a Bombay Slum*, London and New York 1987.

Sharma, Kalpana, *Rediscovering Dharavi: Stories from Asia's Largest Slum*, New Delhi 2000.

4. Film, Literature:

Abbas, Khwaja Ahmad, *Bombay, My Bombay!: The Love Story of the City*, Delhi 1986.

Chandra, Vikram, *Love and Longing in Bombay: Stories*, Boston 1997.

Chitre, Dilip, (ed.), *An Anthology of Marathi poetry, 1945–65*, Bombay 1967.

Jussawalla, Adil J. (ed.), *New Writing in India*, Harmondsworth 1974.

Manto, Sadat Hasan, *Stars from Another Sky: The Bombay Film World of the 1940s*, New Delhi 1998.

Prasad, Madhava, *Ideology of the Hindi film: a Historical Construction*, Delhi 1998.

Rajadhyaksha, Ashish and Paul Willemen (ed.), *Encyclopaedia of Indian Cinema*, revised ed., New Delhi 1999.

5. VISUAL ARTS:

Husain, M. F., *The Genesis of Gaja Gamini*, Ahmedabad 2000.

Hyman, Timothy, *Bhupen Khakhar*, Bombay and Ahmedabad 1998.

Kapoor, Kamala and Desai, Amita (eds.), *Nalini Malani: Medeaprojekt*, Bombay 1997.

Kapur, Geeta, *When was Modernism: Essays on Contemporary Cultural Practice in India*, New Delhi 2000.

Sheth, Ketaki, *Twinspotting: Photographs of Patel Twins in Britain and India*, Heaton Moor, Stockport, England, 1999.

Singh, Raghubir, and Naipual, V.S., *Bombay: Gateway of India*, Bombay 1994.

Taraporevala, Sooni, *The Zorastrians of India: Parsi: A Photographic Journey*, Mumbai 2000.

Tuli, Neville, *The flamed-mosaic: Indian Contemporary Painting*, Ahmedabad 1997.

LAGOS

Achebe, Chinua, catalogue essay for the exhibition 'Statements' Syrian Club, Lagos 1989.

Amuta, Chidi, *The Theory of African Literature*, London 1989.

Appiah, Kwame, Anthony, *In My Father's House: Africa in the Philosophy of Culture*, New York 1992.

Beier, Ulli, *Contemporary Art in Africa*, London 1968.

Duerden, Dennis *The Invisible Present: African Art and Literature*, New York 1975.

Fosu, Kojo, *Contemporary African Artists: Changing Tradition*, New York 1990.

Fuso, Kojo, *20th Century African Art*, Zaria 1986.

Hassan, Salah M., and Enwezor, Okwui, *New Visions: Recent Works by Six Contemporary African Artists*, Eatonville 1995.

Irele, Abiola, *The African Experience in Literature and Ideology*, London 1981.

Jewsiewicki, Bogumil (ed.), *Art and Politics in Black Africa*, Ottawa 1989.

Kelly, Bernice, *Nigerian Artists: A Who is Who and Bibliography*, Washington 1983.

Kennedy, Jean, *New Currents, Ancient Rivers: Contemporary African Artists in a Generation of Change*, Washington 1992.

Littlefield Kasfir, Sidney *Contemporary African Art*, London 1999.

McEwen, Frank, 'The Workshop School' in *Contemporary African Art*, exh. cat., Camden Arts Centre, London 1970.

Miller, Judith von D., *Art in East Africa: A Guide to Contemporary Art*, London 1975.

Mount, Marshall, Ward, *African Art: The Years Since 1920*, Indiana 1973, reprinted New York 1989.

Oguibe, Olu, *Uzo Egonu: An African Artist in the West*, London 1995.

Oguibe, Olu and Enwezor, Okwui (eds.), *Reading the Contemporary: African Art From Theory to the Marketplace*, London 1999.

Perrois, L. ' Through the Eyes of a White Man: From "Negro Art" to African Arts, Classifications and Methods', *Third Text*, London 1989.

Stanislaus, Grace *Contemporary African Artists: Changing Traditions*, New York 1990.

Vogel, Susan et al., *Perspectives: Angles on African Art*, New York 1987.

Vogel, Susan, et al., *Africa Explores: 20th Century African Art*, New York 1991.

Wahlman, Maude, *Contemporary African Arts*, Chicago 1974.

LONDON

Adams, Brooke et al., *Sensation: Young British Artists from the Saatchi Collection*, exh. cat., Royal Academy of Arts, London 1997.

Als, Hilton, *Leigh Bowery*, London 1998.

"Brilliant": new art from London, exh. cat., Walker Art Center, Minneapolis 1995.

The British Art Show 4, exh. cat., The South Bank Centre, 1995.

Collings, Matthew, *Blimey! From Bohemia to Britpop: The London Artworld from Francis Bacon to Damien Hirst*, Cambridge 1997.

Counsell, Melanie, *Catalogue*, exh. cat., Art Angel and Matt's Gallery, London 1998.

Emotion: Young British and American Art from the Goetz Collection, exh. cat., Deichtorhallen, Hamburg, 1998.

Ferguson, Russell et al, *Gillian Wearing*, London 1999.

Freeze, exh. cat., Port of London Authority Building, London 1988.

Gillick, Liam, *The mystery of the missing 100 dollars*, exh. cat., Gio' Marconi, Milan 1992.

Gomez, Edward M., *New Design London: the edge of Graphic Design*, London 1999.

Kent, Sarah et al., *Young British Art: The Saatchi Decade*, London 1999.

Kester, Grant H., *Art, Activism and Oppositionality, Essays from Afterimage*, Durham N.C. and London 1998.

Life/Live: la scène artistique au Royaume-Uni en 1996 de nouvelles aventures, exh. cat., Musée d'Art Moderne de la Ville de Paris, 1996.

Lucas, Sarah, exh. cat., Museum Boymans-van Beuningen, Rotterdam 1996.

Modern Medicine, exh. cat., Building One, London 1990.

Teller, Juergen, *Go-Sees*, Göttingen 1999.

Tillmans, Wolfgang, *Portikus*, Frankfurt 1995.

MOSCOW

Andrews, Richard and Kalinovska, Milena, (eds.), *Art into Life: Russian Constructivism 1914–1932*, exh. cat., Henry Art Centre, Seattle; Walker Art Centre, Mineapolis; State Tretjakov Gallery, Moscow 1990.

Bann, Stephen, (ed.), *The Tradition of Constructivism*, London 1974.

Bochow, Jörg. *Vom Gottesmenschentum zum neuen Menschen. Subjekt und Religiosität im russischen Film der zwanziger Jahre*, Trier 1997.

Bonnel, Victoria E., *Iconography of Power. Soviet Political Postes under Lenin and Stalin*, Berkeley and Los Angeles 1997.

Bowlt, John, *Russian Art of the Avant-Garde: Theory and Criticism 1902–1934*, New York 1976.

Bowlt, John E. and Matich Olga, *Laboratory of Dreams. The Russian Avant-Garde and Cultural Experiment*, Stanford 1996.

Braun, Edward, *The Theatre of Meyerhold. Revolution on the Stage*, London 1979.

Compton, Susan, *Russian Avant-Garde Books 1917–1934*, London 1992.

Cooke, Catherine (ed.), *Russian Avant-Garde Art and Architecture*, Architectural Design Profile, Vol. 53, London and New York 1983.

Dabrowski, Magdalena; Dickerman, Leah; Galassi, Peter (eds.), *Aleksandr Rodchenko*, exh. cat., The Museum of Modern Art, New York 1998.

Efimova, Alla; Manovich, Lev (eds.), *Tekstura: Russian Essays on Visual Culture*, Chicago and London 1993.

Faucherau, Serge (ed.), *Moscow 1900–1930*, New York 1988.

Gassner, Hubertus; Kopanski, Karlheinz; Stengl, Karin (eds.), *Die Konstruktion der Utopie. Ästetische Avantgarde und politische Utopie in den 20er Jahren*, Marburg 1992.

Gray, Camilla. *The Great Experiment: Russian Art 1863–1922*, London 1962.

Khan-Magomedov, Selim O., *Pioneers of Soviet Architecture: The Search for new Solutions in the 1920s and 1930s*, London 1987.

Krieger, Verena, *Von der Ikone zur Utopie*, Cologne 1998.

Leyda, Jay, *Kino: A History of the Russian and Soviet Film*, London 1900.

Lodder, Christina, *Russian Constructivism*, New Haven and London 1983.

Margolin, Victor, *The Struggle for Utopia: Rodchenko, Lissitzky, Maholy-Nagy*, Chicago 1997.

Markov, Vladimir, *Russian Futurism: A History*, London 1969.

Milner, John, *Vladimir Tatlin and the Russian Avant-Garde*, New Haven and London 1983.

Norman Bear, Nancy van, (eds.), *Theatre in Revolution: Russian Avant-Garde Stage Design 1913–1935*, exh. cat., Fine Arts Museum of San Francisco 1991.

Petric, Vlada, *Constructivism in Film: The Man with the Movie Camera. A Cinematic Analysis*, Cambridge 1987.

Rudnitsky, Konstantin, *Russian and Soviet Theatre: Tradition and the Avant-Garde*, London 1988.

Schlögel, Karl, *Moskau lesen. Die Stadt als Buch*, Berlin 2000.

Stites, Richard, *Revolutionary Dreams: Utopian Vision and Experimental Life in the Russian Revolution*, New York 1989.

The Great Utopia: The Russian and Soviet Avant-Garde 1915-1932, exh. cat., Schirn Kunsthalle, Frankfurt; Stedelijk Museum, Amsterdam; Solomon. R. Guggenheim Museum, New York, 1992.

Tolstoy, Vladimir; Bibikova, Irina; Cooke, Catherine, (eds)., *Street Art of the Revolution: Festivals and Celebrations in Russia 1918–33*, London 1990.

Zhadova, Larissa A., *Malevich: Suprematism and Revolution in Russian Art 1910–1920*, London 1978.

NEW YORK

Anti-Illusion: Procedures/Materials, exh. cat., Whitney Museum of American Art 1969.

Earth Art, exh. cat, Andrew Dickson White Museum of Art, Cornell University, 1969.

Gravity and Grace: The Changing Condition of Sculpture 1965–1975, exh. cat. Hayward Gallery, The South Bank Centre, London 1993.

Harry Shunk-Projects Pier 18, exh. cat., Musee d'art moderne et d'art contemporain, Nice 1992.

Information, exh. cat., The Museum of Modern Art, New York 1970.

Lippard, Lucy, *Six Years: The Dematerialization of the Art Object from 1966 to 1972*, New York 1973.

Lippard, Lucy, *From the Center: Feminist Essays on Women's Art*, New York 1976.

Lippard, Lucy, *The Lure of the Local: Senses of place in a multicentered society*, New York 1997.

Morris, Robert. 'Notes on Sculpture, Part 4: Beyond Objects.', *Artforum* 7 no. 8 (April 1969), pp.50–54.

Nemser, Cindy, 'Subject-Object: Body Art.', *Arts Magazine* 46, no. 1 (September–October 1971), pp.38–42.

Schneider, Ira, and Korot, Beryl (eds.), *Video Art: An Anthology*, New York 1976.

Jacobs, Jane, *The Death and Life of Great American Cities*, London 1962

Robins, Corinne, *The Pluralist Era: American Art, 1968-1981*, New York 1984.

Sondheim, Alan, *Individuals: Post-Movement Art in America*, New York 1977.

New York: Downtown Manhattan SoHo, exh. cat., Akademie der Kunste, Berlin 1976.

Brentano, Robyn and Savitt, Mark, (eds.), *112 Workshop/112 Greene Street*, New York 1981.

Waldup, Shelton (ed.), *The Seventies: The Age of Glitter in Popular Culture*, New York and London 2000.

Parker, Rozsika and Griselda Pollock, *Framing Feminism: Art and the Women's Movement 1970–1985*, London, 1992.

The First Generation, 1970–75, exh. cat., Independent Curators, Inc., New York 1993.

Out of Actions: Between Performance and the Object, 1949–1979, exh. cat., curated by Paul Schimmel.

Alternatives in Retrospect: An Historical Overview 1969–1975, exh. cat., The New Museum, New York 1981. Curated by Jacki Apple. Essay by Mary Delahoyd.

Gould, Claudia and Smith, Valerie , (eds.), *5000 Artists Return to Artists Space: 25 Years*, New York 1998.

Making Their Mark: Women Artists Move into the Mainstream, 1970–85, exh. cat., Abbeville Press, New York 1989.

Women Choose Women, January 12 – February 18, 1973: An Exhibition Organized by Women in the Arts, exh. cat, New York Cultural Center 1973.

'Why Have There Been No Great Women Artists?', in Thomas B. Hess and Elizabeth C. Baker (eds.), *Art and Sexual Politics*, New York 1971, pp.1–44.

Cottingham, Laura, *Not For Sale: Feminism and Art in the USA during the 1970s, a video essay*, New York, 1998.

Miller, Stephen Paul, *The Seventies Now: Culture as Surveillance*, Durham and London 1999.

The New Sculpture 1965–75: Between Geometry and Gesture. exh. cat, Whitney Museum of Art, New York 1990.

Reconsidering the Object of Art: 1965–1975., exh. cat., The Museum of Contemporary Art, 1995.

Schoener, Allon (ed.), *Harlem on my mind: cultural capital of Black America, 1900–1968*, revised ed., New York 1995.

Amelia Jones and Andrew Stephenson (eds.), *Performing the body/performing the text*, London 1999.

Goldberg, Rose Lee, *Performance: live art since 1960*, New York 1998.

Five architects: Eisenman, Graves, Gwathmey, Hejduk, Meier, New York 1972.

PARIS

Antliff, Mark, *Inventing Bergson: Cultural Politics and the Parisian Avant-Garde*, Princeton 1993.

Breunig, Leroy, C. ed., *Apollinaire on Art: Essays and Reviews*, New York 1972.

Clark, T. J., *The Painting of Modern Life: Paris in the Art of Manet and his Followers*, London 1985.

Cottington, David, *Cubism and the Shadow of War: The Avant-Garde and Politics in Paris 1905–1914*, New Haven and London 1998.

Daix, Pierre and Rosselet, Joan, *Picasso: The Cubist Years 1907–1916*, London and New York 1979.

Duncan, Carol, 'Virility and Domination in Early Twentieth-Century Vanguard Painting', in *The Aesthetics of Power*, Cambridge 1993.

Fry, Edward F, (ed.), *Cubism*, London 1966.

Golding, John, *Cubism: A History and an Analysis 1907–1914*, London 1959, 1968.

Kodicek, Ann (ed.), *Diaghilev: Creator of the Ballets Russes*, exh. cat., Barbican Art Gallery, London 1996.

L'école de Paris 1904–1929, la past de l'Autre, exh. cat., Musée d'Art Moderne de la Ville de Paris, 2000.

Leighten, Patricia, 'Picasso's Collages and the Threat of War', *Art Bulletin* Vol.67, Dec 1985, pp.653–72

Poggi, Christine, *In Defiance of Painting: Cubism, Futurism and the Invention of Collage*, New Haven and London 1992.

Robbins, Daniel, 'Jean Metzinger: At the Center of Cubism', in *Jean Metzinger in Retrospect*, exh. cat., University of Iowa Museum of Art, Iowa City 1985.

Rosenblum, Robert, 'Picasso and the Typography of Cubism', in Golding, John, and Penrose, Roland (eds.), *Picasso 1881–1973*, London 1973.

Rubin, William, 'From Narrative to "Iconic" in Picasso: The Buried Allegory in *Bread and Fruitdish on a Table* and the Role of *Les Demoiselles d'Avignon*', *Art Bulletin*, vol.65, Dec 1983, pp.615–49

Rubin, William, and Zelevanzky, Lynn (eds.), *Picasso and Braque: A Symposium*, New York 1992.

Silver, Kenneth E., *Esprit de Corps: The Art of the Parisian Avant-Garde and the First World War, 1914–1925*, London 1989.

Spate, Virginia, *Orphism: The Evolution of Non-Figurative Painting in Paris 1910–1914*, Oxford 1979.

Troy, Nancy, *Modernism and the Decorative Arts in France: Art Nouveau to Le Corbusier*, New Haven and London 1991.

Weiss, Jeffrey, *The Popular Culture of Modern Art: Picasso, Duchamp and Avant-Gardism*, New Haven and London 1994.

RIO DE JANEIRO

Brett, Guy, *'A Radical Leap'*, in Ades, Dawn (ed.), *Art in Latin America: The Modern Era, 1820–1980*, exh. cat., New Haven and London South Bank Centre, 1989.

Brito, Ronaldo, *Neoconcretismo*, São Paulo 1999.

Campos, Augusto de, *Balanço da Bossa*, São Paulo 1978.

Freyre, Gilberto, *Master and the Slaves: A Study in the Development of Brazilian Civilization*, Los Angeles 1990.

Gullar, Ferreira, *'Teoria do não-objeto'*, in *Abstracionismo geométrico e informal*, Rio de Janeiro 1987.

Hélio Oiticica, exh. cat., Galerie National du Jeu de Paume, Paris; Centro Hélio Oiticica, Rio de Janeiro; Witte de With, Center for Contemporary Art, Rotterdam 1992.

Johnson, Randal, and Stam, Robert (eds.), *Brazilian Cinema*, New York 1995.

Lucie-Smith, Edward, *Latin American Art of the 20th Century*, London 1993.

Lygia Clark, exh. cat., Fundació Antoni Tàpies, Barcelona 1998.

Oiticica, Hélio, *Aspiro ao grande labirinto*, Rio de Janeiro 1986.

Mindlin, Henrique E., *Modern Architecture in Brazil*, London 1956.

Projeto Construtivo Brasileiro na Arte, exh. cat., MEC, Rio de Janeiro 1977.

TOKYO

11-nin no 1965-75: Nihon no shashin wa kaerareta ka/Eleven Photographers in Japan 1965–75 (Was Japanese photography changed?), exh. cat., Yamaguchi Museum of Art 1989.

1968-nen, barikedo no naka no seishun (1968, youth in the barricades), Tokyo 1998.

1970-nen: Busshitsu to chicaku, Mono-ha to kongen o tou sakka-tachi/Matter and Perception 1970: Mono-ha and the Search for Fundamentals., exh. cat., The Museum of Fine Arts, Gifu 1995.

'Aa! Banpaku' (Ah! Expo '70), *KEN*, no. 1 (July 1970).

Miki Tamon, Minemura Toshiaki, Nakahara Yōsuke, and Tōno Yoshiaki (eds.), *Art in Japan Today II: 1970–1983*, Tokyo 1984.

Azuma Takamitsu, Azuma Setsuko and Azuma Rie, *'Tō no ie' hakusho* (White paper on 'Tower House'), Tokyo 1988.

Dai-10 kai Nihon kokusai bijutsu-ten: Ningen to busshitsu/Tokyo Biennale '70: Between Man and Matter, exh. cat., Tokyo 1970.

Dai-10 kai Nihon kokusai bijutsu-ten: Ningen to busshitsu/Tokyo Biennale '70: Between Man and Matter, Documentation. Tokyo 1970.

Gendai engeki no ato waku 60's–80's (Artworks of contemporary theatre), exh. cat., The Seibu Museum of Art, Tokyo 1988.

Global Conceptualism: Points of Origin, 1950s–1980s., exh. cat., Queens Museum of Art, New York 1999. Has a useful bibliography.

Goodman, David G. *Angura: Posters of the Japanese Avant-Garde*, New York 1999.

Haryo Ichirō, *Sengo bijutsu seisui-shi* (The ups and downs of post-war Japanese art). Tokyo 1979.

Haryu Ichirō, ed. *Wareware ni totte Banpaku towa nani ka* (What is Expo '70 for us?), Tokyo 1969.

Karia, Bhupendra (ed.), *Yayoi Kusama: A Retrospective*, exh. cat., Center for International Contemporary Arts, New York 1989.

Maki Fumihiko and Atlier Hillside, (eds.), *Hirusaido terasu hakusho* (White paper on Hillside Terrace), Tokyo 1995.

Munroe, Alexandra (ed.), *Japanese Art After 1945: Scream Against the Sky*, New York 1994. Has a comprehensive bibliography.

Suzuki Hiroyuki (ed.), *Nihon no gendai kenchiku/Contemporary Architecture of Japan, 1958–1983*, Tokyo 1984.

'"Purovōku" no jidai' (Age of Provoke), *déjà-vu*, no.14, October 1993.

Toshi e (Towards the city), Nihon no kindai/A History of Modern Japan 10, Tokyo 1999

VIENNA

Beller, Steven, *'Modern Owls Fly by Night: Recent Literature on Fin de Siècle Vienna'*, *The Historical Journal*, 31, 3, 1988, pp.665–683.

Beller, Steven, *Vienna and the Jews 1867–1938: a Cultural History*, Cambridge 1989.

Calvocoressi, Richard, et al., *Oskar Kokoschka 1886–1980*, exh. cat., Tate Gallery, London 1986.

Clair, Jean, et al., *Vienne 1880–1938. L'Apocalype Joyeuse*, exh. cat., Centre Pompidou, Paris 1986.

Comini, Alessandra, *Egon Schiele's Portraits*, Berkeley, Los Angeles and London 1974.

Czech, Hermann, & Wolfgang Mistelbauer, *Das Looshaus*, Vienna 1976.

Engelmann, Paul, *Letters from Ludwig Wittgenstein with a Memoir*, trans. L. Furtmüller, Oxford 1967.

Sigmund Freud: The Essentials of Psycho-Analysis. The Definitive Collection of Sigmund Freud's Writing, selected, with an introduction and commentaries, by Anna Freud, London 1986.

Freud, Ernst, Freud, Lucie, and Grubrich-Simitis, Ilse (eds.), *Sigmund Freud. His Life in Pictures and Words*, New York and London 1978.

Janik, Allan, and Toulmin, Stephen, *Wittgenstein's Vienna*, London 1973.

Kallir, Jane, *Richard Gerstl. Oskar Kokoschka*, exh. cat., Galerie St. Etienne, New York 1992.

Kallir, Jane, *Egon Schiele: The Complete Works*, New York 1998.

Keegan, Susanne, *The Eye of God: A Life of Oskar Kokoschka*, London 1999.

Oskar Kokoschka Letters 1905–1976, selected by Olda Kokoschka and Alfred Marnau, London 1992.

Krumpöck, Ilse, *'Schiele-Skizzen im Heeresgeschichtlichen Museum*, *Neues Museum* 3, April 1996, pp.75–81.

Leitner, Bernhard, *The Architecture of Ludwig Wittgenstein. A Documentation*, London and Halifax, Nova Scotia 1973.

Lunzer, Heinz, Lunzer-Talos, Victoria and Patka, Marcus G. (eds.), *'"Was wir umbringen". "Die Fackel" von Karl Kraus*, Vienna 1999.

McGuinness, Brian, *Wittgenstein, A Life: Young Ludwig (1889–1921)*, London 1988.

Nedo, Michael, & Ranchetti, Michele, *Ludwig Wittgenstein: Sein Leben in Bildern und Texten*, Frankfurt am Main 1983.

Rukschcio, Burkhard, & Schachel, Roland, *Adolf Loos. Leben und Werk*, Salzburg 1982.

Scheible, Hartmut, *Arthur Schnitzler*, Reinbek 1976.

Schick, Paul, *Karl Kraus*, Reinbek 1965.

Schorske, Carl E., *Fin-de-Siècle Vienna. Politics and Culture*, New York 1980.

Schorske, Carl E., *'Revolt in Vienna'*, *The New York Review of Books*, 29 May 1986, pp.24–28.

Schröder, Klaus-Albrecht, *Egon Schiele. Eros und Passion*, Munich and New York 1998.

Timms, Edward, *Karl Kraus, Apocalyptic Satirist: Culture and Catastrophe in Habsburg Vienna*, London 1986.

Vergo, Peter, *Art in Vienna 1898–1918: Klimt, Kokoschka, Schiele and their Contemporaries*, London 1975.

Vergo, Peter, *Vienna 1900*, exh. cat., National Museum of Antiquities of Scotland, Edinburgh 1983

Werkner, Patrick, *Austrian Expressionism. The Formative Years*, trans. Nicholas T. Parsons, Palo Alto 1993.

Wittgenstein, Ludwig, *Tractatus Logico-Philosophicus*, trans. D. F. Pears and B. F. McGuiness, London 1961.

Ludwig Wittgenstein: Briefe an Ludwig von Ficker, W. Methlagl and G. H. von Wright (eds.), Salzburg 1969.

Wuchterl, Kurt, and Hübner, Adolf, *Ludwig Wittgenstein*, Reinbek 1979.

Zweig, Stefan, *The World of Yesterday*, London 1943.

FURTHER READING

BOMBAY/MUMBAI

NAVJOT ALTAF
Between Memory and History
2000
Steel, paper, audio, video
installation 610 × 274.5
The artist

BALKRISHNA ART
Fiza 2000
Painted banner, oil on canvas
305 × 610
Balkrishna Art

Film Pageant 2000
Painted banner, oil on canvas
305 × 1220
Balkrishna Art

GIRISH DAHIWALE
'you impregnated me' 1998
Acrylic on canvas 243.8 × 292.1
Niyatee Shinde, Birla Academy of
Art and Culture, Mumbai

'we'll pay our debt sometime'
1998
Acrylic on canvas 243.8 × 292.1
Amrita Jhaveri

**DESIGN CELL KRVIA (Kamla
Raheja Vidyanidhi Institute for
Architecture, Bombay)
TRILOCHAN CHHAYA
DIRECTOR KRVIA; ANIRUDH
PAUL PROJECT
COORDINATOR; KAUSIK
MUKHOPADHYAY; MANOJ
PARMAR; PRASAD SHETTY;
RUPALI GUPTE.
Metropolitan Laboratory** 2000:

1. **State Initiatives**
Book mixed media 43 × 43
2. **Independent Interventions**
Book mixed media 43 × 43
3. **The City: A Contested
Domain**
Map mixed media 200 × 400
4. **The Way We Live**
Multimedia projection, 15 minutes
Kamla Raheja Vidyanidhi Institute
for Architecture, Bombay
The artist. Commission supported
by London Arts

ATUL DODIYA
Missing I 2000
Enamel paint on metal roller
shutter and laminate board
233.7 × 167.6 on 274.5 × 183
The artist. Commission supported
by London Arts

Missing II 2000
Enamel paint on metal roller
shutter and laminate board
233.7 × 167.6 on 274.5 × 183
The artist. Commission supported
by London Arts

Missing III 2000
Enamel paint on metal roller
shutter and laminate board
233.7 × 167.6 on 274.5 × 183
The artist. Commission supported
by London Arts

Missing IV 2000
Enamel paint on metal roller
shutter and laminate board
274.5 × 183
The artist. Commission supported
by London Arts

SHILPA GUPTA
sentiment-express.com 2000
Interactive project on the internet.
The artist supported by Gray Cell
Infotech Pvt. Ltd, India

M.F. HUSAIN
Gaja Gamini 2000
35 mm film, 120 minutes
The artist

**REIMA HUSAIN AND OWAIS
HUSAIN**
Genesis of Gaja Gamini 1999
Digital-Betacam 28 minutes
The artists

Gaja Gamini in Paris 1999
Digital-Betacam 11 minutes
The artists

RUMMANA HUSSAIN
A Space for Healing 1999
Metal implements, PVC poles,
cloth, plastic objects, gold paint,
vermillion red paint and sound
component 500 × 500 × 500
(installed approx.)
Purchased 2000. Queensland Art
Gallery Foundation, Brisbane

JITISH KALLAT
**Lotus Medallion on a Siamese
Twine** 1998
Acrylic on canvas 152.4 × 233.7
Suresh and Saroj Bhayana
Collection, New Dehli

Canis Familiaris / A Dog's Life
1999
Mixed media on canvas
182.9 × 121.9
Bose Pacia Modern Gallery;
Chelsea, New York

Pastime, Activity and Decoding
2000
Mixed media on canvas
152.4 × 213.4
Madhu Singhal, Udaipur

BHUPEN KHAKHAR
Figures in a Landscape 1995
Watercolour on paper 113 × 105
Foundation for Indian Artists,
Amsterdam

**An Old Man from Vasad who had
Five Penises Suffered from
Runny Nose** 1995
Watercolour on paper 116 × 116
The artist

Sahkhibhav 1995
Watercolour on paper 15.2 × 152
Karan and Nisha Grover

**The Picture of their Thirtieth
Anniversary** 1998
Watercolour on paper 110 × 110
The artist

**BHUPEN KHAKHAR IN
COLLABORATION WITH
VAMAN RAO KHAIRE**
**Amitabh Wounded (Two sided
cut-out figure)** 2000
Oil on canvas on board
243.8 × 119.4
The artists. Commission
supported by London Arts

**Rekha at Nathadwara (Two
sided cut-out figure)** 2000
Oil on canvas on board 243.8 ×
121.9
The artists. Commission
supported by London Arts

**Shahrukh with Southern Stars
(Two sided cut-out figure)**
2000
Oil on canvas on board
243.8 × 81.3
The artists. Commission
supported by London Arts

NALINI MALANI
Hamletmachine 2000
Video installation 20 minutes. 4
LCD video projectors, 4 DVD
players, 4 speakers, 2 amplifiers,
salt, mylar, mirror Closed room
400 × 600 × 900
The artist

TYEB MEHTA
Mahishasura 1998
Acrylic on canvas 260 × 175
Glenbarra Art Museum, Japan

Head (Kali) 1996
Acrylic on canvas 75 × 61
Suresh and Saroj Bhayana Family
Collection, New Dehli

KAUSIK MUKHOPADHYAY
Assisted Ready-Mades: Chairs
2000
Mixed media 15 chairs,
dimensions variable
The artist. Commission supported
by London Arts

SWAPAN PAREKH
All works lent by the artist:

From 'Ad Pulls': Killer Jeans
December 1998
Digital bromide 61 × 91.5

From 'Ad Pulls': Times of India
December 1999
Digital bromide 82.4 × 91.5

From 'Ad Pulls': Jadoonet 1
January 2000
Digital bromide 91.5 × 91.5

From 'Ad Pulls': Jadoonet 2
January 2000
Digital bromide 91.5 × 91.5

From 'Ad Pulls': Max Touch
August 1999
Digital bromide 61 × 91.5

From 'Ad Pulls': Easies
April 2000
Digital bromide 61 × 91.5

ANAND PATWARDHAN
**Hamara Shaher
(Bombay Our City)** 1985
Video from original 16mm film.
82 minutes, edited version 60
minutes
The artist

**Pitru Putra Dharamyudh
(Father, Son and Holy War)**
1995
Video from original 16mm film
approx. 120 minutes, edited
version 60 minutes
The artist

SUDHIR PATWARDHAN
Nullah 1985
Oil on canvas 180 × 112
Gurcharan and Bunu Das

Shaque 1998
Acrylic on canvas 92.5 × 92.5
Kanwaldeep and Devinder
Sahney's Collection

Fall 1998
Oil on canvas 152.4 × 106.7
Virginia and Ravi Akhoury

PUSHPAMALA N.
Phantom Lady or Kismet.
A Photoromance by Pushpamala
N. set in Bombay. Concept,
Direction, Performance:
Pushpamala N. Photography
by Meenal Agarwal 1996–8
16 photographs, each 30.5 × 40.6
(edition of 10)
Bradford Art Galleries and
Museums

ASHISH RAJADHYAKSHA
Bombay Lab: Database 2000
Computer database on Domino R5
software on network browser.
Ashish Rajadhyaksha in
collaboration with the Centre for
the Study of Culture and Society,
Bangalore
Ashish Rajadhyaksha. Commission
supported by London Arts

**Shahar aur Sapna: Bombay
Goes to the Movies** 2000
Video Beta SP, 88 minutes
Compilation and text: Ashish
Rajadhyaksha; Editor Narayan
A.V.; Sound: Mohandas V.P
Ashish Rajadhyaksha. Commission
supported by London Arts

SHARMILA SAMANT
Global Clones 1998
Video projection 80 × 88
The artist

KETAKI SHETH
**From 'The Patel Twins in
Britain and India: Twinspotting'**
1995–8
Photographs, all 40.6 × 50.8
All works lent by the artist:

**Luv and Kush at School,
Dharmaj, Gujarat** 1998

**Ramesh and Suresh in
Ramesh's House, Wembley,
Middlesex** 1997

**Yesha and Niddhi on the Swing
in the Porch, Piplav, Gujarat**
1998

**Shilpa and Sheetal in their Car,
Harrow, Middlesex** 1995

**Ram and Lakhan Outside the
Tobacco Field, Ode, Gujarat**
1998

**Nikita and Niral in their
Bedroom, Wembley, Middlesex**
1996

**Priya and Priti at a Patel
Wedding, Middlesex** 1997

**Dilip and Davesh at their
Nephew's Wedding, Radisson
Edwardian Hotel, London** 1998

SUDARSHAN SHETTY
Home 1998
Paint on fibreglass and wood,
stainless steel 176 × 56 × 270
Fukuoka Asian Art Museum

DAYANITA SINGH
All works lent by the artist:

**From 'Masterji': Masterji and
her troupe of extras, rehearses
the steps that Rekha will
perform for the song in the film
– Kismet ki Rekha. Bombay** 1993
Photograph 38.1 × 57.2

**From 'Masterji': 'Bombay
Saphire' Masterji creates
romance on the moon, as part of
a dance sequence in 'Jaan' with
Twinkle Khanna and Ajay
Devgan. Bombay** 1993
Photograph 38.1 × 57.2

**From 'Masterji': 'Basic Instinct'
Masterji Saroj Khan
demonstrates to screen
goddess Rekha, the movements
for the seduction song. Bombay**
1993
Photograph 38.1 × 57.2

**Seven Wonders', built for the
Screen Film awards. Bombay**
2000
Photograph 45.7 × 45.7

**'Interval at Regal'. Art deco
style Regal cinema was
completed in 1934, designed by
Charles Stevens. Mumbai** 2000
Photograph 45.7 × 45.7

**'Liberty Walkway'. The stair
case leading to the boxes at the
art deco Liberty Cinema built in
the late 40s. Mumbai** 2000
Photograph 45.7 × 45.7

**'Bombay castle'. A model of the
English fort of Bombay, at the
Bhau Daji Lad museum, in
Victoria gardens. Mumbai** 2000
Photograph 45.7 × 45.7

'Victoria and Albert Museum' built in 1872 to commemorate the assumption of the title of Empress of India, by her majesty Queen Victoria. In 1975 the museum was renamed Bhau Daji Lad Museum. Mumbai 2000
Photograph 45.7 × 45.7

'Round Table conference'. A model of Gandhi meeting King George at Buckingham Palace. Mana Bhavan Mumbai 2000
Photograph 45.7 × 45.7

'Head Wear'. This cabinet in the Bhau Daji Lad museum, has samples of the head gear worn by all the different communities that lived in nineteenth-century Bombay city. Mumbai 2000
Photograph 45.7 × 45.7

RAGHUBIR SINGH
From 'Bombay: Gateway to India'
Photographs, each 63.5 × 85
Estate of Raghubir Singh

Zaveri Bazaar, Jeweller's Showroom 1991

Office Worker Leaves Home, Dharavi 1992

At an Irani Restaurant, Dhobi Talao 1992

Roadside Food Stall, Worli

Commuters, Mahim 1991

Noticeboard at an Irani Restaurant c.1990

Mango Season, Crawford Market 1993

Dr B R Ambedkar's Birth Anniversary Celebrations 1991

Fishing Boats Being Unloaded, Ferry Wharf 1994

At the Bombay Dyeing Factories Offices 1989

VIVAN SUNDARAM
All works lent by the artist:
From 'Memorial' 1993:
Burial 1
Photograph, steel and glass 35.6 × 50.8 × 76.2
Burial 2
Photograph, steel and glass 43.2 × 48.3 × 63.5
Burial 3
Photograph, steel and glass 43.2 × 61 × 76.2
Burial 4
Photograph, steel and glass 43.2 × 91.4 × 73.7
Burial 5
Photograph, steel and glass 43.2 × 76.2 × 101.6
Burial 6
Photograph, steel and glass 43.2 × 76.2 × 101.6
Photograph by Hoshi Jal, Times of India, Bombay 1993
The artist

Gun Carriage 1995 (remade 2000)
Detail of photograph by Hoshi Jal, Times of India, Bombay 1993, acrylic sheet, steel 106.7 × 292.1 × 104.1

SOONI TARAPOREVALA
From 'The Parsis: A Photographic Journey'
Photographs, all 40.6 × 50.8
All works lent by the artist:

The Unuala boys' navjote ceremony Bombay 1999

Navar Initiate Engrossed in a Video Game 1984

Passing Time 1985

Cyrus Oshidar, Vice President MTV 2000

Behroze Mistry at Home with her dogs Bijoux and Archie 2000

SEN KAPADIA
Architect in charge of Pandal (Pavillion) 2000
Architect's Team: Kalpesh Solanki assistant architect; Sudhir Deshpand structural engineer; Joyce Alvres administrative officer; Sewri Engineering Co fabricators.
Canvas, bamboo, metal pipes, metal drums, cement, plywood, concrete
Main structure 450 × 600 × 600, and bamboo façade with cinema hoarding 620 × 600 × 120
Sen Kapadia. Commission supported by London Arts

LAGOS

CHINUA ACHEBE
Things Fall Apart 1958
Book 19 × 26 (open)
The British Library Board

No Longer at Ease 1960
Book 19 × 26 (open)
The British Library Board

ADEBISI AKANJI
Untitled (Four Screens) c.1966
Cement and metal, each approx. 156.8 × 101.6
National Museum of African Art, Smithsonian Institution, Washington, D.C. Gift of Mr. and Mrs. Walkemar A. Nielsen

BRUNO BARBEY
All works lent by Bruno Barbey/Magnum Photos:

The slums of Warri near oil fields. Nigeria 1979
Photograph 30.5 × 40.6

Lagos cityscape. Nigeria 1974
Photograph 30.5 × 40.6

Group of people at an event. Nigeria 1967
Photograph 30.5 × 40.6

Lagos city Nigeria 1967
Photograph 30.5 × 40.6

GEORGINA BEIER
A Child and A Toy Horse
Oil on canvas
Private Collection

Sunbirds 1964
Oil on board, approx. 122 × 137
Stanley Lederman

J.P. CLARK
Song of a Goat 1961
Book. 20.5 × 13.7 (closed)
The British Library Board

A Reed in the Tide 1965
Book. 19 × 25.5 (open)
The British Library Board

JAMES CUBITT AND PARTNERS: ARCHITECTS
All works lent by James Cubitt and Partners: Architects

Khawam Houses: Victoria Island: Lagos 1965
5 photographs, each 30.5 × 40.6

Four Schools Group, Surelere: Lagos 1963
4 photographs, each 30.5 × 40.6

St David's School: Lagos 1959
Photograph 30.5 × 40.6

Elder Dempster Offices: Marina: Lagos 1963
Photograph 30.5 × 40.6

Khawam House 2: Ikoyi: Lagos 1961
Photograph 30.5 × 40.6

JC&P House; Ikoyi; Lagos 1962
Photograph 30.5 × 40.6

Corona School: Apapa: Lagos 1961
Photograph 30.5 × 40.6

LEON DAMAS
African Songs 1963
Book 19 × 52 (open)
The British Library Board

CYPRIAN EKWENSI
All works lent by The British Library Board:

Jagua Nana 1963
Book 20.2 × 27 (open)

An African Night's Entertainment, illustrated by Bruce Onobrakpeya
Book 19.2 × 26 (open)

People of the City 1954
Book 19 × 26 (open)

Juju Rock 1966
Book 19 × 13 (closed)

ERHABOR EMOKPAE
Eyo 1962
Acrylic on masonite 198.9 × 122.5
National Museum of African Art. Smithsonian Institution, Washington D.C. Gift of Mrs. Louise C. Hill.

BEN ENWONWU
Bust of Nnamdi Azikiwe 1962
Lead, 30 (h)
Mr Atose Aguelle. Courtesy of Nimbus Art Gallery, Lagos

VINCENT AKWETE KOFI
All works lent by Vincent Matey Kofi:

Black Man's Stoicism 1965
Wood 130 × 20 × 20

Moses 1966
Wood 158 × 76 × 28

Motherhood II 1965
Wood 122 × 20 × 20

JACOB LAWRENCE
Four Sheep 1964
Gouache on paper 55.9 × 78.1
Freda and Harry Schaeffer

The Journey 1965
Gouache on paper 55.2 × 74.9
Bill and Holly Marklyn, Seattle

MALANGATANA NGWENYA
The Story of the Letter in the Hat
All works lent by D. and A. d'Alpoim Guedes:

a) The husband departs for work carrying his wife's hidden letter to her lover 1960
Oil on board 69.8 × 40.4

b) The husband returns from work with the lover's reply in his hat 1960
Oil on board 69.8 × 40.4

c) At 2am the wife, Luisa, puts another letter in the hat while the husband sleeps 1960
Oil on board 69.3 × 69.3

d) The husband kills himself by drinking DDT on discovering his wife's betrayal 1960
Oil on board 40.3 × 69.3

UCHE OKEKE
Burial Procession 1961
Oil on board 60.3 × 120.4
Asele Institute

Nok Suite 1958
Pen and ink on paper 50.6 × 70.5
Asele Institute

Drawings 1961
Book 28 × 19.5 (closed)
The British Library Board

CHRISTOPHER OKIGBO
Labyrinths with Paths of Thunder 1971
Book 20.5 × 26.5 (open)
The British Library Board

Limits 1964
Book 20 × 40 (open)
The British Library Board

J.D. 'OKHAI OJEIKERE
Photographs, each 50 × 60
All works lent by C.A.A.C.– The Pigozzi Collection, Geneva

Untitled 1974
Untitled 1968
Untitled 1974
Untitled 1969
Untitled 1969
Untitled 1968
Untitled 1968
Untitled 1970
Untitled 1972
Untitled 1968
Untitled 1970
Untitled 1974
Untitled 1968
Untitled 1969
Untitled 1974
Untitled 1971

BRUCE ONOBRAKPEYA
The Last Supper with 14 Stations of the Cross 1969
Lino Engraving on Paper (14 parts)
Each approx. 22.9 × 58.4
Bruce Onobrakpeya

MARC RIBOUD
Photographs, all dated 1960, each 30.5 × 40.6
All works lent by Marc Riboud/Magnum photos

Elegant lady entering the Gala Reception on Independence Day

Sir James Robertson, the last British Governor of Nigeria, greeting Princess Alexandra of Kent at Lagos Airport

Young Nigerian wearing a suit specially designed for Independence Day

On Independence Day, many Nigerians of all ages wear traditional clothes adorned with the slogans of the day

One of the famous bronzes of Ife exhibited at Lagos museum

Entrance lobby of Lagos museum

Princess Alexandra of Kent reviews Nigerian troops at Lagos Airport

One of Lagos's main streets decorated with new Nigerian flags on the eve of Independence Day

Princess Alexandra with Sir James Robertson, last British Governor, leaving the airport in the Governor's Rolls Royce

Just after the crucial moment of the Independence ceremony a Nigerian Judge shakes hands with a British judge

Nigerian Prime Minister Baleua addressing a meeting at Lagos stadium on the eve of Independence Day

IBRAHIM SALAHI
The Last Sound 1964
Oil on canvas 122 × 122
The artist

Victory of Truth Pre-1967
Mixed media on masonite board
111.8 × 134.6
Hampton University Museum,
Hampton, Virginia

Funeral and a Crescent 1963
Oil on hardboard, approx. 94 ×
97.8
Gift of Mariska Marker. Courtesy
of the Herbert F. Johnson Museum
of Art, Cornell University

Drawings 1962
Book 28 × 19 (closed)
The British Library Board

WOLE SOYINKA
The Lion and the Jewel 1963
Book 18.2 × 23.5 (open)
All works lent by The British Library
Board

A Dance of the Forests 1963
Books 18.5 × 23.5 (open)

Three Plays 1963
Book 21 × 19 (closed)

The Road 1965
Book 18.5 × 23 (open)

IN ADDITION:

FILM:

DURO LADIPO
An introduction to the founder,
playwright, composer, and
principal male actor of the Duro
Ladipo Travelling Theatre
Company of Oshogbo, Nigeria
1967
16 mm film, 30 mins

MAGAZINES:

Amber October 1963
Magazine 22 × 28.5
African Music Archive, University of
Mainz

Amber September 1963
Magazine 22 × 28
African Music Archive, University of
Mainz

Black Orpheus Various dates
Magazines
The British Library Board

Flamingo (Nigerian edition)
May 1st
Magazine 21.5 × 28
African Music Archive, University of
Mainz

Lagos This Week (4 copies)
Magazine
4 parts each 17 × 24.5
African Music Archive, University of
Mainz

Nigeria Magazine
Magazines
Private Collection

Nigerian Morning Post– Special
Souvenir Edition– Hail the New
Republic
Magazine 31 × 38
African Music Archive, University of
Mainz

Paris Match No. 357 11
February 1956
Magazine
Private Collection

Spear September 1963
Magazine 24 × 31
African Music Archive, University of
Mainz

Spear January 1965
Magazine 24 × 31
African Music Archive, University of
Mainz

PHOTOGRAPHS:

Aerial view of Marina and
harbour
Photograph 40.6 × 50.8
Public Record Office Image Library

Boxing in Lagos, Western
Region, Federation of Nigeria
January 1959
Photograph 40.6 × 50.8
Public Record Office Image Library

DRUM NIGERIA
Fela Ransome-Kuti February
1966
Photograph 30.5 × 40.6
Photograph by Drum photographer
© Baileys Archives

This Music Makes them
C-R-A-Z-Y
DRUM December 1959
Photograph
30.5 × 40.6
Photography by Matthew Faji ©
Baileys Archive

This Music Makes them
C-R-A-Z-Y December 1959
Photograph 30.5 × 40.6
Photograph by Matthew Faji ©
Baileys Archives

This Music Makes them
C-R-A-Z-Y December 1959
Photograph 30.5 × 40.6
Photograph by Matthew Faji ©
Baileys Archives

How Far will Destiny Take The
Sardauna of Sokoto – The
Sardauda with some of the men
who advise him on policy
September 1959
Photograph 30.5 × 40.6
Photograph by Drum photographer
© Baileys Archives

Nigeria Welcomes Queen in
African Style – Queen Elizabeth
is greeted by the Emir of Kano
July 1956
Photograph 30.5 × 40.6
Photograph by Camera Press,
London © Camera Press

How We Celebrated
Independence– Key figures in
the ceremonies which brought
our Independence, Princess
Alexandra and Sir Abubakar
Tafawa Balewa January 1961
Photograph 30.5 × 40.6
Photograph by Drum photographer
© Baileys Archives

Constitutional Conference –
Colonial Secretary Alan
Lennox-Boyd talks to, from left,
Premier Awolowo, Premier
Balewa, Premier Sardauna of
Sokoto and Premier Azikiwe
1959
Photograph 30.5 × 40.6
Photograph by London Express
News © Feature Service

A big Day for our Big-Shots! – a
day to remember ... a day of
glory for Nigeria April 1960
Photograph 30.5 × 40.6
Photograph by Drum photographer
© Baileys Archives

Nigeria's Greatest Show!–
Royalty! July 1959
Photograph 30.5 × 40.6
Photograph by Drum Photographer
© Baileys Archive

How Far Will Destiny Take the
Sardauna of Sokoto? – Imposing
ruler of the North September
1959
Photograph 30.5 × 40.6
Photograph by Drum Photographer
© Baileys Archive

Fighting Man of Peace– Sir
Abubakar Tafawa Balewa,
Prime Minister of the Nigerian
Federation for the last two
years July 1960
Photograph 30.5 × 40.6
Photo by Drum Photographer ©
Baileys Archives

Man, Highlife is Getting Crazier
Still January 1959
Photograph 30.5 × 40.6
Photograph by Drum Photographer
© Baileys Archives

The Queen of Nigeria –
Thousands of Nigerians, in gaily
coloured costumes welcomed
Her Majesty Queen Elizabeth II,
and His Royal Highness the
Duke of Edinburgh at the start
of their 19-day tour of Nigeria,
Britain's largest colony. With
her the Oba of Lagos, Adeniji
Adele II February 1956
Photograph 30.5 × 40.6
Photographer unknown © unknown

Last Lap To Independence
August 1961
Photograph 30.5 × 40.6
Photograph by Drum Photographer
© Baileys Archive

Drum Nigeria
Cover. Special Royal Tour Issue
July 1956
Photograph 30.5 × 40.6
© Baileys Archive

Cover. Dr Nnamdi Azikiwe,
Nigeria's Governor general March
1961
Photograph 30.5 × 40.6
© Baileys Archive

Cover April 1961
Photograph 30.5 × 40.6
© Baileys Archives

Cover. Sir Abubakar Tafewa Balewa
October 1960
Photograph 30.5 × 40.6
© Baileys Archive

Family Album 1956–68
Photograph 16 parts, dimensions
variable
Miss Comfort Esusu

Family Album
Photograph, dimensions variable
Ambassador Olusegun Olusola

Family Album 1951–62
Photograph
18 parts, dimensions variable
Miss Seyi Ojo

Family Album 1956–60
Photograph, 6 parts: dimensions
variable
Mr and Mrs Adeneye

Family Album 1953–70
Photograph, 17 parts: dimensions
variable
Mr Rasheed Gbadamosi

Family Album 1956–68
Photograph, 9 parts: dimensions
variable
Alhaji Abdulai

Family Album
Photograph, 47 parts: dimensions
variable
Benson family

Family Album
Photograph, 26 parts: dimensions
variable
The family of the late architect
Akin Tejuoso

Gentlemen Comparing Race
Tips April 8, 1961
Photograph 30.5 × 40.6
© Bettmann/ CORBIS

Housing in Lagos, Western
Region, Federation of Nigeria
January 1959
Photograph 40.6 × 50.8
Public Record Office Image Library

Lady Ademola Honoured in
London July 1959
Photograph 40.6 × 50.8
Public Record Office Image Library

Lagos. Aerial view of
racecourse area
Photograph 40.6 × 50.8
Public Record Office Image Library

Lagos Bridge from Victoria
Island, looking towards Lagos
Photograph 40.6 × 50.8
Public Record Office Image Library

Lagos Racecourse, Western
Region, Federation of Nigeria
January 1959
Photograph 40.6 × 50.8
Public Record Office Image Library

Lagos Racecourse, Western
Region, Federation of Nigeria
January 1959
Photograph 40.6 × 50.8
Public Record Office Image Library

Lagos, Marina, looking towards
Government House
Photograph 40.6 × 50.8
Public Record Office Image Library

Nigerian Broadcasting
Corporation January 1959
Photograph 40.6 × 50.8
Public Record Office Image Library

Nigerian Broadcasting
Corporation January 1959
Photograph 40.6 × 50.8
Public Record Office Image Library

Nigerian Broadcasting
Corporation January 1959
Photograph 40.6 × 50.8
Public Record Office Image Library

Nigerian Broadcasting
Corporation
Photograph 40.6 × 50.8
Public Record Office Image Library

Nigerian Independence,
Drummers December 1960
Photograph 40.6 × 50.8
Public Record Office Image Library

Nigerian Woman Placing Bets
April 8, 1961
Photograph 30.5 × 40.6
© Bettmann/ CORBIS

Portrait of a Flag Seller 31
January 1956
Photograph 30.5 × 40.6
© Bettmann/ CORBIS

Spectating Fans Watching Race
8 April 1961
Photograph 30.5 × 40.6
© Bettmann/CORBIS

Supporters Cheering for
Election Results 16 December
1959
Photograph 30.5 × 40.6
© Bettmann/CORBIS

Townspeople Gathering for a
Race 8 April 1961
Photograph 30.5 × 40.6
© Bettmann/ CORBIS

Traffic policeman at the cross-
roads leading to Marina at C.O.I.
Photograph 40.6 × 50.8
Public Record Office Image Library

Untitled, Lagos 1952
Photograph 40.6 × 50.8
Public Record Office Image Library

Untitled, Lagos
Photograph 40.6 × 50.8
Public Record Office Image Library

Untitled, Lagos
Photograph 40.6 × 50.8
Public Record Office Image Library

West Africa: Federation of
Nigeria, Communications;
railways, Western Region
December 1959
Photograph 40.6 × 50.8
Public Record Office Image Library

West Africa- Federation of
Nigeria, Social Services,
education, Western Region
December 1959
Photograph 40.6 × 50.8
Public Record Office Image Library

In addition: Various photographic
material documenting building
projects in Lagos by: Maxwell Fry
and Jane Drew; John Godwin and
Gillian Hopwood Archive; Oluwole
Olumuyiwa, Architects Co-
Partnership and Alan Vaughan-
Richards
A selection of documentary
material from the BBC and ITN

RECORDS:
All lent by African Music Archive,
University of Mainz:

Caban Bamboo-Bobby Benson
and His Combo
Record cover 18 × 18

Dancing Time No.3 - Pastor Rex
Lawson and his Mayor's Dance
Band
Record cover 18 × 18

Dancing Time No.5 -
Commander in Chief Stephen
Osita Osadebe and His Nigerian
Sound Makers
Record cover 18 × 18

Dancing Time No.7 - Sir Victor
Uwaifo and His Melody
Maestros
Record cover 18 × 18

Great African Highlife Music
No.2
Record cover 31 × 31

The Hit Sound of the Ramblers
Dance Band
Record cover 31 × 31.5

Hubert Ogunde - Song of the
People
Record cover 18.5 × 18.5

Nigerphone
Record cover 17.5 × 17.5
African Music Archive, University of
Mainz

Olaiya's Victories - Victor
Olaiya and his all-Stars
Record cover 26 × 26

Victor Olaiya and His All Stars -
Afro- Rhythm Parade Vol. 7
Record cover 18 × 18

Pastor Rex Lawson and His
Mayor's Dance Band
Record cover 17.5 × 17.5
African Music Archive, University of
Mainz

Ramblers International
Record cover 31 × 31

Rex Lawson's Victories -
Cardinal Rex Lawson and his
Mayor's Band of Nigeria
Record cover 26 × 26

Saturday Highlife
Record cover 18 × 18

Shadow Dance and Music
Originated by Sir Victor Uwaifo
the Maestro- Oh! Love
Record cover 26 × 26

Sir Victor Uwaifo Big Sound-
Sir Victor Uwaifo and His
Melody Maestros
Record cover 26 × 26

Stars of West Africa
Record cover 30.8 × 30.8

Sunny Adé, and his African
Beats
Record cover 31.3 × 31.3

Top Hits from Nigeria
Record cover 18 × 18

Top Hits from Nigeria Vol. 2
Record cover 18 × 18

Top Hits from Nigeria Vol.3
Record cover 18 × 18

LONDON

BANK
Trough (BANK 1989–99; variously
Simon Bedwell, David Burrows,
Dino Demosthenous, John
Russell, Milly Thompson, Andrew
Williamson. Currently Simon
Bedwell and Milly Thompson)
2001
Mixed media 75 × 260 × 60
BANK

The BANK 1996–7
Set of 34 magazines, each
29 × 21
BANK

SALLY BARKER
Sally Barker Gallery
2000–ongoing
Mixed media sculpture, works on
paper 92 × 145 × 120
The artist

HENRY BOND/LIAM GILLICK
Documents Series
Black-and-white and colour
photographs, each 38.7 × 48.8
(with mount)
The artists and Emily Tsingou
Gallery, London

Selected works:

25 July 1990, London England,
15:00
**News Conference on Fast
Breeder Reactor Report House
of Commons Energy
Committee.**

30 October 1990, London
England, 10:30
**Commemorative Plaque
unveiled on site of Fifties '2 is'
coffee bar. Old Compton Street.**

8 November 1990, London
England, 18:00
**The Everest mountaineers with
model of mountain before
lecturing at Royal Geographical
Society. Kensington Grove.**

22 November 1990, London
England, 18:30
**Queen attends opening of the
Nehru Gallery of Indian Art.
Victoria & Albert Museum.**

28 November 1990, London
England, 13:00
**Michael Heseltine at American
Chamber of Commerce lunch.
Grosvenor House.**

17 April 1991, London England,
12:00
**Electric Light Orchestra Part II
launch new single and world
tour with Moscow Symphony
Orchestra. Kensington Palace
Gardens.**

17 April 1991, London England,
14:30
**Atomic Energy Authority media
briefing on 'Chernobyl: Five
Years On.' 11 Charles II Street.**

25 April 1991, London England,
13:45
**Polish President Lech Walesa
on state visit and meets Mrs
Thatcher and Neil Kinnock;
speaks at Young Politicians'
Conference. News conference
at Polish Embassy, Portland
Place.**

25 April 1991, London England,
17:00
**Reception to launch Super-
Commuter, Fred Finn's ten
million mile trip. Roof Gardens,
Kensington.**

16 July 1991, London England,
10:30
**Harpers and Queen Sloane
Ranger of the Year Award.
Sloane Square.**

31 July 1991, London England,
11:30
**Food from Britain news
conference. Report on red meat.
The Livery Hall, Founders Hall,
Cloth Fair.**

2 August 1991, London England,
10:30
**Sentencing of teenager Mark
Acklom, bogus stockbroker
accused of obtaining money and
goods by deception. Inner
London Crown Court.**

7 August 1991, London England,
11:00
**Britain's youngest kidney
transplant patient, 21 month
old Keeley Beeton-Heron,
launches National Kidney
Research Gift of Life day.
Waterloo Station.**

8 August 1991, London England,
11:00
**Cricket, fifth Cornhill Test,
England v West Indies (to 12
August, includes Sunday play).
The Oval.**

18 September 1991, London
England, 10:00
**Private manslaughter
prosecution following
Marchioness disaster. Bow
Street Magistrates Court.**

25 September 1991, London
England, 10:00
**M.P. Dave Nellist under
investigation for alleged links to
Militant summoned before
Labour National Executive
committee meeting. Walworth
Road.**

27 September 1991, London
England, 12:30
**First World Scrabble
Championship. New Connaught
Rooms, Great Queen Street.**

11 February 1992, London
England, 9:30
**Launch of 'Car Crime
Prevention Year'. Queen
Elizabeth II Conference Centre.**

12 February 1992, London
England, 12:00
**Rail Unions launch nationwide
General Election campaign.
RMT Unity House, 205 Euston
Road.**

12 February 1992, London
England, 17:00
**CBI Regional Industrial Trends
Survey news conference.
Centre Point.**

14 February 1992, London
England, 14:30
**Auction of the contents of
Robert Maxwell's London home.
Sotheby's.**

11 February 1992, London
England, 10:00
**Evacuation and closure of
Whitehall and surrounding area
due to discovery of suspect
device. Trafalgar Square.**

28 February 1992, London
England, 9:00
**Closure of all London mainline
stations following bomb
explosion London Bridge
Station.**

6 January 1993, London
England, 10:00
**Opening of the International
Boat Show. Earl's Court.**

6 January 1993, London
England, 16:30
**Candlelit vigil outside office of
British Aerospace organised by
Catholic peace organisation,
Pax Christi, in order to protest
against its alleged involvement
in arms sales to the Middle
East.**

9 January 1993, London
England, 10:00
**'Clinton Economics' one-day
conference organised by the
Transport and General Workers
Union. Chaired by Bill Morris
and addressed by senior aides
of President elect Clinton.
Queen Elizabeth II Conference
Centre.**

6 April 1993, London England,
11:00
**Arts Council and Sports Council
announce plans in reference to
proposed National Lottery.
Royal Society of Arts, John
Adam Street.**

6 April 1993, London England,
14:00
**High Court order to challenge
accidental death verdicts,
sought by relatives of the
victims of Hillsborough football
stadium disaster. Royal Courts
of Justice.**

19 May 1993, London England,
12:00
**Memorial Service for Ed Hinty,
killed in Bishopsgate bombing.
St. Brides, Fleet Street.**

21 April 1994, London England,
12:00
**The Right Honourable William
Waldegrave MP, the Chancellor
of the Duchy of Lancaster,
presents Business Woman of
the Year Award. Claridges.**

TORD BOONTJE
Rough-and-Ready Reading area
2001
Blanket, straps, wood, mixed
media, total floor area: 600 × 400
The artist. Commission supported
by London Arts

SONIA BOYCE
Afro Blanket 1994
37 Afro wigs 139.7 × 137.2
The artist and Wigmore Fine Art

HUSSEIN CHALAYAN
after words 2000
Mahogony wood, fabric, colour
photographs, film variable
Concept Hussein Chalayan;
photography and film by Marcus
Tomlinson
Hussein Chalayan and Marcus
Tomlinson

CITY RACING
CITY RACING family tree 2000
Mixed media 243.8 × 609.6 × 2
CITY RACING

MELANIE COUNSELL
Filing Cabinets (version 3)
2000
6 filing cabinets, cardboard and
sellotape
Floor area: 450 × 400
The artist and Matt's Gallery,
London. Commission supported by
London Arts

KEITH COVENTRY
Burgess Park, SE5 1994
Bronze 154 × 30 × 30
Mr and Mrs Charles Brown and
Emily Tsingou Gallery, London

JEREMY DELLER
Current Research (videos)
1998–ongoing
Installation with 6 monitors; 60hrs
colour sound
The artist and Cabinet, London

TOM DIXON
Installation consisting of the
following objects:

Jack 1996
Polyethylene, light fitting and 40w
bulb 60 × 60 × 60
Eurolounge

Melon 1997
Polyethylene, light fitting and 40w
bulb 30 × 30 × 30
Eurolounge

Octo 1998
Polyethylene, light fitting and 40w
bulb 40 × 40 × 40
Eurolounge

Star 1996
Polyethylene, light fitting and 40w
bulb 30 × 30 × 30
Eurolounge

PAUL ELLIMAN
Alphabet 1991/92
26 photobooth photographs, each
5 × 4
Paul Elliman

Bits 1995
A collection of individual items
presented in a box.
Metal, plastic, cellphones,
aluminium, card and wire
67 × 49 × 4
Paul Elliman

Bits Photograph 1995
Colour photograph 24 × 30.5
Paul Elliman and Nigel Shafran

**City Man Saves 2 in Fireball
Smash** 1997
Printed on newsprint 64 × 45
Paul Elliman

E PLURIBUS UNUM 1998
Downloaded from website
Ink on paper, 8 pages each
29.5 × 21
Paul Elliman

**Collection of letter e's found on
sweets, soft drinks and crisp
packets** 1998/99
Mixed media 30.5 × 25.5 × 4
Paul Elliman

TRACEY EMIN
All The Loving (Underwear Box)
1982–97
Ottoman box with appliqued
letters, underwear from 1982-
1997, accessories, wire, pedestal
71 × 80 × 60.3 (box: 36 × 42.5 ×
29)
Goetz Collection, Munich

TRACEY EMIN/SARAH LUCAS
The Shop 2000
6 C-prints
76.1 × 91.5 each
Jay Jopling/White Cube and Sadie
Coles HQ (London) Photo credit:
Carl Freedman

**Tracey Emin and Sarah Lucas
Talk Shop** 2000
Video projection/15–20mins
DVD/colour/sound
Jay Jopling/White Cube and Sadie
Coles HQ (London)

JASON EVANS
Strictly 1991
8 C-Type colour prints, each 76.2 ×
76.2
Photography Jason Evans
Styling Simon Foxton
Published in i-D, July 1991
Jason Evans and Simon Foxton

ANGUS FAIRHURST
Gallery Connections 1991–6
Audio and mixed media
(desk)/sound 64.5 × 110 × 45
Tate. Presented by the Patrons of
the New Art (Special Purchase
Fund) through the Tate Gallery
Foundation 1997

DAMIEN HIRST
**The Acquired Inability to
Escape, Inverted** 1993
Glass, steel, silicone, MDF table,
chair, ashtray, lighter and
cigarettes 213.4 × 304.8 × 205.1
Private Collection, Courtesy Jay
Jopling/White Cube (London)

GARY HUME
Incubus 1991
Oil on wood 238.9 × 384.6
Tate. Presented by Janet Wolfson
de Botton 1996

IMPRINT 93, curated by Matthew
Higgs 1993–2000
Mixed media: publications
Variable: approximately 50
publications/editions
IMPRINT 93, London

INVENTORY
Accumulate – Replicate 1999
Found objects – wallets, credit
cards, till receipts, ephemera
variable
INVENTORY

INVENTORY
**INVENTORY Archive
(selection)** 1995–2000
Paper and ephemera variable
INVENTORY

Estate Map 1999
Paint and marker pen on
aluminium 182.8 × 121.9
INVENTORY

RUNA ISLAM
Refuse 1996
Light box with 620 35mm slides
40 × 227 × 25
The artist and Jay Jopling/White
Cube (London)

NICK KNIGHT
Access-able 1998
Colour inkjet banner 300 × 2100
Photography Nick Knight; Art
Direction Alexander McQueen;
published by Dazed and Confused,
1998
Nick Knight

Family 1998
12 colour photographs, each
20.3 × 15.2
Photography Nick Knight; Styling
Simon Foxton and Jonathan Kaye;
Model Lee Cole; published in i-D,
November 1998
Nick Knight

MICHAEL LANDY
Costermonger's Stall 1992–7
Wood, gloss paint, tarpaulin,
plastic buckets, electric lights and
flowers 182 × 213 × 213
The Saatchi Gallery, London

MARK LECKEY
We Are Bankside 2001
Video/12mins/colour/sound
The artist; Cabinet, London; Gavin
Brown's Enterprise Corps, New
York. Commission supported by
London Arts

PETER LEWIS
**Big Blue, curated by Peter
Lewis** 1997–2001
Ink on paper, mixed media
variable
The artists and Peter Lewis

SARAH LUCAS
Still Life 1992
Bicycle, C-prints on card, wood
115 × 140 × 56
Sadie Coles HQ, London

NOSEPAINT - BEACONSFIELD
**The NOSEPAINT -
BEACONSFIELD Archive**
1991–2000
Mixed media, Variable/multipart
NOSEPAINT – BEACONSFIELD

**The NOSEPAINT -
BEACONSFIELD Papertrail**
1991–2000
A glimpse into the files of one of
the few surviving artist-led
organisations of the 90s,
Beaconsfield, and its
mythologised predecessor,
Nosepaint 2001
Ink on paper, edition of 200
NOSEPAINT – BEACONSFIELD

HAYLEY NEWMAN
**Connotations - Performance
Images** 1994–1998
The artist; commissioned by Hull
Time Based Arts

Selected works:

Football Audio Cup 1998
Colour C-Type photograhic print
with accompanying text
9 images, 12.7 × 7.9
Photographer Casey Orr

Exploding Lego 1998
Colour C-type photographic print
with accompanying text 50.5 × 76
Photographer Casey Orr

Bass in a Space 1998
Black-and-white photographic print
with accompanying text
21 × 24
Photographer Hayley Newman

**Crying Glasses (An aid to
Melancholia)**
Black-and-white photographic print
with accompanying text 40.2 ×
50.2
Photographer Casey Orr

B(in)
2 black-and-white photographic
prints with accompanying text
39 × 39
Photographer Casey Orr

Spirit
Encapsulated digital colour print
with accompanying text 59 × 83.5
Photographer Casey Orr

CHRIS OFILI
Shithead 1993
Hair, copper wire, elephant dung,
map pins 13 × 14.5 × 16
The artist

JANETTE PARRIS
Bite Yer Tongue 1997
From the series Bite Yer Tongue
1997–ongoing
Ink on paper, 4 works each 37 ×
30 (framed)
The artist

Bite Yer Tongue 1997
Ink on paper 37 × 30
Private Collection, London

Bite Yer Tongue 1997
Ink on paper 37 × 30
Mark Wallinger

Bite Yer Tongue 1997
Ink on paper 37 × 30
Private Collection, London

Bite Yer Tongue 1997
Ink on paper 37 × 30
Private Collection

Skint 1995
Mixed media 56 × 20 × 6
The artist

SIMON PERITON
Forged Private View Invites
1995–7
Card, 3 each 17.5 × 12; 14.5 ×
14.5; 10 × 17
The artist

Private View cards 1990–99
Ink on paper variable
Tate Archive Collection; Gavin Turk;
various London galleries

DONALD RODNEY
**Self-Portrait 'Black Men Public
Enemy'** 1990
5 lightboxes with 5 duratran prints
190.5 × 121.9
Arts Council Collection, Hayward
Gallery, London

JOHNNY SPENCER
Inquiry unit 2000
Silver anodised aluminium, low
voltage Halogen lighting,
photographs Height 40 × diameter
56 × radius 8
The artist. Commission supported
by London Arts

SARAH STATON
Sarah Staton's SupaStore
1993–2000
Mixed media, variable dimensions
The artist

JUERGEN TELLER
Go-Sees series 1998–9
C-prints mounted on board and
framed 107.3 × 149.2 × 2.5
The artist and Lehmann Maupin,
New York

Go-Sees: May 1998
Go-Sees: June 1998
Go-Sees: July 1998
Go-Sees: September 1998
Go-Sees: October 1998
Go-Sees: November 1998
Go-Sees: December 1998
Go-Sees: January 1999
Go-Sees: February 1999
Go-Sees: March 1999
Go-Sees: April 1999

WOLFGANG TILLMANS
Concorde Grid 1997
56 C-prints each 32 × 22
Tate; presented anonymously
2000

Concorde 1996
Colour inkjet 180 × 123
The artist, Maureen Paley/Interim
Art, London

GAVIN TURK
Cavey 1991/97
Ceramic 48.3 × 48.3 × 3
Private Collection, Courtesy Jay
Jopling/White Cube (London)

KEITH TYSON
**Monument to the Present State
of Things** 2000
Steel and newspaper 305 × 114 ×
114
Sammlung Ringier, Zürich

UNDERCURRENTS
**A London Retrospective:
Undercurrents Alternative
News Videos**
Video 60 mins/colour/sound
Undercurrents

MARK WALLINGER
Royal Ascot 1994
Video installation, multipart
The British Council

GILLIAN WEARING
Homage to the woman with the bandaged face who I saw yesterday down Walworth Road 1995
7 mins/black and white/colour, sound and subtitles
Courtesy Maureen Paley/Interim Art, London

RACHEL WHITEREAD
Demolished 1996
Duotone screenprints, each 49 × 74.3
Tate. Purchased 1996

A: Clapton Park Estate, Mandeville Street, London E5; Ambergate Court; Norbury Court, October 1993 1996
A: Clapton Park Estate, Mandeville Street, London E5; Ambergate Court; Norbury Court; October 1993 1996
A: Clapton Park Estate, Mandeville Street, London E5; Ambergate Court; Norbury Court; October 1993 1996
A: Clapton Park Estate, Mandeville Street, London E5; Ambergate Court, Norbury Court; October 1993 1996
B: Clapton Park Estate, Mandeville Street, London E5; Bakewell Court; Repton Court; March 1995 1996
B: Clapton Park Estate, Mandeville Street, London E5; Bakewell Court; Repton Court; March 1995 1996
B: Clapton Park Estate, Mandeville Street, London E5; Bakewell Court; Repton Court; March 1995 1996
B: Clapton Park Estate, Mandeville Street, London E5; Bakewell Court; Repton Court; March 1995 1996
C: Trowbridge Estate, London E9; Hannington Point; Hilmarton Point; Deverill Point; June 1995 1996
C: Trowbridge Estate, London E9; Hannington Point; Hilmarton Point; Deverill Point; June 1995 1996
C: Trowbridge Estate, London E9; Hannington Point; Hilmarton Point; Deverill Point; June 1995 1996
C: Trowbridge Estate, London E9; Hannington Point; Hilmarton Point; Deverill Point; June 1995 1996

MOSCOW

ACHTYRKO
Untitled 1920
Gouache and ink 24.1 × 19.7
Collection Merrill C. Berman

ANATOLI BELSKY
The Communard's Pipe 1929
Lithograph 107.6 × 75.9
Collection Merrill C. Berman

ILYA CHASHNIK
Suprematist Spatial Dimensions No.II 1926
Oil on wood and glass 82.8 × 62.3
Thyssen-Bornemisza Collection, Lugano

Project for a Tribune 1920
Ink and pencil on paper 57.3 × 37.6
Museum Ludwig, Cologne

ILYA CHASHNIK OR NICOLAI SUETIN
Black Triangle with Red Square ('Ex-Libris P.V. Gubar) ?1922
Colour lithograph on gummed paper 6.1 × 5.2
The Judith Rothschild Foundation

Red Triangle with Black Square ('Ex-Libris P.V. Gubar') ?1922
Colour lithograph on gummed paper 6.3 × 5.7
The Judith Rothschild Foundation

ALEKSANDR DEINEKA
Let's Transform Moscow into a Model Socialist City of the Proletarian State 1931
Lithograph 144.8 × 209.6
Collection Merrill C. Berman

MIKHAIL DLUGATCH
Cement 1928
Lithograph 106.7 × 70.8
Collection Merrill C. Berman

ALEKSANDRA EKSTER
Coloured Dynamics 1916–17
Oil on canvas 89 × 54
Museum Ludwig, Cologne

Construction 1922–3
Oil on canvas 89.8 × 89.2
The Museum of Modern Art, New York. The Riklis Collection of McCrory Corporation, 1983

Costume Design for Romeo and Juliet 1922
55 × 34.2
A.A. Bakhrushin State Central Theatrical Museum, Moscow

Costume Designs For 'Romeo and Juliet' 1922
51 × 35
A.A. Bakhrushin State Central Theatrical Museum, Moscow

Design for Mechanical Enginering Pavillion 1923
Collage, mixed media 61 × 89.2
Collection Merrill C. Berman

Set Design for 'Romeo and Juliet' 1922
43.8 × 55.7
A.A. Bakhrushin State Central Theatrical Museum, Moscow

VASILI ELKIN
Untitled
Photocollage 20 × 27.9
Collection Merrill C. Berman

ESTEICHOV
Untitled 1923
Gouache and ink on board 26 × 30.2
Collection Merrill C. Berman

PYOTR GALADCHEV
Counter-Relief 'Rifle with Target' 1924
Coloured wood and metal on wood 56.5 × 40.3 (oval)
Galerie Alex Lachmann, Cologne

Counter-Relief without Title 1921
Cardboard on wood 48.3 × 27.4
Galerie Alex Lachmann, Cologne

ALEKSEI GAN
First Exhibition of Contemporary Architecture 1927
Letterpress 108 × 70.5
Collection Merrill C. Berman

Kino-phot No.2 1922
Magazine 29 × 22
Private Collection

Twenty Years of Works by Vladimir Mayakovsky c.1930
Lithograph 64.8 × 46
Collection Merrill C. Berman

BORIS IGNATOVICH
All works lent by Galerie Alex Lachmann, Cologne:

Aerial Shot of Crossroads 1931
Photograph 17.9 × 23.9

Cranksafts 1930
Photograph 16 × 24.2

Dynamo 1930
Photograph 24 × 17.1

Factory 1931
Photograph 18 × 24

Female Worker Drawing Cables 1930
Photograph 24.4 × 18.3

Inserting Cables 1930
Photograph 23.7 × 17.9

New Building 1930
Photograph 45 × 27.2

Repairing 1930
Photograph 14.3 × 22.2

Spanner on the Controls 1931
Photograph 17.7 × 24.2

Workers Club in Moscow 1931
Photograph 18 × 23.9

VALENTINA KALUGINA
International Women Workers Day 1930
Lithograph 108.9 × 72.1
Collection Merrill C. Berman

Untitled
Lithograph 23.2 × 16.5
Collection Merrill C. Berman

MICHAIL KAUFMAN
Alexander Rodchenko in the Productivist Suit 1922
Modern print 28.5 × 20
Private Collection

IVAN KLIUN
Composition 1917
Oil on canvas 88 × 69
Museo Thyssen-Bornemisza, Madrid

Eight Sketches (Suprematist Studies of Colour and Form) 1917
Oil on paper 27 × 22.5
The Georges Costakis Collection, State Museum of Contemporary Art, Thessaloniki

Suprematism c.1917
Oil on panel 35.6 × 35.7
The Georges Costakis Collection, State Museum of Contemporary Art, Thessaloniki

Suprematist Composition 1917
Oil on wood 35.2 × 28.5
Museum Ludwig, Cologne

Three Colour Composition c.1917
Oil on board 35.4 × 35.7
The Georges Costakis Collection, State Museum of Contemporary Art, Thessaloniki

GUSTAV KLUCIS
Building Socialism under the Banner of Lenin 1931
Lithograph 107.3 × 52.1
Collection Merrill C. Berman

Communism Is Soviet Power Plus Electrification 1930
Lithograph 73.3 × 51.8
Collection Merrill C. Berman

Construction 'Vhutemas' 1919–20
Oil on canvas 50 × 32.5
State Mayakovsky Museum, Moscow

Design for Propaganda Kiosk, Screen and Loudspeaker Platform 1922
Pencil, ink and gouache on paper
The Georges Costakis Collection, State Museum of Contemporary Art, Thessaloniki

Design for Rostrum 1922
Ink, pencil on paper 26.7 × 17.6
The Georges Costakis Collection, State Museum of Contemporary Art, Thessaloniki

Design for Screen, Rostrum and Propaganda Stand 1922
Coloured pencil, inks and watercolour on paper 34.3 × 18.9
The Georges Costakis Collection, State Museum of Contemporary Art, Thessaloniki

Design for Speaker's Platform 1922
Pencil and ink on paper 26.8 × 17
The Georges Costakis Collection, State Museum of Contemporary Art, Thessaloniki

Design for a Kiosk 1922
Linocut 25.1 × 16.5
Collection Merrill C. Berman

Design for a Rotating Agitational Stand for the Fourth Congress of the Comintern 1922
Linocut 23.5 × 14.3
Collection Merrill C. Berman

Design for Screen-Radio Orator No.5 1922
Coloured inks, gouache and pencil on paper 26.6 × 14.7
The Georges Costakis Collection, State Museum of Contemporary Art, Thessaloniki

Front cover from Chetyre Fonetischeskikh Roman (Four Phonetic Novels) by Aleksei Frunchenykh 1927
Woodcut, printed in dark blue 12.5 × 12.5, page 9: 25.2 × 16.7
The Museum of Modern Art, New York. Abby Aldrich Rockefeller Fund, 1977

Methods in Lenin's Language. A. Krushenich,
Book 17 × 13
State Mayakovsky Museum, Moscow

Moscow, Spartakiada 1928
Letterpress 15.2 × 11.4
Collection Merrill C. Berman

Plan for the Socialist Offensive in 1929-30 1929
Photomaquette
Collection Merrill C. Berman

RKP Photomontage 1924
Photomontage 21 × 15
State Mayakovsky Museum, Moscow

Study for Axiometric Painting 1921
13.5 × 20
State Mayakovsky Museum, Moscow

To the Memory of Dead Leaders 1927
Lithograph 38.1 × 58.4
Collection Merrill C. Berman

Vremya No.8 1924
Magazine 24.5 × 16.8
State Mayakovsky Museum, Moscow

Vvypolnim plan velikich rabot 1930
Lithograph 15 × 11
State Mayakovsky Museum, Moscow

We Will Repay the Coal Debt to the Country 1930
Lithograph 101.6 × 71.4
Collection Merrill C. Berman

Untitled 1930
Lithograph 105.1 × 73.7
Collection Merrill C. Berman

Untitled
Photocollage with gouache
Collection Merrill C. Berman

Untitled
Lithograph 103.5 × 74
Collection Merrill C. Berman

Untitled
Letterpress, printed magazine
Collection Merrill C. Berman

Untitled
Vintage photograph/
photomontage
16.5 × 11.8
Collection Merrill C. Berman

Untitled
Lithograph 101.6 × 73
Collection Merrill C. Berman

**GUSTAV KLUCIS, VALENTINA
KALUGINA**
Dynamic City 1923
Lithograph 26.4 × 18.4
The Georges Costakis Collection,
State Museum of Contemporary
Art, Thessaloniki

AZURI KODSHAK
Charlestone No.2 1921
Collage 26.8 × 22.8
Galerie Alex Lachmann, Cologne

ANTON LAVINSKY
Untitled
Lithograph 106.7 × 70.8
Collection Merrill C. Berman

EL LISSITZKY
**Draughtsman, Self-Portrait
with Compass** 1924
Photomontage 26.3 × 29.5
Galerie Alex Lachmann, Cologne

Proun 17 N c.1920
Gouache and watercolour
36.5 × 48.4
Staatliche Galerie Moritzburg
Halle, Landeskunstmuseum
Sachsen-Anhalt

Proun 55 c.1923
Oil on canvas 58 × 47.5
Staatliche Galerie Moritzburg Halle
Landeskunstmuseum Sachsen-
Anhalt

Proun 88 c.1923
Collage on carton 49.9 × 64.7
Staatliche Galerie Moritzburg
Halle, Landeskunstmuseum
Sachsen-Anhalt

Proun 93 (Spiral) 1923
Pencil, Indian ink, gouache and
coloured pencil on paper
36.5 × 48.4
Staatliche Galerie Moritzburg
Halle, Landeskunstmuseum
Sachsen-Anhalt

**Proun P23, Cube with
Hyperbola** 1919
Oil on canvas 77 × 52
Stedelijk Van Abbemuseum
Eindhoven

Proun Room 1923/1965
Wood 310 × 365 × 362.5
Berlinische Galerie,
Landesmuseum fur Moderne
Kunst, Photographie und
Architektur, Berlin. Reconstructed
by the Van Abbemuseum,
Eindhoven

Visiting Card 1924
Paper 10.7 × 14.4
Private Collection

**Book of Verse by Mayakovsky
for the Voice** 1923
Book 65 × 80
State Mayakovsky Museum,
Moscow

Exhibition catalogue
Letterpress 11.1 × 23.9
Collection Merrill C. Berman

**Exhibition Catalogue designed
by El Lissitzky**
Letterpress
Collection Sasha Lurye, Courtesy
Merrill C. Berman

First Kestnermappe Proun,
Published in 1923
Portfolio of lithographs (two with
collage), cover and title page
each sheet 60 × 44, sheet six
44 × 60
Scottish National Gallery of
Modern Art, Edinburgh

Russian Exhibition 1929
Lithograph 124.5 × 90.5
Collection Merrill C. Berman

**Tatlin Working on the
Monument for the Third
International** c.1921
Collage 29.2 × 22.8
Private Collection

Photo Triptych 1924
Photomontage, each 17.2 × 12
Galerie Alex Lachmann, Cologne

VLADIMIR MAYAKOVSKY
About This 1923
Photomontage on paper 36 × 24.5
Private Collection

KASIMIR MALEVICH
**From Cubism and Futurism to
Suprematism, New Painterly
Realism** 1916
Paper
The British Library Board, London

Gota 2-a 1923/1989
Plaster 52 × 26 × 36
Centre Georges Pompidou, Paris.
Musée national d'art moderne
Copy made by Poul Pedersen in
1989

On New Systems in Art 1919
Paper
The British Library Board, London

**Single Page Autograph
Manuscript** 1 July 1916
Work on paper
The Georges Costakis Collection,
State Museum of Contemporary
Art, Thessaloniki

Suprematist Composition
c.1915–16
Oil on canvas 49 × 44
Wilhelm-Hack-Museum,
Ludwigshafen am Rhein

Suprematist Painting 1916–17
Oil on canvas 97.8 × 66.4
The Museum of Modern Art, New
York, 1935

KONSTANTIN MELNIKOV
The Rusakov Club model 1970
Architectural model
60.9 × 121.8 × 101.6
The University of East Anglia
Collection of Abstract and
Constructivist Art, Architecture
and Design

GRIGORI MILLER
October in the Countryside
1927
Photocollage, pencil, gouache
22.5 × 14.6
Collection Merrill C. Berman

VERA IGNATEVNA MUKHINA
**Industrial Worker and
Collective-Farm Woman** c.1938
Porcelain 31 × 24 × 24
Lutz Becker Collection

LIUBOV POPOVA
Painterly Architectonic 1916
Oil on board 59.4 × 39.4
Scottish National Gallery of
Modern Art, Edinburgh

Pictorial Architectonic 1918
Oil on canvas 45 × 53
Museo Thyssen-Bornemisza,
Madrid

**Set Design for 'The Earth in
Turmoil'** 1923
22.7 × 26.8
A.A. Bakhrushin State Central
Theatrical Museum, Moscow

Spacial Force Construction
1921
Oil with marble dust on wood
112.6 × 112.7
The Georges Costakis Collection,
State Museum of Contemporary
Art, Thessaloniki

The Magnanimous Cuckold
1922
Theatre model 105 × 130 × 80
Theaterwissenschaftliche
Sammlung, Universität zu Köln

**Design for Poster or Fresco for
the Cooperative 'Centrifuge'**
1922
Watercolour and ink on paper
33 × 52
Galerie Gmurzynska, Cologne

NICOLAI PRUSAKOV
Khaz-Push 1927
Lithograph 70.2 × 106.1
Collection Merrill C. Berman

The Ranks and the People 1929
Lithograph 37.2 × 24.4
Collection Merrill C. Berman

**The Second Exhibition of Film
Posters** 1926
Lithograph 108.3 × 72.1
Collection Merrill C. Berman

NIKOAI PUNIN
**Monument to the Third
International** 1920
Prospect to Vladimir Tatlin's
Project 28 × 22
Private Collection

ALEKSANDR RODCHENKO
Actress Alexandra Khokhlova
1927
Modern print 38.3 × 28.2
Private Collection

**Advertisement for Mozer
Watches, Sold at Gum** 1923
Letterpress 18.7 × 15.9
Collection Merrill C. Berman

**Advertising Poster for the
State Airline Dobrolet** 1923
34.9 × 45.1
Collection Merrill C. Berman

Architect Alexandr Vesnin
1924
Modern print 29.5 × 21.8
Private Collection

**Architect, Producer and
Designer Alexej Gan** 1924
Modern print 29 × 22.5
Private Collection

Battleship Potemkin 1905 1925
Lithograph 69.9 × 97.8
Collection Merrill C. Berman

Construction on White 1919
Oil on canvas 68 × 45
Private Collection

**Cover Design for Mayakovsky's
Poem 'Pro Eto'** 1923
Photograph 24 × 16.5
State Mayakovsky Museum,
Moscow

Critic Ossip Brik 1924
Modern print 24 × 18
Private Collection

**Eight Photomontages for
Mayakovsky's Poem 'Pro Eto'**
1923
Photomontage
State Mayakovsky Museum,
Moscow

**Filmmaker Esther Schub with a
Cigarette** 1924
Modern print 38 × 28
Private Collection

**Filmmaker Lev Kuleshov on the
Motorcycle** 1926
Modern print 34.5 × 24.5
Private Collection

**Four Constructivists at the
Table: Shub, Rodchenko, Gan,
Stepanova** 1925
Modern print 26.5 × 39.2
Private Collection

**Mess mend or a Yankee in
Petrograd** 1924
Twelve covers of the serial novel
by Jim Dollar. Letterpress
Collection Merrill C. Berman

Kino-phot No.3 1922
Magazine 29 × 22
Private Collection

**LET Aviatic Verses, cover for
the book** 1923
Offprint 22.8 × 15.3
Private Collection

Lili Brik in Rain Coat 1924
Modern print 37.7 × 27.7
Private Collection

**Mayakovsky Smiles,
Mayakovsky Laughs,
Mayakovsky Mocks** 1923
Gouache on paper 17.8 × 14.6
Private Collection

Mossel'Prom-Kino 1924
Letterpress 32.1 × 24.8
Collection Merrill C. Berman

**Non-Objective Painting: Black
on Black** 1918
Oil on canvas 81.9 × 79.4
The Museum of Modern Art, New
York, Gift of the artist, through Jay
Leyda, 1936

Painter Alexander Shevchenko
1924
Modern print 38.5 × 29.2
Private Collection

**Poet Nikoai Aseev in
Rodchenko's Workshop** 1927
Modern print 29 × 22
Private Collection

Poster for 'LEF' 1923
Lithograph
Collection Merrill C. Berman

**Prospect of the Magazine 'LEF'
No.2**
Magazine 23.5 × 15.5
Private Collection

Ray of Death (The Death Ray)
1925
Lithograph 91.1 × 65.7
Collection Merrill C. Berman

Spatial Construction No.10
1920/82
Aluminium 59 × 58 × 59
Galerie Gmurzynska, Cologne

Spatial Construction No.11
1920–1/1995
Aluminium 130 × 85 × 85
Berlinische Galerie,
Landesmuseum fur Moderne
Kunst, Photographie und
Architektur, Berlin
Reconstruction by Alexander
Lawrentjw 1995

Spatial Construction No.12
1920/1973
Aluminium 85 × 55 × 47
Galerie Gmurzynska, Cologne

Spatial Construction No.13
1920–1
Wood 80 × 90 × 85
Galerie Gmurzynska, Cologne

**Study for Poster for the Second
Part of the '5 x 5 = 25'
exhibition** 1921
Collage and gouache 28 × 25
Private Collection, Galerie
Gmurzynska, Cologne

The Sixth Part of the World
1926
Lithograph 106.7 × 69.5
Collection Merrill C. Berman

Untitled 1921
Red and blue wax crayon on paper
48.3 × 32.4
Private Collection

Vavara Stepanova at her Desk
1924
Modern print 28.5 × 38.5
Private Collection

Vladimir Majakovsky in Overcoat and Hat 1924
Modern print
Private Collection

Writer and Critic Sergei Tretyakov 1928
Modern print 29 × 22
Private Collection

Untitled
Lithograph 70.5 × 51.1
Collection Merrill C. Berman

ELRMS SEMENOVA
Untitled 1929
Lithograph 108.6 × 72.7
Collection Merrill C. Berman

ALEKSANDR SHUKHOV
Radio Transmitter on Shabolovka St, Moscow 1919
Model on a scale of 1:50, metal
350 × 90 × 90
The Shchusev State Research
Museum of Architecture, Moscow

ANTONIA SOFRONOVA
Abstraction 1921
Oil on plywood 47 × 40
Private Collection

VLADIMIR STENBERG
Construction 1920
Ink on paper
The Georges Costakis Collection,
State Museum of Contemporary
Art, Thessaloniki

Spatial Construction KP5 42 N IV 1919/73
Iron 264 × 70 × 130
Galerie Gmurzynska, Cologne

STENBERG BROTHERS
A Small Town Idol 1925
Lithograph 108.6 × 69.9
Collection Merrill C. Berman

Costume design for 'Kukirol'
1925
35.2 × 16.5
A.A. Bakhrushin State Central
Theatrical Museum, Moscow

Costume design for 'Kukirol'
1925
35.2 × 16.5
A.A. Bakhrushin State Central
Theatrical Museum, Moscow

Costume design for 'Kukirol'
1925
35.2 × 16.5
A.A. Bakhrushin State Central
Theatrical Museum, Moscow

Costume design for 'Kukirol'
1925
35.2 × 16.3
A.A. Bakhrushin State Central
Theatrical Museum, Moscow

Design for Children's Games
1928
Gouache and pencil 21.6 × 35.6
Collection Merrill C. Berman

Fragment of an Empire 1929
94.3 × 62.2
Collection Merrill C. Berman

High Society Wager 1927
Lithograph 101.6 × 68.6
Collection Merrill C. Berman

Moscow Kamerny Theatre
1923
Lithograph 96.2 × 55.6
Collection Merrill C. Berman

Set Design for 'Kukirol' 1925
59.2 × 79.5
A.A. Bakhrushin State Central
Theatrical Museum, Moscow

Symphony of the Big City 1928
Lithograph 108 × 60.3
Collection Merrill C. Berman

The Solid Appetite 1928
132.7 × 71.1
Collection Merrill C. Berman

GREGORI STENBERG
Spatial Construction KPS 51 N XI 1919/73
Browned and chromium plated
iron, glass and wood 220 × 100 ×
61
Galerie Gmurzynska, Cologne

VARVARA STEPANOVA
'Brandakhlistova Costume for the Play 'Tarelkin's Death'
1922
Crayon on paper 36.5 × 45.5
Private Collection

Costume design for 'Tarelkin's Death' 1922
Collage on paper 34 × 22
Galerie Alex Lachmann, Cologne

Literacy 1925
Lithograph 103.5 × 70.2
Collection Merrill C. Berman

Sketch for 'Study the Old but Create the New' 1919
Gouache on paper 26.2 × 22.5
Galerie Gmurzynska, Cologne

Soviet Cinema No.1 1927
Magazine 34.5 × 26.5
Private Collection

Soviet Cinema No.4 1927
Magazine 34.5 × 26.5
Private Collection

Three Figures on Black 1920
Oil on canvas 71 × 53
Private Collection

NIKOLAI SUETIN
Composition 1922–3
Oil on canvas 65 × 48
Museum Ludwig, Cologne

Spatial Elements 1931
Pencil on cardboard
52.5 × 49.3
Galerie Gmurzynska, Cologne

Suprematist City 1931
Pencil on cardboard 49.4 × 50.5
Galerie Gmurzynska, Collogne

Oh, Costume for the Play 'Tarelkin's Death' 1922
Gouache and crayon on paper
43.2 × 31.6
Private Collection

'The Minser', Design of the Decoration for the Play 'Tarelkin's Death' 1922
Indian ink on paper 45 × 58.5
Private Collection

VLADIMIR TATLIN
Collection of Materials 1914
Reconstruction by Martyn Chalk
1994
Bitumen/sand mixture, iron,
plaster, wood, glass, etc.
60 × 48 × 20
Annely Juda Fine Art, London

Complex Corner Relief 1915
Reconstruction by Martyn Chalk
1994
Iron, aluminium, zinc, etc.
78 × 152 × 76
Annely Juda Fine Art, London

Corner Relief 1915
Reconstruction by Martyn Chalk
1994
Wood, iron, wire 76 × 74 × 55
Annely Juda Fine Art, London

Drawing for a Counter Relief
1915
Pencil on paper 15.7 × 23.5
The Georges Costakis Collection,
State Museum of Contemporary
Art, Thessaloniki

Drawing for a Counter Relief
c.1915
Charcoal on brown paper
23.3 × 15.7
The Georges Costakis Collection,
State Museum of Contemporary
Art, Thessaloniki

Letatlin (Glider) 1932,
reconstruction
Wood, leather, metal, cloth
57 × 260 × 268
Moderna Museet, Stockholm

Poster, 'Not the Old, Not the New, but the Necessary'
c.1920
Ink on paper 48.8 × 212.8
A.A. Bakhrushin State Central
Theatrical Museum, Moscow

SOLOMON TELINGATER
Untitled
Photocollage 25.4 × 32.4
All works Collection Merrill C.
Berman:

Untitled
Photocollage 24.5 × 31.8
Untitled
Photocollage 30.2 × 39.4
Untitled
Photocollage 47.9 × 37.8
Untitled
Letterpress 37.8 × 45.4
Untitled
Photocollage 31.8 × 27

ALEKSANDR VESNIN
Costume design for 'The Man Who Was Thursday' 1922–3
Gouache and ink on paper
39.4 × 27
A.A. Bakhrushin State Central
Theatrical Museum, Moscow

Costume design for 'The Man Who Was Thursday' 1922–3
Gouache and ink on paper
39.2 × 27.3
A.A. Bakhrushin State Central
Theatrical Museum, Moscow

Costume design for 'The Man Who Was Thursday' 1922–3
Gouache and ink on paper
39.5 × 26.8
A.A. Bakhrushin State Central
Theatrical Museum, Moscow

Costume design for 'The Man Who Was Thursday' 1922–3
Gouache and ink on paper
31 × 42.5
A.A. Bakhrushin State Central
Theatrical Museum, Moscow

Project for the Leningrad Pravda Building 1924
Architectural model
243.8 × 61 × 45.7
The University of East Anglia
Collection of Abstract and
Constructivist Art, Architecture
and Design

Small Poster Maquette for 'The Man Who Was Thursday'
1922–3
Gouache on paper 26.5 × 17.7
A.A. Bakhrushin State Central
Theatrical Museum, Moscow

The Man Who Was Thursday
1923
Theatre model 90 × 103 × 81
Theaterwissenschaftliche
Sammlung, Universität zu Köln

KONSTANTIN VIALOV
Cover Design for Culture and Film No.1
Gouache 26.7 × 18.7
Collection Merrill C. Berman

Untitled
Lithograph 40 × 110.8
Collection Merrill C. Berman

ARTIST UNKNOWN
'Genius of Search', Photomontage
for the Cover of the Book 'Mess
Mens' by Marietta Shaginian
1924
Photomontage, gouache and
indian ink on paper 23 × 19
Private Collection

ARTIST UNKNOWN
Dajesh 1929
Letterpress 30.5 × 22.9
Collection Merrill C. Berman

IN ADDITION:

'LEF'
Magazine
Collection Merrill C. Berman

'Novy LEF'
Magazine
Collection Merrill C. Berman

NEW YORK

VITO ACCONCI
Following Piece 1969
Photograph 76.9 × 102.3
Sandra and Stephen Abramson

Room Situation
Two b/w photographs with text on
paper on board, each 93 × 69; 62
× 56.2
Tate. Presented by Barbara
Gladstone, 2001

Seedbed 1972
Photograph 66 × 177.8
Courtesy of Barbara Gladstone
Gallery, New York

LYNDA BENGLIS
For Carl Andre 1970
Pigmented polyurethane foam
142.8 × 135.2 × 117.4
Collection of the Modern Art
Museum of Fort Worth, Museum
Purchase, The Benjamin J.Tillar
Memorial Trust Fund

Contraband 1969
Poured pigmented latex
1030 × 280
Gallery Michael Janssen, Cologne
and Gallery Cheim & Read, New
York

Female Sensibility 1974
Sound, colour, 13 mins
The artist and Video Data Bank,
Chicago

TRISHA BROWN
Film by Babette Mangolte
Roof Piece 1973
Silent, colour, 30 mins
Trisha Brown and Babette
Mangolte

MARY BETH EDELSON
Some Living American Women Artists/Last Supper 1972
Offset print on paper
63.6 × 96.5
Tate

NANCY GRAVES
Isy Boukir 1970
Sound, colour, 20 mins
Courtesy of the Nancy Graves
Foundation, New York and the Arts
Council of England

GUERRILLA ART ACTION GROUP
Letter Action of October 22, 1972 1972
Engraving 19 × 14
Collection of Jon and Joanne
Hendricks

EVA HESSE
Accession 1967
Gouache and pencil on paper
29.2 × 39.1
The Estate of Eva Hesse. Courtesy
Galerie Hauser & Wirth, Zürich

Inside I 1967
Acrylic, string and papier mâché over wood 30.5 × 30.5 × 30.5
The Estate of Eva Hesse. Courtesy Galerie Hauser & Wirth, Zürich

Inside II 1967
Paint, wood, papier mâché, cord and weights 13.3 × 17.8 × 18.1
The Estate of Eva Hesse. Courtesy Galerie Hauser & Wirth, Zürich

Untitled 1968
Gouache and pencil on paper 29.2 × 20.03
The Estate of Eva Hesse. Courtesy Galerie Hauser & Wirth, Zürich

Untitled 1969
Gouache, watercolour, pencil, silverpaint 58.8 × 45.1
Private Collection

NANCY HOLT
Underscan 1974
Black and white, sound, 8 mins
The artist and Video Data Bank, Chicago

JOAN JONAS
Songdelay 1973
Black and white, sound, 18 mins
The artist and Electronic Arts Intermix, New York

Wind 1968
Black and white, silent, 5.37 mins
The artist and Electronic Arts Intermix, New York

ROBERT MAPPLETHORPE
Untitled (Patti Smith) c.1973
Polaroid photographs, 8 works each 45.7 × 38.1 × 3.2
Courtesy of Cheim & Read Gallery, New York

GORDON MATTA CLARK
Bingo, Niagra Falls 1974
Three fragments of a building
a) 175 × 264.3 × 17.5
b) 175.3 × 269.3 × 17.7
c) 175.3 × 246.4 × 17.7
Courtesy the Estate of Gordon Matta-Clark; David Zwirner, New York and Galerie Thomas Schulte, Berlin

Parked Island Barges on the Hudson 1970–71
Pencil, coloured pencils, black ink and markers on yellow legal paper 31.7 × 20.2
Courtesy the Estate of Gordon Matta-Clark and David Zwirner, New York

Islands Parked on the Hudson 1970-71
Pencil, coloured pencils, black ink and markers on yellow legal paper 33 × 51.3
Courtesy the Estate of Gordon Matta-Clark and David Zwirner, New York

Islands on the Hudson 1970–71
Black ink and coloured markers on paper 35.5 × 43
Courtesy the Estate of Gordon Matta-Clark and David Zwirner, New York

Walls paper 1972
Multiple copies of colour-offset prints, dimensions variable
Courtesy the Estate of Gordon Matta-Clark and David Zwirner, New York

MARY MISS
Cut-Off 1974–75
Sound, B/W, 10 mins
Courtesy of the artist and the Arts Council of England

Ladders and Hurdles 1970
Wood and rope 109 × 121 × 609
The artist

Sunken Pool 1974
Photograph 28 × 35.5
The artist

Untitled (Battery Park Landfill) 1973
Photograph 28 × 35.5
The artist

Untitled (Oberlin, Ohio) 1973
Photograph 28 × 35.5
The artist

PETER MOORE
30 Photographs
All works lent courtesy of Barbara Moore:

Ay-O: Rainbow Banner - 9th Annual AG Festival of New York 1972
Charlotte Moorman weaing Nam June Paik's TV Cello and TV Glasses 1971
George Maciunas and Takako Saito: Flux Treadmill 1973
Jackie Winsor piece at 112 Greene Street 1971
Jackie Winsor piece at 112 Greene Street 1971
Jackie Winsor piece at 112 Greene Street 1971
Jackie Winsor piece at 112 Greene Street 1971
Joan Jonas: Delay Delay 1972
Joan Jonas: Delay Delay 1972
Joan Jonas: Delay Delay 1972
Joan Jonas: Mirror Piece 1970
John Cage in Nam June Paik's '212' 1971
John Cage in Nam June Paik's '212' 1971
John Lennon and Yoko Ono, Times Square 1969
Joseph Beuys: Lecture at New School 1974
Joseph Beuys: I Like America and America Likes Me 1974
Kieth Sonnier: Piece 1970
Mabou Mines: The Red Horse Animation 1970
Richard Foreman: Sophia + (Wisdom) Part 3: The Cliffs 1973
Richard Serra: Piece in Bronx 1971
Scott Burton: Streetworks IV 1969
Simone Forti: Huddle 1969
Simone Forti: Rollers 1969
Trisha Brown: A Man Walking Down the Side of A Building 1970
Trisha Brown: A Man Walking Down the Side of A Building 1970

Trisha Brown: Walking on the Wall (rehearsal at the Whitney Museums) 1971
Yvonne Rainer 1972
Yvonne Rainer: A Trio for the Judson Flag Show 1970
Yvonne Rainer: The Grand Union 'War' 1970
Yvonne Rainer: This is the Story of a Woman who... 1973

ROBERT MORRIS
Poster for Voice 1974
Offset lithograph on paper 91.4 × 61
Collection of Maurice Berger

Location Piece 1973
Lead on board, aluminium letters and arrows, and metalic meters 53.7 × 53.7 × 3.8
Tate. Purchased 1974

DENNIS OPPENHEIM
Parallel Stress 1970
3 photographic panels 150.9 × 101.1; 112 × 152.2; 30.5 × 152.7
Tate. Lent by the American Fund for the Tate Gallery, courtesy of John Coplans

Theme for a Major Hit 1974
Cloth, wood and fishing line, motor, audiotape
3 marionettes, each 75 × 25.5 × 9
The artist

ADRIAN PIPER
Food for the Spirit 1971
14 Gelatin prints, each 50.8 × 40.6
Whitney Museum of American Art, New York. Purchased with funds from the Photography Committee

Streetworks Streetracks 1969
Audiotape
Courtesy of the artist and Video Data Bank, Chicago

FAITH RINGGOLD
Peoples Flag Show 1970
Offset, printed in colour 45.7 × 61
Collection of Jon and Joanne Hendricks

The United States of Attica 1971
Offset, printed in colour 55.9 × 69.9
Collection of Jon and Joanne Hendricks

ROBERT SMITHSON
Circular Island 1971
Ink on paper 35.6 × 43.2
The Estate of Robert Smithson. Courtesy James Cohan Gallery, New York

Island Project 1970
Ink on paper 43.2 × 35.6
The Estate of Robert Smithson. Courtesy James Cohan Gallery, New York

Sod Juggernaut 1971
Ink on paper 30.5 × 45.7
The Estate of Robert Smithson. Courtesy James Cohan Gallery, New York

Study for Floating Island to Travel Around Manhattan Island 1970
Pencil 47.6 × 61
Collection of Joseph E. Seagram & Sons, Inc.

Untitled (Meanders) 1970–71
Ink on paper 48.3 × 50.8
The Estate of Robert Smithson. Courtesy James Cohan Gallery, New York

ROBERT SMITHSON AND NANCY HOLT
Swamp 1971
Sound, colour, 6 mins
Courtesy of Nancy Holt and the Estate of Robert Smithson

ANDY WARHOL
Vote McGovern 1972
Colour silk-screen print on paper 87 × 106
Frayda & Ronald Feldman, New York

HANNAH WILKE
S.O.S. Starification Object Series 1974–82
10 b/w photographs, 15 chewing gum sculptures mounted on ragboad
106.7 × 147.3 × 7.6
Private Collection, courtesy Ronald Feldman Fine Arts, New York

HANNAH WILKE
Super T-Art 1974
Black and white photographs 112 × 92
Mustad Collection, Sweden

IN ADDITION:

ARTISTS' POSTER COMMITTEE OF THE ART WORKERS' COALITION (FRAZIER DOUGHERTY; JON HENDRICKS; IRVING PETLIN)
Q. And Babies? A. And Babies 1970
Offset, printed in colour 63.8 × 96.5
Collection of Jon and Joanne Hendricks

MAGAZINES
All lent by The Jean-Noël Herlin Archive Project:

Artforum (April) 1973
Ink on paper 27 × 26.5

Artforum (November) 1973
Ink on paper 27 × 26.5

Art News (No 9 January) 1973
Ink on paper 30.6 × 22.4

Information (edited by Kynaston L. McShine) 1970
(First issue with green fore edges)
Ink on paper 27.5 × 21.2 × 1.4

The Village Voice (vol XIV, No 24) 1969
Ink on newsprint 41.4 × 29

The Village Voice (vol XIV, No 29) 1969
Ink on newsprint 41.4 × 29.5

The Village Voice (vol XVI, No 1) 1971
Ink on newsprint 41.4 × 28.5

PARIS

AUGUSTE AGERO
Portrait of Picasso 1908–10
Plaster 27 × 16 × 13
Fonds National d'Art Contemporain-Ministère de la Culture, Paris

AMADEO DE SOUZA-CARDOSO
Cubist Painting 1913
Oil on canvas 64 × 30
Fundação Calouste Gulbenkian/CAMJAP

Painting 1913
Oil on canvas 64 × 30
Fundação Calouste Gulbenkian/CAMJAP

GUILLAUME APOLLINAIRE
The Bestiary or The Procession of Orpheus Published in Paris in 1911
Book 33 × 24
The Victoria & Albert Museum

ALEXANDER ARCHIPENKO
Black Seated Figure, Concave 1916
Tinted terracotta 55.8 × 21 × 12
Kunstmuseum Düsseldorf

Woman Combing her Hair 1915
Bronze 35.6 × 8.6 × 8.3
Tate. Purchased 1960

EUGÈNE ATGET
Church of St Séverin, Roofs c.1900
Photograph 16.3 × 21.4
The Victoria & Albert Museum

Church of St Séverin, Roofs and Flying Buttresses c.1900
Photograph 16.5 × 20.8
The Victoria & Albert Museum

Church of St Séverin, Roofs and Flying Buttresses c.1900
Photograph
The Victoria & Albert Museum

LÉON BAKST
A Young Divinity, Project for a Costume in 'Narcisse' 1911
Crayon and watercolour on paper 21.1 × 27.9
Musée d'Art Moderne et Contemporain de Strasbourg

Lykenion, Costume Design for 'Daphnis and Chloë' 1912
Pencil, indian ink and watercolour on paper 26.5 × 12.5
The Victoria & Albert Museum

Souvenir Programme from the Théâtre du Chatelet. Bakst's Design for 'Narcisse' and Cast List for 'Le Spectre de la Rose' 1911
Book 34.5 × 52.5
The Victoria & Albert Museum

286

The Chief Eunuch, Project for a Costume in 'Schéhérazade' 1910
Watercolour on paper 35.6 × 22.2
Musée d'Art Moderne et Contemporain de Strasbourg

ALEXANDRE BENOIS
Black Slave, Armida's Favourite, Costume for Nijinsky in 'Le Pavillon d'Armide' 1909
Watercolour 37.6 × 26.5
The Victoria & Albert Museum

CONSTANTIN BRANCUSI
Maiastra 1911
Bronze and stone
90.5 × 17.1 × 17.8
Tate. Purchased 1973

GEORGES BRAQUE
Glass, Bottle and Newspaper 1912
Charcoal, faux-bois wallpaper on paper 48 × 62
Fondation Beyeler, Riehen/Basel

The Candlestick 1911
Oil on canvas 46.2 × 38.2
Scottish National Gallery of Modern Art, Edinburgh

The Mandolin 1914
Collage, drawing, watercolour and gouache 48.3 × 31.8
Ulmer Museum, Ulm

The Sacré-Coeur of Montmartre 1910
Oil on canvas 55 × 40.5
Donation Geneviève et Jean Masurel, Musee d'art moderne de Lille Métropole, Villeneuve d'Ascq

AUGUSTE CHABAUD
Towards the Sacré-Coeur 1907
Oil on cardboard 44 × 74.5
Collection Claude Chabaud

Woman with a Cigarette 1907
Oil on cardboard 28 × 36
Collection Claude Chabaud

MARC CHAGALL
The Anniversary 1908–9
Oil on canvas 62 × 81
Private Collection

The Red Nude 1909
Oil on canvas 84 × 116
Private Collection

The Sister of the Artist / Lisa at the Window 1914
Oil on canvas 76 × 46
Private Collection

GIORGIO DE CHIRICO
Spring 1914
Oil on canvas 35.1 × 27
Private Collection

The Tower c.1913
Oil on canvas 115.5 × 45
Kunsthaus Zürich, Vereinigung Zürcher Kunstfreunde

JOSEPH CSAKY
Figure of a Woman Standing 1913
Bronze 78.5 × 22 × 22.5
Saarland Museum Sarbrücken, Stiftung Saarlandischer Kulturbesitz

NILS DARDEL
Rue Ville de Paris in Senlis 1912
Oil on canvas 91 × 68.5
Moderna Museet, Stockholm

ROBERT DELAUNAY
The City of Paris 1910–12
Oil on canvas 267 × 406
Centre Georges Pompidou, Paris. Musée national d'art moderne. En dépôt au Musée d'Art Moderne de la Ville de Paris

Windows Open Simultaneously (First Part, Third Motif) 1912
Oil on canvas 45.7 × 37.5
Tate. Purchased 1967

SONIA DELAUNAY
Prose on the Trans-Siberian Railway and of Little Jehanne of France 1913
Watercolour and gouache with letterpress printed text on parchment 195.6 × 35.6
Tate. Purchased 1980

ANDRÉ DERAIN
Collioure 1905
Oil on canvas 60.2 × 73.5
Scottish National Gallery of Modern Art, Edinburgh

Head 1912–13
Stone 55 × 38.5 × 4
Galerie Berthet-Aittouarès

Henri Matisse 1905
Oil on canvas 46 × 34.9
Tate. Purchased 1958

Still Life with a Table 1910
Oil on canvas 100 × 81
Musée d'Art Moderne de la Ville de Paris

Waterloo Bridge 1905
Oil on canvas 80.5 × 101
Museo Thyssen-Bornemisza, Madrid

KEES VAN DONGEN
'La Matchiche' 1904–5
Oil on canvas 65 × 54
Musée d'Art Moderne de Troyes, Donation Pierre et Denise Lévy

Mother and Child 1906
Oil on canvas 55 × 46
Private Collection, Courtesy Galerie de la Présidence, Paris

MARCEL DUCHAMP
Coffee Mill 1911
Oil and pencil on board 33 × 12.7
Tate. Purchased 1981

RAYMOND DUCHAMP-VILLON
Germaine 1912–13
Marble 9 × 18.5 × 5.5
Private Collection, London

Large Horse 1914, cast 1961
Bronze 100 × 98.7 × 66
Tate. Purchased 1978

The Football Players 1905
Bronze 68 × 68 × 55
Musée des Beaux-Arts, Rouen, Gift of Duchamp Family

RAOUL DUFY
Street in Celebration 1906
Oil on canvas 55 × 38
Private Collection

The Red Houses of Sainte-Adresse 1910
Oil on canvas 81 × 130
Private Collection, Galerie Daniel Malingue, Paris

JACOB EPSTEIN
Rom 1910
Stone 86.4 × 32 × 33.3
National Museum & Gallery Cardiff

OTTO FREUNDLICH
Composition with a Figure 1911
Oil on canvas 53.5 × 64.4
Musée de Pontoise

Standing Mask 1909
Bronze 51.7 × 42.5 × 44.6
Berlinische Galerie, Landesmuseum für Moderne Kunst, Photographie und Architektur, Berlin

PABLO GARGALLO
Court Singer 1915
Copper 38 × 24 × 10
Family Estate

Portrait of Picasso 1913
Clay 21 × 19.5 × 20
Musée d'art moderne de Céret, France

Volupté 1908
Marble 48 × 28 × 23
Family Estate

ALBERT GLEIZES
Portrait of Jacques Nayral 1911
Oil on canvas 161.9 × 114
Tate. Purchased 1979

NATALIA GONTCHAROVA
Russian Woman with Purple Blouse, Design for 'Le Coq d'Or' c.1914
Watercolour and bodycolour on paper 38 × 26.5
The Victoria & Albert Museum

Russian Peasant in Embroidered Shirt, Design for 'Le Coq d'Or' c.1914
Watercolour and body colour on paper 38 × 27
The Victoria & Albert Museum

Russian Woman in dress with Blue and Red Ornament, Design for 'Le Coq d'Or' c.1914
Watercolour and bodycolour on paper 38 × 26.9
The Victoria & Albert Museum

JUAN GRIS
Bottle of Rosé Wine 1914
Mixed media on canvas 44.5 × 26
Private Collection

Glass and Bottle 1914
Collage 50 × 70
National Gallery of Ireland, Dublin

Guitar on the Table 1913
Oil on canvas 60 × 73.7
La Colección de Arte de Telefónica, Madrid

Houses in Paris 1911
Oil on canvas 40 × 35
Sprengel Museum Hannover

The Book 1911
Oil on canvas 55 × 46
Centre Georges Pompidou, Paris. Musée national d'art moderne. Donation de Louise et Michel Leiris

Vase, Newspaper and Bottle of Wine 1913
Collage 45 × 29.5
La Colección de Arte de Telefónica, Madrid

ISAAC GRÜNEWALD
Iván by the Armchair 1915
Oil on canvas 81 × 115
Moderna Museet, Stockholm

AUGUSTE HERBIN
Landscape at Céret 1913
Oil on canvas 94 × 91.5
Musée d'art moderne de Céret, France

MAX JACOB
Saint Matorel, Paris 1911
Book 28 × 22.5
Bibliothèque nationale de France

FRANÇOIS KUPKA
Fugue à deux couleurs et pour Amorpha, chromatique chaude 1911
Oil on canvas 84 × 128
Centre Georges Pompidou, Paris. Musée national d'art moderne. Don de Eugénie Kupka

Fugue in Two Colours 1911–12
Oil on canvas 66 × 66.5
Centre Georges Pompidou, Paris. Musée national d'art moderne

ROGER DE LA FRESNAYE
The Factory at La Ferté-sous-Jouarre 1910–11
Oil on canvas 60 × 73
Musée des Arts décoratifs, Paris

HENRI LAURENS
Head 1915
Mixed media 52.5 × 39.5
Private Collection, Paris

Woman with a Mantilla 1915
Wood 55 × 37 × 25
Private Collection

FERNAND LÉGER
Landscape 1914
Oil on canvas 100 × 83
Centre Georges Pompidou, Paris. Musée national d'art moderne. Donation Geneviève et Jean Masurel. En dépôt au Musée d'art moderne de Lille Métropole Villeneuve d'Ascq

WILHELM LEHMBRUCK
Large Kneeling Figure 1911
Bronze 178 × 71 × 141
Landesmuseum Mainz

JACQUES LIPCHITZ
Sculpture 1916
Plaster 116.9 × 36.8 × 34.2
Tate. Presented by the Lipchitz Foundation 1982

Spanish Servant Girl 1915, cast 1960s
Plaster 88.9 × 22.8 × 13.9
Tate. Presented by the Lipchitz Foundation 1982

LOUIS MARCOUSSIS
Gaby 1912
Print 18.8 × 14.2
Bibliothèque nationale de France

The Beautiful Martinican 1912
Print 28.7 × 22.2
Bibliothèque nationale de France

FILIPPO MARINETTI
Words of Freedom 1914–15
8 works on paper, each 32.5 × 22
Futuristi

ALBERT MARQUET
Notre-Dame in the Snow c.1910
Oil on canvas 100 × 81
Musée d'Art Moderne de la Ville de Paris

Quai Saint-Michel with Smoke 1908–9
Oil on canvas 65 × 81
Private Collection, Courtesy Galerie de la Présidence, Paris

HENRI MATISSE
André Derain 1905
Oil on canvas 39.4 × 28.9
Tate. Purchased with assistance from the Knapping Fund, the National Art Collections Fund and the Contemporary Art Society and private subscribers 1954

Portrait of Marguerite 1906–7
Oil on canvas 54.6 × 45
Dépôt au Musée Matisse du Cateau-Cambrésis

Rue du Soleil, Collioure 1905
Oil on canvas 48 × 55
Dépôt au Musée Matisse du Cateau-Cambrésis

The Red Carpets 1906
Oil on canvas 88 × 90
Musée de Grenoble

Standing Nude 1907
Oil on canvas 92.1 × 64.8
Tate. Purchased 1960

JEAN METZINGER
Woman with Lace 1916
Oil on canvas 100 × 81
Musée d'Art Moderne de la Ville de Paris

AMEDEO MODIGLIANI
Bust of a Young Woman 1908
Oil on canvas 57 × 55
Donation Geneviève et Jean Masurel, Musée d'art moderne de Lille Métropole, Villeneuve d'Ascq

LIST OF EXHIBITED WORKS/PARIS

Head c.1911–12
Limestone 63.5 × 12.5 × 35
Tate. Transferred from The Victoria
& Albert Museum 1983

Portrait of Diego Rivera 1914
Oil on cardboard 104 × 75
Kunstsammlung Nordrhein-
Westfalen, Düsseldorf

JULES PASCIN
Woman with Yellow Boots
1908
Oil on canvas 72.5 × 59.5
Theo Waddington Fine Art,
London/Forum Gallery, New York

La Toilette 1912
Oil on canvas 60 × 40.5
Private Collection

In the Bar Bal Tabarin 1913
Oil on canvas 90 × 72
Private Collection

FRANCIS PICABIA
Reverence 1915
Oil on canvas 99.1 × 99.1
The Baltimore Museum of Art,
Bequest of Saidie A. May

PABLO PICASSO
Bottle and Newspaper 1913
Collage 45 × 48
National Gallery of Ireland, Dublin

Bottle on the Table 1912
Charcoal and newspaper on paper
62 × 47.5
Fondation Beyeler, Riehen/Basel

Musical Instruments and Skull
1914
Oil on canvas 43.8 × 61.8
Donation Geneviève et Jean
Masurel, Musée d'art moderne de
Lille Métropole, Villeneuve d'Ascq

Still Life 1914
Painted wood and upholstery
fringe 25.4 × 45.7 × 9.2
Tate. Purchased 1969

The Beer-glass 1909
Oil on canvas 81 × 65.5
Donation Geneviève et Jean
Masurel, Musée d'art moderne de
Lille Métropole, Villeneuve d'Ascq

Three Figures under a Tree
1907
Oil on canvas 99 × 90
Musée Picasso, Paris

Woman with a Guitar 1914
Oil, sand and charcoal on canvas
115.5 × 47.5
The Museum of Modern Art, New
York, Gift of Mr and Mrs David
Rockefeller, 1975

HANS PURRMANN
Factory Landscape in Corsica
1912
Oil on canvas 50 × 60
Wilhelm Lehmbruck Museum,
Duisburg

DIEGO RIVERA
Still Life 1916
Oil on wood 60 × 40
Tate. Purchased 1959

HENRI ROUSSEAU
The Chair Factory 1909
Oil on canvas 38 × 46
Paris, Musée national de
l'Orangerie, collection Jean Walter
et Paul Guillaume

GINO SEVERINI
Articulated Dancer 1915
Oil on canvas with mobile
elements 65.5 × 54
Fondazione Magnani-Rocca,
Mamiano di Traversetolo

**Still Life with the Newspaper
'Lacerba'** 1913
Paper, gouache, crayon, charcoal,
chalk and indian ink 72.3 × 57.5
Musée d'Art Moderne, Saint-
Étienne. Dépôt F.N.A.C. Paris

**Suburban Train Arriving in
Paris** 1915
Oil on canvas 88.6 × 115.6
Tate. Purchased with the
assistance from a member of the
National Art Collections Fund
1968

LEOPOLD SURVAGE
Twelve Coloured Rhythms
1913
Watercolour 26 × 35
Cinémathèque française, Paris

JACQUES VILLON
Marcel Duchamp Reading 1913
Print 39 × 29.5
Bibliothèque nationale de France

**Portrait of an Actor (Félix
Barré)** 1913
Print 40 × 31.5
Bibliothèque nationale de France

MAURICE DE VLAMINCK
Bridge 1910
Oil on canvas 54 × 65
Private Collection, Galerie de la
Présidence, Paris

The Red Trees 1906
Oil on canvas 68 × 81
Centre Georges Pompidou, Paris.
Musée national d'art moderne

OSSIP ZADKINE
Bust of a Young Girl
c.1914–1917
Bronze 48 × 26 × 14
Musée Zadkine de la Ville de Paris

Heroic Head c.1909–10
Granite 29 × 27 × 28
Musée Zadkine de la Ville de Paris

ARTIST UNKNOWN
**Front page of *Le Théâtre*,
Tamara Karsavina as The
Firebird** 11 May 1911
Periodical, tinted photograph 35.1
× 24.9
The Victoria & Albert Museum

**Tamara Karsavina in 'The
Firebird'** 1911
Postcard from a photograph by
Hoppe 13.4 × 8.4
The Victoria & Albert Museum

Vaslav Nijinsky in 'Le Festin'
1909
Postcard from a photograph by
'Bert' 13.4 × 8.4
The Victoria & Albert Museum

**Vaslav Nijinsky in 'Le Spectre
de la Rose'** 1911
Postcard from a photograph by
'Bert' 13.8 × 8.4
The Victoria & Albert Museum

**Vaslav Nijinsky in 'Le Spectre
de la Rose'** 1911
Postcard from a photograph by
'Bert' 13.3 × 8.6
The Victoria & Albert Museum

**Vaslav Nijinsky in
'Schéhérazade'** 1910
Postcard from a photograph by
'Bert' 13.4 × 8.7
The Victoria & Albert Museum

RIO DE JANEIRO

ROBERTO BURLE MARX
**Perspective view of the
Flamengo Landfill** 1961
Pencil on paper 49.5 × 70
Courtesy of Acervo Burle Marx &
Cia., Ltd.

SÉRGIO CAMARGO
**Large Split White Relief No.
34/74** 1964–5
Relief of split limewood cylinders
on plywood backing, painted white
212 × 92 × 27
Tate. Purchased from the artist
through Signals London (Grant-in-
Aid) 1965

Relief 1964
Painted wood 89 × 89 × 7
Courtesy of Luiz Buarque de
Hollanda

Relief 1969
Painted wood 160 × 105
Estate of Sérgio Camargo

AMÍLCAR DE CASTRO
**Journo do Brasil, Sunday
Supplement: The Neoconcrete
Experience** 1960
Ink on paper 58 × 39.5
Projeto Hélio Oiticica

**Journo do Brasil, Sunday
Supplement: Neoconcrete
Manifesto** 1960
Ink on paper 58 × 79
Projeto Hélio Oiticica

**Journo do Brasil, Sunday
Supplement: Theory of the
Non-Object** 1959
Ink on paper 28 × 79
Projeto Hélio Oiticica

Untitled 1960
Iron 43 × 54 × 81
Collection Museu de Arte Moderna
do Rio de Janeiro – MAM/RJ

Untitled 1960
Iron 101 × 136 × 128
Collection Museu de Arte Moderna
do Rio de Janeiro – MAM/RJ

LYGIA CLARK
Beast 1963
Aluminium
Collection Maria Cristina
Burlamaqui

Beast c.1963
Aluminium 80 × 80 × 15
Collection Eugênio Pacelli Pires
dos Santos

Beast c.1963
Aluminium 100 × 100 × 45
Collection Eugênio Pacelli Pires
dos Santos

Beast: Project for a planet
1963
Aluminium
Collection Maria Cristina
Burlamaqui

Cacoon 1959
Iron 42.5 × 42.5 × 6.5
Collection Eugênio Pacelli Pires
dos Santos

Counter-relief 1959
Industrial paint on wood
140 × 140 × 2.5
Courtesy of Luiz Buarque de
Hollanda

Modulated surface 1958
Industrial paint on wood
41.5 × 114
Courtesy of Luiz Buarque de
Hollanda

Unity 1958
Industrial paint on wood
30 × 30
Courtesy of Luiz Buarque de
Hollanda

Unity 1958
Industrial paint on wood
30 × 30
Collection Maria Cristina
Burlamaqui

Unity 1959
Industrial paint on wood
30 × 30
Collection Museu de Arte Moderna
do Rio de Janeiro – MAM/RJ

Unity 1958
Industrial paint on wood
30 × 30
Courtesy of Luiz Buarque de
Hollanda

Unity V 1958
Industrial paint on wood
29.85 × 29.85
Fundación Eduardo F. Costantini

Unity VI 1958
Industrial paint on wood
29.85 × 29.85
Fundación Eduardo F. Constantini

LE CORBUSIER
**Drawing of the autoroute
building project for Rio de
Janeiro** 1929
Pencil, crayon and charcoal on
paper 71 × 75
Collection Fondation Le Corbusier

MILTON DACOSTA
Composition 1958/9
Oil on canvas 65 × 81
Courtesy of Luiz Buarque de
Hollanda

**Construction on black
background** 1956/7
Oil on canvas 37 × 46
Collection José Paulo Gandra
Martins

In red 1958
Oil on canvas 22 × 27
Collection Luiz Buarque de
Hollanda

In red 1961
Oil on canvas 60 × 73
Collection José Paulo Gandra
Martins

In red 1958
Oil on canvas 24 × 19
Collection Eugênio Pacelli Pires
dos Santos

In red 1960
Oil on canvas 27 × 22
Collection Eugênio Pacelli Pires
dos Santos

In red 1960
Oil on canvas 27 × 22
Collection Eugênio Pacelli Pires
dos Santos

MARCEL GAUTHEROT
Canoas House c.1960
Photograph 50 × 40
Collection Instituto Moreira Salles

Flamengo Landfill c.1960
Photograph 50 × 40
Collection Instituto Moreira Salles

**Ministry of Education and
Culture** c.1960
Photograph 50 × 40
Collection Instituto Moreira Salles

Orfeu da Concerção Stage Set
c.1960
Photograph 50 × 40
Collection Instituto Moreira Salles

Pedregulho Housing Complex
c.1960
Photograph 50 × 40
Collection Instituto Moreira Salles

FERREIRA GULLAR
**Poem from Lygia Clark's
exhibition catalogue** 1958
The artist

ANTONIO CARLOS JOBIM
How Insensitive (music score)
1961
Musical score (ink on paper)
30 × 22
Jobim Music Archive

The Composer Plays 1963
CD
Jobim Music Archive

OSCAR NIEMEYER
Canoas House 2000
Ink on paper 50 × 70
The artist

HÉLIO OITICICA
All works lent by Projeto Hélio
Oiticica:

Bilateral (692) 1959
Oil on wood 180 × 158 × 3

Bilateral (695) 1959
Oil on wood 122 × 172 × 2

Bilateral (Classical) (693)
1959
Oil on wood 122 × 94 × 2

Bilateral (Teman) (696) 1959
Oil on wood 126 × 126 × 2

Equal Bilateral (698) 1960
Oil on board. 5 pieces, each
54 × 54 × 2

**Fireball (754) B2 Fireball box 2
Platonic** 1963
Oil on wood 61 × 23 × 23

**Fireball (757) B5 Fireball box 5
IDEAL** 1963
Oil on wood 43 × 50 × 22

**Fireball (758) B6 Fireball box 6
Egyptian** 1963/4
Oil on wood 55.5 × 24 × 67

Fireball (765) 1964
Disposable boxes, oil on wood,
painted nylon net, yellow plastic
81 × 30 × 28

Monochromatics 1959
Oil on wood 38 parts: 30 × 30

Spacial Relief (736) 1959
Oil on wood 149 × 62 × 8.5

Spacial Relief 1959/1999
Oil on wood 165 × 69 × 20

Spacial Relief 1959/1999
Oil on wood 135 × 135 × 21

Spacial Relief (733) 1959
Oil on wood 98 × 120 × 20

Spacial Relief (738) 1959
Oil on wood 63 × 148 × 15

Neoconcrete Relief 1960
Oil on wood 30.5 × 122

Neoconcrete Relief 1960
Oil on wood 83 × 160

JOSÉ OITICICA FILHO
All works lent by Projeto Hélio
Oiticica:

Botafogo 1946
Photograph 38 × 29.5

Eggs in High Key c.1950
Photograph 31 × 36

Form 1 c.1950
Photograph 39.5 × 31

Form 2 c.1950
Photograph 39.5 × 31

Form 23 c.1950
Photograph 43 × 36

Gávea c.1950
Photograph 43 × 32

Incorporeal c.1950
Photograph 40 × 31

Obvious Composition 1955
Photograph 39.5 × 31

Similar Triangles 1953
Photograph 39 × 31

Untitled c.1950
Photograph 39.5 × 30

Untitled c.1950
Photograph 29.5 × 30

Untitled c.1950
Photograph 35.5 × 29

Untitled c.1950
Photograph 35.5 × 29

Untitled c.1950
Photograph 34 × 30

Untitled c.1946
Photograph 40 × 30

LYGIA PAPE
Tecelares 1950
Engraving on wood 50 × 25
All works lent by the artist

Tecelares 1950
Engraving on wood 50 × 50

Tecelares 1950
Engraving on wood 50 × 50

Tecelares 1950
Engraving on wood 30 × 30

Tecelares 1950
Engraving on wood 30 × 30

Tecelares 1955
Engraving on wood 80 × 60

Tecelares 1955
Engraving on wood 70 × 50

Tecelares 1955
Engraving on wood 70 × 50

Tecelares 1955
Engraving on wood 70 × 66

Tecelares 1955
Engraving on wood 70 × 50

AFFONSO EDUARDO REIDY
**Sketch of the Museum of
Modern Art framed within Rio
de Janeiro's landscape** 1947
Pencil on paper 30 × 70
Núcleo de Pesquisa e
Documentação – NPD-FAU/UFRJ

**Sketch of the Museum of
Modern Art framed within Rio
de Janeiro's northern landscape**
1948
Pencil on paper 40 × 70
Núcleo de Pesquisa e
Documentação – NPD-FAU/UFRJ

FRANZ WEISSMANN
All works lent by the artist unless
otherwise stated:

Concretist Column 1952/2000
Painted iron 50 × 50 × 300

Linear Sculpture 1954/1998
Steel 64 × 74 × 42

Linear Sculpture 1954/1998
Steel 66 × 76 × 34

Linear Sculpture 1954/1998
Steel 57 × 53 × 32

Neoconcrete Column No. 1
1958
Painted iron
170 × 70 × 45
Collection Lygia Pape

Neoconcretist Column No.3
1958/2000
Painted iron 80 × 80 × 200

Open Cube 1958
Aluminium 10 × 10 × 10

Open Cube 1953
Painted iron 15 × 15 × 15

ARTIST UNKNOWN
**Antonio Carlos Jobim and
Oscar Niemeyer in Brasilia**
1960
Photograph 18 × 24
Jobim Music Archive

**Hélio Oiticica, Jean Boghici,
Lygia Clark, Ferreira Gullar and
Teresa Aragão, Carnival, Rio**
1961
Photograph 50 × 40
Ferreira Fullar Archive

TOKYO

AKASEGAWA GENPEI
Greater Japan Zero-Yen Note
1967
Printed matter, glass jar, cash
mailers and cash, dimensions
variable
Courtesy Shiraishi Contemporary
Art Inc., and Nagoya City Art
Museum, Tokyo

**Greater Japan Zero-Yen Note
(poster)** 1967
Blueprint
Courtesy Shiraishi Contemporary
Art Inc., and Nagoya City Art
Museum, Tokyo

Virgin City 1969
Poster for The Situation Theatre
(Red Tent) 72.8 × 81.4
Musashino Art University Museum
and Library

HIKOSAKA NAOYOSHI
All works lent by the artist:

Floor Event 1970
Slide presentation Photographs
by: Yasunao Tone and Hikosaka
Naoyoshi

**Floor Event (invitation
postcard)** 1971
Silkscreen and offset 10 × 14.5

On Practice (August 1973)
Ink on paper, dimensions variable

Repitition/Reversal (Hanpuku)
1974
Book. Jacket designed by Kimura
Tsunehisa 19.5 × 13.5 × 2.5

**Untitled (Two Concentric Circle
Graphs as the Rising Sun Flag:
'1970, the Boiling and Hollowing
of Tokyo')** 2000
Paint on wood, 2 panels each
259 × 139.7

**HIRANO KōGA (WITH OYOBE
KATSUHITO AND KUSHIDA
MITSUHIRO)**
**The Dance of Angels Who Burn
Their Own Wings** 1970
Poster for Theater Center 68/70
(Black Tent) 97.8 × 76.4
Musashino Art University Museum
and Library

HORI KOSAI
**Revolution: Ceiling, Wall, Floor
(documentary photograph by
Hikosaka Naoyoshi)**
Photograph, 4 parts, each 15.4 ×
24
The artist

**Revolution: Ceiling, Wall, Floor
(invitation postcard)** 1971
Silkscreen 14.5 × 10
The artist

**Revolution: Ceiling, Wall, Floor
(wall paintings)** 1971
Crayon on paper, 35 parts each
90.5 × 59.5
The artist

HORIKAWA MICHIO
All works lent by the artist unless
otherwise stated

**The Nakanomata River Plan 17
(stone received by the artist)**
1972
Stone, wire and postal tags
9 × 11 × 11

**The Nakanomata River Plan 17
(stone received by Maeyama
Tadashi)** 1972
Stone, wire and postal tags
9 × 11 × 11
Maeyama Tadashi

**The Shinano River Plan
(document card with receipt
from Akatsuka Yukio)** 1969
Ink, stamp, receipt on printed card
20 × 20

**The Shinano River Plan
(document card with receipt
from Shimizu Kusuo)** 1969
Ink, stamp, postcard on printed
card 20 × 20

**The Shinano River Plan 11
(document card)** 1969
Ink, stamp, clipping, finger print,
type on printed card 20 × 20

**The Shinano River Plan 11
(documentary photograph of
stone received by Maeyama
Tadashi)** 1969
Photograph 8.4 × 12.3

**The Shinano River Plan 12
(document card with mailing
list)** 1969
Ink on printed card 20 × 20

**The Shinano River Plan 12
(document card with post office
receipt countersigned by
Yamamoto Takashi)** 1969
Ink, stamp, post office receipt on
printed card 20 × 20

**The Shinano River Plan 12
(document card with
stonecutter's receipt
countersigned by Yamamoto
Takashi)** 1969
Ink, stamp, stonecutter's receipt
on printed card 20 × 20

**The Shinano River Plan 12
(stone received by Takiguchi
Shuzo)** 1969
Stone, wire and postal tags
6.5 × 10.5 × 7
The Museum of Modern Art,
Toyama

**The Shinano River Plan 12
(document card with two
photographs)** 1969
Photographs on printed card
20 × 20

**The Shinano River Plan 12
(stone received by Yamamoto
Takashi)** 1969
Stone, wire and postal tags
9 × 12.5 × 11
Collection Tabata Yukihito

**The Shinano River Plan:
Christmas Present (letter from
American Embassy)** 1972
Typed, ink on paper 30 × 21

**The Shinano River Plan:
Christmas Present (sheet from
Mental Hygiene Study
Institute)** 1970
Card, printed matter 30 × 21

ISOZAKI ARATA
Electric Labyrinth 1968/1990
Transparency of 1990 silkscreen
based on a 1968 work 300 × 90
The artist

**The Dismantling of
Architecture (Kenchiku no
kaitai)** 1969–73/1975
Book 22.2 × 16.2 × 3.2
Shiina Misao

**TAKI KōJI AND NAKAHIRA
TAKUMA, eds.**
**First Abandon the World of
Certainty (Mazu tashikarashisa
no sekai o sutero)** 1970
Book 21 × 14.5 × 2.2
Kaneko Ryuichi

KOSHIMIZU SUSUMU
From Surface to Surface
1971/1994
Wood, 15 parts, each
300 × 40 × 6
The artist. Courtesy Tokyo Gallery

KUSAMA YAYOI
A Snake 1974
Sewn, stuffed fabric and silver
paint 25 × 30.5 × 650
D'Amelio Terras Gallery, New York

Lying With Birds 1975
Collage 37.5 × 52.5
The artist

Now That You've Died 1975
Collage 54 × 39
Setagaya Museum

Spirits Returning Home 1975
Collage 53 × 38
Setagaya Art Museum

LEE UFAN
From Line 1973
Mineral pigment on canvas
127 × 182
Museum of Contemporary Art,
Tokyo

**In Search of Encounter (Deai o
motomete)** 1971
Book. Jacket design by Nakahira
Takuma 19.5 × 14 × 2
The artist. Courtesy Tokyo Gallery

MATSUZAWA YUTAKA
My Own Death 1970
Panel, cloth 91 × 91 × 3.3
The artist

Postcard Paintings 1967
Printed matter 14.8 × 10
The artist

Postcard Paintings 2000
Printed matter 14.8 × 10
The artist

YOKO ONO
Cheers To Women On Top 1973
45 rpm record, jacket, lyric card,
CD transfer
record radius: 18, jacket: 18.2 ×
18.2, lyric card 16.5 × 18.3
The artist

**Japanese Men Sinking (Nippon
dansei chinbotsu)** 1973
Magazine pages pasted in
scrapbook 32.4 × 31.1 × 1.9
The artist

OYOBE KATSUHITO
Communication Plan No.1 1969
Poster for Theater Center 68/69
79.1 × 54.7
Musashino Art University Museum
and Library

**OYOBE KATSUHITO (WITH
HOSOE EIKŌ AND GŌDA
SAWAKO)**
The Bengal Tiger 1973
Poster for The Situation Theatre
(Red Tent) 109.4 × 78.7
Musashino Art University Museum
and Library

SEKINE NOBUO
Phase of Nothingness: Oilclay
1969
Documentary photograph
The artist

Phase: Sponge 1968/2001
Metal and sponge (reconstruction)
165 × 150 × 150
The artist

UNO AKIRA
The Baron Burabura 1970
Poster for Tenjō Sajiki 104.8 × 73
Sasame Hiroyuki

YAMANAKA NOBUO
All works lent by Tochigi
Prefectural Museum of Fine Arts

B&W Contact Pinhole (10-4)
1972
Photograph 25.2 × 31

B&W Contact Pinhole (10-5)
1973
Photograph 25.2 × 31

B&W Contact Pinhole (10-9)
1973
Photograph 25.2 × 31

B&W Pinhole (13-2) 1973
Photograph 25.3 × 31.1

B&W Pinhole (13-3) 1973
Photograph 25.2 × 31.1

B&W Pinhole (13-10) 1973
Photograph 25.3 × 31.1

Colour Pinhole (11-1) 1973
Photograph 29 × 24.4

Colour Pinhole (12-1) 1973
Photograph 24.5 × 29.1

Colour Pinhole (12-2) 1973
Photograph 24.5 × 29.1

**Pinhole Camera (concept card,
included in 'Expression in Film
'72: Ting, PLace, Time Space –
Equivalent Cinema', exh. cat.,
Kyoto Municipal Museum of Art
1972** 1972
Printed card 13 × 18.2

**Projecting a Film of a River
onto the River** 1971
Documentary photograph
20.3 × 25.4

**Projecting a Film of a River
onto the River (invitation
postcard)** 1971
Silkscreen 2 × 14.5 × 10

YAMASHITA KIKUJI
Encounter 1971
Oil on canvas 112 × 162.1
Gallery Nippon

Focal Point 1970
Collage 41 × 28.5
Gallery Nippon

Picking Up a Day's Work 1970
Collage 36 × 22.5
Gallery Nippon

YOKOO TADANORI
John Silver: Love In Shinjuku
1967
Poster for The Situation Theatre
(Red Tent) 103 × 74.6
Musashino Art University Museum
and Library

Solicitation for Subscribers
Poster for Tenjō Sajiki 103 × 73
Musashino Art University Museum
and Library

IN ADDITION:

MAGAZINES:

**Bijutsu shihyō (Art History and
Criticism) No.5** 1972
Magazine 21 × 15
Art Library, Museum of
Contemporary Art, Tokyo

**Bijutsu shihyō (Art History and
Criticism) No.6** 1973
Magazine 21 × 15
Art Library, Museum of
Contemporary Art, Tokyo

**Bijutsu shihyō (Art History and
Criticism) No.7** 1974
Magazine 21 × 15
Art Library, Museum of
Contemporary Art, Tokyo

Provoke, No.1 1968
Magazine 21 × 21
Kaneko Ryuichi

Provoke, No.2 1968
Magazine 24.2 × 18
Kaneko Ryuichi

Provoke, No.3 1969
Magazine 23.9 × 18.5
Kaneko Ryuichi

PHOTOGRAPHS:

**Constructions: A Pedestrian's
View (From Tower House to
Towers 1967-74)** 2000
Slide presentation of photographs
by Franck Robichon

**Slide presentation of news
photographs from Kyodo News,
The Mainichi Newspaper, Asahi
Shimbun and Watanabe Hitomi**
1967–1970

VIENNA

PETER ALTENBERG
'Gleanings' 1930
First edition, published in Vienna
Private Collection, Edinburgh

The War! c.1918
Postcard inscribed by Peter
Altenberg 9 × 14
Private Collection, Galerie St.
Etienne, New York

'Semmering' 1912
Fourth enlarged edition, published
in Berlin
Private Collection, Edinburgh

**Thirty Framed Postcards
Inscribed by Peter Altenberg**
1907–18
Varied dimensions
Museen der Stadt Wien, Vienna

JOSEF CARL
'The Perfidious Ally'
Gouache on paper 50.8 × 36.5
Heeresgeschichtliches Museum
im Arsenal, Vienna

'Wilsons Peace Treaty'
Gouache on paper 50.8 × 36.5
Heeresgeschichtliches Museum
im Arsenal, Vienna

'Group of Four … Dance'
Gouache on paper 50.8 × 36.5
Heeresgeschichtliches Museum
im Arsenal, Vienna

ALBIN EGGER-LIENZ
Northern France 1917
Oil on canvas 118 × 231
Otto Huber

SIGMUND FREUD
The Interpretation of Dreams
1900
First German edition, published in
Leipzig and Vienna
The Freud Museum, London

**The Psycho-pathology of
Everyday Life** 1904
First German edition in book-form
published in Berlin, annotated by
Freud
The Freud Museum, London

**Three Essays on the Theory of
Sexuality** 1905
First German and English edition,
published in Leipzig and Vienna
(1905) and London (1910)
The Freud Museum, London

**Furniture, antiquities and
effects from Freud's consulting
room including couch, armchair,
Biedmeier cabinet, Turkish rug,
wall-hanging, Egyptian funerary
head, plaster reproduction of
the classical relief, Gradiva, and
colour print (1907) of Abu
Simbel (based on a 1905
gouache by Ernst Koemer)**
The Freud Museum, London

RICHARD GERSTL
Nude Self-Portrait 1908
Oil on canvas 141 × 109
Leopold Museum, Private
Foundation, Vienna

Self-Portrait c.1907
Pen and ink on paper 45 × 31.5
Private Collection, Galerie St.
Etienne, New York

Self-Portrait c.1908
Wash, pen, ink and charcoal on
paper 40 × 29.5
Private Collection, Galerie St.
Etienne, New York

OSKAR KOKOSCHKA
Adolf Loos 1909
Oil on canvas 74 × 91
Staatliche Museen zu Berlin,
Nationalgalerie

Baron Viktor von Dirsztay
1911
Oil on canvas 98.5 × 73
Sprengel Museum Hannover

**View from the Barracks at
Sveta Maria** 1916
Coloured charcoal, charcoal and
pencil on paper 31.2 × 48
Kunsthaus Zug/Depositum
Stiftung Sammlung Kamm

Church at Selo 1916
Crayon and pastel on paper
30.5 × 43
Fondation Oskar Kokoschka,
Musée Jenisch, Vevey

Conte Verona 1910
Oil on canvas 70.6 × 58.7
Private Collection, Marlborough
International Fine Arts

The Baka in the Dugout 1916
Watercolour, crayon and black
chalk on paper 30.5 × 43.1
Fondation Oskar Kokoschka,
Musée Jenisch, Vevey

Illustration for 'Man of Images'
1916
Book of Lithographs published by
Paul Cassirer 36.5 × 29
Fondation Oskar Kokoschka,
Musée Jenisch, Vevey

Egon Wellesz 1911
Oil on canvas 75.5 × 68.9
Hirshhorn Museum and Sculpture
Garden, Smithsonian Institution,
Gift of Joseph H. Hirshhorn
Foundation, 1966

Felix Albrecht Harta 1909
Oil on canvas 73 × 52
Hirshhorn Museum and Sculpture
Garden, Smithsonian Institution,
Gift of Joseph H. Hirshhorn
Foundation 1966

Female Nude with Stockings
Pencil and watercolour on paper
45.1 × 30.9
Kunsthaus Zug/Depositum
Stiftung Sammlung Kamm

Girl Leaning 1907
Pencil on paper 31 × 45
Leopold Museum, Private
Collection, Vienna

**Hans Tietze and Erica Tietze-
Conrat** 1909
Oil on canvas 76.5 × 136.2
The Museum of Modern Art, New
York. Abby Aldrich Rockefeller
Fund, 1939

**Heavenly and Earthly Love
(Murderer Hope of Women IV)**
1910
Ink and pencil on paper
26.7 × 18.5
Moderna Museet, Stockholm

Hermann Schwarzwald I 1911
Oil on canvas 90 × 65
Staatsgalerie Stuttgart

Ludwig von Ficker 1915
Oil on canvas 100.3 × 74.3
Tiroler Landesmuseum
Ferdinandeum, Innsbruck

Mother and Child 1907/8
Ink, gouache, watercolour and
pencil on paper 45 × 31
Museen der Stadt Wien, Vienna

Murderer, Hope of Women
1907
Poster for 'Der Sturm'. Colour
lithograph on paper
34.5 × 25.5
Fondation Oskar Kokoschka,
Musée Jenisch, Vevey

Murderer, Hope of Women I
1910
Ink and pencil on paper 25.5 × 20
Kunsthaus Zug/Depositum
Stiftung Sammlung Kamm

Murderer, Hope of Women II
1910
Ink and pencil on paper 27.5 ×
27.5
Kunsthaus Zug/Depositum
Stiftung Sammlung Kamm

Murderer, Hope of Women III
1910
Pen and ink over pencil on paper
24.7 × 18.5
Graphische Sammlung der
Staatsgalerie Stuttgart

Nude in Profile 1908
Conte crayon and watercolour on
paper 48.5 × 31
Fondation Oskar Kokoschka,
Musée Jenisch, Vevey

Nude with Back Turned c.1907
Pen, ink, gouache and chalk on
paper 45.1 × 31.1
The Museum of Modern Art, New
York. Rose Gershwin Fund

Pietà 1908–9
Poster for 'Kunstschau'
Colour lithograph on paper 125 ×
81
Fondation Oskar Kokoschka,
Musée Jenisch, Vevey

Lotte Franzos 1909
Oil on canvas 114.9 × 79.3
The Philipps Collection,
Washington, D.C.

Projectile Gun in Covered
Position 1916
Crayon and black chalk on paper
48.2 × 32.2
Leopold Museum, Private
Foundation, Vienna

Reclining Nude 1912–13
Black chalk on paper 31 × 45
Fondation Oskar Kokoschka,
Musée Jenisch, Vevey

Reclining Nude Boy with Knees
Pulled Up 1912–13
Black crayon and watercolour over
pencil on paper 45.1 × 31.7
Graphische Sammlung der
Staatsgalerie Stuttgart

Savoyard Boy 1912–13
Black chalk and watercolour on
paper 25.4 × 31.5
Leopold Museum, Private
Foundation, Vienna

Snake Dance 1910
Ink and pencil on paper 23.2 × 22
Kunsthaus Zug/Depositum
Stiftung Sammlung Kamm

Seated Nude Old Woman with
Stockings 1907
Pencil and watercolour with white
heightening on paper 45.1 × 31.7
Sylvia Eisenburger-Kunz

Seated Woman 1907–8
Pencil on paper 41 × 30.6
Fondation Oskar Kokoschka,
Musée Jenisch, Vevey

Self-Portrait 1913
Oil on canvas 81.6 × 49.5
The Museum of Modern Art, New
York. Purchased 1940

Self-Portrait 1910
Poster for 'Der Sturm'
Colour lithograph on paper
70 × 46.5
Fondation Oskar Kokoschka,
Musée Jenisch, Vevey

Sleeping Nude 1912–13
Black crayon on paper 31.6 × 42.2
Fondation Oskar Kokoschka,
Musée Jenisch, Vevey

Soldiers with Crucifixes 1917
Blue crayon on paper 39.2 × 29.9
Private Collection, Germany

Stag, Fox and Magician 1907
'Kabarett Fledermaus' Programme
Colour lithograph on paper
24.4 × 23.5
Fondation Oskar Kokoschka,
Musée Jenisch, Vevey

Standing Nude Boy 1907
Pencil and watercolour on paper
44.9 × 31.8
Private Collection, Germany

Nude Boy Standing on Right
Leg, in Profile c.1912–13
Black chalk, watercolour and
gouache on paper 40 × 31.1
Private Collection, Germany

Standing Nude Girl 1908
Pencil, watercolour and ink on
paper 44.7 × 30.1
Private Collection, Germany

The Acrobat c.1907
Pencil on paper 44.5 × 30.5
Private Collection, London

Standing Nude Girl c.1907
Pencil and gouache on paper
43.2 × 29.2
Private Collection, London

The Firstcomer May Comb
Sweet Lilith's Hair 1910
Brush and ink on paper
24 × 43
Kunstmuseum Bern, Hermann und
Margrit Rupf-Stiftung

Tom di Tolmino 1916
Watercolour, crayon and black
chalk on paper 30.4 × 43
Fondation Oskar Kokoschka,
Musée Jenisch, Vevey

Two Girls Trying on Clothes
1908
Ink watercolour and gouache on
paper 44 × 30.8
Private Collection, Germany

Young Girl with Naked Torso
1908
Watercolour on paper 45 × 31
Leopold Museum, Private
Foundation, Vienna

KARL KRAUS
The Last Days of Mankind
1919
First edition in book-form,
published in Vienna
Wiener Stadt– und
Landesbibliothek,
Druckschriftensammlung, Vienna

The Last Days of Mankind
1922
Book
Wiener Stadt– und
Landesbibliothek,
Druckschriftensammlung, Vienna

KARL KRAUS (ed.)
'Die Fackel'
Number 404, December 1914
Periodical published in Vienna
Private Collection, Edinburgh

The Ravens
From 'The Last Days of Mankind'
Archive film footage

Tourist Trips to Hell
Archive film footage

ADOLF LOOS
House on the Michaelerplatz
Blueprint 40 × 82
Albertina, Loos Archive, Vienna

AFTER ADOLF LOOS
House on the Michaelerplatz
1909–11
Made by Hans Kropf, Graz
1984–5. Model, plastic approx.
60 × 100, scale 1:50
Museen der Stadt Wien, Vienna

ADOLF LOOS
My House on the Michaelerplatz
1911
Poster for a lecture 80 × 60
Museen der Stadt Wien, Vienna

Ornament and Crime 1913
First edition in book-form,
published in Paris
Wiener Stadt– und
Landesbibliothek,
Druckschriftensammlung, Vienna

ROBERT MUSIL
Young Törless 1906
Book
Wiener Stadt– und
Landesbibliothek,
Druckschriftensammlung, Vienna

EGON SCHIELE
Act of Love (Coitus) 1915
Gouache and pencil on paper
49 × 30.9
Leopold Museum, Private
Foundation, Vienna

Dead Girl 1910
Watercolour and charcoal on paper
30.4 × 43.8
By Kind Permission of the Earl and
Countess of Harewood

Dead Mother (I) 1910
Oil and pencil on wood 32 × 25.7
Leopold Museum, Private
Foundation, Vienna

Female Torso Seen from the
Back 1913
Pencil and gouache on paper
47.8 × 32
Leopold Museum, Private
Foundation, Vienna

Fighter 1913
Gouache and pencil on paper
48.8 × 32.2
Private Collection, Austria

Girl with Black Hair 1911
Watercolour and pencil on paper
56.6 × 36.2
The Museum of Modern Art, New
York. Gift of the Galerie St.
Etienne, New York in memory of Dr
Otto Kallir; promised gift of Ronald
S. Lauder; and purchase

Black-Haired Girl with Raised
Skirt 1911
Gouache and pencil on paper
55.9 × 37.8
Leopold Museum, Private
Foundation, Vienna

Heinrich Wagner, Lieutenant in
the Reserve 1917
Gouache and black crayon on
paper 45.1 × 29.7
Heeresgeschichtliches Museum
im Arsenal, Vienna

Infant Lying on its Back 1910
Gouache, watercolour and black
crayon on paper
Leopold Museum, Private
Foundation, Vienna

Kneeling Male Nude (Self-
Portrait) 1910
Watercolour, gouache and black
crayon on paper 62.7 × 44.5
Leopold Museum, Private
Foundation, Vienna

Lieutenant Weippel 1918
Black crayon on paper 46 × 29.9
Heeresgeschichtliches Museum
im Arsenal, Vienna

Newborn Baby Holding its Hand
in Front of its Face 1910
Watercolour and black crayon on
paper 31.9 × 44.9
Leopold Museum, Private
Foundation, Vienna

Newborn Baby with Bent Knees
1910
Watercolour, black crayon and
gouache on paper 29 × 43
Leopold Museum, Private
Foundation, Vienna

Nude Leaning on his Elbow,
Seen from the Back 1910
Gouache, watercolour and black
crayon on paper 44.7 × 30.2
Leopold Museum, Private
Foundation, Vienna

Nude Male Torso 1910
Gouache, watercolour and black
crayon on paper 44.8 × 27.9
Leopold Museum, Private
Foundation, Vienna

Nude Self-Portrait in Grey with
Open Mouth 1910
Gouache and black crayon on
paper 44.8 × 31.5
Leopold Museum, Private
Foundation, Vienna

Nude Self-Portrait, Squatting
1916
Gouache and pencil on paper
29.5 × 45.8
Graphische Sammlung Albertina,
Vienna

Nude With Violet Stockings
1912
Watercolour, pencil, brush and ink
on paper 32 × 47.3
The Museum of Modern Art, New
York. Mr and Mrs Donald B Straus
Fund

One-Year Volunteer Private
1916
Gouache and pencil on paper
47.2 × 30.5
Leopold Museum, Private
Foundation, Vienna

Portrait of a Russian Soldier
1915
Charcoal and tempera on paper
44.8 × 29.5
Staatliche Graphische Sammlung
Munich

Portrait of Arnold Schoenberg
1917
Pencil, charcoal, coloured chalks
and watercolour on paper
40.5 × 27
By Kind Permission of the Earl and
Countess of Harewood

Prisoner! 1912
Watercolour and pencil on paper
48.2 × 31.7
Graphische Sammlung Albertina,
Vienna

Proletarian Girl in Black 1910
Gouache and pencil on paper
45 × 31.4
Private Collection, Galerie St.
Etienne, New York

Reclining Woman with Blond
Hair 1914
Gouache over pencil on paper
31.7 × 48.5
The Baltimore Museum of Art,
Fanny B. Thalheimer Memorial and
Friends of Art Funds

Red-Haired Girl with Spread
Legs 1910
Gouache, watercolour and pencil
on paper 43.9 × 30.4
Leopold Museum, Private
Foundation, Vienna

Russian Officer, Prisoner of War
1916
Gouache, watercolour and pencil
on paper 46.5 × 30.5
Leopold Museum, Private
Foundation, Vienna

LIST OF EXHIBITED WORKS/VIENNA

Seated Male Nude 1910
Watercolour and charcoal on paper
43.7 × 30.3
Kunsthaus Zug/Depositum
Stiftung Sammlung Kamm

Seated Male Nude (Self-Portrait) 1910
Oil and gouache on canvas
152.5 × 150
Leopold Museum, Private
Foundation, Vienna

Seated Nude Girl 1910
Gouache and black crayon with
white heightening on paper
44.8 × 29.9
Graphische Sammlung Albertina,
Vienna

**Seated Semi-Nude with Red
Hair** 1910
Watercolour over black chalk on
paper 44.4 × 31.1
By Kind Permission of the Earl and
Countess of Harewood

**Self-Portrait in Black Cloak,
Masturbating** 1911
Gouache, watercolour and pencil
on paper 48 × 32.1
Graphische Sammlung Albertina,
Vienna

**Self-Portrait with Bare
Stomach** 1911
Watercolour and pencil on paper
55.2 × 36.4
Graphische Sammlung Albertina,
Vienna

**Self-Portrait with Hunched and
Bared Shoulder** 1912
Oil on wood 42.2 × 33.9
Leopold Museum, Private
Foundation, Vienna

**Self-Portrait with Lowered
Head** 1912
Oil on wood 42.2 × 33.7
Leopold Museum, Private
Foundation, Vienna

**Self-Portrait with Striped
Armlets** 1915
Gouache and pencil on paper
49 × 31.5
Leopold Museum, Private
Foundation, Vienna

Semi-Nude (Self-Portrait)
1911
Gouache, watercolour and pencil
on paper 44.7 × 31.3
Leopold Museum, Private
Collection, Vienna

Semi-Nude Girl Reclining 1911
Gouache, watercolour and pencil
with white heightening on paper
45.8 × 30.9
Graphische Sammlung Albertina,
Vienna

Sick Girl, Seated 1910
Pencil, watercolour and gouache
on paper 44.3 × 30
Leopold Museum, Private
Collection, Vienna

Woman Wrapped in a Blanket
1911
Watercolour and pencil on paper
44.7 × 31.1
The Museum of Modern Art, New
York. The Joan and Lester Avnet
Collection

**Standing Female Torso with
Olive-Green Shirt** 1913
Pencil, watercolour and gouache
on paper 48 × 31.9
Leopold Museum, Private
Collection, Vienna

**Standing Male Nude with Arm
Raised** 1910
Watercolour and charcoal on paper
44.5 × 30.8
The Museum of Modern Art, New
York. Gift of Ronald S Lauder

Prostitute 1912
Watercolour and pencil on paper
48.1 × 31.3
The Museum of Modern Art, New
York. Purchased from Galerie St.
Etienne

The Dancer 1913
Gouache, watercolour and pencil
on paper 47.8 × 31.9
Leopold Museum, Private
Collection, Vienna

Two Reclining Nudes 1911
Watercolour and pencil on paper
56.5 × 36.8
The Metropolitan Museum of Art,
New York. Bequest of Scofield
Thayer, 1982

Woman Undressing 1914
Gouache and pencil on paper
47 × 32.4
Private Collection, Galerie St.
Etienne, New York

**ARTHUR SCHNITZLER
La Ronde** 1896–7
First edition in German
Wiener Stadt– und
Landesbibliothek,
Druckschriftensammlung, Vienna

**OTTO WAGNER
The City** 1911
First edition in German, published
in Vienna
Wiener Stadt– und
Landesbibliothek,
Druckschriftensammlung, Vienna

Nuts and Bolts
Ink and watercolour 34.5 × 53.6
Kupferstichkabinett Akademie der
Bildenden Künste, Vienna

**Project for Hotel Wien,
Karlsplatz, Vienna, Detail of the
Façade** 1913
Ink, watercolour and pencil on
paper 60.5 × 39.8
Kupferstichkabinett Akademie der
Bildenden Künste, Vienna

**Project for Hotel Wien,
Karlsplatz, Vienna, View from
Below and Detail of Cornice**
1913
Ink, coloured pencils and pencil on
paper 60.5 × 43
Kupferstichkabinett Akademie der
Bildenden Künste, Vienna

**Project for Hotel Wien,
Karlsplatz, Vienna** 1913
Coloured pencils, ink and pencil
58.5 × 38.3
Kupferstichkabinett Akademie der
Bildenden Künste, Vienna
Kupferstich

Presentation Card c.1911
Ink and pencil on paper
24.1 × 28.2
Kupferstichkabinett Akademie der
Bildenden Künste, Vienna

**AFTER OTTO WAGNER
The City**
Made by the Master Class of Prof.
Wilhelm Holzbauer, 1997, after
the illustration 'Centre of the XXII.
District in Vienna', published in
'The City', Vienna, 1911
Model, wood, Scale 1:2000,
129 × 196
Museen der Stadt Wien, Vienna

**HERWARTH WALDEN (ed.)
'Der Sturm' Number 20, 14 July
1910**
Periodical published in Berlin
Richard Calvocoressi, Edinburgh

**LUDWIG WITTGENSTEIN
Tractatus Logico-Philosophicus**
1921
First edition in German, published
in Leipzig
Wittgenstein Archive, Cambridge

**LUDWIG WITTGENSTEIN
House for Margaret
Stonborough-Wittgenstein,
Vienna 1926-28**
Photographs taken by Bernhard
Leitner and Elisabeth Kohlweiss,
each 88 × 88
Bernhard Leitner

**House for Margaret
Stonborough-Wittgenstein,
Vienna 1926-8**
Photograph 89 × 88
Bernhard Leitner

**House for Margaret
Stonborough-Wittgenstein,
Vienna 1926-28** 1998
Photographs taken by Bernhard
Leitner and Elisabeth Kohlweiss,
each 89 × 88
Bernhard Leitner

**AFTER LUDWIG
WITTGENSTEIN
House for Margaret
Stonborough-Wittgenstein,
Vienna 1926-8**
Recent model, scale 1:50,
28.5 × 49 × 42
Akademie der Bildenden Künste,
Vienna

**Wittgenstein's Photograph
Album** c.1930
16 × 10
Wittgenstein Archive Cambridge

**Photograph of Wittgenstein's
Army Platoon** c.1914–18
Photograph 8.8 × 12.5
Wittgenstein Archive, Cambridge

**Wittgenstein's Military Identity
Card**, 30.6.1918
Photograph on card 11.2 × 7.1
Wittgenstein Archive, Cambridge

LENDERS TO THE EXHIBITION

PRIVATE COLLECTIONS

Alhaji Abdulai
Sandra and Stephen Abramson
Mr and Mrs Adeneye
Mr. Atose Aguelle
Virginia and Ravi Akhoury
Navjot Altaf
Asele Institute
Avalanche Archives, Gilbert and
 Lila Silverman, Detroit
Baileys Archive
Balkrishna Art
Centre for the Study of Culture and
 Society, Bangalore
BANK
Sally Barker
Luiz Buarque de Hollanda
Lutz Becker
Lynda Benglis
Maurice Berger
Merrill C. Berman
Galerie Berthet-Aittouarès
Suresh and Saroj Bhayana Family
Henry Bond/Liam Gillick
Tord Boontje
Sonia Boyce
Mr and Mrs Charles Brown
Gavin Brown's Enterprise Corps,
 New York
Trisha Brown
Maria Cristina Burlamaqui
Acervo Burle Marx & Cia., Ltd.
Cabinet, London
Richard Calvocoressi
Estate of Sérgio Camargo
Claude Chabaud
Hussein Chalayan
Cheim & Read Gallery, New York
CITY RACING
James Cohan Gallery, New York
Sadie Coles HQ (London)
CORBIS
Fundación Eduardo F. Constantini
Melanie Counsell

D. and A. d'Alpoim Guedes
D'Amelio Terras Gallery, New York
Gurcharan and Bunu Das
Jeremy Deller
Atul Dodiya
Electronic Arts Intermix, New York
Paul Elliman
Sylvia Eisenburger-Kunz
Miss Comfort Esusu
Eurolounge
Jason Evans
Frayda and Ronald Feldman
Forum Gallery, New York
Simon Foxton
José Paulo Gandra Martins
Gargallo Family Estate
Mr. Rasheed Gbadamosi
Barbara Gladstone Gallery, New
 York
Galerie Gmurzynska, Cologne
Goetz Collection, Munich
Nancy Graves Foundation, New
 York
Gray Cell Infotech Pvt. Ltd., India
Karan and Nisha Grover, India
Ferreira Gullar Archive
Shilpa Gupta
Earl and Countess of Harewood
Galerie Hauser & Wirth, Zürich
Pat Hearn Gallery, New York
Jon and Joanne Hendricks
Jean-Noel Herlin Archive Project
The Estate of Eva Hesse
Hikosaka Naoyoshi
Nancy Holt
Hori Kosai
Otto Huber

Reima Husain and Owais Husain
M.F. Husain
Instituto Moreira Salles
INVENTORY
Runa Islam
Arata Isozaki
Gallery Michael Janssen, Cologne
Amrita Jhaveri
Jobim Music Archive
Joan Jonas
Jay Jopling/White Cube (London)
Kaneko Ryu*ichi
Sen Kapadia
Bhupen Khakhar
Nick Knight
Koshimizu Susumu. Courtesy
 Tokyo Gallery
Kusama Yayoi
Galerie Alex Lachmann, Cologne
Mark Leckey
Fondation Le Corbusier, Paris
Stanley Lederman
Bernhard Leitner
Peter Lewis
Sasha Lurye
Maeyama Tadashi
Nalini Malani
Fondazione Magnani-Rocca,
 Mamiano di Traversetolo
Babette Mangolte
Bill and Holly Marklyn
Vincent Matey Kofi
Matsuzawa Yutaka
Estate of Gordon Matta-Clark
Matt's Gallery, London
Lehmann Maupin, New York
Mary Miss
Barbara Moore
Kausik Mukhopadhyay
Mustad Collection, Sweden
Hayley Newman
Oscar Niemeyer
Nimbus Art Gallery, Lagos
Gallery Nippon, Tokyo
NOSEPAINT – BEACONSFIELD
Chris Ofili
Miss Seyi Ojo
Ambassador Olusegun Olusora
Yoko Ono
Bruce Onobrakpeya
Dennis Oppenheim
Projeto Hélio Oiticica
Eugênio Pacelli Pires dos Santos
Maureen Paley/Interim Art,
 London
Lygia Pape
Swapen Parekh
Janette Parris
Anand Patwardhan
Simon Periton
C.A.A.C.– The Pigozzi Collection,
 Geneva
Adrian Piper
Private Collection, Ronald Feldman
 Fine Arts, New York
Private Collection, Galerie Daniel
 Malingue, Paris
Private Collection, Galerie St.
 Etienne, New York
Private Collection, Marlborough
 International
Private Collection, Galerie de la
 Présidence – Paris
And those Private Collectors who
 wish to remain anonymous
Ashish Rajadhyaksha in
 collaboration with the
Sammlung Ringier, Zurich
Franck Robichon
The Judith Rothschild Foundation,
 New York
Saatchi Gallery, London
Kanwaldeep and Devinder Sahney

Ibrahim Salahi
Sharmila Samant
Cosmos Andrew Sarchiapone
Sasame Hiroyuki
Freda and Harry Schaeffer
Galerie Thomas Schulte, Berlin
Joseph E. Seagram & Sons, Inc.
Sekine Nobuo
Nigel Shafran
Ketaki Sheth
Shiina Misao
Shiraishi Contemporary Art Inc
Danyanita Singh
Madhu Singhal Udaidur
Estate of Raghubir Singh
Estate of Robert Smithson
Johnny Spencer
Sarah Staton
Vivan Sundaram
Tabata Yukihito
Sooni Taraporevala
Juergen Teller
Wolfgang Tillmans
Tokyo Gallery
Marcus Tomlinson
Emily Tsingou Gallery, London
Gavin Turk
Lee Ufan.
Undercurrents
Video Data Bank, Chicago
Theo Waddington Fine Art, London
Mark Wallinger
Franz Weissmann
White Columns
Wigmore Fine Art
David Zwirner, New York

PUBLIC COLLECTIONS

Amsterdam, Foundation for Indian
 Artists
Baltimore, The Baltimore Museum
 of Art
Basel, Fondation Beyeler,
 Riehen/Basel
Berlin, Berlinische Galerie,
 Landesmuseum für Moderne
 Kunst, Photographie und
 Architektur
Berlin, Staatliche Museen zu
 Berlin, Nationalgalerie
Bern, Kunstmuseum
Bombay, Kamla Raheja Vidyanidhi
 Institute for Architecture
Bradford Art Galleries and
 Museums
Brisbane, Queensland Art Gallery
 Foundation
Cambridge, Wittgenstein Archive
 Cambridge
Cardiff, National Museum &
 Gallery Cardiff
Cateau-Cambrésis, Dépôt au
 Musée Matisse du Cateau-
 Cambrésis
Céret, Musée d'art moderne de
 Céret, France
Cologne, Museum Ludwig
Cologne,
 Theaterwissenschaftliche
 Sammlung, Universität zu Köln
Dublin, National Gallery of Ireland
Duisburg, Wilhelm Lehmbruck
 Museum
Dusseldorf, Kunstmuseum
Dusseldorf, Kunstsammlung
 Nordrheim-Westfalen
Edinburgh, Scottish National
 Gallery of Modern Art
Eindhoven, Stedelijk Van
 Abbemuseum

Fort Worth, Modern Art Museum
 of Fort Worth
Fukuoka Asian Art Museum
Glenbarra Art Museum, Japan
Grenoble, Musée de Grenoble
Halle, Staatliche Galerie
 Moritzburg Halle,
 Landeskunstmuseum Sachsen-
 Anhalt
Hampton University Museum,
 Hampton, Virginia
Hannover, Sprengel Museum
Innsbruck, Tiroler Landesmuseum
 Ferdinandeum
Ithaca, Herbert F. Johnson
 Museum of Art, Cornell
 University
Lisbon, Fundaçao Calouste
 Gulbenkian
London, Arts Council Collection,
 Hayward Gallery
London, Arts Council of England
London, Public Record Office
 Image Library
London, The British Council
London, The British Library Board
London, The Freud Museum
London, The Saatchi Gallery
London, Tate
London, Victoria and Albert
 Museum
Ludwigshafen am Rhein, Wilhelm-
 Hack Museum
Lugano, Thyssen-Bornemisza
 Collection
Madrid, La Colección de Arte de
 Telefónica
Madrid, Museo Thyssen-
 Bornemisza, Madrid
Mainz, African Music Archive,
 University of Mainz
Mainz, Landesmuseum
Moscow, A. A. Bakhrushin State
 Central Theatrical Museum
Moscow, State Mayakovsky
 Museum
Moscow, A M Rodchenko and V F
 Stepanova Archive
Mumbai, Birle Academy of Art and
 Culture
Munich, Staatliche Graphische
 Sammlung
Musashino Art University Museum
 and Library
New York, Bose Pacia Modern
 Gallery
New York, The Metropolitan
 Museum of Art, New York
New York, The Museum of Modern
 Art, New York
New York, Whitney Museum of
 American Art
Norwich, The University of East
 Anglia Collection of Abstract
 and
Constructivist Art, Architecture
 and Design
Paris, Bibliothèque nationale de
 France
Paris, Centre Georges Pompidou,
 Musée national d'art moderne
Paris, Cinémathèque française
Paris, Fonds National d'Art
 Contemporain-Ministère de la
 Culture
Paris, Musée d'Art Moderne de la
 Ville de Paris
Paris, Musée des arts décoratifs
Paris, Musée Picasso
Paris, Musée Zadkine de la Ville
 de Paris
Paris, Musée national de
 l'Orangerie

Pontoise, Musée de Pontoise
Rio de Janeiro, Museu de Arte
 Moderna
Rio de Janeiro, Núcleo de
 Pesquisa e Documentaça*o
Rouen, Musée des Beaux-Arts
Saint-Étienne, Musée d'Art
 Moderne
Sarbrücken, Saarland Museum,
 Stiftung Saarlandischer
 Kulturbesitz
Setagaya Art Museum
Stockholm, Moderna Museet
Strasbourg, Musée d'Art Moderne
 et Contemporain de Strasbourg
Stuttgart, Staatsgalerie
Thessaloniki, The Georges
 Costakis Collection, State
 Museum of Contemporary Art
Tochigi Prefectural Museum of Fine
 Arts
Tokyo, Museum of Contemporary
 Art, Tokyo
Tokyo, Nagoya City Art Museum
Tokyo, Shiraishi Contemporary Art
 inc., and Nagoya City Art
 Museum
Toyama, The Museum of Modern
 Art, Toyama
Troyes, Musée d'Art Moderne de
 Troyes
Ulm, Ulmer Museum
Vevey, Fondation Oskar
 Kokoschka, Musée Jenisch
Vienna, Graphische Sammlung
 Albertina
Vienna, Albertina, Loos Archive
Vienna, Heeresgeschichtliches
 Museum
Vienna, Kufperstichkabinett
 Akademie der Bildenden
 Künste
Vienna, Leopold Museum – Private
 Foundation
Vienna, Museen der Stadt Wien
Vienna, Wiener Stadt– und
 Landesbibliothek,
 Druckschriftensammlung
Villeneuve d'Ascq, Musée d'art
 moderne de Lille Métropole
Washington, Hirshhorn Museum
 and Sculpture Garden,
 Smithsonian Institution
Washington, National Museum of
 African Art, Smithsonian
 Institution
Washington, The Philipps
 Collection
Zug, Kunsthaus Zug / Depositum
 Stiftung Sammlung Kamm
Zürich, Kunsthaus Zürich

LENDERS TO THE EXHIBITION

TATE

Curators: Lutz Becker; Richard Calvocoressi and Keith Hartley; Donna De Salvo; Emma Dexter; Okwui Enwezor and Olu Oguibe; Serge Fauchereau; Geeta Kapur and Ashish Rajadhyaksha; Reiko Tomii; Paulo Venancio Filho with Michael Asbury

Contributing Authors: Ziauddin Sardar; Joachim Schlör; Sharon Zukin

Century City Curatorial Team:
Project Director: Iwona Blazwick
Project Manager: Sarah Tinsley

Bombay/Mumbai/Lagos/London:
Project Leader: Emma Dexter
Project Team: Sophie Clark, Juliet Bingham, Claire Fitzsimmons, Matthew Gansallo, Tanya Barson, Kirsten Berkeley, Jemima Montagu, Arshiya Lokhandwala, Grant Watson

New York/Rio de Janeiro/Tokyo:
Project Leader: Donna De Salvo
Project Team: Sophie McKinlay, Adrian George, Tina Fiske, Amanda Cachia, Melia Marden

Moscow/Paris/Vienna:
Project Leader: Susan May
Project Team: Susanne Bieber, Caroline Hancock, Sarah Carrington

Tate Team: Rachel Barker, Andrew Brighton, Ray Burns, Jane Burton, Helen Cleaveley, Rachel Davies, John Duffet, Stephen Dunn, Rick Forbes, Matthew Gale, Nickos Gogolos, Brian Gray, Tim Green, Penny Hamilton, Roy Hayes, Isla Johnston, Pip Laurenson, Ben Luke, Jerry Mawdsley, Brian McKenzie, Elizabeth McDonald, Lyndsey Morgan, Frances Morris, Derek Pullen, William Rallison, Nadine Thompson, Daniel Tompkins, Piers Townshend, Dominic Willsdon, Calvin Winner

Art Installation: Phil Monk

Architects: Caruso St John

Design: SMITH (Stuart Smith, Geoff Parsons)

Tate Publishing: Rosey Blackmore, Celia Clear, Frances Croxford, Tim Holton, Mary Richards, Odile Matteoda-Witte, Emma Woodiwiss

BOMBAY/MUMBAI

All the participating artists, photographers, film-makers, architects, along with their respective teams and sources, are listed in the catalogue and exhibition. As also the private collectors, museums and galleries who have generously lent works. We gratefully acknowledge them for making this project possible. Thanks to Sen Kapadia, Rahul Mehrotra, Anirudh Paul, Aspi B. Mistry, for help with conceptualising Bombay/Mumbai. Darryl D'Monte for configuring the city's Timeline. Kumar Shahani, Madhava Prasad and Khalid Mohamed for their inputs on Bombay cinema. Nalini Malani, and Atul Dodiya for help in the making of the exhibition. Shireen Gandhy of Gallery Chemould for facilitating the process of the exhibition from start to finish. Karan Grover and Prakash Rao, for technical help. The staff and faculty of the Centre for the Study of Culture and Society, Bangalore, for institutional support and use of their archive. The Centre for Education and Documentation (CED), The Culture Company, and Balkrishna Art for additional source material. Roshan Jagatrai and the Shahani family, Sonia and Dushyant Mehta, Nalini Malani and Shailesh Kapadia for generous hospitality during our Mumbai work-visits. Arshiya Lokhandwala, Shilpa Gupta, Sharmila Samant, Tony Stokes for help in installation. Finally, thanks to Tejaswini Niranjana for her participation and for reading the catalogue and exhibition texts, and to Vivan Sundaram for his support at every stage of the project: from the initial conceptualisation to the production and installation of the exhibition.
Geeta Kapur

LONDON

I would like to thank all the participants, lenders, curators, gallerists and others who gave their time so enthusiastically to this project, but in particular those who have made new work, or reconstructed existing work, or helped in other ways. For ideas and inspiration I am indebted to Val Williams's and Brett Roger's exhibition and catalogue 'Look at Me – Fashion and Photography in Britain, 1960 to the Present', British Council, 1998, and to Claire Catterall, Curator of 'Stealing Beauty', ICA London, 1999. In addition much valued advice has come from: Carl Freedman, Laura Godfrey-Isaacs of home, Denise Hawrysio, Gareth Jones, Martin Maloney, Martin McGeown, Steve McQueen, Alistair O'Neill, Gilles Peterson and Judith Watt. I would also like to thank the following for their time and assistance: Chris Allen, Dave Beech, Jake and Dinos Chapman, Tamsin Dillon, Gavin Fernandes, Louis Nixon, Lisa Panting, Jemima Stehli and Andrea Tarsia; and the Cabinet, Sadie Coles HQ, Interim Art, Matt's, Lehmann Maupin, Victoria Miro, Anthony Reynolds, Saatchi Gallery, Emily Tsingou, White Cube and Wigmore Fine Arts galleries. In addition invaluable assistance has come from Katy Baggott, Irene Bradbury, Catherine Johnston of Eurolounge, Sotiris Kyriacou, Annika McVeigh, Diane Symons for the Estate of Donald Rodney, and Charlotte Wheeler.
Emma Dexter

LAGOS

I would like to extend my immense thanks and gratitude to those who critically contributed to the research and production of the Lagos section of the *Century City* exhibition: Curatorial Assistants Irene Small and Lauri Firstenberg; Research Assistants Irene Small and Kunle Tejuoso; Uchechukwu Nwosu; Sereba Agiobu-Kemmer; Marie Human, Bailey's Archive, Johannesburg; Wolfgang Bender, African Music Archive, University of Mainz; Hugh Alexander, Public Records Office, UK; David Strettels, Magnum; Afolobi Kofo-Abayomi; Jackie Phillips; Peter Obe; Bruce Onobrakpeya; Yusof Grillo; Ulli and Georginia Beier; Uche Okeke, Asele Institute; Zbyszek Plocki, James Cubitt Architects; John Godwin and Gillian Hopwood; Nadja Rottner; Muna el Fituri; Thelma Golden; Steve Rhodes; Tunji Okegbola, Daily Times of Nigeria; Elder J.B. Daramola, National Archives Department, Federal Ministry of Information and Culture, Lagos; Mr. Adeniram, Director of National Archives, Ibadan; Umebe N. Onyejekwe, National Museum, Lagos; Dr. Yaro Gella and Vicky James, National Commission for Museums and Monuments, Abuja; J. P. Clark; David Araedeon, University of Lagos; Frank and Emily Aig-Imoukhuede; Bolaji and Kemi Balogun Family.
Okwui Enwezor

MOSCOW

I would like to thank the following collectors and curators for their generous help and good advice: Merrill C. Berman, Rye, New York; Militadis Papanikolaou, Thessaloniki; in Cologne, Evelyn Weiss, Chrysanthi Katrouzinis, Alex Lachmann, Gerald Kohler; in Moscow, Svetlana Strizhneva, Natalya Adaskina, Tatiana Gubanova, Tatiana Borisnova Klim, Igor Kazous, Alexandr Lavrentiev, the staff of the British Council in Moscow, Sasha Dugdalc, Masha Kozlovskaya, and my translator Dasha Rozenshein. I remember with love and gratitude Camilla Gray, the author of the first study on the Russian and Soviet avant-garde *The Great Experiment: Russian Art 1863–1922* which was published in 1962. Thirty years ago, in 1971, the year of her death, she organised for the Hayward Gallery the exhibition *Art in Revolution* which she dedicated to the artists of that forgotten avant-garde.
Lutz Becker

NEW YORK

I would like to extend my deepest appreciation to the numerous individuals who have made possible the New York section of Century City, especially the participating artists who have assisted us: Lynda Benglis, Mary Miss, Babette Mangolte, Mary Beth Edelson, Dennis Oppenheim, Vito Acconci, Joan Jonas, Nancy Holt, Trisha Brown, and Adrian Piper. Barbara Moore graciously opened up her archives, as did Jean Noel Herlin, Jon and Joanne Hendricks, Paul Ha, Janis Ekhdahl, Don Clampett and the Village Voice. Tina Fiske has provided invaluable research throughout. For help in securing loans in the USA, my sincere thanks to Barry Rosen, Carla Caccamise Ash, Barry Winiker, Ronald and Frayda Feldman, Mark Nochella, Barbara Gladstone, Jessica Frost, Elyse Goldberg, James Cohan, Carlos Basualdo, Joan Hendricks, Maurice Berger, Jan Schollenberger, James Ingo Freed, Catherine, Morris, John Chiem, Linda Kramer, Howard Read, Robert Del Principe, Amy Plumb, Angela Choon, David Zwirner, Daniel Reich,Eugenie Tsai, Sylvia Wolf, Maxwell Anderson, Michael Auping, Marla Price and Abina Manning; in London, The Lux; in Switzerland, Florian Berktold and Ulrike Groos; and in Germany, Markus Muller, Michael Janssen and Thomas Schulte. For their advice, I am grateful to Holly Solomon, Jane Crawford, Chuck Helm, William Horrigan and Nina Yankowitz; and to Sacha Craddock and Linda Norden, for critical reading of the essay and generous counsel throughout.
Donna De Salvo

PARIS

In addition to all the lenders to the exhibition listed in this book I would also like to thank: Patrick Bongers; Comité Picabia; Christian Derouet; Anne-Marie Di Viste; Guy Krohg; Sylvian Laboureur; Claude Laurens; Bertrand and Olivier Louquin; Jackie Monnier; Andrea Nuti; Galerie Maeght, Paris; Josette Rasle; and Gina and Romana Severini.
Serge Fauchereau

RIO DE JANEIRO

Ana Holck, Amílcar de Castro, Cesar Oiticica and Projeto Hélio Oiticica, Cláudia Ricci, Cosac & Naify Edições, Dora Jobim and Jobim Music, Eduardo Constantini, Elisabete R. de Martins, Eugênio Paccelli, Fernando Ortega, Ferreira Gullar, Fondation Le Corbusier, Franz Weissmann, Haruyoshi Ono and Burle Marx and Cia. Ltda., Instituto Moreira Salles, José Paulo Gandra Martins, Maria Carmem Zilio, Maria Cristina Burlamaqui, Museu de Arte Moderna do Rio de Janeiro, Noemia Buarque de Holanda, Núcleo de Pesquisa e Documentação FAU/UFRJ, Lygia Pape, Oscar Niemeyer, Raquel Arnaud, Waltraub Weissmann.
Paulo Venancio Filho

TOKYO

I would like to extend my utmost gratitude to all the lenders and artists. The following art professionals generously assisted my research: Akashi Hitoshi, Amiya Yoshiko, Dehara Hitoshi, Fukushima Fumiyasu, Hitomi Iwasaki, Jon Hendricks, Kokatsu Reiko, Kubota Maho, Masuda Rei, Karla Merrifield, Mitsuzono Setsuko, Onodera Reiko, Oyobe Katsuhito, Seki Naoko, Shiraishi Kazumi, Takakura Isao, Takemoto Katsuko, Watanabe Yoko, Yagi Hiromasa, Yamada Satoshi, Yamamoto Hozu, and Yamamoto Kazuhiro. I am immensely indebted to those who shared their ideas and experiences with me: Jane Farver, Futagawa Yoshio, Kashiwagi Hiroshi, Kondo Tatsuo, Maki Fumihiko, Masuda Akihisa, Minemura Toshiaki, Miyamoto Ryuji, Moriyama Daido, Alexandra Munroe, Nakahira Eiko, Martin Parr, Sawada Yoko, Suzuki Hiroyuki, Takanashi Yutaka, Taki Koji, Tani Arata, Tan'o Yasunori, Yamashita Masako and Yasumi Akihito. Last but not least, I thank Kathleen M. Friello, Nakajima Masatoshi, Nakajima Yasuko and Jeff Rothstein for their invaluable editorial, research and moral support.
Reiko Tomii

VIENNA

In selecting our section of Century City and in researching this essay, we have benefited from the help and advice of the following people: in Vienna, Hermann Böhm, Emil Brix, Günter Düriegl, Wolfgang and Jutta Fischer, Antonia Hoerschelmann, Brigitte Holl, Renata Kassal-Mikula, Edelbert Köb, Monika Knoffler, Markus Kristan, Ilse Krumpöck, Bernhard Leitner, Rudolf and Elisabeth Leopold, Rudolf Niedersüss, Walter Obermaier, Klaus-Albrecht Schröder, Romana Schuler, Pierre Stonborough, Ursula Storch, Patrick Werkner, Johann Winkler, Christian Witt-Dörring, Gloria Zultano, Alfred Weidinger; in Austria, Daisy Bene, Otto Huber; in Switzerland, Bernhard Blatter, Matthias Haldemann, Mr & Mrs Peter Kamm, Dominique Radrizzani; in New York, Garry Garrels, Jane Kallir, Ronald Lauder, William Lieberman, Renée Price, Cora Rosavear; in USA, Peter and Lili Knize; in London, Lutz Becker, Erica Davies, Ellen Josefowitz, Gilbert Lloyd, Michael Molnar, Richard Nagy, Johnny Stonborough, Robin Symes, Michael Zimmerman; in Cambridge, Michael Nedo; and in Scotland, Andrew Barker, Iain Boyd-Whyte, Giles Havergal and Alice O'Connor. Our thanks to them, to all the lenders and to Susan May and Susanne Bieber at Tate Modern.
Richard Calvocoressi and Keith Hartley

PHOTOGRAPHIC CREDITS

All works are Courtesy The Artist or The Estate of the Artist unless otherwise stated.

BOMBAY 18 National Film Archive of India, Pune; 19 Hoshi Jal, Courtesy Times of India, Mumbai; 23, 27 (right), 33 (below), 38 (below) Prakash Rao; 28, 30 (above) Dayanita Singh; 30 (right) The Culture Company, Mumbai; 34 Queensland Art Gallery Foundation, Brisbane; 35 (above) Ram Rahman, New Delhi; 37 Photo by Meenal Agarwal, courtesy of Bradford Art Galleries and Museums; 39 Fukuoka Asian Art Museum **LAGOS** 42, 52 Bruno Barbey/Magnum Photos; 50, 62 National Museum of African Art, Smithsonian Institution, Washington, D.C.; 51 Public Record Office Image Library; 53 DRUM Photographer/ Baileys Archives; 55 From the archive of John Godwin and Gillian Hopwood; 56 C.A.A.C. – The Pigozzi Collection, Geneva; 58, 60 African Music Archive, University of Mainz; 59 Published by Heinemann, London, Melbourne, Toronto. Wrapper design by Peter Edwards; 65 (above) Nimbus Art Gallery, Lagos; 67 Courtesy Stanley Lederman **LONDON** 73 (right) Tate Gallery Photographic Department; 73 (below) The artists and Emily Tsingou Gallery, London; 77 Arts Council Collection, Hayward Gallery, London; 82 The artist and Lehmann Maupin, New York; 84 The artist and Cabinet, London; 85 Maureen Paley/Interim Art, London; 86 The artist and the Saatchi Gallery, London; 89 Photo Hugo Glendenning, Courtesy Jay Jopling/White Cube, London; 90 Courtesy Jay Jopling/White Cube, London; 91 The artist and Sadie Coles HQ, London; 92 Hussain Chalayan and Marcus Tomlinson **MOSCOW** 96, 112 Galerie Alex Lachmann, Cologne; 98, 99, 100, 109, 117, 118 Collection Merrill C. Berman. Photo: Jim Frank; 104 Markus Lemberger, Joachim Werkmeister, Graphische Gruppe Ludwigshafen; 105 Museum Ludwig, Cologne; 106 (left) Shchusev State Research Museum of Architecture, Moscow; 106 (right) Gallery Gmurzynska, Cologne; 110 Staatliche Galerie Moritzburg, Halle (photo: Reinhard Hentze); 111 Thyssen Bornemisza Collection, Lugano; 113 State Museum of Contemporary Art, Thessaloniki; **NEW YORK** 122, 129 Babette Mangolte; 125 The Andy Warhol Foundation Inc./Art Resource, NY; 127 National Gallery of Canada, Ottowa; 128 Photo by Peter Moore, Courtesy the Estate of Peter Moore; 131 Pat Hearn Gallery; 132 Tate Gallery Photographic Department; 134 (below) The artist and Video Data.Bank, Chigago; 134 (right), 135 Gallery Cheim & Read, New York; 137 Barbara Gladstone

Gallery, New York; 139 Rosemary Mayer **PARIS** 148 R.M.N.– Picasso; 150, 152, 156, 171 Tate Gallery Photographic Department; 154 Musée Picasso, Paris; 155 Collection Cinémathèque française, Paris; 157 (above) Wilhelm Lehmbruck Museum, Duisburg; 157, 158 Collection Violet; 159 Dépot Musée du Matisse du Cateau-Cambrésis; 160 (centre), 162 Galerie Daniel Malingue; 160 (below) Centre Georges Pompidou, Paris; 161, 166, 167 Musée d'Art Moderne de Lille Métropole Villeneuve d'Asq; 163 Fondation Beyeler, Riehen/Basel; 165 Musée d'Art Moderne. Saint-Etienne; 166 Branger-Viollet; 168 The Victoria & Albert Museum, London; 172 Musée d'art moderne de la Ville de Paris. Photo: Photéque des Musées de la Ville de Paris/Delepelaire **RIO DE JANEIRO** 176, 183, 184, 185, 186 (above) Photo Marcel Gautherot. Collection Instituto Moreira Salles; 178 Photo Pedro Franciosi. Museu de Arte Moderna do Rio de Janeiro; 179 Courtesy Eugenio Pacelli Pires dos Santos; 180 Ferreira Gullar personal archives; 182 Collection Fondation Le Corbusier, Paris; 186 (right) Jobim Music Archives; 188, 189, 195 Projéto Helio Oiticica; 191 Tate Gallery Photographic Department; 193 (below) Cosac & Naify Editions Ltd; 194 (below) Luiz Buarque de Hollanda; 194 (above right) Jose Paulo Gandra Martins **TOKYO** 198 Asahi Shimbun; 200 Franck Robichon; 203 The Mainichi Newspapers; 204, 205, 206 Osiris, Tokyo; 207, 208 Musashino Art University Museum and Library, Tokyo; 210 (right) Museum of Contemporary Art, Tokyo; 214 (far left) SCAI The Bathhouse, Tokyo. Photo courtesy Nagoya City Art Museum; 214 (left) Maeyama Tadashi; 216 Gallery Nippon, Tokyo; 217 Japan Society, New York; 218 Setagaya Art Museum, Tokyo; 219 (below right) Tochigi Prefectural Museum of Fine Arts **VIENNA** 227, 235, 240, 243 Leopold Museum, Private Foundation, Vienna; 224, 228, 230 (right), 241 Museen der Stadt Wien, Vienna; 229 Staatliche Museen zu Berlin, Nationalgalerie. Photo Jörg P. Anders, Berlin; 231 Loos Archive, Albertina, Vienna; 232 Atelier Joël-Heinzelmann, Berlin; 236 Photo Edmund Engelman. Courtesy Thomas Engelman, Newton; 237 Szépművészeti Muzeum, Budapest. Photo András Rázsó; 238 Marlborough International Fine Art; 239 Photo Anton Josef Trcka; 242 Graphische Sammlung Albertina, Vienna; 244 Wittgenstein Archive, Cambridge. Photo Bernard Leitner and Elisabeth Kohlweiss; 245 Wittgenstein Archive, Cambridge; 246 247 Heeresgeschichtliches Museum im Arsenal, Vienna

COPYRIGHT CREDITS

Every effort has been made to trace the copyright owners of the works reproduced. The publishers apologise for any omissions that may inadvertently have been made.

All works are © The Artist or © The Estate of the Artist unless otherwise stated.

BOMBAY 16, 25, 27 (above) Photographs © 2001 by Succession Raghubir Singh. All rights reserved; 18 © National Film Archive of India, Pune; 19 © Times of India, Mumbai; 27 (right) © Prakash Rao, Mumbai 2001 **LAGOS** 42, 52 © Bruno Barbey/Magnum Photos; 53 © Baileys Archives **MOSCOW** Ignatovich; El Lissitzky; Rodchenko; Stepanova; Telingater © DACS 2001; Gontcharova; Vesnin © ADAGP, Paris and DACS, London 2001 **NEW YORK** Trisha Brown's *Roof Piece*, Richard Foreman's *Hotel China* and Yvonne Rainer's *Film About a Woman Who...* Copyright © Babette Mangolte, all rights of reproduction reserved; Benglis © DACS, London and VAGA, New York 2001; Matta-Clark © ARS, NY and DACS, London 2001; Moore © The Estate of Peter Moore, DACS, London and VAGA, New York 2001; Warhol © The Andy Warhol Foundation for the Visual Arts, Inc./ARS, NY and DACS, London 2001 **PARIS** Archipenko, Braque; Chagall; de Vlaminck; Dufy; Kupka; Leger; Pascin; Purmann; Severini; Survage © ADAGP, Paris and DACS, London 2001; Delaunay © L & M Services B.V. Amsterdam 20010101; Picasso © Succession Picasso/DACS 2001 **VIENNA** Kokoschka © DACS 2001; Loos © DACS 2001

LUTZ BECKER is a freelance curator based in London. He recently co-curated the celebrated *Art and Power* exhibition in London, Berlin and Barcelona, and *Das 20. Jahrhundert. Ein Jahrhundert Kunst in Deutschland* at the National Gallery in Berlin. **IWONA BLAZWICK** is a curator and critic, and is Head of Exhibitions and Display at Tate Modern. She has curated numerous exhibitions on modern and contemporary artists, themes and movements from around the world. Recent publications include contributions to *Ilya Kabokov* (1999), *Fresh Cream* and the *Carnegie International* (2000). **RICHARD CALVOCORESSI and KEITH HARTLEY**, Director and Senior Curator at the Scottish National Gallery of Modern Art, Edinburgh have curated and written for a number of outstanding shows. Hartley was co-curator of *The Romantic Spirit in German Art, 1790–1990* in Edinburgh, London and Munich. Calvocoressi curated the comprehensive survey of Oskar Kokoschka's work at the Tate Gallery in London. **EMMA DEXTER** is a Senior Curator at Tate Modern. She was previously Director of Exhibitions at the ICA, where she curated solo exhibitions by Marlene Dumas, Gary Hume, Sarah Sze, Thomas Scheibitz and Steve McQueen, as well as numerous group shows. Prior to the ICA she was Director of Chisenhale Gallery, London, where she commissioned Rachel Whiteread's *Ghost*. **DONNA DE SALVO** is a Senior Curator at Tate Modern with an extensive history of exhibitions and publications on contemporary art and culture, including the exhibitions *Hand-Painted Pop: American Art in Transition 1955–1962* (1992) and *Ray Johnson: Correspondences* (1999); and on artists including Barbara Bloom, Gerhard Richter, John Chamberlain, Cy Twombly and Barnett Newman. **OKWUI ENWEZOR** is a curator and writer based in New York. He is the artistic director of *Documenta XI*. He is founding editor and publisher of *NKA: Journal of Contemporary African Art*, based at African Studies Center, Cornell University, New York, and visiting professor at University of Umea, Sweden and The School of the Art Institute of Chicago. **SERGE FAUCHEREAU** is a curator and author whose first major exhibitions include *Paris-New York*, *Paris-Berlin* and *Paris-Moscow* at the Centre Pompidou, Paris in the 1970s. Recently he has curated *Forjar El Espacio*, an exhibition touring Spain and France through 1999/2000. He is currently preparing *Madrid-Paris* for the Reina Sofia, Madrid. Key publications include monographs on Arp, Kupka, Leger, Malevich, Mondrian and on the Cubist and Surrealist movements.

GEETA KAPUR is a critic and curator based in New Delhi. She is a founder-editor of *Journal of Arts & Ideas* (New Delhi) and advisory editor to *Third Text* (London), *Marg* (Mumbai) and *Visual Arts and Culture* (Sydney). She has published monographic studies on Indian artists, anthologies of contemporary Indian art, and a series of essays on the cultural politics of Indian Modernism. **OLU OGUIBE** is an artist, art historian and poet based in New York. His publications include *Uzo Egonu: An African Artist in the West* and *Reading the Contemporary: African Art from Theory to the Marketplace* (with Okwui Enwezor). **ASHISH RAJADHYAKSHA** is a film theorist and cultural historian from Bombay. He is author of *Ritwik Ghatak: A Return to the Epic* (1984) and co-editor of the *Encyclopaedia of Indian Cinema* (1995/1999). He has worked extensively on the social/cultural history of Bombay. He is an expert on Indian cinema, Marathi theatre and literature. **ZIAUDDIN SARDAR** is editor of *Third Text* and Visiting Professor of Postcolonial Studies, Department of Arts Policy and Management, The City University, London. His most recent publications include *Postmodernism and the Other* (1998), *Orientalism* (1999); and *The Consumption of Kuala Lumpur* (2000). **JOACHIM SCHLÖR** is a researcher at Moses Mendelsohn Center, Potsdam, Berlin. His publications include *Nights in the Big City* (1998) and *Tel Aviv: from Dream to City* (1999). **REIKO TOMII** is a curator, art critic and writer based in Tokyo. She is a contributing editor for *Yoko Ono: A Multimedia Retrospective* (2000). She has been involved in the genesis of several exhibitions including *Global Conceptualism: Points of Origin 1950s–1980s* (Queens Museum of Art, NY, 1999) and *Six O'Clock Observed: Photo by Toyo Tsuchiya* (Asian American Arts Center, NY, 1999). **PAULO VENANCIO FILHO** is art critic and associate professor of art history at the Federal University of Rio de Janeiro. He is the author of articles published in the following catalogues: *Tunga/Cildo Meireles* (Kanaal Art Foundation, Belgium), *Transcontinental* (Verso, London-New York), *Cartographies* (National Gallery of Canada), *America: bride of the sun* (Royal Museum of Fine Arts, Antwerp), *Inside the Visible* (The Institute of Contemporary Art, Boston), Zeitwenden (Kunstmuseum, Bonn). **SHARON ZUKIN** is Professor of Sociology at Brooklyn College, New York. Her publications include *Loft Living: Culture and Capital in Urban Change* (1982) and *The Culture of Cities* (1995).

Tate relies on a large number of supporters – individuals, foundations, companies and public sector sources – to enable it to deliver its programme of activities both on and off its gallery sites. This support is essential in order to acquire works of art for the Collection, present education, outreach and exhibition programmes, care for the Collection in storage and enable art to be displayed, both digitally and physically, inside and outside Tate. Your funding will make a real difference and enable others to enjoy Tate and its Collections, both now and in the future. There are a variety of ways in which you can help support Tate and also benefit as a UK or US taxpayer. Please contact us at:

The Development Office
Tate, Millbank, London SW1P 4RG
Telephone: 020 7887 8000
Facsimile: 020 7887 8738

American Fund for the Tate Gallery
1285 Avenue of the Americas
(35th fl)
New York
NY 10019
Telephone: 001 212 713 8497
Facsimile: 001 212 713 8655

DONATIONS

Donations, of whatever size, from individuals, companies and trusts are welcome, either to support particular areas of interest, or to contribute to general running costs.

Gifts of Shares
Since April 2000 we are able to accept gifts of quoted share and securities. These are not subject to capital gains tax. For higher rate taxpayers, a gift of shares would save income tax as well as capital gains tax. For further information please contact the Campaigns Section of the Development Office.

Gift Aid
Through Gift Aid, you are able to provide significant additional revenue to Tate for gifts of any size, whether regular or one-off, since we can claim back the tax on your charitable donation. Higher rate tax payers are also able to claim additional personal tax relief. A Gift-Aid Donation form and explanatory leaflet can be sent to you if you require further information.

Legacies and Bequests
Bequests to Tate may take the form of either a specific cash sum, a residual proportion of your estate or a specific item of property such as a work of art. Tax advantages may be obtained by making a legacy in favour of Tate; in addition, if you own a work of art of national importance you may wish to leave it as a direct bequest or to the Government in lieu of tax. Please check with Tate when you draw up your will that it is able to accept your bequest.

American Fund for the Tate Gallery
The American Fund for the Tate Gallery was formed in 1986 to facilitate gifts of works of art, donations and bequests to Tate from United States residents. It receives full tax exempt status from the IRS.

MEMBERSHIP PROGRAMMES

Members and Fellows
Individual members join Tate to help provide support for acquisitions for the Collection and a variety of other activities, including education resources, capital initiatives and sponsorship of special exhibitions. Benefits vary according to level of membership. Membership costs start at £24 for the basic package with benefits varying according to level of membership. There are special packages for supporters of Tate Liverpool and Tate St Ives.

Patrons
Patrons are people who share a keen interest in art and are committed to giving significant financial support to Tate on an annual basis, specifically to support acquisitions. There are four levels of Patron: Associate Patron (£250), Patrons of New Art (£500), Patrons of British Art (£500) and Patrons Circle (£1000). Patrons enjoy opportunities to sit on acquisition committees, special access to the Collection and entry with a family member to all Tate exhibitions.

Tate American Patrons
Residents of the United States who wish to support Tate on an annual basis can join the American Patrons and enjoy membership benefits and events in the United States and United Kingdom. Single membership costs $1000 and double membership $1500. Please contact the American Fund for the Tate Gallery for further details.

Corporate Membership
Corporate Membership at Tate Liverpool and Tate Britain, and support for the Business Circle at Tate St Ives, offers companies opportunities for exclusive corporate entertaining and the chance for a wide variety of employee benefits. These include special private views, free admission to paying exhibitions, out-of-hours visits and tours, invitations to VIP events and talks at the workplace. Tate Britain is only available for entertaining by companies who are either Corporate members or current Gallery sponsors.

Founding Corporate Partners
Until the end of March 2003, companies are also able to join the special Founding Corporate Partners Scheme which offers unique access to corporate entertaining and benefits at Tate Modern and Tate Britain in London. Further details are available on request.

Corporate Investment
Tate has developed a range of imaginative partnerships with the corporate sector, ranging from international interpretation and exhibition programmes to local outreach and staff development programmes. We are particularly known for high-profile business to business marketing initiatives and employee benefit packages. Please contact the Corporate Fundraising team for futher details.

CHARITY DETAILS
Tate is an exempt charity; the Museums & Galleries Act 1992 added the Tate Gallery to the list of exempt charities defined in the 1960 Charities Act. The Friends of the Tate Gallery is a registered charity (number 313021). The Tate Gallery Foundation is a registered charity (number 295549).

TATE MODERN:
Donors to the Capital Campaign by Category in alphabetical order

Founders
The Arts Council of England
English Partnerships
The Millennium Commission

Founding Benefactors
Mr and Mrs James Brice
The Clore Foundation
Gilbert de Botton
Richard B and Jeanne Donovan Fisher
Noam and Geraldine Gottesman
Anthony and Evelyn Jacobs
The Kresge Foundation
The Frank Lloyd Family Trusts
Ronald and Rita McAulay
The Monument Trust
Mori Building Co., Ltd
Mr and Mrs MD Moross
Peter and Eileen Norton, The Peter Norton Family Foundation
Maja Oeri and Hans Bodenmann
The Dr Mortimer and Theresa Sackler Foundation
Stephan Schmidheiny
Mr and Mrs Charles Schwab
Peter Simon
London Borough of Southwark
The Starr Foundation
John Studzinski
The Weston Family
Poju and Anita Zabludowicz

Benefactors
Frances and John Bowes
Donald L Bryant Jr Family
Sir Harry and Lady Djanogly
Donald and Doris Fisher
The Government Office for London
Mimi and Peter Haas
The Headley Trust
Mr and Mrs André Hoffmann
C. Richard and Pamela Kramlich

Major Donors
The Annenberg Foundation
The Baring Foundation
Ron Beller and Jennifer Moses
Alex and Angela Bernstein
Mr and Mrs Pontus Bonnier
Lauren and Mark Booth
Ivor Braka
Melva Bucksbaum
Edwin C Cohen
Carole and Neville Conrad
Michel and Helene David-Weill
English Heritage
Esmée Fairbairn Charitable Trust
Friends of the Tate Gallery
Bob and Kate Gavron
Giancarlo Giammetti
The Horace W Goldsmith Foundation
Lydia and Manfred Gorvy
The Government of Switzerland
Mr and Mrs Karpidas
Peter and Maria Kellner
Mr and Mrs Henry R Kravis
Irene and Hyman Kreitman
Catherine and Pierre Lagrange
Edward and Agnes Lee
Ruth and Stuart Lipton
James Mayor
The Mercers' Company
The Meyer Foundation
Guy and Marion Naggar
William A. Palmer

The Nyda and Oliver Prenn
 Foundation
The Rayne Foundation
John and Jill Ritblat
Barrie and Emmanuel Roman
Lord and Lady Rothschild
Belle Shenkman Estate
Hugh and Catherine Stevenson
Charlotte Stevenson
David and Linda Supino
David and Emma Verey
Clodagh and Leslie Waddington
Robert and Felicity Waley-Cohen

Donors
The Asprey Family Charitable
 Foundation
Lord and Lady Attenborough
David and Janice Blackburn
Mr and Mrs Anthony Bloom
Mr and Mrs John Botts
Cazenove & Co.
The John S Cohen Foundation
Ronald and Sharon Cohen
Sadie Coles
Giles and Sonia Coode-Adams
Alan Cristea
Thomas Dane
Judy and Kenneth Dayton
The Fishmongers' Company
The Foundation for Sport and the
 Arts
Alan Gibbs
Mr and Mrs Edward Gilhuly
Helyn and Ralph Goldenberg
The Worshipful Company of
 Goldsmiths
Pehr and Christina Gyllenhammar
Richard and Odile Grogan
The Worshipful Company of
 Haberdashers
Hanover Acceptances Limited
Jay Jopling
Howard and Linda Karshan
Lady Kleinwort
Brian and Lesley Knox
The Lauder Foundation – Leonard
 and Evelyn Lauder Fund
Ronald and Jo Carole Lauder
Leathersellers' Company
 Charitable Fund
Lex Service Plc
Mr and Mrs Ulf G.Linden
Anders and Ulla Ljungh
Mr and Mrs George Loudon
David and Pauline Mann-Vogelpoel
Nick and Annette Mason
Viviane and James Mayor
Anthony Montagu
Sir Peter and Lady Osborne
Maureen Paley
Mr Frederik Paulsen
The Pet Shop Boys
David and Sophie Shalit
William Sieghart
Mr and Mrs Sven Skarendahl
Sir Paul and Lady Smith
Mr and Mrs Nicholas Stanley
The Jack Steinberg Charitable
 Trust
Carter and Mary Thacher
Insinger Townsley
The 29th May 1961 Charitable
 Trust
Dinah Verey
The Vintners' Company
Gordon D Watson
Mr and Mrs Stephen Wilberding
Michael S Wilson

and those donors who wish to
remain anonymous

TATE COLLECTION DONORS

Tate Collection Founders
Sir Henry Tate
Sir Joseph Duveen
Lord Duveen
Heritage Lottery Fund

Tate Collection Benefactors
American Fund for the Tate Gallery
Douglas Cramer
Friends of the Tate Gallery
The Kreitman Foundation
Sir Edwin and Lady Manton
The Henry Moore Foundation
National Art Collections Fund
National Heritage Memorial Fund
Patrons of British Art
Patrons of New Art
Janet Wolfson de Botton

Tate Collection Major Donors
Edwin C Cohen
The Getty Grant Program
The Horace W Goldsmith
 Foundation
C. Richard and Pamela Kramlich
The Robert Lehman Foundation,
 Inc
The Leverhulme Trust

Tate Collection Donors
Howard and Roberta Ahmanson
Lord and Lady Attenborough
Mr Tom Bendhem
Robert Borgerhoff Mulder
The British Council
Neville and Marlene Burston
Mrs John Chandris
The Clothworkers Foundation
The Daiwa Anglo-Japanese
 Foundation
Judith and Kenneth Dayton
Foundation for Sport and the Arts
Mr Christopher Foley
The Gapper Charitable Trust
The Gertz Foundation
The Great Britain Sasakawa
 Foundation
HSBC Artscard
Sir Joseph Hotung
Mr and Mrs Michael Hue-Williams
The Idlewild Trust
The Japan Foundation
The Kessler Family Re-Union
Mr Patrick Koerfer
John Lyon's Charity
The Paul Mellon Centre for Studies
 in British Art
Peter and Eileen Norton, The Peter
 Norton Family Foundation
Mr David Posnett
The Radcliffe Trust
The Rayne Foundation
Mr Simon Robertson
Lord and Lady Rothschild
Mrs Jean Sainsbury
Scouloudi Founation
Stanley Foundation Limited
Mr and Mrs A Alfred Taubman
The Vandervell Foundation
Mr and Mrs Leslie Waddington

and those donors who wish to
remain anonymous

Tate Collection Sponsor
Carillion plc
Paintings Conservation
(1995–2000)

**TATE FOUNDING CORPORATE
PARTNERS**

AMP
Avaya UK
BNP Paribas
CGNU plc
Clifford Chance
Energis Communications
Freshfields Bruckhaus Deringer
GLG Partners
Goldman Sachs International
Lazard
Lehman Brothers
London & Cambridge Properties
 Limited
London Electricity plc, EDF Group
PaineWebber
Pearson plc
Prudential plc
Railtrack PLC
Reuters
Rolls-Royce plc
Schroders
UBS Warburg
Wasserstein Perella & Co
Whitehead Mann GKR

TATE MODERN DONORS

Founding Benefactor
The Paul Hamlyn Foundation

Donors
The Annenberg Foundation
Sophie and Karl Binding Stiftung
Canton of Basel
Mr Edwin C Cohen
The Elephant Trust
The Great Britain Sasakawa
 Foundation
The Government of Switzerland
The Japan Foundation
London Arts
Pro Helvetia
The Judith Rothschild Foundation

and those donors who wish to
remain anonymous

TATE MODERN SPONSORS

Founding Sponsors
Bloomberg
Tate Audio, Reading Points, Audio
Points (2000–2003)

BT
Tate Modern: Collection
(2000–2002)

Unilever
The Unilever Series (2000–2004)

Major Sponsors
CGNU plc
Century City: Art and Culture in the
Modern Metropolis (2001)

Ernst & Young
Tate Modern Visitor Centre
(1997–2000)

PaineWebber
Office for the Tate American Fund
(1999–2001)

Tate & Lyle PLC
Tate Friends (1991–2000)

Sponsors
Deutsche Bank
Herzog & de Meuron: 11 Stations
(2000)

The Guardian/The Observer
Media Sponsor for the Tate 2000
Launch (2000)
Media Partner for Century City: Art
and Culture in the Modern
Metropolis (2001)